Moira Roth

PERFORMANCE
BY ARTISTS

Edited by
AA BRONSON & PEGGY GALE

ART METROPOLE
217 Richmond Street West, Toronto, Canada

ACKNOWLEDGEMENTS

Our thanks to the artists and writers who so generously contributed information, photographs and articles to this book.

A special thankyou to Martha Fleming, Shelagh Young and Tim Guest for their continuing patient help on this lengthy project; and to René Blouin and Grace Dencker for their aid in translation.

All photos courtesy of the artist except where otherwise noted. ·

We wish to thank the Canada Council for their support of this publication and also for their continuing support of Art Metropole.

Typesetting by Type A, Toronto.
Printed by Webcom, Scarborough.

Cover: Ulrike Rosenbach
Back cover: Clive Robertson

CONTENTS

PREFACE

PERFORMANCE BY ARTISTS has gone through many transformations in the course of its preparation, but the original form has been maintained: a narrow time reference in the present and a broad geographical one.

In English, French, German, Italian, the word is always the same: "performance" as both term and concept is international in application. Yet this single word should not imply homogeneity of intent or execution. In Canada and the USA there seemed to be a strong reference in performance work to entertainment, commercial television and advertising, broader media issues. General Idea, Clive Robertson, Tom Sherman and Laurie Anderson all touch on different such aspects, as do many of the productions from the Western Front in Vancouver. Performances seemed more narrative, discursive, story-oriented, and longer in length — extending to a full evening's programme. The European works as a whole seemed more theoretical, more intellectualised — if only because of the apparent rejection of those qualities of narration and entertainment. Many of the pieces were/are very short, summary demonstrations of a single idea. Some performances seemed almost to negate time, as in the tableaux vivants of Luigi Ontani, or to sidestep it as an issue, as in the actions of Marina Abramović and Ulay. Both these latter examples can also be seen as a form of extended sculpture, moving through space volumetrically.

In both Europe and America there seemed to be significant numbers of performances by women, original in form, varied in content, and addressing a broad range of issues. It seemed important to consider works by women in this context as offering a possible insight into the development of performance activity and rationale overall.

These are the ideas with which we started. Yet as the materials for the book were collected, and the individual essays and photoworks produced, these easy generalities seemed less and less verifiable. Just as performance activity clearly cannot simply be relegated to current fashion, a general trend on the international scene, neither do national characteristics hold, nor convenient categories. The work produced today is new, in that it has not evolved in a linear fashion from events at the turn of the century, nor directly from dada, or Happenings, or Fluxus, or body art. Yet all of these ingredients surface to different degrees in the work of the various individuals. Acconci and Beuys, in the context of this book, are closest to the foundations of current activity. The others diverge, dancing to different tunes.

The intention of *Performance By Artists* has not been to *define* current performance, but to point out its variety and interrelationships. The extended bibliography refers to other areas (theatre, dance, writing), and extends backwards in time beyond the range of a single volume. And since the texts and pieces have been compiled, already *Performance By Artists* is situated in the (immediate) past.

We had intended to specify the differences between current performance in North America and Europe, to offer contrasts between the different centres and issues. Instead we have found parallels and underlying consistencies. The work, and the commentaries, come from individuals.

Peggy Gale
June, 1979

INTRODUCTION: NOTION(S) OF PERFORMANCE[1]
NOTION(S) DE PERFORMANCE

Chantal Pontbriand

PERFORMANCE est un mot qui, appliqué au vocabulaire de l'art contemporain, peut poser quelque difficulté: certains, comme l'artiste allemand Klaus Rinke, diront qu'il s'agit là d'un terme essentiellement nord-américain. Rinke préfère au mot performance les mots action ou demonstration[2], estimant que l'utilisation du premier terme est due davantage à une confusion des genres entre la musique, la danse et les arts visuels. La performance peut par ailleurs être assimilée à une *intervention*, tant soit peu qu'elle intervienne dans la réalité physique ou sociale. Elle est aussi art corporel, mais va au delà du style dont les considérations narcissiques peuvent être limitatives, de même que l'insistance sur la présence même du corps.

Que la performance emprunte aux domaines connus de la musique, du théâtre ou de la danse, qu'elle soit une extension des problématiques visuelles et spatiales ou temporelles purement formelles, ou qu'elle utilise simultanément des données de chacune des possibilités énumérées, définitivement, il s'agit d'un phénomène différent, difficile à définir, caractérisé par la multiplicité des tendences et des formes.

"Les oeuvres d'art emergent d'un dialogue complexe entre le moi et la société, des intérêts particuliers du "monde de l'art" et ainsi de suite. L'artiste peut décider d'implanter son oeuvre dans le courant de l'art contemporain, ce qui résulte en une tendance vers le formalisme et la tentative de pousser "un peu plus loin" un aspect particulier de l'art déjà existant. L'artiste peut cependant choisir de se tourner vers lui-même, au sens d'examiner le rapport entre le moi et la société, le moi et l'histoire. En résumé, l'artiste peut choisir d'étudier la position du moi dans le monde."[3]

PERFORMANCE is a word which, when applied to the vocabulary of contemporary art, can present some difficulty: some, such as German artist Klaus Rinke, say that this is essentially a North American term. Rinke prefers the words *action* or *demonstration*,[2] as he feels that using the latter term comes more from a confusion of genres among music, dance, and visual arts. Peformance can elsewhere be assimilated into *intervention*, insofar as it may intervene in a physical or social reality. It is also body art, but goes beyond the style whose considerations of narcissism can be restricting just as can the requirement that the body itself be present.

That performance borrows from the known territory of music, theatre or dance, that it is an extension of visual and spatial problems or purely formal problems, or that it uses simultaneously the givens of each of the possibilities noted, definitively, makes it

(Cette dernière attitude, soulignée par Alan Sondheim, auteur de *Individuals*, explique vraisemblablement l'éclectisme caractéristique de l'art d'aujourd'hui.)

Hypothétiquement, il se peut aussi que la performance en temps que phénomène qu'on tente ici de circonscrire, dépasse la forme qu'on lui attribue habituellement, celle de mise en scène dans un temps et un lieu donnés, temps et espace clos, pour fair éclater ce qui reste du théâtre traditionnel, ce lieu, cet espace, ce temps, ce moment, et leur substituer la multiplicité, la simultanéité, la totalité dans l'espace et dans le temps.

Cela pourrait vouloir dire qu'on peut considérer que la notion de performance est une caractéristique fondamentale du post-modernisme. Pour ce, il faut prendre comme prémisse que le post-modernisme correspond à la remise en question de langages, de condes établis, au décloisonnement des disciplines, à l'éclatement des structures hiérarchisantes entre l'institution — le producteur — le produit — le récepteur. "Performance, the unifying mode of the postmodern", dit Michel Benamou.[4]

La performance: phénomène de l'art d'aujourd'hui, problématique de la post-modernité. La performance s'associe au rituel, à la technologie, s'associe à l'être comme au faire, au processus plus qu'au produit fini. Elle se déroule dans le temps, cherche l'éphémère, capte la vie dans un effort désespéré pour chercher autrement ce à quoi ne répondent plus les oeuvres silencieuses du musée.

Bien que l'idée de performance soit présente dans les deux cas, il faut distinguer entre la performance *en direct* et la performance *en différé*. La photographie, la vidéo, le film, l'enregistrement sonore et certaines formes de sculpture/environment (comme

a different phenomenon, difficult to define, characterised by the multiplicity of tendencies and forms.

"Works of art emerge out of a complex dialogue between self and society, individual concerns of the "art world", and so forth. The artist may choose to embed his or her work into the mainstream of contemporary art, which often results in a tendency toward formalism and the attempt to carry one particular aspect of already existing art "one step further". But the artist may also choose to turn inward, in a sense — to investigate the relationship between self and society, self and history. In short, the artist may choose to examine the position of the self in the world."[3]

(The preceding attitude, underlined by Alan Sondheim, the author of *Individuals*, seems to explain the eclectism characteristic of today's art). Hypothetically, it may also be that performance as the phenomenon we are attempting to define here, goes beyond the form we would attribute to it by habit, that of a performance in a given time and place, a closed time and space, in order to shatter what remains of traditional theatre — that place, that space, that time, that moment — and to substitute for them multiplicity, simultaneity, totality in space and time.

That could mean that we may consider the notion of performance as a fundamental characteristic of post-modernism. For this, we must take it as a premise that post-modernism corresponds to the calling into question of languages, of established codes, to the breaking down of divisions between disciplines, to the explosion of hierarchical structure between institution — producer — product — receiver. "Performance, the unifying mode of the postmodern", says Michel Benamou.[4]

Performance: a phenomenon of art today, a problem of post-modernism. Performance is associated with ritual, with

10

celle de Aycock, Morris, Nordman, Smithson, Trakas par exemple, dans le cas d'oeuvres qui comportent des éléments de présence ou d'occupation de l'espace, ou de participation du spectateur) sont souvent le support d'oeuvres où la performance est en différé. Il est évident dans ce cas quil ne s'agit pas seulement de documentation mais de véritables performances in actu.

En 1967, le critique américain Michael Fried s'éleva contre une certain tendance qu'avaient les minimalistes à insister sur la notion de *presence* comme caractéristique fondamentale de leur travail, la présence comme élément de liaison avec le spectateur (*the beholder*).

"A ce moment, je désire faire une revendication que je ne peux espérer prouver ou justifier mais que je crois néanmoins vraie: à savoir, que le théâtre et la théâtralité sont aujourd'hui en guerre, pas seulement avec la peinture moderniste (ou la peinture et la sculpture modernistes), mais avec l'art en tant que tel — et dans la mesure où les différents arts peuvent être considérés comme modernistes, avec une sensibilité moderniste en tant que telle. Cette revendication peut être divisée en trois propositions ou thèses:
1) *Le succès et même la survie des arts en est arrivé à dependre de plus en plus de leur capacité de faire echouer le théâtre. (. . .)*
2) *L'art degenère quand il se rapproche du théâtre. (. . .)*
3) *Les concepts de qualité et de valeur — dans la mesure ou ceux-ci sont essentiels a l'art même — sont significatifs ou entièrement significatifs, seulement dans le cas particulier de chacune des disciplines. Tout ce qui se situé entre les arts est théâtral.*"[5]

La théâtricalité qui en 1967 pouvait choquer une partie de la critique américaine, a trouvé aujourd'hui une majorité de sympathisants parmi les artistes et les critiques pour qui le formalisme Americain des années soixante, et le dogmatisme avec lequel il a été protessé, representant une at-

technology, it is associated with being as much as with doing, with the process more than the finished product. It unwinds in time, seeks out the ephemeral, captures life in a desperate effort to search in a different way for something to which the silent works of the museum no longer reply.

Although the idea of performance is present in both cases, we must distinguish between *direct* and *deferred* performance. Photography, video, film, sound recording, and certain forms of sculpture/environment (like those of Aycock, Morris, Nordman, Smithson, Trakas for example, in the case of works that comprise elements of 'presence' or the occupation of space, or the participation of the spectator) are often the media for works where the performance is deferred. Clearly, in these cases, it is not simply a matter of documentation but of genuine performances in actu.

In 1967, the American critic Michael Fried rose against a certain tendency evidenced by the minimalists, to insist on the notion of *presence* as a fundamental characteristic of their work, presence as a connecting element with the spectator (*the beholder*).

"At this point I want to make a claim that I cannot hope to prove or substantiate but that I believe nevertheless to be true: *viz.*, that theatre and theatricality are at war today, not simply with modernist painting (or modernist painting and sculpture), but with art as such — and to the extent that the different arts can be described as modernist, with modernist sensibility as such. This claim can be broken down into three propositions or theses:
1) *The success, even the survival of the arts has come increasingly to depend on their ability to defeat theatre. (. . .)*
2) *Art degenerates as it approaches the condition of theatre. (. . .)*
3) *The concepts of quality and value — and to the extent that these are central to art itself — are meaningful, or wholly meaningful, only within the*

titude beaucoup trop reductiviste. En effet, se rapprocher de la vie, c'est une fascination qui hante les artistes depuis le début de ce siècle, qui pour ce faire n'ont cessé de trouver des moyens très diversifiés: la mécanisation, le film, la vidéo, le disque, le ready-made, le collage, le hasard, la politique, le spectacle. Ce qui frappe, c'est l'aspect transitif de tous ces moyens, le désir de mettre en relief le processus derrière l'oeuvre, le temps qui passe et la façon dont les objets, les personnes, les comportements, les situations évoluent, se métamorphosent dans le temps et dans l'espace.

Dans cette valorisation du temps, il y a valorisation de la mémoire et du subconscient, des pouvoirs associatifs du cerveau. Pour ne pas dire de l'autobiographie et de l'individualité.[6]

Guy Scarpetta, dans un texte intitulé *le Corps americain, publie dans un recent Tel Quel* consacré aux Etats-Unis, écrit:

"Ce geste "minimal" des performances peut donc être saisi comme décomposition critique du code théâtral, lié aux préoccupations parallèles d'autres pratiques, ainsi qu'à l'exploration des "intersections des différénts langages qu'il intègre. L'important me semble être qu'en ce moment ce geste expérimental trouve un prolongement et une nouvelle dimension dans un "renouveau" du code théâtral lui-même (mais le terme de "théâtre" est sans doute trop limitatif, face à l'ampleur de cette nouvelle phase, qui est peut-être, plus profondément une réinvention "post-minimale" de l'opéra): re-confrontation non synthétique des codes, dialectique ouverte, où danse, gestes, théâtre, voix, musique, cinéma, "tableaux" visuels se réarticulent autrement "in progress"."[7]

Le renouveau du code théâtral, Antonin Artaud y faisait appel déjà, dans *le Théâtre et son Double:*

"Briser le langage pour toucher la vie, c'est faire ou refaire le théâtre; et l'important est de ne pas croire que cet acte doive demeurer sacré, c'est-à-

individual arts. What lies between the arts is theatre."[5]

The theatricality which in 1967 could shock a part of the American critical world, has found today a majority of sympathisers among artists and critics for whom American formalism of the 60s, and the dogmatism with which it was expressed, represented a far too reductivist attitude. In effect, to get closer to life is a fascination that has haunted artists since the beginning of the century and which, in order to achieve it, have continued to find very diverse means: mechanisation, film, video, records, ready-mades, collage, chance methods, politics, public events. What is particularly noticeable is the transitory aspect of all these media, the desire to put the process behind the work into high relief, the time that passes and the way that objects, people, behaviour, and situations evolve, metamorphose in time and space.

In this development of time there is also a valorisation of memory and the subconscious, the associative powers of the brain. This is not to ignore autobiography and individuality.[6]

In a text entitled *Le corps américain*, published in a recent *Tel Quel* dedicated to the USA, Guy Scarpetta wrote:

"This 'minimal' gesture of performances can thus be understood as the critical breakdown of the theatrical code, linked with parallel preoccupations in other practices, just as it is in the exploration of the 'intersections' of different languages that it integrates. The important fact seems to me that in this moment the experimental gesture finds an extension and a new dimension in a 'renewal' of the theatrical code itself (but the term 'theatre' is doubtless too limiting, faced with the breadth of this new phase, which is perhaps more deeply a Post-minimal re-invention of opera): a non-synthetic re-confrontation of the codes, an open dialectic, where dance, gestures, theatre, voice,

dire réservé. Mais l'important est de croire que n'importe qui ne peut pas le faire, et qu'il y faut une préparation.

Ceci m'amène à rejeter les limitations habituelles de l'homme et des pouvoirs de l'homme, et à rendre infinies les frontières de ce qu'on appelle la réalité. Il faut croire à un sens de la vie renouvelé par le théâtre, et où l'homme impavidement se rend le maître de ce qui n'est pas encore, et le fait naître. Et tout ce qui n'est pas ne peut encore naître pourvu que nous ne nous contentions pas de demeurer de simples organes d'enregistrement. Aussi bien, quand nous prononçons le mot de vie, faut-il entendre qu'il ne s'agit pas de la vie reconnue par le dehors des faits, mais de cette sorte de fragile et remuant foyer auquel ne touchent pas les formes. Et s'il est encore quelque chose d'infernal et de véritablement maudit dans ce temps, c'est de s'attarder artistiquement sur des formes, au lieu d'être comme des suppliciés que l'on brûle et qui font des signes sur leurs bûchers."[8]

Pourquoi vouloir un renouveau sinon pour toucher la vie.... On a voulu voir à travers la peinture de Jackson Pollock plus que la peinture/objet et on en a tiré la peinture/action. Cela faisait partie de cette volonté de sortir du cadre et de plonger dans l'espace tridimensionnel, de permettre au pulsionnel de refaire surface.

Si l'art depuis toujours et maintenant mieux que jamais entretient un étonnant dilemne/dialogue entre lui-même et la vie, l'illusion et la réalité, la sensibilité et la raison, on peut presque parler d'un système de contradictions qui produit la succession des avant-gardes. Ce dilemne c'est le porte-flambeau de l'avant-garde au xxe siècle. Jusque dans les années 50, les artistes monteront littéralement sur scène pour crier leur liberté et leur révolte, en plus de chercher tous les moyens pour intégrer le mouvement et le spectateur à l'oeuvre. Futuristes, Dadaistes, Surréalistes, membres du Bauhaus, artistes des Happenings et de Fluxus. Longue période de gestation qui aboutit pendant les années 50, dans un

music, cinema, visual 'tableaux', are linked differently 'in progress'."[7]

As for the renewal of the theatrical code, Antonin Artaud had already made that appeal in *The Theatre and its Double*:

"To break the language in order to touch life, is to make or remake theatre; and the important fact is not to believe that this act must remain holy or private. But it is important to believe that not anyone can do it, and that preparation is needed. This brings me to reject the habitual limitations and powers of man, and to render infinite the frontier of what is called reality. One must believe in a sense of life renewed by the theatre, where the undaunted man makes himself master of that which does not yet exist, and he brings it to life. And everything that does not exist cannot yet be born, so long as we are not satisfied to live with simple recording instruments. As well, when we pronounce the word of life, we must understand that it's not a question of life recognised by the outside appearance of facts, but of this sort of fragile and moving home which forms do not touch. And if there is still something infernal and truly evil in these times, it is to linger artistically on forms, rather than being like the torture victims who are burned and who make signs at the stake."[8]

Why do we want a renewal if not to touch life . . . We wanted to see through the painting of Jackson Pollock more than the painting/object, and from it we drew action-painting. That was part of this willingness to break ranks and to plunge into three-dimensional space, to permit inner drives to come to the surface.

If art has always — and now more than ever — maintained an astonishing dilemma/dialogue between itself and life, illusion and reality, sensitivity and reason, one may almost speak of a system of contradictions which produce a succession of avant-gardes. This dilemma is the gateway to the avant-garde of the twentieth century. In the 50s, artists would literally rise on stage to cry out their liberty and their revolt, rather

13

déplacement vers les Etats-Unis signalé par la guerre, à une cristallisation des avant-gardes, à une identification de l'objet avec la pratique.

Et c'est le théâtre qui accueille le mieux ce désir de passer de l'objet à l'acte, d'une problématique de la représentation vue comme projection de soi et du monde à une représentation vécue (une non-representation), *dans laquelle on est*, plutôt qu'à distance de soi.

Au sujet d'Artaud, dont les textes pourraient être considérés comme précurseurs, Jacques Derrida écrit:

"Le théâtre de la cruauté n'est pas une représentation. C'est la vie elle-même en ce qu'elle a d'irreprésentable. La vie est l'origine non représentable de la représentation. "J'ai donc dit "cruauté" comme j'aurais dit "vie" (1932, IV, p.137 [Artaud]." Cette vie porte l'homme mais elle n'est pas d'abord la vie de l'homme. Celui-ci n'est qu'une réprésentation de la vie et telle est la limite — humaniste — de la metaphysique du théâtre classique."⁹

Plus loin:

"Certes, la scène ne représentera plus, puisqu'elle ne viendra pa s'ajouter comme une illustration sensible à un texts déjà écrit, pensé ou vécu hors d'elle et qu'elle ne ferait que répéter, dont elle ne constituerait pas la trame. Elle ne viendra plus répéter un present, représenter un présent qui serait ailleurs et avant elle, dont la plénitude serait plus vieille qu'elle, absente de la scène et pouvait en droit se passer d'elle: présence à soi du Logos absolu, présent vivant de Dieu. Elle ne sera pas davantage une représentation si représentation veut dire surface étalée d'un spectacle offert à des voyeurs. Elle ne soufrira même pas la présentation d'un présent si présent signifie ce qui se tient *devant* moi. La représentation cruelle doit m'investir. Et la non-représentation est donc représentation signifie aussi déploiement d'un volume, d'un milieu à plusieurs dimensions, expérience productrice de son propre espace. *Espacement,* c'est-à-dire production d'un espace qu'aucune parole ne saurait résumer ou comprendre, le supposant d'abord lui-même et faisant appel à un temps qui n'est plus celui de la dite linéarité phonique, appel

than searching out means to integrate the movement and the viewer with the work. Futurists, Dadaists, Surrealists, members of the Bauhaus, artists of Happenings and Fluxus. The long period of gestation came to a head during the 50s, in a shift towards the USA brought on by the war, in a crystallisation of the avant-gardes, in an identification of object with actual practice.

And it is the theatre which best welcomes this desire to pass from object to act, through the problem of representation seen as a projection of the self and the world to a lived representation (a non-representation), *in which one is*, rather than at a distance from oneself.

On the subject of Artaud, whose writings could be considered as precursers, Jacques Derrida writes:

"The theatre of cruelty is not a representation. It is life itself in what is non-representable in life. Life is the non-representable origin of representation. 'So I said "cruelty" as I would have said "life" (1932, IV, p. 137) [Artaud].' This life carries man but it is not first of all the life of man. *That* is only a representation of life and as such is the humanist limit of the metaphysics of classical theatre."⁹

And further on:

"Certainly, the stage will no longer represent, since it will not be added as a sensitive illustration to an already-written text, thought or lived outside of it and which it could only repeat, of which it would not constitute the frame. It would no longer repeat a *present*, represent a present which would be elsewhere and before it, whose fullness would be older than its own, absent from the stage and able to assume the right to pass it by: the presence of the self in the absolute Logos, the living presence of God. Neither would it be more a representation, if representation means a surface spread with a spectacle offered to viewers. It will not even suffer the presentation of a present, if present signifies that which is *before* me. The cruel representation must be invested in me. And non-

14

à 'une notion nouvelle de l'espace' et à 'une idée particulière du temps.'."[10]

En essayant d'expliquer et de pousser plus loin, c'est-à-dire vers une nouvelle pensée théâtrale, la thèse d'Artaud, Derrida aborde certaines idées qui touchent la performance de près. Par example, la non-représentation dont il parle dans le texte cité, est un aspect de la performance qu'il précise avec la notion d'*espacement*. En fait, il est certain que la performance fait appel à de nouvelles manières de concevoir l'espace et le temps. Il s'agit surtout aujourd'hui de les concevoir comme éléments de mesure, comme limites, contextes et média plutôt que comme véhicules ou réceptacles. La performance est basée sur un temps réel et non fictif. Sur un espace réel et non fictif. La littéralité du temps et de l'espace est une composante de base. Une performance dure souvent le temps du processus qui la soustend.

Par exemple, en s'inspirant de Michael Nyman[11] qui, ayant réfléchi sur la musique expérimentale, en est venu à différencier les processus qui déterminent la structure, le temps, la durée de l'oeuvre, on peut distinguer les procussus suivants:

1) les processus déterminés par le hasard (*chance determination processes)*: le I Ching, les partitions "trouvées", par exemple, les imperfections sur une feuille de papier, ou le bottin téléphonique. Il sffit de créer un système à partir d'une grille quelconque. Une pratique fréquente chez Cage et avec Fluxus;

2) les processus déterminés par les exécutants (*people processes*): le déroulement du processus s'appuie sur l'individualité, sur la capacité de chacun à réaliser le processus. Se retrouve chez les danseurs ou chez les musiciens qui utilisent l'improvisation;

representation is therefore innate representation, if representation stands also for the deployment of a volume, of a lace with several dimensions, the productive experience of its own space. *Spacing out*, that is, the production of a space which no word could summarise or comprehend, supposing itself first and recalling a time which is no longer that of the stipulated phonic linearity, a call to 'a new notion of space' and 'a particular idea of time.' "[10]

In trying to explain and to push further, that is, towards a new theatrical thought as in Artaud's thesis, Derrida reaches certain ideas which touch closely on performance. For example, the non-representation of which he speaks in the above text, is an aspect of performance which he clarifies with the notion of *spacing out*. In effect, it is certain that performance calls for new ways of conceiving space and time. Especially today it is a matter of conceiving them as elements of measure, as limits, contexts and media rather than as vehicles or receptacles. Performance is based on a real and not fictional time. On a real and not fictional space. The literalness of time and space is a basic component; a performance often lasts for just the period of time required for the process itself.

For example, taking a cue from Michael Nyman[11] who, having reflected on experimental music, is brought to differentiate between the processes which determine the structure, time, duration of the work, one can distinguish the following processes:

1) process determined by chance (*chance determination processes*): the I Ching, "found" scores, for example the imperfections on the surface of a sheet of paper, or the phone directory. To create a system from some sort of grid is sufficient. A common practice with Cage and Fluxus;

3) les processus contextuels: processus qui tiennent compte des autres exécutants ou des spectateurs (ces derniers peuvent influencer la tournure ou la longueur de l'oeuvre). Par exemple, Max Dean qui met en place un processus par lequel les spectateurs en faisant assez de bruit, peuvent déclencher un mécanisme qui retient la corde avec laquelle il sera pendu sans leur intervention;

4) les processus répétitifs: comme pour la musique répétitive. "In repetition, the 'unforeseen' may arise through many different factors, even though the process may, from the point of view of structure, be totally foreseen.";

5) les processus électroniques: avec la musique électronique, la vidéo. *Queen of the South* d'Alvin Lucier en est un exemple; (j'ajouterais) les processus relatifs aux matériaux utilisés: le temps de regarder une série de diapositives, le temps d'écouter une bande sonore. S'applique à beaucoup de performances audio-visuelles comme *For Instants* de Laurie Anderson.

L'espace réel peut aussi modifier la performance. Trisha Brown qui réalisa une pièce en fonction des toits de New-York ou Joan Jonas, en fonction des rochers de la Nouvelle-Ecosse. La plupart du temps, la performance est *situationnelle* et prend son essort dans un lieu et un temps précis. Par exemple, Marina Abramovic et Ulay, à la Foire de Bologne en 1978, situés face à face, nus, de chaque côté de la porte du musée de Bologne, créèrent une situation où chaque visiteur devait passer entre eux, en les frôlant, pour pénétrer dans le musée. Une caméra vidéo retransmettait la scène sur un écran placé dans la salle principale du musée où avaient lieu les performances normalement.

2) process determined by the performers (*people processes*): the development of the process depends on the individuality or capacity of each one to direct the process. It is found with dancers or musicians who use improvisation;

3) *contextual process*: a process taking account of the other performers or spectators (the latter can influence the direction or length of the work). For example, Max Dean, who set up a process in which the spectators, making enough noise, could release a mechanism holding the cord by which he would be suspended in air without their intervention;

4) *repetitive process*: as in repetitive music. "In repetition, the 'unforseen' may arise through many different factors, even though the process may, from the point of view of structure, be totally foreseen.";

5) electronic process: with electronic music or video. *Queen of the South* by Alvin Lucier is an example of this: (I would add) the processes relating to materials used: the time required to look at a series of slides, the time to listen to a sound track. This applies to many audio-visual performances, such as *For Instants* by Laurie Anderson.

Real space can also modify performance. Trisha Brown carried out a piece on the rooftops of New York, or Joan Jonas interacted with the cliffs of Nova Scotia. Most of the time, performance is *situational*, and develops in a precise place and time. For example, Marina Abramovic and Ulay, at the Bologna Art Fair in 1977, stood nude, face to face, on either side of the door to the Bologna museum, and created a situation where each visitor had to pass between them, brushing against them, in order to enter the museum. A video camera relayed the scene to a screen placed in the

Mais la performance n'est pas que temps et espace, elle est aussi son, geste, mouvement, accessoire. Le répertoire de l'accessoire, quand il apparît comme composante d'une oeuvre, et cela n'est pas toujours nécessaire, est vaste et peut comprendre un objet à connotations symboliques, autant qu'un objet à fonction usuelle, ou un objet qui cumule ces deux aspects. Le décor est peu utilisé, en dehors de l'espace même où a lieu la performance, mais peut prendre une importance certaine comme chez Bob Wilson ou Richard Foreman où il est articulation de l'espace. Rappelons la scène finale d'*Einstein On the Beach*, où tous les exécutants se trouvent réunis dans une structure cellulaire constituée de boîtes superposées et illuminées.

Quant au son et au geste, le désir de rapprochement entre la vie et l'art permet de constater que la distinction entre bruit et musique, entre l'activité corporelle quotidienne (*task*) et la danse, s'est amoindrie. Il en est de même pour la voix qui est une voix parlante ou chantante plutôt que projetée, voix que souvent d'ailleurs on entend enrigistrée sur cassette ou sur bande, ou amplifiée au microphone. Laurie Anderson et Vito Acconci utilisent plus particulièrement la voix enregistrée.

Les limites de l'art sont repoussées au maximum, et cela donne lieu aussi à un décloisonnement des disciplines qui implique:
1) que l'artiste n'a plus besoin d'être un virtuose;
2) que l'oeuvre peut se passer d'être un *chef-d'oeuvre* et peut quand même avoir une valeur tout en agissant sur l'artiste et sur le spectateur;
3) qu'une oeuvre peut être éphémère, ou changeante, ou différente selon les circonstances;
4) que l'instrumentation peut en être très

main gallery of the museum where the performances normally took place.

But performance is not only time, it is also sound, gesture, movement, accessories. The repertory of props, when they appear as components of a work (and that is not always necessary) is vast and can comprise an object with symbolic connotations as well as an object with ordinary uses, or an object which combines both of these aspects. Sets are seldom used, apart from the space itself where the performance takes place, but they can take on a certain importance as with Bob Wilson or Richard Foreman where they become an articulation of the space. We may recall the final scene of *Einstein on the Beach*, where all the performers were reunited in a cellular structure made up of superimposed and illuminated boxes.

As for sound and gesture, the desire to bring art and life together lets us see that the distinction between noise and music, between daily body activities (*task*) and dance, is reduced. The same is true for the voice which speaks or sings rather than being projected, a voice which often is heard from elsewhere, recorded on a cassette or tape, or amplified by a mike. Laurie Anderson and Vito Acconci in particular use the recorded voice.

The limits of art are pushed to the maximum, and that also makes room for a blurring of boundaries between disciplines which implies:
1) that the artist no longer need be a virtuoso;
2) that the work can do without being a masterpiece and can all the same have an active value for both artist and spectator;
3) that a work can be ephemeral, or changing, or different according to circumstances;

17

variée et comporter des éléments très sophistiqués, comme la technologie des média, vidéo, film, photo, ou des formes d'art classique, danse, musique, ou très banales, comme des objets trouvés ou des formes d'art populaire;

5) que les frontières entre les arts ont tendance à disparaître, sinon à devenir moins claires, le son occupant l'espace devient sculpture par exemple, la sculpture devenant architecture tant soit peu que l'espace soit pris comme médium, etc....

Dans les échanges interdisciplinaires qui mènent à la performance, notons celui de la sculpture et de la danse, tels qu'illustrés dans ce tableau imaginé par Yvonne Rainer dans les années 60:

4) that the instrumentation can be very varied and comprise very sophisticated elements, like the technologies of the media, video, film, photography, either the classic art forms, dance, music, or very banal ones, such as found objects or popular art forms;

5) that the boundaries between the arts have a tendency to disappear, or at least become less clear, the sound occupying space becoming sculpture for example, sculpture becoming architecture as the space itself is taken as a medium . . .

In the interdisciplinary exchanges that lead to performance, let us note that of sculpture and dance, such as those illustrated in a table conceived by Yvonne Rainer in the 60s:

OBJECTS DANCES

eliminate or minimize

OBJECTS	DANCES
1. role of artist's hand	phrasing
2. hierarchical relationship of parts	development and climax
3. texture	variation: rhythm, shape, dynamics
4. figure reference	character
5. illusionism	performance
6. complexity and detail	variety: phrases and the spatial field
7. monumentality	the virtuosic movement feat and the fully-extended body

substitute

OBJECTS	DANCES
1. factory fabrication	energy equality and "found" movement
2. unitary forms, modules	equality of parts
3. uninterrupted surface	repetition or discrete events
4. nonreferential forms	neutral performance
5. literalness	task or tasklike activity
6. simplicity	singular action, event, or tone
7. human scale	human scale[12]

L'attitude que décrit ce tableau appelle un renouvellement de la mise en scène. A ce sujet, Jean-François Lyotard affirme:

" . . . la mise en scène transforme les signifiants écrits en parole, chant at mouvement, exécutés par des corps capables de bouger, chanter et parler, et cette transcription est faite à l'intention d'autres corps vivants — les spectateurs — capables d'être mis en mouvements par ces chants, mouvements et mots. C'est cette transcription sur et pour des corps, considérée dans ses potentialités multisensorielles, qui constitue le travail caractéristique de la mise en scène. Son unité élémentaire est, comme le corps humain, polyesthétique: capacité de voir, d'entendre, de toucher, de bouger . . . L'idée de performance (la représentation de ce soir), même si elle reste vague, semble étroitement liée à l'idée d'inscription sur le corps."

Et pour arriver à une nouvelle définition, que l'on peut assimiler à la performance, il dit:

" . . . la mise en scène consiste en un groupe complexe d'opérations; chacune d'elles transcript un message écrit dans un code, un système donné (écriture littéraire, notation musicale) et le transforme en un message capable d'être inscrit sur des corps humains et transmis par ceux-ci à d'autres corps humains; une sorte de somatographie. Bien plus important, et moins dépendant du contexte classique, est le simple fait de la transcription — c-à-d le fait de modifier la surface d'inscription — appelons-le un diagraphe, qui sera dorénavant la caractéristique principale de la mise en scène."[13]

La performance crée une situation qui ne réfléchit pas une inscription corporelle mais qui permet au spectateur de vivre une situation, de la vivre à travers certains mécanismes mis en place à cet effet. C'est ce qui arrive dans *la Région centrale* de Michael Snow, selon Lyotard. Je crois que cela arrive aussi dans la musique de Phil Glass où un processus répétitif ayant été établi, le spectateur est envoûté par le processus plus que par la virtuosité des exécutants ou par l'intérêt dramatique de la musique.

The attitude outlined in this table calls for a renewal of production values. On this subject, Jean-Francois Lyotard affirms:

" . . . the mise-en-scène turns written signifiers into speech, song, and movement, executed by bodies capable of moving, singing and speaking, and this transcription is intended for other living bodies — the spectators — capable of being moved by these songs, movements and words. It is this transcribing on and for bodies, considered as multi-sensory potentialities, which is the work characteristic of the mise-en-scène. Its elementary unity is polyesthetic like the human body: capacity to see, to hear, to touch, to move . . . the idea of performance (in French: la représentation de ce soir, this evening's performance) even if it remains vague, seems linked to the idea of inscription on the body."

And in order to arrive at a new definition, that can be assimilated to performance as it is understood now, he says:

" . . . mise-en-scène consists of a complex group of operations, each of which transcribes a message written in a given sign, system (literary writing, musical notation) and turns it into a message, capable of being inscribed on human bodies and transmitted by those to ther bodies; a kind of somatography. Even more important, and less dependant on the classic context, is the simple fact of transcription — that is the fact of change in the space of inscription — call it a diagraphy, which henceforth will be the main characteristic of mise-en-scène."[13]

Performance creates a situation which does not reflect a use of the body but which permits the spectator to live a situation, to live it through certain mechanisms set up for that effect. This is what happens in *la Région centrale* by Michael Snow, according to Lyotard. I believe that it happens also in the music of Phil Glass where a repetitive process having been established, the spectator is enveloped by the process more than by the virtuosity of the performers or by the dramatic interest of the music.

S'il s'agit de mettre sur pied une situation, il s'agit aussi de laisser vivre cette situation. alors que le contexte classique était extrêmement rigide dans sa structure, la performance est ouverte bien que structurée. Certains points sont fixés d'avance, mais il y a place pour l'improvisation, la spontanéité, l'adaptabilité au moment de la réalisation. Les facteurs qui conditionnent ou complémentent le scénario original sont des facteurs de temps et d'espace, oui, mais aussi il faut tenir compte du facteur public.

Avec la performance, on peut parler, comme Roland Barthes l'a fait pour l'écriture, du *degre zero* de la représentation. Là, il y est permis de ne rien dire, de laisser entrer le vide, le silence, comme Cage l'a fait, pour redécouvrir le plein.

"La vacuité se présente comme seule chance, car c'est uniquement en retrouvant le zéro que l'homme arrive à agir sans être détourné par *l'ecran de l'intellectualite,* du *langage et du moi* et à s'ouvrir ainsi à la circulation des énergies."[14] (Cette phrase est tirée d'un essai sur *la Vacuité* par Georges Banu.)

La circulation des énergies est mieux permise quans il s'agit d'une communication directe. Ceci implique la suppression d'intermédiaires entre le *performer* et le spectateur. Il est habituel dans la performance que l'artiste participe lui-même à l'activité:
a) comme seul exécutant,
b) comme exécutant avec d'autres,
c) que la performance soit exécutée sous son entière direction.

Il vient à propos de citer le théâtre de Richard Foreman, qui même s'il n'*acte* pas lui-même, se situe dans l'espace scénique où son travail de direction et de régie est à la vue du spectateur qui est lui-même intégré vu la disposition du théâtre où ont lieu toutes les représentations de ses oeuvres.

If it's a question of establishing a situation, it's also one of living through this situation. While the classic context was extremely rigid in its structure, performance is open although structured. Certain points are fixed in advance, but there is room for improvisation, spontaneity, adaptability in the moment of presentation. The factors conditioning or completing the original scenario are the factors of time and space, yes, but we must also keep in mind the public factor.

With performance, one can speak as Roland Barthes did for writing, of a "degree zero" of representation. There, it is permitted to say nothing, to let the void enter, or the silence as Cage did, in order to rediscover the whole.

"Emptiness is presented as the only chance, for it is only in rediscovering zero that man comes to act without being diverted by *the screen of intellectuality, of language and of the ego*, and thus to open up his energies to circulation."[74]

The circulation of energies is better permitted when it's a question of direct communication. This implies the suppression of intermediaries between the performer and the spectator. It is common in performance that the artist himself participates in the activity:
1) as sole performer,
2) as a performer with others,
3) that the performance be executed wholly under his direction.

It is pertinent here to cite the theatre of Richard Foreman, who even if he does not act himself, places himself in the scenic space where his work as director and producer is in the view of the spectator, who himself is integrated into the layout of the theatre where all the presentations of Foreman's works take place.

This essential role of the artist as per-

Ce rôle essentiel de l'artiste comme exécutant met de l'emphase sur la localisation (le lieu du corps) de la performance et souligne l'importance du faire, de la pratique que l'on ne peut détacher du résultat. Il en est de même pour Philip Glass qui joue avec son ensemble, pour Trisha Brown qui danse avec les autres membres de sa compagnie. Une association étroite est à faire valoir entre l'expression et la représentation.

Il est à propos de noter que, bien que l'improvisation ait eu une influence notoire sur la performance à travers la pratique instrumentale, la danse, le Happening, deux points sont à différencier: l'importance de l'auteur et la notion de structure ouverte.

La performance appartient à son auteur, elle est parcelle de vie personnelle livrée au spectateur. En ce sens, elle est livraison d'intensités pulsionnelles. Elle est donc difficilement répétable ou reprise par un autre artiste. Philip Glass, La Monte Yonge, Terry Riley ne considèrent pas que leur musique peut être jouée par d'autres. Et il est certain que personne ne peut danser *comme* Trisha Brown ou Simone Forti.

L'artiste est une source de procédés, une source d'énergies à la base du déroulement des activités qui ont lieu devant le spectateur. Son corps est en articulation avec l'espace. Il y a dans cet espace un échange d'énergies, une dépense de cette énergie *vitale* qui produit une transformation. c'est cette transformation que le spectateur voit, entend, perçoit. Transformation, transcription, changement dans l'espace de transcription, c'est la diagraphie que Lyotard affirme comme étant la nouvelle mise en scène.

Si voir, c'est percevoir, c'est à dire que le spectateur fait aussi partie de la representation. La representation est un transfert d'énergies. L'artiste charge l'espace d'une

former puts an emphasis on the localisation (the place of the body) of the performance and underlines the importance of the making, of the practice, that one cannot detach from the results. The same is true for Philip Glass who plays with his ensemble, for Trisha Brown who dances with the other members of her company. A tight association emphasises the interplay between expression and representation.

It is useful to note that although improvisation had an acknowledged influence on performance through instrumental practice, dance, and Happenings, two points should be differentiated: the importance of the author and the notion of open structure.

The performance belongs to its author, it is a piece of personal life handed over to the spectator. In this sense, it is a giving over of driving intensities. It is therefore difficult to repeat or to be done again by another artist. Philip Glass, La Monte Young, Terry Riley do not feel that their music can be played by others. And it is certain that no one can dance *like* Trisha Brown or Simone Forti.

The artist is a source of procedures, a source of energies basic to the development of activities taking place before the spectator. His/her body is in articulation with the space. In this space there is an exchange of energies, an expenditure of this *vital* energy which produces a transformation. It is this transformation that the spectator sees, hears, perceives. Transformation, transcription, a change in the space of transcription, that is the diagraphy that Lyotard affirms as comprising the new performance.

If seeing is perceiving, it is to say that the spectator is also part of the performance. The performance is a transfer of energy. The artist charges the space with a presence. The spectator participates in this

présence. Le spectateur participe de cette présence en autant qu'il s'y reconnaisse, qu'il y trouve le signe de quelque chose à quoi s'associer. Le sens de l'oeuvre est donc directement lié à la reconnaissance de soi dans l'autre — à la présence où se confondre.[15]

Mais, la performance est plus, elle nous confronte à la chose directement, et non pas à sa représentation. Elle est articulation de la vie même, plutôt qu'illusion. Elle est une carte, une écriture qui se déchiffre dans l'immédiat, dans le présent, dans la situation présente, une confrontation avec le spectateur. Annette Michelson, analysant l'état actuel des arts de la scène, écrit:

"Il y a dans le renouvellement contemporain des modes de représentation, deux mouvements de base divergents qui façonnent et animent ses principales innovations. La première, ancrée dans les prolongements idéalistes d'un passé chrétien, est mytho-poétique par ses aspirations éclectiques par ses formes et constamment traversée par le style dominant et polymorphe qui constitue le vestige le plus tenace du passé: l'expressionnisme. Les porte-parole sont: pour le théâtre, Artaud et Grotowski, pour le cinéma, Murnau et Brakhage, et pour la danse, Wigman et Graham. La seconde, conséquemment profane dans son engagement à l'objectification, procède du cubisme et du Constructivisme; ses approches sont analytiques et ses porte-parole sont: pour le théâtre, Meyerhold et Brecht, pour le cinéma, Eisenstein et Snow et pour la danse, Cunningham et Rainer. La nouvelle danse et le nouveau cinéma ont fleuri en ce pays dans ce dernier contexte se développant comme les exemples les plus soutenus et les plus radicaux de son entreprise esthétique. Cette radicalité s'est retrouvée dans une condition à la fois luxueuse et difficile, celle d'être sans foyer. La nouvelle danse tout comme le nouveau cinéma vit et se développe à SoHo et dans ses quartiers attenants qui constituent le centre de notre commerce dans les arts visuels. Ils existent et fonctionnent toutefois entièrement en périphérie de l'économie de leur monde, stimulés par le travail et la production de cette économie, sans support, sans place dans la structure de son marché. La nouvelle danse

presence insofar as he recognises it, finds in it the sign of something with which he associates himself. The sense of the work is therefore directly linked to the recognition of the self in the other — to the presence where they merge.

But now performance is more, it confronts us directly with the thing itself and not with its representation. It is an articulation of life itself, rather than an illusion. It is a map, a script, that is deciphered at once, in the present, in the present situation, a confrontation with the spectator. Annette Michelson, analysing the current state of theatre arts, writes:

"There are, in the contemporary renewal of performance modes, two basic and diverging impulses which shape and animate its major innovations. The first, grounded in the idealist extensions of a Christian past, is mytho-poetic in its aspirations, eclectic in its forms, and constantly traversed by the dominant and polymorphic style which constitutes the most tenacious vestige of the past: expressionism. Its celebrants are: for theatre, Artaud, Grotowski, for film Murnau and Brakhage, and for dance, Wigman, Graham. The second, consistently secular in its commitment to objectification, proceeds from Cubism and Constructivism: its modes are analytic and its spokesmen are: for theatre, Myerhold and Brecht, for film, Eisenstein and Snow, for dance, Cunningham and Rainer.

New dance and new film in this country have flourished within the latter context, developing as the most sustained and radical instances of its esthetic enterprise. The condition of that radicality has been the painful luxury of homelessness. New dance, like new film, inhabits and works largely out of SoHo and those adjunct quarters which constitute the center of our commerce in the visual arts. They live and work, however, entirely on the periphery of their world's economy, stimulated by the labor and production of that economy, with no support, no place in the structure of its market. New dance and new film have been in part and in whole, unassimilable to commodity value.

et le nouveau cinéma n'ont pu être assimilés, en partie ou en entier aux valeurs marchandes.

Ils existent et se développent dans leur habitat comme dans une réserve; ils sont condamnés à l'auto-référence. Le résultat est un art du discours critique auto-analytique jusqu'à la consommation totale, en tout point explicatif des problèmes qui accompagnent la révision constante de la grammaire et de la syntaxe de ce discours. Si la Danse sous ses formes les plus innovatrices a insisté sur l'altération des *termes* du discours, forcé un nouveau rapport entre l'exécutant et le public, décrété et solicité de nouvelles façons d'attirer l'attention et d'obtenir satisfaction, ceci est dû, en partie, au fait que le public a été lui aussi l'élément le plus problématique dans la dialectique de la performance."[16]

Dans une table ronde réunissant Trisha Brown, Robert Dunn, Richard Foreman, Yvonne Rainer, Daniel Ira Sverdlik et Twyla Tharp, sur le sujet de la performance, un des thèmes à revenir d'une façon obsessionnelle est celui de ce rapport avec le spectateur. Foreman surtout insiste sur le changement qui doit se produire dans la perception du spectateur:

"N'est-t-il pas juste de dire que la plupart des gens, même si ce n'est pas leur faute, ne sont pas préparés adéquatement à certains nouveaux modes de représentation? Ils ne savent sur quel élément structural de la représentation se concentrer. Il me semble que nous travaillons tous au niveau du matériau, l'arrangeant de nouveau afin que la performance qui en résulte reflète plus exactment non pas une perception du monde — mais les rythmes d'un monde idéal d'activité, refait, pour mieux arriver au type de perception que nous désirons.

Nous présentons alors au public des objects étranges qui ne peuvent être appréciés que si le public est préparé à adopter de nouvelles habitudes de perception — des habitudes qui se heurtent à celles qu'on leur a enseigné à utiliser pour des performances classiques afin d'être récompensés par les plaisirs espérés. En ce qui concerne les performances classiques, le public découvrira que s'il permet à son attention d'être menée par un désir-pour-les-douceurs enfantin et

Existing and developing within their habitat as if on a reservation, they are condemned to self-reflexiveness. The result is an art of critical discourse, consumingly auto-analytical, at every point explicative of the problems attendant upon the constant revision of the grammar and syntax of that discourse. If dance in its most innovative instances has insisted on the alteration of the *terms* of discourse, pressed for an altered relationship between performer and audience, decreeing and soliciting new modes of attention and of gratification, this is, in part, because the audience has been, as well, the most problematic element in the dialectic of performance."[16]

In a panel bringing together Trisha Brown, Robert Dunn, Richard Foreman, Yvonne Rainer, Daniel Ira Sverdik and Twyla Tharp, on the subject of performance, one of the themes coming back again and again was this rapport with the spectator. Foreman especially insisted on the change which must be produced in the spectator's perception:

"Isn't it fair to say that most people, through no fault of their own, are improperly trained to watch certain new modes of performance? They don't know upon which "strata" of the performance structure to concentrate. It seems to me that all of us here are working on material, rearranging it so that the resultant performance more accurately reflects not a perception of the world — but the rhythms of an ideal world of activity, remade, the better in which to do the kind of perception we would like to be doing.

We are, then, presenting the audience with objects of a strange sort, that can only be savored if the audience is prepared to establish new perceptual habits — habits quite in conflict with the ones they have been taught to apply at classical performance in order to be rewarded with expected gratifications. In classical performance, the audience learns that if they allow attention to be led by the kind of childish, regressive desire-for-sweets, the artist will have strategically placed those sweets at just the "crucial" points in the piece where attention threatens to climax. In our work, however, what's presented is not what's "appealing" (the minute something is appealing it's a

23

rétrograde, l'artiste aura placé ces douceurs aux endroits stratégiques dans la pièce où l'attention menace d'atteindre son apogée. Dans notre travail, ce qui est présenté n'est toutefois pas ce qui est "attrayant" (au moment où une chose est attrayante, elle fait référence au passé et à un "goût" hérité.) — mais plutôt ce qui n'a jusqu'ici pas encore été organisé en gestalt reconnaissables; tout ce qui a jusqu'ici "échappé à l'attention". Et la tentation contre laquelle nous luttons tous, je crois, est celle de devenir prématurément "intéressés" à ce que nous découvrons."[17]

Si la performance déroute nos habitudes de perception, si elle n'offre pas ce climax, cette structure à laquelle nous avons été habitués, même conditionnés par une certaine pensée traditionnelle, elle nous met face-à-face avec de nouvelles réalités: une manière adaptée de comprendre, d'appréhender l'espace et le temps dans lesquels nous vivons. La performance nous plonge *dans* l'espace et nous pousse à vivre dans le temps une succession d'intensités qui forment la trame d'une expérience nouvelle, et nécessaire.

Montréal
Mars, 1979.

reference to the past and to inherited "taste") — but rather to what has heretofore not been organized into recognizable gestalts; everything that has heretofore "escaped notice". And the temptation each of us fights, I think, is to become prematurely "interested" in what we uncover."[17]

If performance redirects our habits of perception, if it offers us no climax, that structure to which we have been accustomed, even conditioned by a certain traditional thought, puts us face to face with new realities: a way of understanding, apprehending the space and time in which we live. Performance plunges us *in* space and pushes us to live in a succession of intensities in time which form the frame of a new and necessary experience.

Montreal
March, 1979

translated by Peggy Gale

1. Ce texte a été écrit d'après une conférence donnée à la Galeries Nationale, Ottawa, en décembre 1977.
2. "Klaus Rinke", interview par George Jappe, *Studio International,* spécial Performance, juillet/août 1976.
3. Alan Sondheim, *Individuals,* Post-Movement Art in American, New York, E.P. Dutton and Co., Inc., 1977, p. vii, viii.
4. Michel Benamou, "Presence and Play", *Performance in Postmodern Culture,* ed Michel Benamou et Charles Caramello, Madison, Wisc., Coda Press, 1977, p.3.
5. Michael Fried, "Art and Objecthood", *Minimal Art,* ed. Gregory Battcock, New York, E.P. Dutton & Co., Inc., 1968, p.136–142.
6. Voir au sujet de l'autobiographie, du narcissisme, de l'autore-présentation en art contemporain, l'article de Peter Frank: "Auto-Art: Self-Indulgent? And How!", *Art News,* septembre 1976.
7. Guy Scarpetta, "le Corps américain", *Tel Quel,* Spécial Etats-Unis, Paris, 1977, nos 71–73, p.255-256.
8. Antonin Artaud, *le Théâtre et son Double,* Paris, Gallimard, coll. Idées, 1964, p.
9. Jacques Derrida, *l'Ecriture et la Différence,* Paris, Ed. du Seuil, coll. Tel Quel, 1967, p. 343.
10. Idem, *Ibid.,* p. 348-349.
11. Michael Nyman, *Experimental Music: Cage and Beyond,* New York, Shirmer Books, 1974, p. 5-8.
12. Yvonne Rainer, "A Quasi Survey of Some "Minimalist" Tendencies in the Quantitatively Minimal Dance Activity Midst the Plethora, or an Analysis of Trio A", *Minimal Art,* op. cit., p. 163.
13. Jean-Françcois Lyotard, "The Unconscious as Mise-en-scène", *Performance in Postmodern Culture,* op. cit., p. 88. Je regrette de ne pas disposer du texte français original.
14. Georges Banu, "la Vacuité: utopie impossible", *l'Envers du théâtre, Revue d'esthétique,* Paris, U.G.E., 1977, nos 1/2, p. 69.
15. Voir la critique de la notion de présence que fait Jacques Drrida dans *la Dissémination* ("la Double Séance").
16. Annette Michelson, "Yvonne Rainer, Part I: the Dancer and the Dance", *Artforum,* Janvier 1974.
17. "Performance, a Conversation", ed. Stephen Kock, *Artforum,* décembre 1972.

ARTISTS

VITO ACCONCI

Steps Into Performance (And Out)

1. INTO ACTION

At the beginning, setting the terms: if I specialize in a medium, I would be fixing a ground for myself, a ground I would have to be digging myself out of, constantly, as one medium was substituted for another — so, then, instead of turning toward 'ground,' I would shift my attention and turn to 'instrument,' I would focus on myself as the instrument that acted on whatever ground was, from time to time, available.

But I'm focusing on myself from a distance, as if from above: I see myself, I see the land, figures, around me ... (I'm too far away to be seen as a 'self': I'm seen from the outside: I can be considered only as a 'physical mover.')

But, probably, I should not be seen at all: it's as if an action moves too quickly for an image to take place, have a place (but an image, though unseen, might have already had its effect on the action). If there has to be an image, it would be: not a picture made *of* an action (or of a person performing an action) but a picture made *through* an action (through person to action).

In the beginning was the word: start an action by stating a scheme — from there, the action takes off (takes me off) where it will. The general method is: find a way to tie myself in to an already existent situation — set myself up as the receiver of an action/condition that's already occurring outside me.

Apply a language: 'I' attend to 'it.' (My attention, then, is on 'art-doing' — ways to make art — rather than on 'art-experiencing' — ways to 'see' art. 'Art-experiencing' is treated as an assumption, a casual by-product.)

There's no audience (or, if there is an audience, terms of 'subject' and 'object' are reversed). More blatantly: it's as if a viewer has no place here — after all, I take on the viewer's function, I act as the audience for the situation outside me.

But, once the action is done, an audience comes in, as if from the side. The action was done not as a private activity (there was no notation of my interpretations, my feelings, my subjective experience) but as an exemplar, a model (there was the listing of facts). The action was done, then, from the beginning, so that it could be turned into reportage, into rumor: the action, that started with a word (diagram-sentence), was done only to return to words (small talk).

This is 'performance' only in the sense of: 'the act or process of carrying out something: the execution of an action.' The appropriate medium, then, is that which packages, summarizes, achievement — magazines, news media.

28

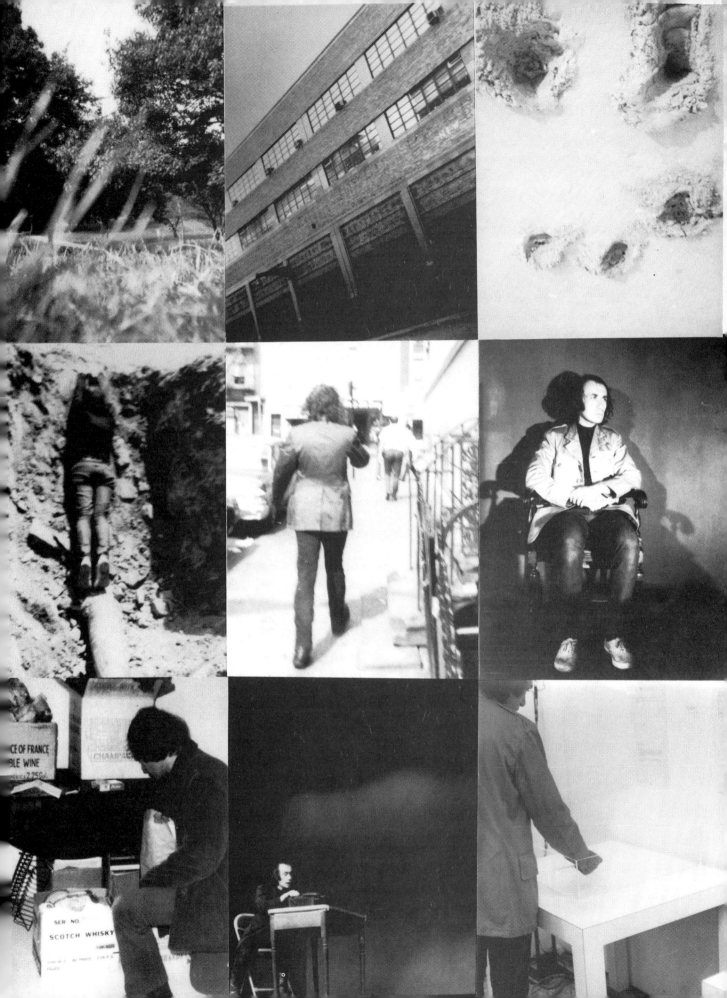

2. AS PERSON

What's developed, thus far, is a contradiction: the 'I' that has been attending to 'it' (as long as that 'I' is seen from a distance as a moving integer, moving object) has become no more than an 'it' itself. If I am using myself, then, I have to come back to myself (rather than retreat into 'it,' into 'things'); that self has to be lived up to (self as 'person' — person as 'motivational/interpretative agent').

In the back of my mind is starting to form a notion of a general condition of art-making: behind every (at least, western) art-work there's an artist — art-work, then, as the sign of an artist (or, conversely, art-work as a cover for the artist — but, in either case, the self is there, in the background, potentially presentable). A logical consequence, then: push the self up to the foreground (art as presentation of self/presentation of artist).

Forming a(n) (art)self. Applying a language: rather than attend to 'it,' 'I' attend to 'me.'

The form is frontal ('Here I am'); the movement is circular; the method is closure. 'It,' at least for the time being, fades away: the action is isolated from its surroundings — 'I' have only 'me,' 'I' need only 'me.' I am the agent of an action and, at the same time, the receiver of the action; 'I' initiate an action that ends up in 'me.'

(In the background, a notion of a general condition of art-experiencing: viewer, entering gallery/museum, orients himself/herself to an art-work as if toward a target, viewer aims in on art-work. This condition of target-making, then, can be a pre-condition: it can be used, beforehand, as a condition for art-doing — art-doing becomes isomorphic with art-experiencing. I can focus in on myself, turn in on myself, turn on myself, treat myself as a target; my activity of target-making, in turn, is treated as a target by viewers.)

The appropriate medium is film/photo (whether or not actual film/photo is utilized): I'm standing in front of a camera — the camera is aiming at me, the camera is (literally) shooting me — all the while, I can be doing what the camera is doing, I can be aiming in on myself. Over all, the film frame being formed separates my activity from the outside world, places me in an isolation chamber (a meditation chamber where I can be—have to be—alone with myself). The implication might be: soon I'll come out, this is only a training ground, it doesn't stop here. But, in the meantime, as far as the viewer can see, I'm caught in a trap.

This can be defined as 'performance' in the sense of 'something accomplished' (the accomplishing of a self, an image, an object).

On the one hand, the system is 'open': if I turn on myself (applying stress to myself), I make myself vulnerable, make myself available to (grabable by) a viewer.

On the other hand, the system is 'closed': if I both start and end the (same) action, I'm circling myself up in myself, I've turned myself into a self-enclosed object: the viewer is left outside, the viewer is put in the position of a voyeur.

(It's as if I got side-tracked: I started out by thinking of 'you' — but, then, working on myself in order to have myself presented to you, I became wrapped up in myself. So my concentration, my efforts, remained on 'art-doing,' not 'art-experiencing.' But, no matter how self-enclosed I became, I must have had a viewer in mind all the time: by closing myself up in myself, I've fixed an image of myself, and that image has to have someone in mind, someone it can be presented to: it's as if, under the guise of concentration, training, meditation, all I was doing was setting up a pose.)

'I,' then, attending to 'me,' fixes a 'me' (while leaving the 'I' ineffectual to change it). 'Person' is hardened, objectified; the viewer, in turn, can come only so far, the viewer is hardened in front of that 'person.' (I might have looked at you straight in the eye, but I've turned you to stone ...)

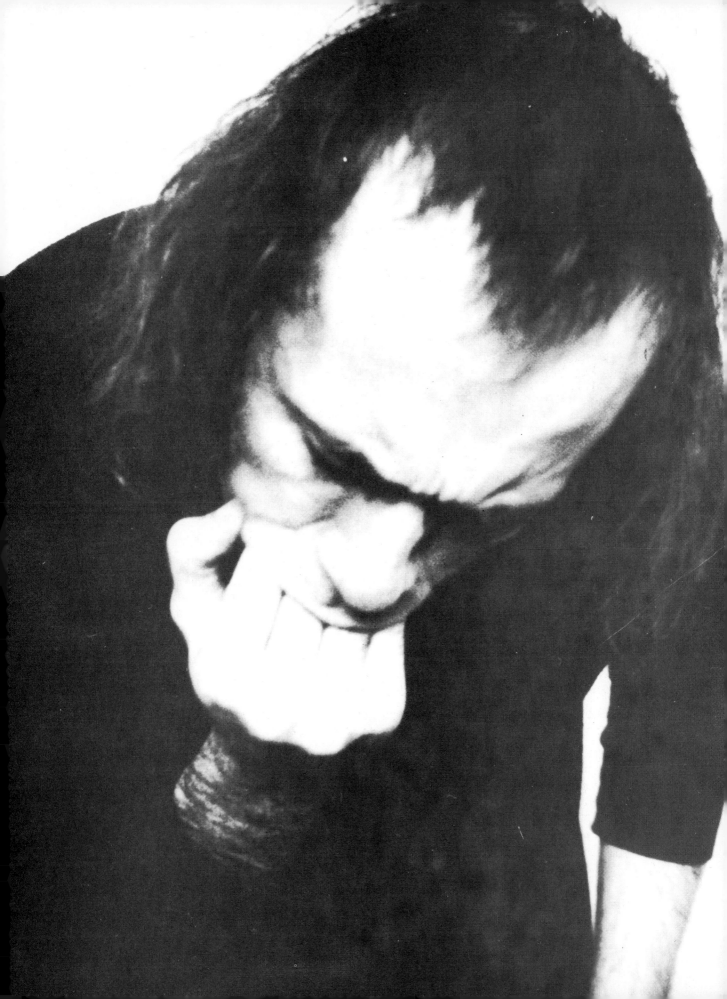

3. ON STAGE

If 'person' (the saying of the word) results in the opposite of person, then 'person' might have to be doubled: to get to 'person,' go 'inter-person' (the introduction of another agent.)

The appropriate medium here is video: video as rehearsal (contrasted to film as a finished image) — video as an image about to be — video as dots, separate dots about to come together to be seen (almost as a last resort) as an image. The notion of video, then, as a backdrop, functions as an impulse to the connection/combination of elements/agents.

(Setting the stage: the 'other element' might be an object: an object is in front of the viewer — I am in front of the object, between object and viewer — I attend to, concentrate on, that object — if that concentration is carried to an extreme, I blend with that object, disappear into it — the object and I have formed a wall in front of the viewer … Or, to look at it another way: the object, concentrated on so doggedly by a person, becomes personalized, personified …)

Two people, then, take their positions opposite each other, encountering each other. Apply a language: 'I' attend to 'him'/'her' while 'he'/'she' attends to 'me.'

The guise is: the breaking of the circle of 'I'/'me.' But the circle has only bulged, the circle is maintained as it is enlarged, now, to include — along with 'I'/'me' — 'he'/'she' and 'him'/'her.' Concentrating on each other, we bound ourselves together in a circle: to keep our concentration, we need no one else, we have no use for anyone else. Concentrating on each other, we form a 'magic circle,' a 'charmed circle' no audience can enter.

This is 'performance' almost in the sense of a traditional 'play.' 'He'/'she' and 'I' make up the boundaries of a stage in front of the audience; the audience is witness to the physical movements of a plot: A leads B on, B becomes stronger than A, A and B combine into a union … Enclosed in each other, we build a house for ourselves — the audience looks in through the 'fourth wall.'

The more each of us gets into the other's person, the less of a person each of us is to the audience: we are not 'persons' but 'representatives' (of a mystery, of an interaction ritual, of a psychology …)

Right before their eyes, then, we've made our exit. The physical movements of the plot are only blandishments to the audience; we have our own (mental) plot (we have our conspiracy): ideally, we've started a relationship — or confirmed a relationship, or reversed a relationship — that by this time is taking place elsewhere. So, by now, we're out of 'art': the audience is left with nothing, the audience is left with only an empty stage.

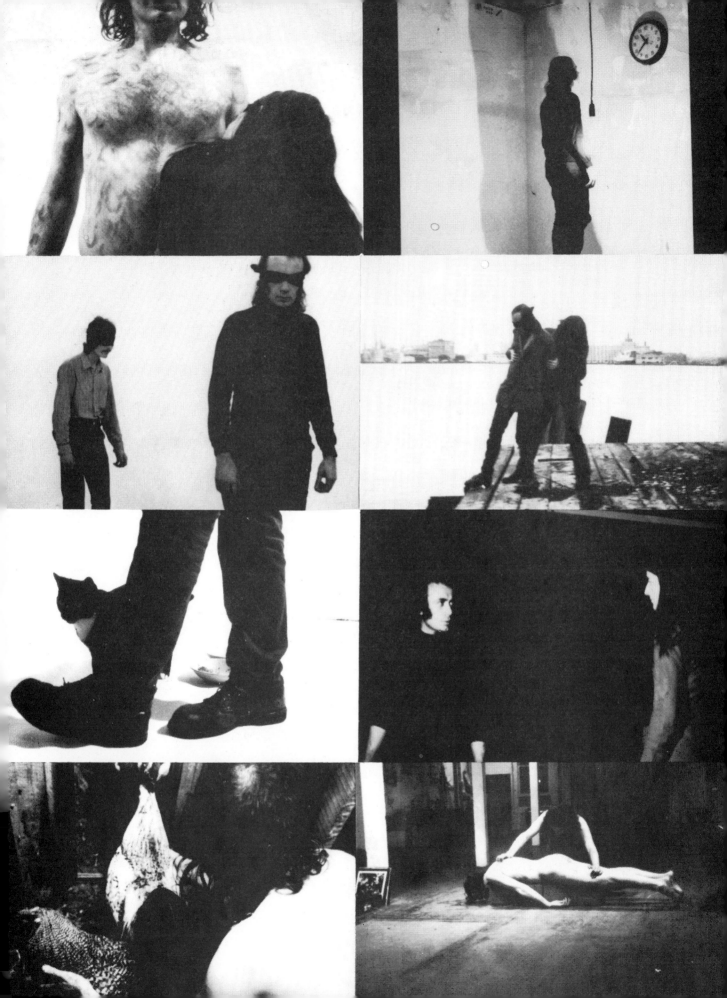

4. TO THE VIEWER

To get back to 'art,' I have to make contact with those people who share in an art context: my space and viewers' space should come together, coincide. A piece, then, takes place is a gallery/museum, in an habitual art situation: the gallery/museum, then, is treated as a meeting place, a place to start a relationship.

(In the background: revise the notion of art as 'presentation of a self/an artist': art, then, as a gift from artist to viewer: art, further, as exchange between artist and viewer ...)

Applying a language: 'I' attend to 'you' (while 'you' attend to 'me' — but, once I've occupied the subject-place of 'attending,' 'you' have almost no time to do the traditional work of art-attending, 'you' attend to 'me' only as a by-product, only as reciprocity.)

The choice of place is, specifically, not 'theater-space' (a place that an audience comes *to,* sits *in*) but 'gallery-space' (a place that an audience passes *through*).

The terms set up are: 'I'/'space'/'you' ('you'/'space'/'me').

The basic structure: I set up a point (I set myself up as a point) at one end of a space — the space, whatever its shape, narrows into a channel between 'you' and 'me' — viewers 'flow' toward that point while, at the same time, that point *points to* ('I' as a system of feelers toward) viewers.

But, as long as 'you' can focus on 'me,' the space around fades away: a direct line cuts through that space, almost in spite of the space — the space is peripheral, the space is only a background, a performance set (we might as well be anywhere/it's as if we're nowhere). I've retained, then, a 'stage' for myself: this is a stage you can enter — but, since it keeps its aura of a stage, you remain off-stage (and only mentally on, as if at a movie, as if in front of a book), no matter how close you come.

The basic structure, then, should be *of* the space and not *within* the space: not performance *in* a space but performance *through* a space. If, for example, I'm not so clearly visible, then you the viewer can be 'in a space' rather than 'in front of me' — you are in a space where I happen to be in action. (In the space, we're making a place for ourselves, together; you are performing for me as much as I'm performing for you.)

This is 'performance' in the sense of 'carrying something through' (carrying through a space — performing a space — carrying myself through you throughout a space).

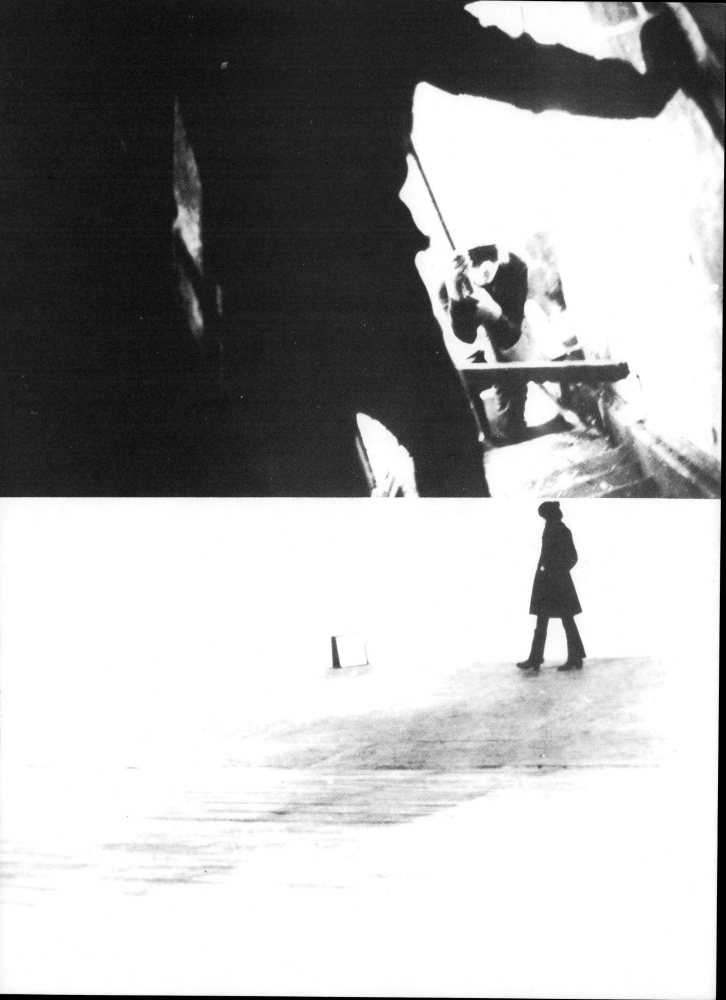

5. OUT OF MY PAST

Once I am under cover, things move too quickly, there's nothing to stop me: since I'm not seen anyway, there doesn't have to be a performance; since there's no actual performance, this is only a place for potential performance; since there's no 'fact' here, I can withdraw into the past, disappear in the future; since my mode of being is so fluid, I can move through the viewer, past the viewer …

To stop myself, I have to come back into the space. In order to come back to the space, I have to face 'you.' In order to keep facing you, I need something to anchor me in the place where you are. But I have that anchor within me: now that I've gone into the past (or into the future, or into metaphor), 'I' can never be the same again: 'I' has a history, an autobiography: the past, that I could have withdrawn into, is brought back here, imported: the past functions as a weight that keeps me in place here. In order to face you, I have to face up to myself.

(In the background: a notion of art as privacy that results in publicness — a private life makes a deposit in a public space, where private times come together in a public function.)

Gallery/museum, then, is used as a buffer-zone: I bring something private into a public space — once that privacy is made public, I can't deny it — once it's brought back, later, to privacy, there's no reason not to face it.

Applying a language: 'I' attend to 'you' through 'me' / 'I' attend to 'me' through 'you.'

It's this phase of the work that might, finally, be claimed as 'performance': roleplaying — I act out my life in front of others, I change my life to be handed over to others.

Gallery returns to theater. Image-structure: spotlight — performance arena — seating arrangement. (granted that a gallery is for observing: as gallery-goers, then, are observing me, from the outside, I can, all the while, be observing myself, 'from the inside.')

The gallery is turned into itself: the gallery is turned into, literally, a museum. This is where I place my past in the spotlight, let it harden. Now that I've faced myself, I can leave my (old) image here, as a museum-piece. This gives you a quick introduction to 'me'; I've left my autobiography as a calling card.

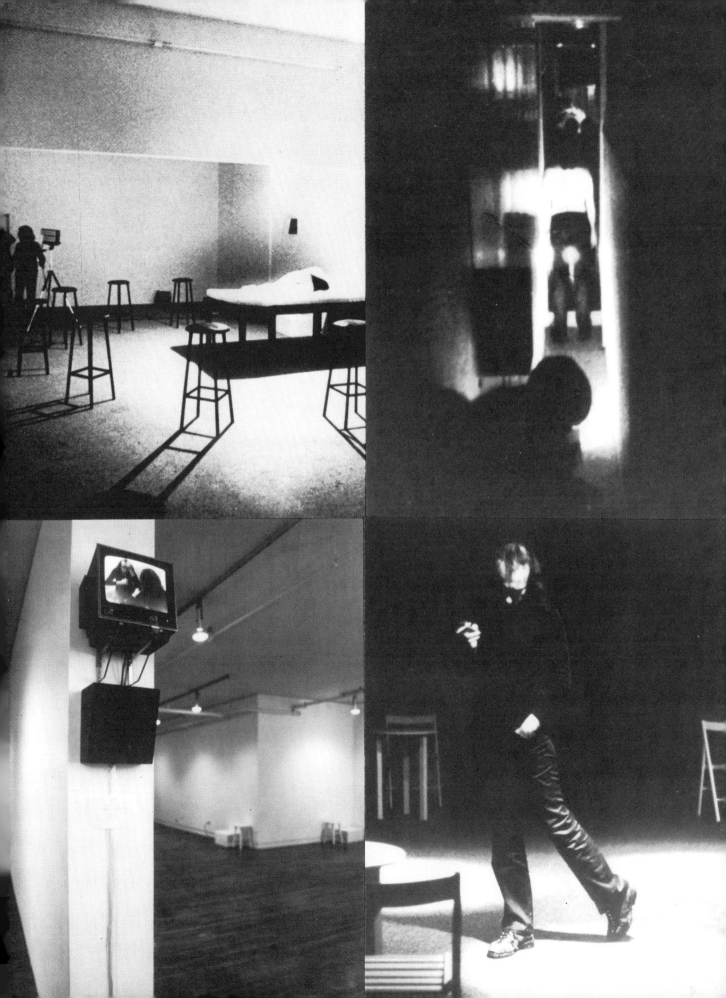

6. ADDENDA: AFTER PERFORMANCE IS OVER

1. As long as I'm there, in person, a piece is restricted by (to) my 'personality': I can deal only with my person (physical), my past (psychological), my relation with you the viewer.

2. As long as I'm there, in person, I can go within and deal with (isolation-chamber) self — but I can't step out of myself far enough to deal with (external causes of) self.

3. For an extra-personal world to come in, I have to go out. (I have to leave room for that world to turn in, and not merely to add an atmosphere, a background, to my 'person.')

4. As long as I'm there, in person, 'you' and 'I' remain on opposite sides, no matter how close we come; we remain 'artist' and 'viewer.'

5. As long as I'm there, in person, no matter how hidden I might be, I'm in the spotlight, I'm the 'star-attraction' you came for.

6. In order for you to have room of your own, in order for you to be free to move around the space, I have to move aside, I have to move out of your way.

7. Behind the scenes, then, there's a structure of performance: I move from place to place (exhibition space to exhibition space) — I act (build) according to the space — I move on to another place.

8. Behind the scenes, there's costuming, role-playing: a piece is directed toward a particular cultural space — a piece in New York is different from a piece in LA is different from a piece in Milan is different from a piece in Cologne.

9. On the scene, I've left my voice, as if calling a meeting to order. (My voice is left as an oppression that, eventually, people will have to react against, leaving the space, ending the meeting and starting an action.)

10. Scenes from people's performance: Wall (presence/body-to-body) — Ladder (direction/escape) — Machine (action/explosion).

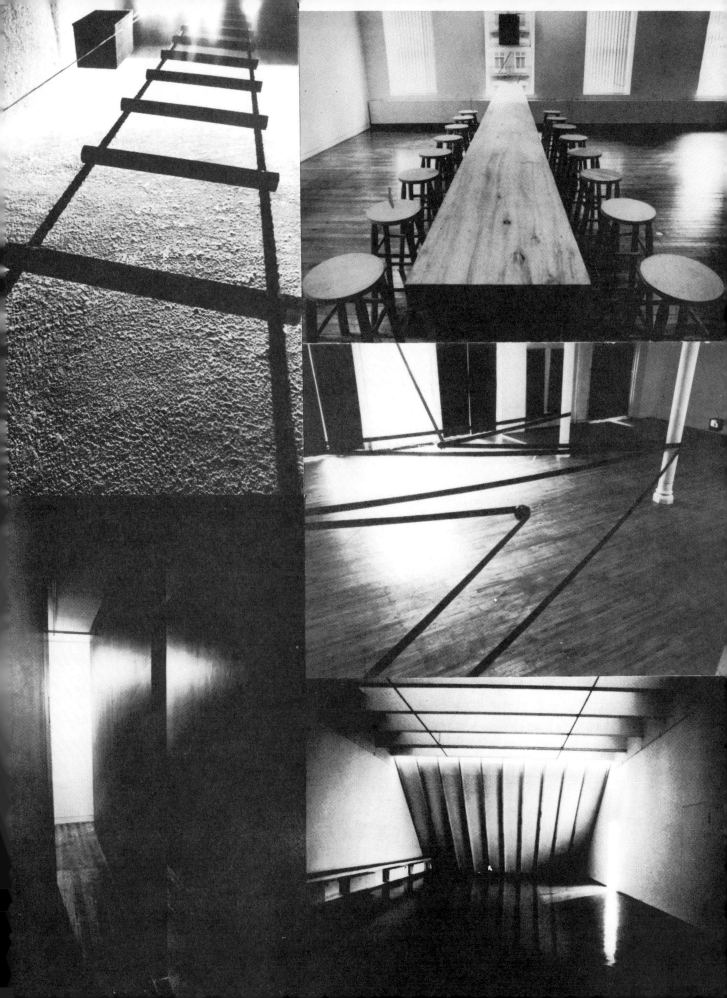

PHOTOGRAPHS

1. LAY OF THE LAND (photo piece; summer 1969): lying down in a field, camera held at five points on my reclining body, shooting out at landscape
2. THROW (photo piece; summer 1969): snapping photos in the motion of throwing a ball
3. PUSH-UPS (photo piece; summer 1969): successive photos, one-hundred push-ups in one spot
4. IMITATIONS (photo piece; summer 1969): taking positions that imitate — extend — close a landscape
5. FOLLOWING PIECE (activity, one month; October 1969): each day, following a different person until he/she enters a private place
6. PERFORMANCE TEST (performance; December 1969): staring at each member of the audience, left to right, front to back, one minute each
7. ROOM PIECE (installation/activity; January 1970): transferring contents of my apartment to gallery — using the contents as usual
8. LEARNING PIECE (performance; April 1970): singing with Leadbelly, learning his song, first one phrase, then two phrases, then three …
9. SERVICE AREA (installation/activity; summer 1970): my mail forwarded to the Museum of Modern Art, NY — my space in the show used as my mail box
10. HAND AND MOUTH (film; summer 1970): pushing my hand into my mouth, choking, releasing my hand, repeating the action until I am exhausted and the film is over
11. APPLICATIONS (performance/film; December 1970): she applies kisses to my chest, I rub the kisses on to his back
12. SECOND HAND (performance; January 1971): following the movements of the second hand of a clock — 'becoming' clock-time
13. ASSOCIATION AREA (video, one hour; February 1971): trying to imitate each other's movements, though neither of us can see or hear the other
14. SECURITY ZONE (activity/photo piece; February 1971): alone on a pier with a person I don't trust — an attempt to improve a personal relationship
15. ZONE (one-hour performance/film; April 1971): walking a circle around a cat, enclosing the cat in the circle
16. PULL (one-hour performance; April 1971): each of us tries to lead the other into a circle
17. COMBINATION (performance, six hours; June 1971): my body becomes a house for roosters
18. SOUNDING BOARD (performance, one hour; July 1971): music beneath me — he pounds the music on top of me, drives the music into me
19. CLAIM (performance, three hours; September 1971): hypnotizing myself into sole possession of a basement-space
20. SEEDBED (installation/performance, eight hours a day; January 1972): I function as a 'floor' for viewers — using viewers' footsteps to excite me — using my excitement to connect with viewers
21. RECEPTION ROOM (installation/performance; March 1973): '… I can show what I'm ashamed of: they can see the pimples on my legs, the pimples on my ass …'
22. PROPS (installation/performance; March 1973): '… If you don't come up behind me, if you don't do something behind my back, then I'd know I can trust you …'
23. AIR TIME (installation/performance; April 1973): '… Once they see that that's how I am with you, I'll have to admit it … I have to realize that I'll never change … the only solution is, our relationship has to end …'
24. BALLROOM (performance; November 1973): '… Neither Kathy nor Nancy really understands me … but you'll understand me …'
25. WHERE WE ARE NOW (WHO ARE WE ANYWAY?) (installation, NY; November 1976): '… Now that we know we failed (and what do you think, Bob?) …'
26. TONIGHT WE ESCAPE FROM NEW YORK (installation, NY; February 1977): '… You made it: you're a nigger — higher, higher …'
27. THE GANGSTER SISTER FROM CHICAGO VISITS NEW YORK (A FAMILY PIECE) (installation, NY; November 1977): '…Mama…mama…Sister — sister — we have to know: where does the smell go — sister?…'
28. VD LIVES / TV MUST DIE (installation, NY; February 1978): '… I'll take your picture with my brownie … Zap — you're sterile …'
29. ASYLUM (ALL THE OTHERS SEEK ASYLUM) (installation, Luzern; April 1978): '… We're ready, we're ready. we're ready … How can they know that in here there's nothing but shit?…'

LAURIE ANDERSON

NOTES FROM "LIKE A STREAM"

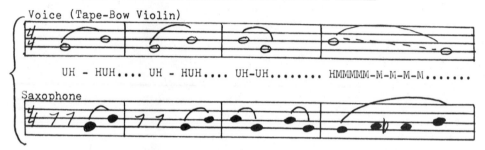

VOICE/SAXOPHONE EXCHANGE FROM "LIKE A STREAM"

"Like a Stream" is an extended piece for voice, tape, and instruments. Several versions of it were performed in the spring of 1978; at the Walker Art Center (Minneapolis), And/Or (Seattle), Portland Center For The Visual Arts, and the Kitchen (New York City). The tape sections are played on Tape-Bow instruments — bowed instruments with audio playback heads mounted on the bridges; horsehair on the bow is replaced by strips of quarter inch audiotape. Much of the information recorded on the bows is reversible, sounds which make as much sense on an upbow as a downbow: breathing (In/Out), walking (Forward/Back), vocal sounds such as uh-huh...uh-uh (Yes/No) and uh-hhu-uh (tonal, colloquial "I don't know"), water (up and down stream). The pitches and rhythm of the instrumentation derives from these tape sounds. The talking solos are performed as non-theatrically as possible. One of the issues in doing the piece became emphasizing somewhere between distracting and simply odd, the importance of speaking *over* the music. The texture of the piece also seemed to evolve out of the tones of voices of the readers. My favorite version remains the Minneapolis performance, the flat and slightly nasal Scandinavian overtones, partly because it's the part of the country I learned English in, and partly because it sounds so much like the way it looks: blank, flat, spare.

The timing and counterpoint in "Like A Stream" was a slowly shifting and dissolving series of images (slides) which also commented on the text. Phrases passed from bass to cello like slow motion football as one image slowly evolved into the next.

The following texts are a selection from the spoken "Like A Stream" solos.

1. It was the night flight from Houston—almost perfect visibility. You could see the lights from all the little Texas towns far below. I was sitting next to a fifty-two year old woman who had never been on a plane before. Her son had sent her a ticket and said, "Mom, you've raised ten kids, it's time you got on a plane." She was sitting in the window seat staring out. She kept talking about the Big Dipper and the Little Dipper and pointing. Suddenly I realized she thought we were in Outer Space looking down at the stars. I said, "I think those lights down there are the lights from little towns."

2. I saw a photograph of Tesla who invented the Tesla Coil. He also invented a pair of shoes with soles 4 inches thick to ground him while he worked in his laboratory. In this picture, Tesla is sitting in a chair, wearing the shoes, and reading a book by the light of the long, streamer-like sparks shooting out of his transformers.

3. A long time ago, New Mexico was green with many small blue lakes. Gradually, the limestone shores slipped down into the lakes and coated the bottoms. The wind stopped blowing and for hundreds of years there was no rain. The sides of the lakes crumbled away. Then the soil around the lakes blew away. Now the bottoms of the lakes are on tall platforms, and nobody in Albuquerque knows why.

4. It was an ancient Japanese pot, incised with grooves. Thin-ridged grooves. Grooves all around it. It looked like one of those collapsible paper lanterns. It was an experiment. The pot was placed on a turntable and the turntable began to revolve. A needle was set into the groove. A stereo needle. They were waiting to hear the voice of the potter potting the pot 2,000 years ago. They were hoping the sounds of the potter had somehow been embedded into the wet clay. And stayed there, intact, clinging to the ridges of the clay. The pot turned around and around like a record being treadled into the third dimension. It turned. They listened. They were listening. Some of them heard an unidentifiable Japanese dialect, rapid and high. Some of them heard high-pitched static. The needle dug into the pot, wearing away the clay. The ridges were crumbling away. The needle was getting blunt. More and more blunt...it was that scientific. Blunter and scientific. More blunt...and more scientific.

5. I can draw you with no ears. I can draw you so that you have no ears at all.

6. I wanted you. And I was looking for you. I wanted you and I was looking for you all day...but I couldn't find you. I couldn't find you.

7. I dreamed I was a dog in a dog show and you came by and pointed me out and you said, "Look, look, look! Now *there's* a dog for you!"

8. I met a French woman in New York. She was new to New york and didn't have any friends. She was very lonely and disoriented; didn't like the food; thought the English language sounded "like always you are selling something". It was fall and she spent most of her time walking around the city. She had the eccentric habit of picking up leaves from the sidewalk and taking them home where she would try to revive them. She was rarely successful at this and her whole apartment was full of jars of moldy water and rotting leaves.

9. His house was full of clocks. Clocks of all kinds. He was very particular about setting them so that they all told exactly the same time. But not only the same time...he set them so that they all ticked on exactly the same beat. So his whole house sounded like "TICK!!......TICK...........TICK!!"

10. Looking into his eyes was like walking into a large municipal building. He had perfected an arrangement of his face that suggested International Style architecture—a subtle, yet daring, blend of American industry's most durable (yet flexible) materials.

11. I don't know...I've got a feeling this isn't what I paid my money for...I mean....I've got a funny feeling this isn't...it just isn't...you know...what I paid my money for...

12. SPACE: what you damn well have to see. People don't know how dangerous a love song can be.

13. When Bobby got back from his first trip to Las Vegas, he said he noticed he was pausing just a little longer than usual after putting his money into parking meters and xerox machines.

14. I got a letter from a woman in Holland. She was writing to ask what it was like to be an artist living in New York. She wrote, "Please to informate me, for I look with a great deal of surprise in my eyes for the New World and especially for the town of New York. For example, where are the questions: 1) How is it to leave your own town

and so to go to New York? What means it? And how feels it? 2) What means New York in the social way? Do cafes? 3) How did you become a good house to live in? 4) What do you do to be living? 5) What means New York? What means the people living in this town? How feels it? And, what needs it?"

15. Did he fall...or was he pushed?

16. Dan said he was on a plane flying over Greenland with a bunch of Texans and they had binoculars. They were looking for polar bears down on the ice. White bears down on the white ice (from about 6,000 feet). And they said, "Look! I think I see one now! Look! Down there! I think maybe I see one. Down there! Maybe that's one. It *could* be one."

17. Last night I dreamed I was in bed sleeping. I dreamed all night I was just lying in bed dreaming I was sleeping. Last night I dreamed I was sleeping.

18. Every time he took a drag on his cigarette, he thought of Frank Sinatra smoking and singing, "Smoke...makes a staircase.....for you to descend."

19. It was that way for him. Some days he was flying. Flying easily. Everything seemed so easy. White light. Great ideas. And then it would change. For no reason it changed. It left him and suddenly nothing worked. He was depressed. He was clumsy. He burned the toast, dented the car. And then it would change again. It changed fast and for no reason it changed. Everything was easy again. And he went to the doctor and the doctor said "....chemical imbalance...." and gave him some chemicals and cured him. Cured him until it was all even again. Every day same thing. And he was so relieved to know he hadn't been crazy... "It's not me...it's my biochemistry."

20. Dad said last spring there were a lot of geese in his wheat field and the geese grew, the wheat grew. The wheat grew and the geese got bigger too. But the geese always grew just slightly faster than the wheat and all you could see was their long necks waving above the fields of grain and he said, "Look! They look like cobras out there in that wheat field!"

21. Well, Mom said, "Honey don't put that money in your mouth.

You never know where money has been." Pop said, "Put your money where your mouth is and you'll never have to talk again. Cause money talks, and nobody walks." He said, "Money talks and nobody has to walk."

22. If you can't talk...if you...if you can't talk about...about..if you...just..all you have to do is...point to it...just point to it...

23. It is 1947 in this newsreel. New York City in 1947. The American Legion is having a parade and each state has chosen a theme. They are marching down Broadway the way Broadway used to look. The Vermonters have come as Minutemen this year striding along with muskets mounted on their shoulders. The Montana delegates are fancy rodeo/ranchers mounted on slow, obviously rented, Palominos. This year Iowa has come as a corn field. Husks and stalks belted on, they zig zag down Broadway in no discernible pattern. Cut to Ike who is smiling and waving faster than in real life. His smile comes and goes rapidly, with no space in between.

24. I met a man in Canada and every day he had the same thing for lunch. He had a carrot and he had a bowl of chocolate pudding. First he ate the carrot into the shape of a spoon. Then he ate the pudding with the spoon-shaped carrot; and then he ate the carrot.

25. He was a piano tuner in Los Angeles; he had never been outside of the city limits and he explained to all his customers, "The reason I have never left Los Angeles is that people are in trouble every where. Every where you go, there are people who are in trouble."

26. In my dream I am your customer.

27. There are Eskimos who live above the timber line. There's no wood there for the runners on their sleds so instead they use long frozen fish which they attach to the bottoms of their sleds to slip across the snow.

28. I met a man on the Bowery and he was wearing ancient, greasy clothes. And brand new bright white socks and no shoes. Instead, he was standing on two pieces of plywood, and as he moved along the block, he bent down, moved one of the pieces slightly ahead and stepped on it, then moved the other piece slightly ahead and stepped on it.

29. Diane says she likes the way people do one thing so they'll have to do something else to counteract it. She's talking now...she's looking directly into the sun...directly into the sun...she's shading her eyes now. Still talking.

30. I read about a rabbit in a laboratory. They held the rabbit's head, eyes open, pointed towards a window. For twenty minutes, staring at the bright window. Then they chopped the rabbit's head off, peeled the tissue off its eyes, dyed it, and under the microscope, like film, it developed: two windows imprinted on the rabbit's eyes. And they said, "Look! This rabbit has windows on its eyes!"

31. Oh. Oh. Oh. I like the way you look. Oh. Oh. I like the way you talk. Oh. I like the way you walk. But most of all I like the way you look...(at me).

32. He was so smart, he wore his brains on his sleeve. That's how smart he was.

33. No one has ever looked at me like this before. No one has ever stared at me like this for such a long time. For so long...this is the first time any one has ever looked at me...*stared* at me like this for so long.....for such a long time....

34. I met a writer at a cocktail party. This writer used "I" in all his books. He was famous for the way he used "I" in all the books he wrote. At the party, people kept coming up to him and saying, "Gee! I really like your work..." And he kept saying, "Thanks, uh, thanks...but I'm not very representative of myself..."

36. I saw a sign in the bathroom at the library. It was in red magic marker and it read, "I LIKE GRILS" in messy longhand. Underneath, in neatly pencilled caps was, "YOU MEAN *GIRLS*, DON'T YOU?" Below that, in the same red magic marker, was, "NO I MEAN GRILS!"

37. In the Greyhound bus station, there was a man who was drunk and drinking out of a paper bag. He kept coming up to me and saying, "Your beauty can only be compared to......(indistinct)...can only be..can only be compared to....(indistinct).....to....."

38. One night we asked the ouija board about our past lives. I have

lived 9,361 times. My first life on the planet was as a racoon. When Don asked what he had been before, the board spelled out, "First you were a cow, and then you were a bird, and then you were another bird, and then you were a hat." We didn't understand about the hat so we asked the ouija who explained that the feathers from the bird had been made into a hat which counted as a long and quiet kind of "half-life".

39. I went to a palm reader and the odd thing about the session was that almost everything she said was totally wrong. She said, "I see here that you love to fly..." and planes terrify me. She said, "I read here that someone named Terry is the most important person in your life," and I have never known anyone with that name except once I had a fish named Terry. She gave me all this information, however, with such certainty that I began to feel I was walking around with a pair of false documents permanently tattooed to my hands. Had I known a Terry? The parlor was full of books and magazines in Arabic and I could hear people in the next room speaking rapidly in what sounded like that language. Suddenly it occurred to me that maybe it was a translation problem...maybe she was reading my palm from right to left instead of left to right. I gave her my other hand, thinking it might be analogous to a mirror situation. She also put her hand out. We sat there for what seemed like several minutes...awkwardly holding our hands out...until I realized that this was not a participatory ritual...that she was waiting for money.

JOSEPH BEUYS

The following pages are excerpted from
*Report to the European Economic Community on the
feasibility of founding a 'Free International University
for Creativity and Interdisciplinary Research' in Dublin,*
by Caroline Tisdall, at the suggestion of Joseph Beuys
as his contribution to *Performance by Artists.*

Concept and Origins of the Free International
University for Creativity and Interdisciplinary
Research

Part 1 : General Principles

1.1. This project originated in 1972 as the result of
disquiet on the part of a number of individuals
about the present state of education, and its
failure to prepare students for an active and
creative role in society.

1.2. The roots of this failure were analysed as
extending from the political pressure exerted on
all State-run institutions to prepare specialists,
even when the demand for specialists in some
fields had diminished and changed, to the inability
of the present structure of education to renew
itself in the face of contemporary developments.

1.3. It was further felt that the traditional education
structure perpetuates the forms of segregation that
have contributed to the current crisis in society,
and that it does so in the following ways :

a) the division of the disciplines for the training of
experts, with no substantial comparative method,
reinforces the idea that only specialists can con-
tribute to the basic structures of society : economics,
politics, law and culture.

b) the separation of creative fields from social or
scientific fields in turn reinforces the notion
that creativity is restricted to those trained as
artists, architects, musicians etc.;

c) this in turn separates the creative, social and
scientific fields to the extent that it becomes
almost impossible to conceive of the notion of
creativity in its widest sense being applied to
that of economics, politics or law. As a result
the most essential social structures develop in
an increasingly abstract and isolated fashion;

d) the reliance on accumulated fact within each
discipline passes for education. The student is
rarely called upon to develop an independent,
organic or comparative model of thinking. He is
insufficiently prepared either to make an imag-
inative contribution to his own field, or to
relate it to the life of society;

e) the separation of learning and research levels
results in lack of learning through experience,
and is further increased by the divorce of research
and learning from society in general and the comm-
unity in particular. The result is a still greater
abstraction of learning;

f) because of the social isolation of academic studies,
schools, universities and research institutes are not
functioning as energy centres within the community,
and the loss is mutual.

g) the hierarchy of society and the inequality of
opportunity is further perpetuated by restricted
entrance to higher education. The competitiveness
generated by such a system is undemocratic, inorg-
anic and uncreative ;

h) the restriction of experimental or progressive
learning methods to private schools further rein-
forces the system of privilege ;

i) falling standards and disaffection at all levels
of education are a practical proof of the impotent
state of the present system, and are a direct
reflection of the state of society.

1.4. Such feelings are widely felt among academics,
 non-academics, professionals and non-professionals,
 but an active focal point for constructive action
 is needed. It is not sufficient to criticise :
 functional and constructive models of a better
 structure must be demonstrated.

1.5. The need for such initiatives coincides with a time
 of economic crises. This is exactly the time when
 new constructive thinking is needed, and it is also
 the time when governments feel least willing to
 justify experiment. The result leads to apathy and
 failure to provide for the future.

1.6. Those attempts to establish alternative models
 must generally look elsewhere for financial
 support, create an examinable structure, and then
 present it to Ministries and Departments of
 Education as a viable alternative.

1.7. Education should be seen as an area of freedom
 for the development of such viable alternatives
 if it is not merely to perpetuate the status quo.

1.8. In every field of activity and in many countries
 there are individuals who doubt the viability of
 the totally specialist attitude and who advocate
 an interdisciplinary approach which can more
 effectively parallel the complexity of society
 while achieving an overall outlook.

1.9. Europe is remarkably lacking in any facilities for
 the regular discussion and comparison of such ideas,
 based on the concept of a permanent conference,
 development of research, and dialogue with the
 community, involving its direct participation.

Part II. Founding Concept and Manifesto
of the Free University.

1.10. As a result of such thinking, a group was
 founded in Düsseldorf to investigate the
 possibilities of establishing an alternative
 model of education.

1.11. In 1972 this founding group, which included
 prominent cultural figures among whom were the

sculptor and educationalist Prof.Joseph Beuys
and the writer and Nobel Prize winner Heinrich
Böll, both of whom are involved with the Dublin
project, published the manifesto of which the
following are exerpts:

'Creativity is not limited to people practising
one of the traditional forms of art, and even in
the case of artists creativity is not confined to
the exercise of their art. Each one of us has a
creative potential which is hidden by competitive-
ness and the aggressive pursuit of success. To
recognise, explore and develop this potential is
the task of this school.

Creation involves not merely talent, intuition,
powers of imagination and application, but also
the ability to shape material which could be
extended to other socially relevant spheres.

Conversely, when we examine the ability to organise
material that is expected of a worker, a housewife,
a farmer, doctor, philosopher, judge or works
manager, we find that their work by no means
exhausts the full range of their creative abilities.

Creative democracy is increasingly discouraged
by the growth of bureaucracy, coupled with
aggresssive proliferation of standardised mass-
- culture. Political creativity is reduced to
the mere delegation of decision-making and power.
The imposition of an international cultural and
economic dictatorship by the constantly expanding
media-combines leads to a poverty of articulation,
learning and the quality of verbal expression.

In the consumer society, when democratic creativity,
imagination and intelligence are not articulated and
their expression prevented, they can become harmful
and damaging, and find outlets in corrupted criminal
creativity. Criminality can arise from boredom and
repressed and inarticulated creativity. To be reduced
to consumer values, and to see democratic potential
reduced to occasional elections can also be regarded
as a rejection or dismissal of democratic creativity.

Environmental pollution advances with the pollution
of the individual. Hope is rejected as utopian or
illusionary, and discarded hope breeds violence.
In the school we shall research into the numerous
forms of violence, which are by no means confined
to the use of weapons or physical force.

As a forum for the confrontation of political or
social opponents, the school can set up a permanent
seminar on social behaviour and its articulate
expression.

The specialist's insulated point of view places
the arts and other kinds of work in sharp oppo-
sition, whereas it is crucial that structural,
formal and thematic problems of the various work
processes should be constantly compared with one
another.

The school does not discount the specialist,
nor does it adopt an anti-technological stance.
It does however reject the notion of experts and
technicians being the sole arbiters in their
respective fields. In a spirit of democratic
creativity, without regressing to mechanical
defensive or aggressive cliches, we shall disc-
over the inherent reason in things.

The founders of the school look for creative
stimulation from foreigners working here. This
is not to say that it is a prerequisite that
we learn from them or they learn from us. Their
cultural traditions and way of life encourage an

exchange of creativity that must go beyond
preoccupation with various art forms to a comp-
arison of the structure, formulations and verbal
expressions of the pillars of social life: law,
economics, science, religion, and then move on
to the investigation and exploration of 'democratic
creativity' or 'creative democracy'.

Since the school's concern is with the values
of social life, we shall stress the conciousness
of solidarity. The school is based on the princ-
iple of interaction, whereby no institutional
distinction is drawn between teachers and learners.
The school's activity will be accessible to the
public, and it will conduct its work in the public
eye. Its open and international character will be
constantly reinforced by events.

It is not the aim of the school to develop polit-
ical and cultural directions, or to form styles,
or to provide industrial and commercial prototypes.
Its chief aim is the encouragement, discovery and
furtherance of democratic potential and the expres-
sion of this in a world increasingly manipulated
by commercial publicity, political propaganda,
the culture business and the press.'

1.12. Since the Manifesto was written the concept of
 the Free University has expanded and developed
 with the adherence of people from more fields
 and countries (see Section 3), and with the pract-
 ical possibility of setting up such a model in
 Dublin (see Section 2).

1.13. Comparison has been made with other initiatives
 to implement alternative models (see Section 5),
 and is now felt that the concept of the Free
 University is sufficiently developed to seek the
 financial backing to begin in 1976.

DANIEL BUREN

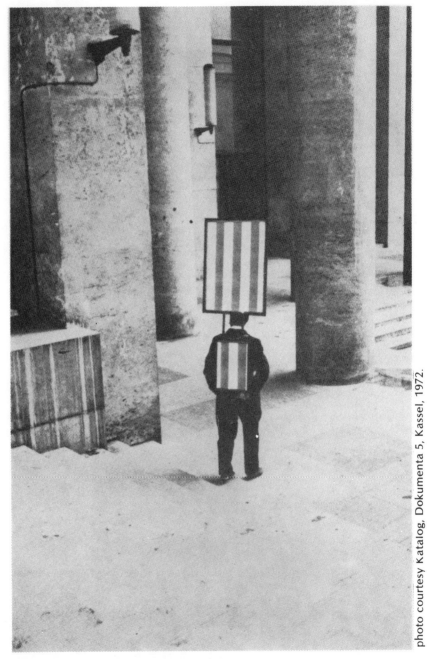

photo courtesy Katalog, Dokumenta 5, Kassel, 1972.

Sandwich-man, Paris, April, 1968.

Act III: New York City, The New Theatre. January 15, 1973. Photo courtesy John Weber.

7 Ballets in Manhatten: May, 1975, "Wall Street". Photo courtesy D.B. (white & green).

Continuing Piece 1977-1978: The Brooklyn Bridge, March, 1978. Photo courtesy D.B. (white & yellow).

7 Ballets in Manhattan: May, 1975, "Greenwich Village". Photo courtesy D.B. (white/black & white/yellow).

7 Ballets in Manhattan: May, 1975, "Soho". Photo courtesy D.B. (white/black, white/green, white/yellow, white/red, white/blue).

Performance with Video-tape Recorder in Situ, Fine Arts Building, January, 1975.

COUM TRANSMISSIONS

Annihilating Reality

by Genesis P. Orridge and Peter Christopherson

"SCENES OF VICTORY"

COUM has changed. That is good. Up until late 1976 we performed many actions as art in streets, galleries and festivals. We explored our own neuroses and exposed them publicly. The article/directive "Annihilating Reality" grew from our conclusions through doing all these actions. We found the artworld on every level less satisfying than real life. For every interesting performance artist there was a psychopath, fetishist or intense street individual who created more powerful and socially direct imagery. We also were unhappy about art being separated from popular culture and the mass media. It seemd to us that it was far more effective propaganda/information dispersal to be written up the the NEWS section of daily papers than in a back page column of a specialist Art journal. Now we much more rarely make actions in Art spaces, we create private documentation. We have moved into the public arena and are using popular cultural archetypes. We live our lives like a movie, we try to make each scene interesting viewing. We use the press to record our activities like a diary. Our documentation is newspapers and magazines.

COUM TRANSMISSIONS has a diverse membership. At its active core are Peter Christopherson, Cosey Fanni Tutti and Genesis P-Orridge. Cosey Fanni Tutti is working as a professional striptease dancer and topless go-go dancer in London pubs, Peter Christopherson is using photography to create private archetypal situations and Genesis P-Orridge is producing private images as Art and then deliberately attempting to manipulate the media to absorb them as "News" and via the news media distribute these images into hundreds of thousands of ordinary homes to see if it stays art, mutates or just what the implications of elite versus popular are. We try not to mystify or use complicated words unnecessarily. Explanations are always oblique however.

COUM are sometimes distrusted and disliked. People always pretend to want to be lifted out of themselves, but in reality they are terribly afraid of anything REALLY happening to them. We want people to be themselves, and the price of that is to abandon the false ideas one has of oneself. There is no *implicit* value in anything. People like the sham artists who soothe them with aesthetic platitudes. They dread having to face reality in any form.

Without experiment there is no hope. Without hope there is no point. With no point life is a lie.

COUM is a fusion, not merely of Art, but of many regenerative ideas. The subconscious must be brought out and given life so it engulfs us with its honesty and accuracy. Once Art is brought into line with everyday life and individual experience in public situations, it is exposed to the same risks, the same unpredictable coincidences, the same interaction of living forces. Coum is therefore both a serious and tragic emotional stimulus combining the fruit of experience to create precious, yet expendable, moments in time.

COUM is a mirror of all it coums across and all who coum across it, in any of its forms. With man becouming more and more conscious of his mortality and isolation, his sense of loneliness and meaninglessness is becouming unendurable. All that we look at is false. In an age where the image is pillaged, only the anonymous survives. In an age where order is power, think what chaos provides. COUM do not believe that the nature of the final action is important.

COUM TRANSMISSIONS
London HQ., 1978

65

AA Kommune, Selbst Darstellung in Gols, Austria

Series of famous groups going into the house of Guglielmo Achille Cavellini in Brescia, Italy on 15 February 1976

This photograph portrays a fictional situation, posed by professional boy models. Similarity to persons living or dead is unintentional

Hearsay: Dervishes dancing to music, sticking spikes through their tongues and cheeks. Pulling a Kris into their chests. Watched on TV right this minute. What makes a performance, art? What are its qualities, strengths, directions, functions? Seven years in Tibet, before the Chinese arrived. Ritual and music performed. How does a conversant insider perceive it? How much can an unversed outsider follow? Is it possible to exist, be justified by, creating curiosity, sheer human interest?

'Psychic reality, and its structuring in terms of internal objects and internal-object relations, is made manifest in fantasy. The myths and legends of primitive peoples, folk-lore and the imaginative creations of literature and art in all ages constitute a continuous revelation of the fantasy-life of the human race, and throw tremendous light on the workings of the unconscious'.
Harry Guntrip

Hearsay: Aztec ceremonies using control codes, Mayan rituals with acceptance of slaughter of animals, people slowly tortured to death, the art of society and part of instinctive collective fantasy. Dean Corll, arrested 7 August 1973 in Houston, Texas, murdered and sexually assaulted 27 teenage boys. Hermann Nitsch's OM Theatre slaughter 100 sheep in castle grounds in art ritual, selected crowd of art and social élite guests watching, mid-summer's day. High on blood. Is it only legality that prevents the artist from slaughter of human beings as performance?

Hearsay: Ian Brady and Myra Hindley photographed landscapes on the Moors in England where they had buried children after sexually assaulting and killing them. Landscapes that only have meaning when perceived through their eyes. Art is perception of the moment. Action. Conscious. Brady as conceptual performer?

'We have but two alternatives left, either the crime that will make us happy or the noose that

'It is the assignment of the artist to destroy art, that means coming closer to reality. Because I knew no other way than art to get to reality, I intensified my actions to extremely aggressive undertakings. Suddenly I stood there alone. I could not abolish the discrepancy between art and reality, I couldn't achieve an identity through art, I couldn't unify art with reality'.
Otto Muehl

'Art unmasks itself here as a derivative of reality. Reality without art is only half-reality. Art without reality is no art'.
AA Kommune

Heresy: You can hang a theory, context and significance onto almost anything. That is not a primary justification. A public should not feel that they need to understand, or that meaning is in any way integral to the possibility of inclusion in a work.

'I wore a special costume designed by Janco and myself. My legs were encased in a tight-fitting cylindrical pillar of shiny blue cardboard which reached to my hips so that I looked like an obelisk. Above this I wore a huge cardboard coat-collar, scarlet inside and gold outside, which was fastened at the neck in such a way that I could flap it like a pair of wings by moving my elbows. I also wore a high cylindrical, blue and white striped witch-doctor's hat'.
Hugo Ball

Heresy: Performances, especially outdoors, are by their nature more immediately inclusive. Benefiting from surprise and human curiosity. Often the bias against Modernism and an art context can thus be sidestepped. This mental inclusion by fascination creates a situation where the public create by expectation and empathy.

'We are ever more attracted by our own existence. Every work of art is nothing but the mystique of the being. The aesthetic which pushes us until horror'.
Hermann Nitsch

'As Houdini rose from the couch the boy smashed him in the stomach. Houdini gasped.

Monte Cazazza, Berkeley California. Drinking wine in his bedroom, Nov. 1976.

Moors murderers Ian Brady and Myra Hindley were jailed for life in 1966. Victim John Killbride, aged 12, was sexually assaulted. His body was found in a shallow grave (arrowed) by police searchers on the moors. Brady denied all knowledge of his death, but the Attorney-General said that Killbride was 'killed by the same hands' as the other Moors victims

Retouched photo of Dean Corll, the Houston mass murderer. Origin of photo unknown

Hermann Nitsch

Compression of carotid artery against the transverse processes of the cervical vertebrae

Harry Kipper in performance at Reading University, England, 1977, as character 'Professor Hay'.

Otto Muehl *Omo Head*

Photo of a page from Jerry Dreva's book *Wanks For The Memories*. 1000 orgasms in black-bound volumes sent to friends in the mail as completed. Fusion of obsession and art and correspondence. Stains are actual semen, dated.

Cosey Fanni Tutti of COUM from pornographic magazine "*Playbirds*", 1976. Modelling as subliminal performance for public consumption.

will put an end to our unhappiness'.
De Sade

Hearsay: What separates crime from art action? Is crime just unsophisticated or 'naive' performance art? Structurally Brady's photos, Hindley's tapes, documentation.

'The imagination will not down. If it is not a dance, a song, it becomes an outcry, a protest. If it is not flamboyance it becomes deformity; if it is not art, it becomes crime'.
William Carlos Williams

'Off to the side, atop the plastic sheeting, lay a hunting knife and its scabbard. An open paper bag held a can of acrylic paint that gave off a faint smell reminiscent of banana oil. A military-type gas mask lay near the bed. A portable radio was rigged to a pair of dry cells, giving it increased volume and power, and a vacuum cleaner was plugged in at the wall. Men's clothing was strewn about, and there was a wide roll of clear plastic of the same type that covered the floor'.
Jack Olsen

Hearsay: The real continuous thread of human art and life is discovering the fundamental, tribal essence of a superficially non-tribal society.

Hearsay: Performance art is investigation, a learning situation, actual and direct. People have to be able to emotionally touch art, to feel it allows them to exist.

'He got a movie camera and made movies with all the kids that lived around the farm. There were two sisters about a half a mile down the way that played with him all the time, and they'd take a movie of one of 'em laying on a table, pretending they were making a doctor movie. They put a sheet over her, and then they got chicken livers and stuff like that, and they'd take kitchen tongs and pretend to be pulling these organs out of her, while Dean handled the camera'.
Jack Olsen

He hadn't been ready. He was white but he set himself and the boy hit again to feel what seemed like an oak plank. Houdini's side bothered him. During the matinée he suffered pains in his right side but faithfully chose to ignore it. By evening it was worse and Bess wanted to call a doctor. "No" was the answer'.
Allan Ruppersberg

'The central interest is distortion; personal distortion manifested through the body and motivated by physical contact. It is important that this distortion should be operative both in form and content; it could also be extended to areas directly related to the personal outside of cultural traditions (such as art)'.
Denis Masi

'Therefore, one must take reality into account and actually my awareness of the real, depending on my mood, has thousands of facets . . . '
Urs Lüthi

Heresy: In performance art transience plays a large part. It is mortal like us. Is born and dies. Immediately it becomes more universally acceptable. An invisible thing happens between doer and watcher. Each watcher interprets slightly differently, each is right for himself in interpretation. The sum total of all interpretations is probably still only *part* of the whole meaning, which is immortal. There is no conclusive truth, so everyone in a sense is the artist.

Heresy: Art is too often a pale reflection of what already exists. Especially performance art. The pictures in tit magazines are negated in content by repetition. They serve however an incantatory function. Magic. Cosey Fanni Tutti in her action 1973–76, *Prostitution*, discovered the owners of these magazines need them as much as the customers they despise. One man at Premier Camera Club, once a week, photographs a different girl in the same pose and underwear. He keeps all these variations in a huge book, years of photographs. If this

Motivation

Photo of Jewish concentration camp victim

Police photo of outfit worn by Edward Paisnel, the Beast of Jersey, when he committed sexual assaults. He was convicted largely on the evidence of seminal stains.

Sheba, a champion tassel twirler of 1972

Urs Lüthi. Photo from 'Transformer' catalogue

Rudolph Schwarzkogler. *3rd Action.* Born Vienna 1940, died Vienna 1969.

Enrico Job *The Confession*, Friday 14 March 1975. 6 am

Buby Durini

Ralph Ortiz "*Chicken Destruction Realization.*" 1966.

Hearsay: The first time I heard of Monte Cazazza in San Francisco he was walking the streets dressed as an old woman; loaded revolver in holster around his waist; he was carrying a small suitcase containing a dead cat and bottle of petrol. He would visit artist friends at their flats. Sit down, open the case, put the dead cat on the floor, pour petrol on it, set it alight. All his spare money is spent on guns. Instead of knocking at Anna Banana's door he threw a brick through the window.

Hearsay: Edward Paisnel, known as the Beast of Jersey, was found guilty of thirteen charges of attacks on six people on Monday 13 December 1971. On 13 September 1440 Gilles de Rais was found guilty of 34 murders, though it is believed his victims numbered over 300. Rais, Prelati, Poitou made crosses, signs, and characters in a circle. Used coal, grease, torches, candles, a stone, a pet, incense. Words were chalked on a board. Could these rituals preceding child murders, in another context and properly photographed, become Beuysian performance? Are photos of Schwarzkogler reputedly cutting off his penis made acceptable by being framed on a white wall?

'We should take into account that the turbulent imagination of puberty always has an affinity with crime'.
Andre Glucksmann

'At the cinema we kill with the murderer and die with his victim.'
A. Poittier

'There is nothing either fundamentally good, nor anything fundamentally evil; everything is relative, relative to our point of view, that is to say, to our manners, to our opinions, to our prejudices. This point once established, it is extremely possible that some thing, perfectly indifferent in itself, may indeed be distasteful in your eyes, but may be most delicious in mine'.
De Sade

were framed and mounted in rows in one of our minimal galleries, with a fashionable artist's name given as its creator, would that make it acceptable to you? Is the photographer then an artist? Is the model an artist? If the artist chooses to be the model is it then art?

'The artistic nude gets out of its traditional constriction and, similar to a wreckage, it finally liberates itself from the reproduction machinery used for information. The artistic nude and spectacle have by now become a single thing'.
Rudolf Schwarzkogler

Heresy: Performance art can be like a priest in a church, a special atmosphere, intangible, always unique. Something belonging only to those present. Like a death in a close-knit family. Described later, or in photographs, it's not the same; it never can be. Performances are not the thing in itself, nor are bi-products like photographs. All are luxuries after merely being alive and sharing in that fact.

'The artist should have the opportunity to place environmental situations in such a way that they are useful for consciousness. These situations should not limit somebody but should help to free activities. For instance people should be continuously aware of time in their environment. By this experience everybody could measure the degree of intensity or dullness of the life he is living'.
Klaus Rinke

'Since then I have been interested in all abnormal situations like ecstasy, spasm, psychoses, breakdowns, humiliations, etc'.
Arnulf Rainer

Heresy: Mail Art, Correspondence Art is a performance art in an open system. Open systems can still be art. Infiltration of mass media and systems is vital. It means subliminal performance art reaches an arbitrary, unchosen, unsafe public.

The Magician, 1911. Aleister Crowley at his altar, magically robed, and equipped with wand, bell, sword, cup, phial of holy Abra-Melin oil. His hand rests on the Stele of Revealing. The book is *The Book of the Law*. He is crowned with the Egyptian Uraeus serpent and upon his finger is the ring of Nuit

Photo from *Water and Power* magazine, US 1976, sent in by a reader, of his wife

Photo courtesy of *Pussy Cat*, the world's leading magazine for Rubber enthusiasts, 33 Park Lane, London W1

Photo of lesbian couple just after being legally married in a church. *The Groom Was A Woman* 1975

COUM Transmissions action "*Landscape*", 1975, London.

Gina Pane "*Je*" Action in Brugges, Belgium, Nov 11, 1972.

Allan Kaprow *Chicken Happening* New York

"Arthur Turner" Live on the Bat Plane. Photo by Al Ackerman, reprinted courtesy of New Gulf Bulletin.

Hearsay: Action is merely a discussion of possibilities. Action is a therapy for facing oneself. What makes an action art? What gives it purpose, or is purpose enough? Performance art in particular must admit it is everyone else.

Hearsay: Crime is affirmation of existence in certain cases, high crime is like high art. We are looking for our self-image. Looking is the thing itself, to forget we are only looking is the threat, we fail as soon as we think we know what we are looking for. Mystery is not cheap, emotion is not alien to art. Performance art is probably the Shaman, Mystic, Lunatic, Buddha, visionary of contemporary times, in a post-religious era a crucial and reponsible function best kept away from dealers who are the Pardoners of our culture.

'Tommaso held him with one arm behind his back, and Ugo began to slaughter him, first in the stomach, then the face. A bit of blood spurted from his teeth at once, and from an eyelid, and he threw up. Then Shitter got out too, and with a kind of moan, began to hit him in the face, the belly, adding a few kicks. When Tommaso let go and the man fell to the pavement, Shitter gave him a couple more kicks in the back and all over, wherever they happened to land. Then they rolled him swollen and bleeding down the railway embankment, into a clump of bushes'.
Pier Paolo Pasolini

'He learns and then practices the art of gently removing flesh from bones; he then extracts the marrow, usually by sucking it out, and pours molten lead into the cavity'.
De Sade

'Frykowski suffered sixteen defensive wounds in his left arm trying to ward off the Evil. Fifty-one wounds Tex dealt to the spleen, abdomen, left lung, right back, heart, chest, hands. And still the man who twenty-five years before survived the Nazi atrocities in Poland crawled on, till he

'Though great works are surely still possible and may be looked forward to, it is in the sense that they may be moments of profound vision into the workings of things, an imitation of life, so to speak, rather than artistic tours de force, ie, cosmetics'.
Allan Kaprow

'System of possible movements transmitted from the body to the environment: body "haunting" space: availability: a situation on which I am required to act, wherever I may happen to be at the time'.
Vite Acconci

Heresy: What is the performance artist's relationship with society? Is he necessary? Is art meaning just bogus significance? When does decoration become life? In what context can art operate? Marina Abramovic invited visitors to a Naples Gallery to choose from knives, loaded guns, torture instruments on the floor and do what they wanted to her. Two men stabbed her in the throat. Then tried to put the gun in her mouth and make her pull the trigger. She struggled to stop them. Her dealer tried to stop them. Why do this in a Gallery? What change takes place if she goes to a rough dockside bar and risks her life there? Perhaps provoking a real fight, then using this 'real' information complements it by experiencing. Why does performance art have to be presented? Infiltration of real life is no different but you alone perceive this moment, and that makes you the artist, all else is pure luxury.

'Gingerbread material consisting of: enriched flour, sugar, dried molasses, shortening with freshness preserver, leavening, salt, vegetable gum, spices, caramel colour, was rolled into dough and shaped to resemble a human form. These figures were slowly eaten and digested. Later my intestinal tract was emptied. Ten samples of faeces were placed on glass slides. These samples were viewed under a microscope at magnifications of $\times 280$ to

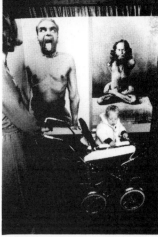

From *Bodylanguage* catalogue, Graz 1973

From the collection of Peter Christopherson. Private, personal self-mutilation fetish

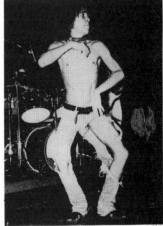

Iggy & The Stooges performing in New York. Iggy Pop is reputed to be the first rock star to actually have intercourse with a groupie on stage. Actually killed chickens on stage. Photo courtesy collection of Mick Rock

First arrest photos of Charles Manson. Photo courtesy of the FBI

FCI TERMINAL ISLAND 3845-CAL.

crumpled'.
Ed Sanders

Hearsay: An almost metabolic need in men brings us together, creates performance art, and there is really nothing that much more special about being an artist unless he makes a special attempt to be everyone else. Otto Muehl's AA Kommune has seen that art must deal with the existing structures of a mass society with its tribal cultural experiment. Art performance will become academies of possibility by groups.

'The main task of the concentration camp was to lead the prisoners within them to a natural death, following exploitation of their labour power. The Majdanek camp near Lublin was established in the autumn of 1940 and was liberated by the Soviet army on July 22 1944. The official number of victims of all nationalities in this camp reached 360,000 dead'.
Tadeusz Mazur

'He possessed extraordinary powers. He gave the impression that he did not touch the ground at all, and he would go round the circle at a pace so great that one constantly expected him to be shot off tangentially. In the absence of accurate measurements, one does not like to suggest that there was some unknown force at work, and yet I have seen so many undeniable magical phenomena take place in his presence that I feel quite sure in my own mind that he was generating energies of a very curious kind. The idea of his dance was, as a rule, to exhaust him completely. The climax was his flopping on the floor unconscious. Sometimes he failed to lose himself, in which case, of course, nothing happened; but when he succeeded the effect was superb. It was astounding to see his body suddenly collapse and shoot across the floor like a curling stone'.
Aleister Crowley

Hearsay: A new generation of performance artists has arrived. They use existing situations to

× 3000'.
Dennis Oppenheim

Heresy: Chris Burden sits on a chair for about 36 hours until, exhausted, he falls off onto the floor. A chalk mark is made round him, like a corpse in a movie murder. Gina Pane in April 1971 in her studio climbs 30 times up and down a ladder with sharp points on the rungs, barefoot, until she reaches her limits of endurance.

'The line between art and life should be kept as fluid, and perhaps indistinct, as possible. Therefore, the source of themes, materials, actions, and the relationships between them are to be derived from any place or period *except* from the arts, their derivatives, and their milieu'.
Allan Kaprow

'Deprivation that calls for supernormal reactions in an attempt at stabilisation: stress: turning in on myself, turning on myself: performance as alibi (resulting in a presented piece of biography that, ordinarily, would not have been part of one's active biography at all)'.
Vito Acconci

' . . . magic is a thing which every community must have, and in a civilization that is rotten with amusement, the more magic we produce the better. If we were talking about the moral regeneration of our world, I should urge the deliberate creation of a system of magic, using as its vehicles such things as the theatre and the profession of letters, as one indispensable kind of means to that end'.
R. G. Collingwood

Heresy: Because art has divorced itself from culture and mass taste via language and meaning, it feels superior and then irrelevant and insecure. Its lofty ideals and pretensions require degrees in semantics before you can even view it, and usually it's a minor, once-only-interesting point that's obscured by critical clouds.

actually affect society from the inside, to subliminally infiltrate popular culture aware of their perception as art but realising their redundancy. Peter Christopherson joins the Casualties Union, learns to simulate perfectly cuts, heart attacks, fits, bruises. He goes to a training course. Why is he there? He wants to expand his art, he is able to get photos of boys simulating injury. They are not aware of his reasons, his motives are provocative. He makes an advert for national television, trying to give the kiss of life to a drowned boy. Nothing is real except the medium. Millions see his performance, none of them knows. Cosey Fanni Tutti models for pin up and porno magazines, in order to get magazines containing her image. The public buy them, see her, do not know her, do not have to know it's her performance art. Jerry Dreva in Wisconsin masturbates onto the pages of a book thinking of passers-by he liked. Each volume is sent away to friends who correspond by mail. The artist understands his action and needs no more, it isn't to do with recognition any more. Arethuse launches spacecraft in a bay in Sayville, New York, one night. The work is that it receives a mention in a general newspaper. Art magazines never hear. People can enjoy performance without being aware of it. COUM model for LP cover, it becomes a scandal in America, is resting in living rooms and flats, no one knows it was them.

'Vaguely conscious of that great suspense in which we live, we find our escape from its sterile, annihilating reality in many dreams, in religion, passion, art; each a forgetfulness, each a symbol of creation'.
Arthur Symons

'You are not you, you are just reflections, you are reflections of everything that you think that you know, everything that you have been taught. My reality is my reality, and I stand within myself on my reality. The truth is now; the truth is right here; the truth is this

Heresy: Dennis Oppenheim observes obsessively his faeces. The Marquis de Sade also obsessively investigated faeces. One is cool art, one is quirkiness, which is more *interesting*?

Heresy: There is a political and social threat involved in the direct person-to-person attributes of performance art and mail art. No social ticket is required, no venue, the price of a stamp or your own body are the only needs. The threat is biggest for the art world, art market. Solving art problems is coincidental.

'The task of Art is to make itself touchable'.
Eugenio Carmi

'Art is everything that men call Art'.
Dino Formaggio

'Which men?' and 'Which Art?'
Eugenio Carmi

'Art works best when it remains unacknowledged. It observes that shapes and objects and events, by displaying their own nature, can evoke those deeper and simpler powers in which man recognises himself. It is one of the rewards we earn for thinking by what we see'.
Rudolf Arnheim

Heresy: A lot of the best, youngest, performance artists have an incredibly sophisticated perception of art media, galleries, socialites. Followers more often of William S. Burroughs than of Marcel Duchamp, of *Sounds* rather than *Artforum*, they affirm individualism in a depersonalised age. They recognize only each other. The basic tenet is that art is the perception of the moment. And in the perception of the moment, all things are art.

'For man, codes and signs differ according to his environment, the education he has received, and his social background. The peasant who looks at the sky is creative because he "perceives" it by

minute, and this minute we exist'.
Charles Manson

deciphering its codes on the basis of which he will invent behaviour'.
Eugenio Carmi

'Art is a self-respecting search for the unknown. As such, it does not necessarily correspond to its common image. It is not bound to generate objects. It is creative energy whose centrifugal force generates gestures or looks, objects or projects and situations'.
Eugenio Carmi

Quotational Bibliography:
AA Kommune – Manifesto' (Gols, Austria) 1975.
Acconci, Vito – statements in 'Performance' catalogue (John Gibson Gallery, New York) 1971.
Arnheim, Rudolf – *Film as Art* (London) 1958.
Ball, Hugo – from *Dada* by Hans Richter (London) 1965.
Carmi, Eugenio – 'Eugenio Carmi' catalogue (Galleria S. Benedetto, Brescia, Italy) 1975.
Collingwood, R. G. – *The Principles of Art* (London) 1938.
Crowley, Aleister – *The Confessions of Aleister Crowley* edited by John Symonds and Kenneth Grant (New York) 1969.
Formaggio, Dino – 'Eugenio Carmi' catalogue (Brescia, Italy) 1975.
Glucksmann, André – *Violence on the Screen* (London) 1971.
Guntrip, Harry – *Personality and Human Interaction* (London).
Kaprow, Allan – *Assemblage, Environments & Happenings* (New York) 1971.
Lüthi, Urs – *Il Corpo Come Linguaggio* by Lea Vergine (Milan) 1974.
Manson, Charles – 'Your Children' trial transcript (New York) 1973.
Masi, Denis – statement from *Il Corpo Come Linguaggio*, op. cit.
Mazur, Tadeuz – *We Have Not Forgotten* (Warsaw, Poland) 1961.
Muehl, Otto – statement from *Contemporary Artists* (London) 1977.
Nitsch, Hermann – statement from *Il Corpo Come Linguaggio*, op. cit.
Oppenheim, Dennis – statement from *Il Corpo Come Linguaggio*, op. cit.
Olsen, Jack – *The Man With The Candy: The Story of The Houston Mass Murders* (London) 1975.
Pasolini, Pier Paolo – *A Violent Life* (London) 1968.
Poittier, A. – 'Cinema et Criminalite' in *Revue de Science Criminelle* (Paris) 1957.
Rainer, Arnulf – statement in *Il Corpo Come Linguaggio*, op. cit.
Rinke, Klaus – statement in *Il Corpo Come Linguaggio*, op. cit.
Ruppersberg, Allen – from transcript of videotape *A Lecture on Houdini* (New York) 1973.
Sade, Marquis de – *120 Days of Sodom* (New York) 1966.
Sanders, Ed – *The Family* (New York) 1972.
Schwarzkogler, Rudolf – statement in *Il Corpo Come Linguaggio*, op. cit.
Symons, Arthur – *The Symbolist Movement In Literature* (London) 1899.

General Reference Books:
'TRANSFORMER: Aspekte der Travestie', catalogue of Kunstmuseum Lucerne, Switzerland, 1974; *Water and Power.* the magazine of enemas, water sports, spanking, infantilism (New York) 1976; *A Pictorial History of Striptease* by Richard Wortley (London) 1976; *Crimes and Punishment: Part 2* magazine (London) 1976; *OM Theatre* by Hermann Nitsch (Romenthal, West Germany) 1975; *Drum and Candle* by David St. Clair (London) 1971; *A Heritage of Horror* by David Pirie (London) 1973; *Wanks For The Memories: The Seminal Work/Books of Jerry Dreva* by Jerry Dreva (South Milwaukee) 1976; *The Beast of Jersey* by his wife Joan Paisnel (London) 1972; 'Body language' catalogue (Graz, Austria) 1973; *Very Special People* by Frederick Drimmer (New York) 1973; *The Job* by William S. Burroughs and Daniel Odier (London) 1968; *Magick in Theory and Practice* by Aleister Crowley (New York); *Anthropology Through Science Fiction* edited by Carol Mason, Martin Greenberg, Patricia Warrick (London) 1976; *The Art of The Film* by Ernest Lindgren (London) 1948; 'Happening and Fluxus', Kunstverein catalogue (Cologne) 1970; *The Throwaway Children* by Lisa Aversa Richette (New York) 1969; *Juvenile Delinquency* by Richard R. Korn (New York) 1968; *The Flight From Reason* by James Webb (London) 1971; *A General Textbook of Nursing* by Evelyn C. Pearce (London) 1937; *Prostitutes* by Denise Winn (London) 1974; *Mass Murder in Houston* by John K. Gurwell (Houston) 1974; *The Great Beast* by John Symonds (London) 1971; *Pussy Cat Magazine: The World's Leading Magazine for Rubber Enthusiasts*, 33 Park Lane. London W1, England; *Sexy Confessions of a Shop Assistant.* Tabor Publications, London 1976; Catalogue of '9th Biennale de Paris', 1975.

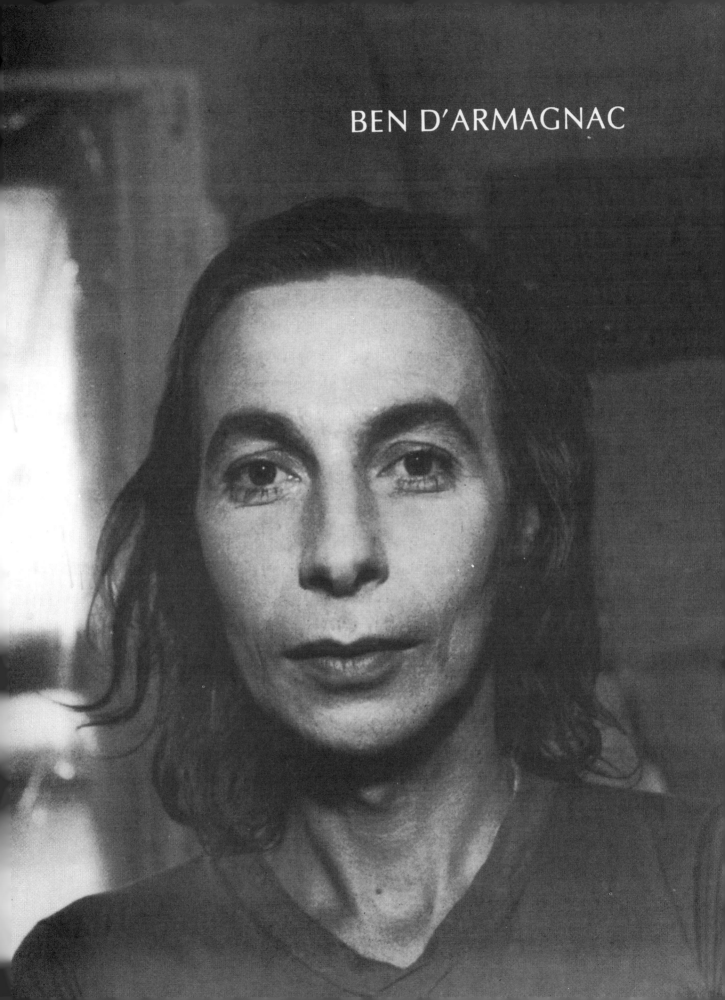

BEN D'ARMAGNAC

BEN D'ARMAGNAC TALKS TO LOUWRIEN WIJERS

Ben D'Armagnac SAYS: "It is difficult to explain everything now, because lately I have been explaining it to people so often."

"You are sure you would like to explain it once again?"

"I think it is a good thing to do. I expect that some people who see me there (at the Brooklyn Museum) will be confused in a way, just like the ones who were confused by hearing a sound tape (Ben D'Armagnac did an installation at 112 Greene Street in New York on April 8 and 9, 1978, where a tape with the sound of water was to be heard) when they expect a performance in the way I usually do them. Perhaps it is also a good thing that I would not have to explain my moves, or the point that I have reached now over and over again; that it is just written down."

"It might even be a relief for you to have it in black on white so that you don't ever have to explain it again."

"Exactly. Because I think at a certain point I don't want to do that any more. Someone changes and that is it then. You can't always go on in the same vein, you have to move into that renewal every now and then. And that always implies threadbareness. But I do not feel like telling that over and over again. It could be of course that after that performance they say: Hey, hey Mister D'Armagnac, what is this supposed to mean? In fact I feel right now the same, on a totally different level though, as in Amsterdam, Goethe Institute, that white space with that washstand (installation summer 1972). Well, in fact I am back there again, only I will be in it myself this time. That white space was in fact my voyage of discovery towards performing. Then I did a performance on my own, without admitting people. The next one was where I sat in that cage."

"And there were people."

"Yes of course there were people. So in fact one could say that I have done a performance on my own with water, in my room (the 112 Greene Street installation) with nobody there . . ."

"A private performance."

"A very private performance; and now the thing is in fact between a performance and an installation. And it could very well be that when I come back to New York I would be into total performance again. I am now at half a performance and half an installation. In fact I find myself going quite fast; question myself if in fact it is okay to go so fast. Not that I panic . . . All the time I do in fact feel quite good about it. Last night I was thinking about what you had said, I found that really quite nice. I had asked you: how do you handle your work and then you said: Oh Bernard, I go and sit in a corner and I know exactly where I should sit — and I remember very well that you said that — and within ten minutes I know what I should do. Well, what I am going to do now in the Brooklyn Museum has come to me in exactly the same way. Only I have more mistrust regarding myself — or

mistrust, watchfulness is probably a better word. I kind of have to protect myself in a good sense."

"You may have a bigger responsibility because there is an audience, whereas when I do something I in fact never make it for the others."

"That could be. With me those people are very near. I even find I have to reckon with how those people are entering, where they can enter. First of course I choose the spot where I think it is best for me to do something — but at the same time I am very occupied with: Where would the people have to come up against me and where can they see me, or where would I like them to see me, but could they be standing there . . . It is like that every time. In the first instance I go from myself of course, but then immediately the others are there."

"Then you think about a lot more."

"I am not sure, I am not sure . . . Because you of course are also very much aware of the fact that you are going to bring it to the outside."

"Yes, but everything I do, I do for myself and for — I'll say in the way I feel it — and for God."

"Could you say that again. You make it for yourself and . . ."

"For myself in relation to God, I could say."

"Yes, I understand."

"In fact I make a vow with my work each time. I shows where I am."

"Yes, I understand that, then indeed it is different with us, although I am busy with that divinity in my mind. I notice that mainly through the way in which I am now dealing with my work. Would you mind if I explained to you what kind of a video-tape I am going to make for PS 1? I think in that tape I am really . . . and I only realized that much later, because I had written down the idea quite quickly . . . and then I thought: Hey, that has indeed to do with where I want to go. I'll say more about that later, about that divinity . . . but when I am thinking about that videotape, I am thinking it will be a tape in which I am very much involved with my body. I am going to show parts of my body on that video tape. But first I am going to sit somewhere in a very beautiful spot. Then I take a tape recorder and I look carefully at all the different parts of my body, which I will show later on that video. And then I name them all. After that I'll go to PS 1 and there you will hear that tape where I name all the parts of my body . . . so you hear that from a very different space from the PS 1, you hear those words coming from the very beautiful spot, and in PS 1 I will answer. So you hear for instance "feet" — that is *voeten* (Dutch) isn't it? — and then I answer "feet" there and I show part of my foot. And in such a way I will go around my whole body. And perhaps I will show only one nail of my foot . . . I probably do not want you to see my whole hand. I have a feeling that I will keep the camera very close to my body, showing small parts. I feel I will go to that other spot first, because there I will answer the divine. I am then somehere in a kind of Divine atmosphere; something very beautiful, and I will be answering the divinity in myself in fact later in PS 1, in that studio. So it strikes me that I am occupied by such things. I thought myself that this must be the beginning of something. You know, that I may want to work in this way in the

future. That is I think why the two of us were quarrelling about the performance of Reindeer Werk (Saturday night, April 29 at Sharon Avery Redbird Gallery in Brooklyn). In fact I find it okay what those guys are doing. But perhaps I revolt for a moment against it because part of it, the emotionality, I know very well, but I find one has to go past that. Then you arrive somewhere, where indeed things for me are much more pure . . . I would almost like to say that as soon as that emotion comes in, one should already be at work on banishing it."

"To keep the people clean?"

"Yes, yes, exactly. Yes and I think that is a very difficult path to take I also think that this perhaps will be the essence for a new series of performances for me and that I will probably be working on that again for two years or maybe longer! I don't know."

"With that voyage of discovery?"

"Yes with the voyage of discovery on that level. I consider emotion alright — but I myself want to be much more vigilant all the time, to bring it back to neutrality again."

"Does this transaction in style have to do with your experiences in New York now?"

"Well, I think I felt already in my last five performances that there was something somehow twisted, you know what I mean. As a matter of fact it is very dangerous, tricky, because at a certain point you can handle emotions very well. Then you can from one minute to another switch the points, and emotions just pour. I believe emotions are such a strong source, that you really never have to be afraid that they won't

come. Of course I start with the idea that one is very sensitive. If you are very sensitive you feel all day long so many things around you; you are being so shocked by things, puzzled, and you have so much fun too. If you are trained to keep that path to your mind clear, then I feel it is too easy. I think I was confronted with that in my last four or five performances. I found myself thinking: Well Bernard you are doing that very easily, perhaps a little too easily. I do not want to say now that I have made mistakes, done the wrong things, because I think I did stop at exactly the right moment. I think I experienced the danger of the last four performances, but I knew I could not alter that in Europe. Here I almost defended myself by not getting involved in the world around me, by not having so many acquaintances here and not going around the clubs and the parties. In that barrenness I have been able to think out how these things fitted together. But then I really felt, I cannot go on with this."

"I asked . . ."

"Yes, you asked if New York had done that for me (Ben D'Armagnac has decided to live in New York for half a year: the Brooklyn Museum Series came towards the end of his stay) Well, New York . . . but I knew beforehand in Holland, that in New York I would be able to create a situation in which I would be putting myself absolutely threadbare; I would absolutely arrive at the impossible, concerning the work. And in fact I like that."

"Can I perhaps say something else before. You asked me earlier: did you in fact have a good time with Lotti? (Lotti Heyboer, a former girlfriend) and I said:

yes, but . . . and we talked about my relationships with women before that, and I told you that I had in fact been quite awful with women. Not right. And you then said: did that have to do with your mother? I said: I think it did have to do with my mother. In that way I do feel that such things were an important part of my emotions in the last performances. My performances had partly also to do with a kind of revolt. The desire to fight things, not accept them. But I believe that now it does not interest me any more, so I can't enter into fights anymore from that corner. At the same time, because I have worked very hard at those specific emotions, I discovered the danger of emotions as such. Because I think: Okay, you have used these emotions quite a lot, you are done with it. It is alright if emotion comes back in the next performances, but I want to be . . ."

"Balanced?"

"I want to restore the balance. Something like that."

"Could it be that, when performances in the visual arts started a few years ago, they were mainly based on emotions. If that were true, one could say that something very different were coming up now. We have seen an awful lot of emotional performances in the last few years, by so many different people."

"I do think we have enough drive towards something else. I don't think emotion is strong enough to resist what is happening right now. If you follow history, then you'll always see that emotion has been the beginning of something. If I think of COBRA and I think of what happened after the war, then I see how Karl Appel worked at it.

That was an incredible emotion, but then there has to be something deeper. I believe people, the world, arm themselves against emotions. In a city like this, you have to hit hard to break through to people. For instance during the performance of Reindeer Werk, I twice heard those people say: yes, but I see that in the streets. Of course it is very annoying when people say such a thing, but naturally it is strange when these guys do this in a gallery; their emotion immediately reminds people here of New York's dangers, the strange people walking around, the horrible things that happen here. You see that moment that they have already shut themselves off from that, and they are not going to open up for the same thing again, or they would go crazy here; so you see them blankly watching that performance. I have been paying attention to that because people were at a certain point coming to me, to ask me what I thought of it, because they seemed to think that I had something to do with it. Then they made that remark. I said: Well, I think you should not look at it this way, I think you have to go a little further . . . But for me it was typical of what that emotion does to people. I believe we have to work on something very different. And I would not be able to say to you on what exactly."

"You are asking me: What direction is it going? I feel I should think about it, but I do not want to think about it, because I do not want to know. I am convinced that we have to be able to work on something other than emotion. And at this point it is again my voyage of discovery to find out what I should be doing, how I am going to deal with

myself and with this world. I have always been convinced that I have to go very slowly. I should not pass over certain things. I have to go step by step. That may make you very tired, to have to go so slowly, but my track happens to be such. You see, one can never go twice through a certain stage. Each stage has so many details. In this world, because of all the demands you are confronted with, you tend to know intellectually that you can pass over one, two and three and that you in fact can go very easily on to four. I see many people do that and very often watch that with amazement. I know for myself though that I should not do that. Even if I know exactly what one, two and three are intellectually, I still have to go through them emotionally. That sometimes makes it seem as if I am wasting time, filling in something that I know already. But whenever I have tried in my life to jump from one to four, then I have always been confused afterwards."

"Your work reflects the development of your life?"

"Yes exactly. I am of course more mature all the time. At least I do my best for that. And I do hope I have more insight each time, insight into myself and the things that happen around me. And I don't think that we can still save it with emotion, we are past saving it with that. Hope that my ripening goes on so smoothly and strongly that I indeed arrive at that point where I am myself but at the same moment the exact counterbalance for what is happening around me."

"That is very clear."

"I think that works automatically. If I keep following each part."

"Therefore it is probably very meaningful where you are."

"Of course. If I tell you something about my going to live in France you nod and understand, so do Gerrit (Dekker) and Johanna (d'Armagnac) but for me it is much, much bigger than I can ever tell you. Just as I felt in Amsterdam that I had to go to New York and in New York I came to that threadbareness, I come to that crisis — that good crisis — which shows me very well how things are. With that same urge I now feel: I have to go to France. That has to do with that position-finding. Or perhaps I am missing the point..."

"Yes, when I say it is important where you are I am thinking more in terms of cultures. You receive and respond. I mean if you would be in Tokyo for some time you might be doing different performances than in New York."

"No, no, no I don't think so. If one speaks about the counterbalance that an artist can give in relationship to the world, then I do believe each artist has a specific part that he can handle. And I think that the part which I handle towards the world is the same everywhere. It has to do with a few things only, those things which I see in people and of which I think I am able to do something there: I can be a counterbalance in that."

"Which parts are they?"

"That is the insensitivity and the carelessness which I see in people. And both Tokyo and New York have a certain superficiality, a certain degeneration, a certain decay. Something happens to people in New York which also happens to the people in Tokyo. There may be a difference in the cultures but in essence

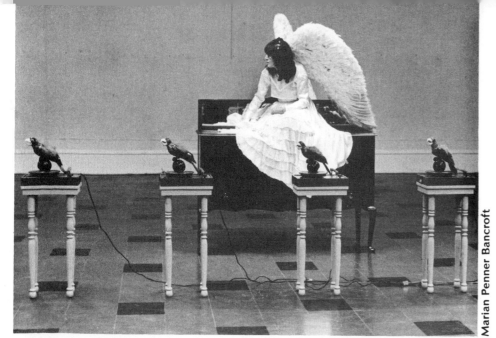

Marian Penner Bancroft

Lights turn up to:

white or light-walled stage area in a room or gallery. In the middle of the stage area is a large candy-apple red buffet with a low mirrored back. I am seated on the buffet with my head and back in profile. I wear a white satin dress with lace down the front skirt. One bare foot is visible (toes). I am also wearing large wings made of chicken feathers over foam rubber. There are long feathers on the tips and outer edges and finer ones over the rest of the wings.

In front of the buffet is a row of 5 identical grey tables 30 inches high. They stand about 2 feet apart and a yard from the buffet. Exactly fitting the top of each table is a red turntable. On each turntable is a dark red ceramic apple and on that is a red parrot

I'll still see the same. And as long as I am on this world I will be shocked or amazed by it. I think such feelings immediately arouse in me a desire for a kind of counterbalance. But in fact I never think about these things. It just happens. Perhaps I am one day going to be invited to do something in Tokyo. Then I will have to bounce against the heart of the matter; when I have passed a certain habituation I am going to somehow feel free in such a city and then I will see people do exactly the same things as they do here and then I'll be just as shocked as I am here in New York. I only have a very small part with which I can work, you know."

"You sometimes say that each piece for you is chastening."

"Of course. When I think essentially why I do things — it almost troubled me just now when I was talking about my being a counterbalance for the world around. Then all of a sudden it sounds so social. I believe such things happen automatically in me. And I think things evolve equally; my cutting off a certain period has to do with looking at people in a different way too. I really believe everything has to do with each other. But I do not think it is good for me to realize the greatness of all things all the time. I have to stick to myself mainly. And then of course I hope that it means more than my chastening only. Thank God I have come across reactions from people who feel it is more."

"I would like to ask you if you would go back to painting or to doing something in a space where there are no people."

"Well, I can firmly say yes to that. I can see very well that at a certain point I might not like to do performances any more and I would like to start a different thing. That can of course be anything. It could be painting, but it could also be film or it could be video, I do not know. I can't survey that. But, indeed, I can with all my heart say yes to that. And I do not even think that it is that far away. I know the time for it has not come yet, I still have a lot of thngs to do in order to reach that point. But quite often I find myself thinking about it. I get visions, but on the other hand I think: Bernard, let it go. Push it aside for the time being. The same thing as with France. Now I have to push France aside, although I know France is very important since it has to do with the point I have come to. I need to have bigger extremes. The vision I have of France is that it is the opposite of where I am now. I find it okay to be here, but I want to be here in a stronger situation. I need France for that. But I have to wait for that too. And in the same way I come across a part of me, which you just named, and it could easily be that I have to wait another six years for that. Or I don't know, I can't say a length of time, but it is going to be long."

New York City
Tuesday May 2nd, 1978, 9:30 pm.
Magoo's Restaurant on Sixth Avenue
below Canal
(Translation by L.W.,
edited by Peggy Gale)

GATHIE F

Re

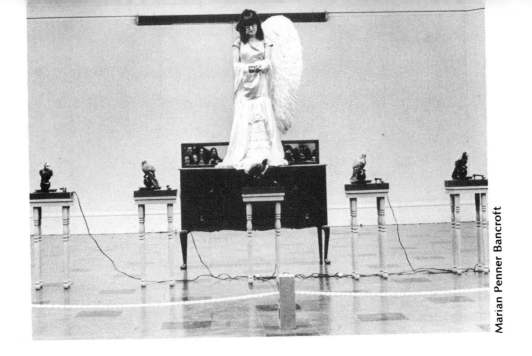

with an open yellow beak. All the parrots face right, as I do.

Movement begins between 5 and 7 seconds after lights go up.

The first parrot begins to turn on the turntable as he sings *Row, Row, Row Your Boat*. The second parrot turns and sings the second part of the round, and so on, till all parrots have begun. I sing the 6th part. As each parrot finishes the song it stops turning. When I have finished the song I wait 4 seconds and slowly stand up on the buffet. The parrots are facing all directions. I stand tall for a few seconds, then raise my hands to the back of my neck and undo the buttons of my dress. I slide it down my shoulders. I unbutton the sleeve buttons and pull the

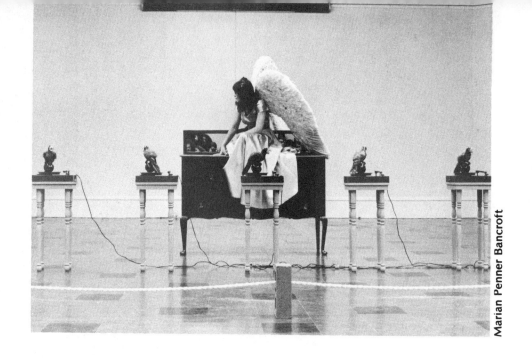

sleeves off, revealing the top of a shiny grey satin dress beneath the white one. I undo the waist buttons in the back and slip the dress down lower. The wings bounce a bit as I step out of the dress. I hang the white dress over my left arm and again stand tall in the middle of the buffet, in long grey satin, and white wings. After about 4 seconds a rumble is heard to stage right and an old-fashioned wringer-washer appears, pushed by a woman wearing an ordinary skirt and blouse. She trundles the washing machine in front of the parrots to stage left (about 15 feet from the buffet). She retraces her steps to her entrance and fetches a wash basket, a carton of soap, and a small white stool. She places the stool and wash basket behind the wringer, sets

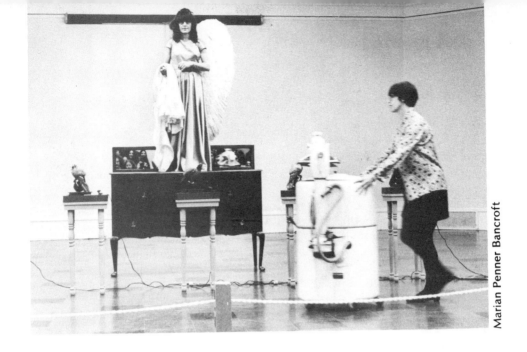

down the soap and plugs in the washing
machine. She walks over to the buffet, takes
the white dress from my arm, returns with it
to the washer, puts it in with a dash of soap,
and starts the washer. She stands quietly, but
relaxed, as she washes the dress (a few
minutes). She stops the machine, pulls up the
wet dress, and puts it through the wringer.
She lets it drop in the basket, picks up the
basket and the soap, and leaves walking in
front of the parrots once more. I stand for 4
seconds after her exit and slowly sit down in
my previous position. Parrot number one
begins to turn and sing *Row, Row, Row Your
Boat*. Parrot number 2 follows, etc., until all 5
parrots and I have sung the song. Three
seconds and lights out.

Performances:

1968 *A Bird is Known by his Feathers Alone,* Vancouver Art Gallery
1969 *Skipping Ropes, Hair Piece,* UBC Festival of the Arts, Vancouver.
 Film of Girl Walking Around a Square Room in Gallery, People Walking, Vancouver Art Gallery.
 Some are Egger than I, New Era Social Club and Arts Club, Vancouver.
 Eighty Eggs, Douglas Gallery, Vancouver.
1970 *Crocheted Geodesic Dome,* UBC Festival of Arts, UBC, Vancouver.
1971 *Some are Egger than I,* Vancouver Art Gallery.
 Ballet of Bass Baritone: Picnics, Vancouver Art Gallery (a collaboration of pieces with Tom Graff).
 Cross Campus Croquet, UBC Festival of the Arts, UBC, Vancouver.
1972 *Orange Peel, Red Angel, Three Part Invention or Home Movie, Chorus, Clouds, A Bird is Known by his Feathers Alone (revised),* Vancouver Art Gallery and Nova Scotia College of Art & Design, Halifax.
 Cross-Canada Tour: Red Angel, Three Part Invention or Home Movie, Picnics, Cat Piece, Some are Egger than I, Skipping Ropes, A Bird is Known by his Feathers Alone.
1975 National Gallery of Canada, Ottawa.
1976 Winnipeg Art Gallery, Winnipeg.

GENERAL IDEA

An Anatomy of Censorship

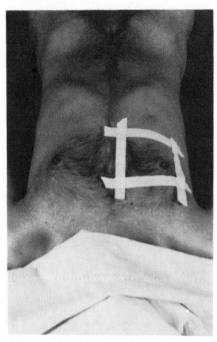

Everybody wants to be a fascist.
In the corporations, in the media, in the super-
markets, in the schools, in the family.

The laws focus attention on parts of her body
by outlawing public exposure. Censorship of
her body transforms desire into fantasy . . . let's
call it neurosis.

*You looked like love at first sight — and
somehow my first arrested sight froze into a cer-
tain way of containing you.*

*Your recurring image brings back alive my con-
suming cannibal hunger. I want to capture you
and wolf you down over and over.*

Video surveillance makes every public place a hospital ward. Human bodies become possible locations for disturbance of the peace, whether through disease or disorder.

What can you do but dish yourself up? I want you — to have and to hold and to keep on holding. Sign yourself over to me.

I WANNA GO PEEPEE.

The family is the basic unit of totalitarian control. We were all taught a little self-discipline. We all know about 9 to 5.

It was a political decision to call obsession abnormal. The control of public desire was taken away from the police & given to the psychiatrists.

So what? I feast my eyes on you. So? So, they're bigger than my stomach. What do I do? Diet? Push myself away from your tableau? Cling free?

So I'm attached, should I cut you off? Or is it cut me off you? Maybe abstinence . . . self-control . . . discipline . . . a little distance.

Even the most modern techniques of police surveillance cannot monitor the perverse mutations of today's specialized minority groups. Culture no longer reproduces . . . it multiplies.

So what if I don't want to repress my obsessions? So what if I want to ride them out? Are you listening? I — don't — want — to — want — not — to — want — you.

TALK LIKE A BABY!
TALK LIKE A BABY!

I LOVE YOU, DADDY.

Everywhere the totalitarian machine searches for found formats to inhabit; discos, singles bars, therapy groups, open marriages, gay liberation groups. Everybody wants to be a consumer statistic.

We all like to excite ourselves by breaking the law. Minor censorships allow the law to be safely broken. The human taste for scandal is limited, yet fulfilled.

Look at me — look at me when I'm looking at you. You can look . . . just like me . . . when I'm looking at you . . . and I can look like you, looking at me.

This autopsy makes you go to pieces. You come apart at the seams. I struggle to juggle the pieces as I fall head over heels until once again . . . it figures.

We survey a lover's body, focusing on the details of thighs, nipples, wrists, the roots of the hair. It is by such surveillance that we transform lovers into corpses.

As I chart your territory with my eyes, my fingers, and my at-long-last silent tongue, it all seems momentarily within my grasp as I grope to envelope the spreading of my desire.

WHOSE BABY ARE YOU!
WHOSE BABY ARE YOU?

I WANT MY MUMMY!

LUIGI ONTANI

An Endless Interview

On the 2nd of July, 1977, Luigi Ontani who had been in Holland for almost one month — minus one day — finally realized his tableau-vivant called 'Muzikale Hel' (Musical Hell) at the Round Dome Church in the Singel in Amsterdam. His last chance. The next day he had to leave the country because his air ticket had expired.

That Saturday night around ten a huge crowd lines up before the Church entrance. Luigi keeps them waiting in the dim sunset light on the canalside for another 20 minutes. The rumour that he still has to be dressed goes from mouth to mouth to satisfy the people.

When the large green doors at last open the crowd enters a cupola forty meters high filled with Bach music specially played on a harp for the artist. Everywhere around on the white pillars, the white walls and the white round roof are colour projections: slides giving views of our mythological universe, very often with Luigi as Mercury, Mars, Venus, Neptune . . . or as himself sitting on the flying carpet and drifting over paradise. On the right side of the majestic church organ, in a projection of orange and yellow flames, stands Luigi Ontani on a balcony thirty meters above the floor, dressed in cauliflowers that hide his head and turn his naked body into a divine male sculpture. Directly opposite him, but on a lower gallery, one sees a small golden harp in a bright flow of light, with a blue image of Luigi projected within the instrument's frame. The object draws each spectator immediately into his own infinity; it is of exquisite beauty.

Most people sit on the ground or lie down, unbend by the harmonizing atmosphere. Meditating on the golden harp in a position right under the purgatory with Luigi in it, all of a sudden *peng*, a strawberry falls before my feet. So besides cauliflowers, Luigi must be wearing strawberries too.

Later, near midnight, Luigi shows me five cauliflowers and long strings of juicy strawberries now helplessly lying in a cardboard box. We who are helping Wies Smals of Gallery De Appel to collect the 27 slide projectors may eat as many as we want of the enormous red fruits.

When almost everybody is gathered on a night street-terrace with Luigi enjoying his glass of mineral-water, the best remembered of what he tells a circle of votaries is:

"The harp is the essence of what I did tonight."

"The idea for this tableau-vivant was inspired by a triptych of Jeroen Bosch."

"I could have showed the harp only. The rest was in fact added. The rest was superabundance."

"In the additions I was led by three factors, namely the fable, mythology and my geographical whereabouts. These three things have their bases in alibi, harmony and abundance."

"I work with superabundance because life is full of it. My eagerness to work in this big church shows the same inclination towards superabundance."

"I hope all the images expressed the irony of superabundance. I carefully consider my irony within the fundamental idea of abundance, like in a melody. It is a pretension of lucidity to show something that is already known but to wrap it up in abundance. That is what I have done in this church tonight."

I ask him how many slides there were. He says: "25, because I like the number seven. In every action I use seven in one way or another."

Before leaving for home Luigi promises that we will tape an interview on my recorder. It is agreed that the next day he and I are to meet with our bikes outside the green and white tea garden in the Vondelpark.

When I arrive I do not see Luigi yet, but very soon he steps off a romantic old fashioned woman's bicycle. The picture he makes in the Sunday summer setting is of a colour-conscious tastefulness. He wears beige velours pants, a beige silk waistcoat, a turquoise silk shirt over a beige silk shirt, turquoise high-heeled shoes, shiny purple socks, a purple bough stuck behind a cupido broach on his beige shirt, and thin purple hair pins to keep his long wavy hair in place. Luigi's face has the transparent radiance that one sees on holy men.

Calmly he shows the way to a free table. I say that the image of what he did last night becomes more and more beautiful in my mind. He says that he shows timeless beauty and accentuates serenity by using the elements which are part of the infinite culture which we consciously or unconsciously all know.

I produce the recorder. "No, no," says Luigi. "We will do that later. I'll show you to a quiet spot where we can do the interview."

We talk about India, where Luigi has been twice. He tells of the temple near Denares where for ages they have been singing an endless song, kept on by different people all the time. He used to go there at

Luigi makes
Four times the call of a coot
AAAAAQUE, AAAAAQUE, AAAAAQUE, AAAAAQUE
Then he says:

ALIBI . **ALIBI**

ARMONIA **HARMONY**

REDONDANZA **ABUNDANCE**

SIMILITUDINI **SIMILARITIES**

SENZA FINE **WITHOUT END**

And again Luigi makes deep in his throat
Four times the call of the coot:
AAAAAQUE, AAAAAQUE, AAAAAQUE, AAAAAQUE

(taped by LOUWRIEN WIJERS at the Amsterdam Vondelpark)

night in a rowboat to listen to the song and children would come with him to listen too. He finds India so nice because all living beings are there together in a wonderful harmony. He says: "Birds swarm chirping around you and sit on your shoulder whereas here almost every dog is anxiously chained."

"You don't eat meat." He says: "That is not because of Hinduism. I do not like the taste of it. Our culture gives plenty of food, I only take a small part of that."

We come to the subject of his age but he says he is never to give his temporary age to anybody. People can inform in his country or steal his passport if they feel a need to find out.

Luigi drinks tea. He would have liked to order Camomile tea, but the restaurant did not have it.

While riding on our bikes through the park Luigi tells about the small prison-like cell where he lives in Rome. A cheap, sober shelter, but he assures me that Rome does have plenty of incredibly expensive luxury apartments.

We reach the quiet spot and sit under his favourite hollow tree near the shore of a big lake. I have the recorder at hand. Again Luigi says "No, no. Wait till I know how to say it." Silently we sit side by side. Luigi points out a brown duck to me. I show him three young coots in their nest. Then he pushes me. I switch on the machine. Four times he imitates the call of a coot. Silence. Then he says in Italian: *Alibi — Armonia — Redondanza — Similitudini — Senza Fine* and again four times he gives the call of coots. A silent instruction tells me to turn off the recorder. I am flabbergasted. "It is an endless interview," Luigi adds with a smile. Without further explanation he asks me to take a picture of him. "But Luigi", I protest, "tell me more about the five words!" He says:

"My work and my life are so far based on these five conceptions. In the future I will add two more words. I do not know them yet. My life and work will encompass no more than those seven basic ideas. One of the two words is almost clear to me. Rimbaud says it in a poem. Do you know this poem?" He recites a few lines but I do not recognize them. "The last word will come before I die," Luigi assures me and he emphasizes that the seven words will be all there is to know about him and his work.

I take pictures of him with the bike and the tree and he photographs me on my bike leaning against the hollow tree.

On our way to the Seriaal Gallery where Luigi has to be, we see a display of modern sculpture on a sidewalk. There is for instance a big pink box with water running out of it. We stop and look at them. Luigi comments: "Such works are made by people with negative thoughts. All they can produce are negative forms. The pedestrians that pass these pieces will take up the hostile vibrations, which is dangerous, it may make them aggressive." Extenuating he adds: "I am so serious about art. I find art at least has to have the positivity of eternal life."

The people who are at that moment in the Seriaal Gallery listen giggling to Luigi's endless interview on my tape. In the house of Aggie Smeets where Luigi lived during his stay in Amsterdam, he shows me the brown rice he eats and a greek tea he is fond of. With two neatly packed bags and an old pigskin trunk we drive to the airport. There will not be anyone in Rome to welcome Luigi back home. He lives alone, and says it is hard for him to keep a relationship going because he needs his solitude so much.

This is the story of our meetings on the 2nd and 3rd of July.

Amsterdam,
September 1977

CHARLEMAGNE PALESTINE

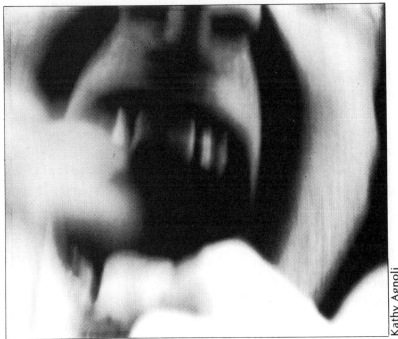

Kathy Agnoli

France Morin interviewed Charlemagne Palestine in Montreal on March 24, 25 and 26, 1978.

France Morin: Charlemagne Palestine, you are Russian American. Were you of the generation that came to America or was it your grandparents?

Charlemagne Palestine: My mother and father were both children when they came to America. They were born in Russia and both came around the same time, the second immigration of Russians around 1913. From Minsk, which at that time was considered to be part of Poland. My father came from Odessa. Both their families established themselves in New York. In mother's family there were seven children. My grandmother left my grandfather for another man in the Yiddish theatre. She disappeared and left the seven children with him. He had a breakdown, heartbroken and everything and the family split up. Some of them went to orphanages, some of them went to different places. My mother got married very young to my father. He had her work for his aunt, cleaning the house for room and board and a little money. That went on for a very long time and finally they got married. So she married, in a sense, out of necessity, not to be out in the street; I don't think she ever really loved him. She openly admits it now.

Was she a happy woman, when you were a kid?

No, she was very energetic, in fact if anything did affect me, it is the fact that I never really had a father and that my mother was so energetic all the time. She was always working, she was always doing things in order to compensate for, I guess ... she was never a submissive woman, she was never in love. Even if she loved music, she loved to listen to the radio, she would cry when she listened to a beautiful song but I never got a sense that men had any real

vitalness in her life except maybe as the key to survival. In fact, the only man I ever remember her having a real strong powerful, emotional and poetic link with was me. I was in a sense her only husband and perhaps still am.

You are talking of a very early age?

We are talking about the beginning, as soon as I could walk, or talk, or take over, she was my protector against my father. Eventually my father liked me because I sang in the synagogue and he used to like to come and hear me sing. I was six or seven, seven maybe. I used to do imitations of Johnny Ray and Frank Sinatra's songs, that kind of stuff for the neighbours. As a little kid, they tried to get me on Children's Hour and Ted Mack's Amateur Hour because I was a real entertainer. I would sing all these songs that were on the hit parade like I was a crooner. A little kid doing stuff like tearing his shirts and singing. My mother always used to show me to all the neighbours.

Did you consider yourself as a hero or did you feel lonely?

I never considered myself a hero. No, I was a lonely kid, but I was always making things, doing things. I was also a very precocious kid.

And what about school?

I was just like I am now. I had a lot of style. Teachers either loved me or hated me. I could not memorize things well and stuff like that. I was good at math for a while and then I got bored with it ... I had style, the way I talked, the way I thought, the way I would get somebody else in trouble; I was a cute kid, I had a lot of theatricality about me. But I was not a good student. Women were always my allies. They always helped me all through my schooling.

What kind of relationship did you have with

your brother?

I never really had any relationship with him. He had a relationship to me in that he was always envious on the one hand and idolizing on the other. It turns out that finally he wanted to be an entertainer. My mother would call him your lazy middle-of-the-road-kind-of-guy. That was the way he always was. Then, later on in life ... he had a funny way about him, because our family has a funny way about them. You know, we are nutsy-kookoo and Slavic and his physicality was very strange. He had a lot of charisma but he never used it and finally, later on in life, it got stronger. Some people start very excited and then they peter out, but he began to look more and more intense every year. The last year I saw him, he followed me all around New York. We would go from bar to bar and he would imitate my actions. He would stand in different parts of the bar and he would do these antics. The first time we ever had a comic show together was the last year of his life. He would even imitate some of my style; he would watch how I would do something then he would do it the same way. It is like he was playing the salesman, he was beginning to understand purely what delivery was about and he was shockingly good.

He never had a chance to perform publicly before he died?

Actually, he began to call me up on the phone a lot, at four, five in the morning, the last months and I had the vision once of holding the phone and it was shaking, so intense was his delivery. I had the first terror ever that he was going to surpass me. I remember feeling it the first time and did not have much more time to experience it because he was dead soon after. That is why he died, he could not handle it. It is like, as a magician, I was given my stripes early so I slowly learned to use it. I went through bad times around fifteen or sixteen, going to a psychiatrist. I did not know how to use all this power, all this energy, all this knowledge. But I had many years to slowly learn how to deal with the energy I had inside me. With him it came like a geyser that had been stocked up for years. All of a sudden the cork pulled out and it was like a champagne bottle gone berserk.

I guess it changed a lot of things in your life?

It changed everything. First of all, I became the comic, I had always been a bit of a comic, the idea of the comedian, of he who stands, who looks around and speaks of it became a part of my work almost instantly. Within a few months there was a piece, I did not even know, it was unconscious, but I took on his life, I added his quest to my own. I had always seen the image of the world with him in the middle and me on the edge. He was going to have children in the middle of the world and I would always be tightroping on the edge. The second he died, I started pulling away from the edge and started moving closer to the middle.

... moving away from the edge because you were afraid ... of doing the same thing?

I knew that I could not die. I had a death wish from the time I was very young. He became me in some strange way, I don't know, I am even wondering if he did not become me. This may sound bizarre, but maybe there was a sacrifice that was supposed to happen in my family and I was to be the early sacrifice. My psychiatrist said that if I had not come to him, I would be dead. So maybe he saved me. Somebody was supposed to die. A death wish is not something that everybody just has. I almost did die a couple of times, car accidents, etc.

You seem to always be running away from death?

Yes. I once told a friend: "Death is at my

heels every minute and I just keep running away from it." In some way that is how I feel deep inside. It is survival. It is the idea that at any moment the enemy is everywhere. If I stop for just a minute I will be killed.

It gives you that incredible impression of "readiness" ... I guess for whatever can happen.

Yes I am ready, that's all. I am not terrified. I am not optimistic. I am not pessimistic. I'm just ready.

Did you believe in a God or the notion of a superior force?

He is invisible, that is the big difference between Catholic kids and Jewish kids. We are waiting for the Messiah, so we figure the Catholics saw this guy come around and they chose too early. It is all from the same source, but from our source, he has not come yet. Nor do we believe and I don't think we ever will, that God is about love, God is somebody like the kids who used to wait for me after school. God is Jehovah, God is very temperamental and unpredictable. He is not what we call "good". Every so often, he throws his power around. I don't trust him. I spar with God. He manifests himself in his power. Storms are his power, the sun is his power, the moon is his power, the sea is his power, the mountains, the wind, that is when I see him. That is how he shows himself to me.

How can you feel some relationships with people from the same part of the world when your origins are so unprecise?

The only way I have come to understand my own heritage is by searching my own body. That is the only way I found out. I found out a lot because I have begun, almost like a historian, digging into myself for answers.

... and how did you get involved in the field of entertainment?

My mother wanted me to be the big deal, like a Jerry Lewis, Tony Bennett, Frank Sinatra, like the important Jewish entertainers anyway. For a Jew, the great singer was Al Jolson, he was like a cantor, like the cantor for the populace. Then there are the great Jewish actors like Edward G. Robinson, Louie Strasberg, they all come from the Yiddish theatre. So there is the actor, there is the singer, the crooner, then the cantor, then there are the rabbis, the rabbis of entertainment. Then there are the buffoons of which we have a great many. I feel I encompass them all. I have begun to encompass all the traditions of those public members, the cantors, which proved that through the power of their voice and sentiment, through song, uplift the people. The actor who through the power of his persona and his delivery, uplifts the people and then the comic who through the power of his comedy shows people their foibles. Those are the three major models of male Jewishness, of what the great master was in the village, the magician, the medicine man or the shaman, plus also the power of dance, not secular dance, but sacred dance which is what the Hassids used to do. They were like dervishes. Their dances would get faster and faster and they'd do it for hours and hours, jumping up and down. In that sense I am a Hassid as well. So I encompass in my work all the properties of the artisan building temples. Filling places with magical papers and things that transform. I am like a middleman between God and that is what my role is even in Soho, I am not just an artist. I am very much a senator in the family and many people have a moral or spiritual role in their life so that they can feel better about their life. I am probably intuitively just living a rabbinical life, that shamanism is not just in my work. But nothing in my work has anything to do

with Jewishness.

What about your education, you studied classical music?

Theory mostly, conducting, composition; I said to the teachers: "If I don't bother you, don't bother me." We made a deal. Since I was good at doing things intuitively, I had genius immunity. I would disappear for months, come back and still could do better than anybody else. I just learned what attracted me. I am still that way. I could never learn a subject, just to learn it.

You also said before that you conducted an orchestra, that you sang, do you ever want to go back to those activities?

I was supposed to be a great singer, I studied with the same teacher as Frederico von Stade, now a famous opera singer. We used to sing duets together. Then, I studied conducting at the same time as many conductors like Michael Tilson Thomas, George Cleave, who are now quite well-known. I just had to live out a much more complex and far-reaching vision. Now I could go back to these other things. It would be fun conducting, I would not mind spending a year conducting, a year writing, a year doing a film. That is my dream now. That is my ideal, to spend every minute of my life working on all possible endeavours until I die.

How did you get involved with the art world?

In the art world I started by getting involved with multi-media. It was in the sixties, the early sixties and it had to do with electronic music, lasers, light, film, dance. It was a hodge-podge. When I started: there was Cage, Stockhausen and computerists like Xenakis. To me, Cage's personality permeated his approach though his content seemed to me very hodge-podgy and unclear. I brought unification of content, where every element I dealt with was focused in itself, was communicative in itself and could relate to any other medium. I was involved with electronics, I was involved with dance but in a superficial way, not superficial in terms of my involvement but in what they were as mediums; I consider that it was superficial as part of a stereotype. All I met were stereotypes. I tried to merge all these stereotypes together to come up with something.

You were living in New York at that time, what was your relationship with the art world? In terms of history, did you like the abstract expressionist painters, for example?

I just loved the Jewish New York painters. I even did a few paintings. Now I am thinking of painting again, going back to the way I used it then, right out of the tube. I would do long continuous gestures and then I would pinch them onto the canvas. Like long snakes. I did a whole series of paintings like these close to fourteen years ago. As far as the art world, I met Tony Conrad in the experimental film world and Mort Subotnick in electronic music. That was my link with the multi-media world. I also studied with Pran Nath in 1969 where I met La Monte Young. We were both doing continuities.

You were also playing the bells at that time, around 1965-66, what exactly were you playing?

Well, I was supposed to play just hymns but soon I began to play John Cage's music for carillon. I began to play my own pieces around 1965 that were all about pure sonorous ringing. I would be up in the tower and the bells would ring and ring enveloping me in their gyrations and vibrations. I began to play a continuous work evolving each day with another segment, realizing finally that I had created a soap opera, one piece that lasted for five years.

Was it structured in any way or totally im-

provised?

It is just like I do now. With my performances people often want to know if it is notated. I can only work in the spontaneous moment, I can create a work that has all the elements of a finished work because I carry it with me. When I am given to do it at the intense moment, it all comes out right. I cannot do it in the abstract, I can't do it alone or privately, I have to be in a public place and then it comes out as though it were written. It is not improvised. That is just my style which is about the moment. People have said I was involved with the sound as an object, making the sound like a sculpture. It is pure sensuality, what makes me feel good, then I look at what makes other people respond and then I decide how to use that knowledge. But first I indulge myself completely.

Did "glory" preoccupy you from the beginning?

Yes, from the beginning I wanted to be *the*. It is just about power, what you are doing is harnessing anxiety into power, into energy which is the most powerful thing you can harness. There are two energies, there's faith, people who have positive faith, they become like the great protestants, or the missionaries. That is using power coming from a positive notion, even if a perverse one. Then, there is the harnessing of the negative notion. I was the harnesser of such a powerful negative notion that it has made me superman in a certain way. It could be dangerous.

How do you deal with all that energy?

Energy is a powerful thing. Lots of energy is dangerous unless you know where to put it. Energy can break windows, yet the energy, if it were used correctly, could build a table. I had an incredible amount of energy and it was all negative energy, all self-destructive energy. Once I began to let it out in the

right place, it did not matter what its source was. There were all these little pixies inside of me with little knives stabbing themselves that made me a generator of one of those big engines and by the force of their stabbings created my power. When it was backing up, like a clogged toilet, everything shorted and I was a mess. Once I began to let it out in things that gave pleasure, I became better at it. Now I am much more relaxed, but still these little pixies are stabbing themselves and it is still an energy source, but now it's successful business. The method has not changed, it won't change.

What about this sentence: "This pain and this feeling of impotency comes back all the time, everything just looks so bleak all of a sudden." Is this sensation depressing?

No, I don't think so, it's just a price, that's the price. So maybe once every day for half an hour I feel like that or maybe for an hour or maybe for more, the price for living a life like I'm living. It doesn't seem like such a terrible price for glory ... It just seems like that's my destiny and that's the way it has to be and so it doesn't seem contradictory to me. Look at people who work in a factory, I'm sure they feel exactly that way more often than I. It's sad for them too and they rarely have any sense of glory in their lives, only degradation in a certain way, and humiliation. I don't feel any more humiliation, degradation, impotency or fatalism than they do.

And when you said: "Sometimes I'm afraid of going too far"?

I'm not afraid of insanity but in a way what manifests itself in me is to get myself killed. I don't think I've ever been prone to the kinds of extremes that insanity shows itself in. I'm prone to extremes but it's not the kind that would happen just in my mind. It's the kind that would take me somewhere, I would do something beyond the fringe in

my body. If I had a weird idea, I would not just leave it in my head, I would say: o.k. body do this weird thing, and wind up on the edge of a cliff, in the middle of a pit or walking the edge of a volcano. I would not get that kind of sickness which would be purely abstract, it's not in my nature. Trying things out that are physically dangerous, that's where my danger is. I use my body as a framework. I used to live such a dangerous life when I wasted it in terms of my career. I felt I was wasting it, wasting my sense of adventure for nothing. I've set up my regular life in a much more mundane way. I've set it up so that I could, when I work, be much more abandoned. My life totally revolves around dedication to my work and part of that is its building up my sense of boredom in my everyday life so when I finally do something, it's jet-propelled.

What was your feeling as far as the German and Austrian artists who injured themselves physically?

It's very different from me. I feel that the Germans need a lot more to make them feel emotionally. Pain is something that is challenging to them; they have to do things physically to themselves to feel violent pain. I never got the sense, unless I'm wrong, that they were experiencing the euphoria of pain. I don't even have to touch myself sometimes and I am in the euphoria of pain. The idea of external pain isn't as powerful in my world as internal pain is, especially the euphoria of it. The numbness of seeing blood is interesting, but that to me is not nearly as powerful as the sensations of internal pain. That's why love's pain or fear's pain is more challenging to me than being maimed. It's not as poetic and that's why it does not really entice me. If there's a good reason, if each action is related to a dramatic necessity, then for me, the viewer,

it evokes a profound response. Why a slit in the cheek? Why a puncture in the stomach? Why a slice in the groin? Then it is not only in itself but it also gives one insight into the life of the person doing the sacrifice. I rarely got that expanded sense of any of those works and consequently it never really stayed with me; my memory of it is very small because it didn't hit in my universal cavern of experience.

Do you feel related to Jackson Pollock?

I feel very close to Pollock. There are a few artists that I feel close to. I feel very close to him and to Rothko. I would probably say that in some strange way I'm the living hybrid, in my own work, of the physical gestuality of Pollock and the spiritualistic colour chemistry of Rothko. If these two had conceived a child, I'm it. Both of them have a relationship with death that is close to mine. One was suicidal and the other one played with danger. One lived dangerously externally, the other had a strong self-destructive inner haunting.

Why do you think they both committed suicide?

It's easy. You live a life. I am sitting here. I am trying to do something that is difficult with incredibly constant frustrations. One can't be a hero in the world, what is a hero in the world? When people like what you do, that is not satisfactory ... when you like what you do, that is not satisfactory, the pain is constant, it is always there and the only things that make it better are daily escapes. If you could always be in pleasure, that would be good. So you have that. Maybe food would make you feel better, maybe drink. If you obliterate yourself, that does not feel so good. Maybe if you made love all the time, every woman, every place ... well that does not do it. Each one does it for a while, has its time. Or if you could just work, but then you start to work and you

cannot work. Then health, there are so many things. Like my initial energy, once I am up, in the day, very often, if I unleashed it pure, it would want to maybe blow-up a city, by my own hand. So with that energy everyday, when you just happen to let it go, there is always the fear that it will come back on you and even, perhaps, kill you. It is having that kind of energy that is dangerous, especially in a heritage that externalizes and plays out such madness. These kinds of demons or energies manifest themselves very physically. They don't stay in the mind. They bounce out into the body and into reality. That is what both of them seemed to have.

I guess that at some point it gets quite frustrating for an artist to have an audience as limited as the art world?

It's paying your dues, just paying all your dues. It gave me a chance to work things out. Like I was doing my thesis or something. Here I am now at thirty-three and I'm ready. I'm ready for the entire world. It took me till now. Now, I've graduated. I'm ready for anything. All of my means, all of my thoughts all the elements that make me who I am are churning, all the organs inside are healthy and ready. Maybe this is the halfway mark, I am ready for things that I will be remembered for. Until now, it was preparation, now come the epics. Because finally that is what I want to leave, behind, great epics, not just little bittly tiddly farts.

Do you feel that it's happening more and more, that the "art" performer would like to have a larger audience, would like to get out of galleries?

Sure, it's in the air. We all tried things out in the art world and now we are just getting too good.

So you think of the art world as of your practising field?

Practising ground for performance perhaps. Art is what the art world is. So now I intend to concentrate just my visual art for the art world.

Are you thinking more precisely of the performers than of any other group of artists?

Performers didn't have another world to work in. I think for visual art, the art world is the art world. It's the home of visual art, and there's no two ways about it. Everything else is sort of a little like having visiting immigrant status, but you're not really a resident of that world, financially and every other way.

What about this idea we had talked about in New York, a theatre, a home for performers?

Yes, it would be a home for young artists, like a camp until one finds their way. I'm thinking about it. It would be like a family. I, the father, Elaine Hartnett, an important female performance artist, the mother. A place for individuals, for loners, for people who just want to grope in that nebulous space called performance, that no-man's-land, not really dance or exactly anything else, that homeless theatre.

How would you define performance?

For me performance is everywhere, it includes everything and everyone — all response, all intents, all things related to the individual and the world. Every moment is a performance, every gesture, every sip, every mouthful, every spoken word, every single thought in time, every twitter of one's eyebrows. All human transactions, telephone conversations, sleeping, fucking, shitting, all is performance but unframed. All the genre called performance or theatre does is to frame and package rarifications of this continuous spaghetti of living content. Like we were out last night, we did a performance with that other person in the park because everything created responses from the minute we walked out the door.

All those things happen as a New Yorker. That's what I've always lived all my life. When you set up an energy, it creates a response, it accelerates, creating a chain reaction of energies and responses: that's a performance, so I'm performing all the time. For me, performance is being *on*, you feel *on* and the world around you treats you differently. Life is a performance, I see people around me performing, some are better than others, for me it begins with attitude. Performance is attitude, performance is a continuum that's always going on, it's just a question of focus, if you decide to perceive it, it becomes a framed performance for you but it's going on twenty-four hours a day.

Do you feel that it's all too new, it's too soon to feel where it's all going, that there is no way to have any historical perspective?

Yes, that's why it needs a home, but if I do build a home I'm too much at the beginning, what happens is that after I'm dead and after a few of us are dead, if I built a theatre, The Charlemagne Palestine Home for Performance, well already there's a tradition. People would have a place to perform and they would not be alone. Theatre has a home, art has a home, now performance needs a home. Yes! Performance needs a home in a larger sense, not just one place like I'm interested in starting, but many oases that give aesthetic freedom, architectural flexibility but exist more tangibly so that a more stable public could follow its development over the next decades. Not just a neighbourhood or underground public. But in order to continue, we must find a support system that's not too commercially obsessed so that the concept of just entertainment isn't forced but not a no-strings endowment which often inspires inaction.

But now it's even taught in school?

It's too new. It still isn't the right time, it takes more than fifteen years. It began only fifteen years ago or so. It'll take a decade or so, more. I mean now I'm thinking of the idea, I'm sure a few others are thinking of it too, the idea of centres, homes.

Let's talk about the scenarios of your performance?

I never take notes. It just happens, one step follows the next. And of course, when I know I have to do something like a performance, it is an intensified kind of instinctual certainty that makes me think more intensively and finally make fatalistic decisions of destiny.

You just talked about your animals. They are public now. Teddy is even doing a piece of his own. They are part of your work, of your life ... were they always with you?

No. I went through a whole period when I didn't have them. From around the time I was thirteen, when I left home, for ten years I didn't have them. I don't know what I did without them. For those long amounts of time I spent with women, I was always with women, women had that place. They were my teddy bears. In bed, it was the only place I felt secure. The animals have proven now that they are an important part of life to me. If I had had them for a little while and gotten rid of them, then I would say they were a passing phase. But Teddy has gone the seven-year line. To me, when something lasts at least seven years, it remains with you internally for the rest of your life. I am going to start becoming like a director, a writer, not only about him but about everything so he will have his life. I am going to keep every element contained in my work.

You are pretty much a loner?

I call myself a public hermit.

We talked about the animals before, I guess you give the same importance to the

scarves, the knives and even the cognac?

Oh yes, they are always around me. I wear them, they are very soothing to me. They're real therapeutic, they're my safety. They're my symbol, whenever I am around, one sees them all. When I enter a space, it reinforces my waning knowledge that I exist. It's the same with cognac, it's symbolic. In many religions, there are always trance tools. It can be the smell of incense, of herbs, like Sufis use in rituals. Cognac is my peyote, so when I take it, it puts me into another world, where I experience pure emotive energy easier.

And what about your relationship with the audience? Somebody once said: "It's mainly the 'charisma of the performer' that makes a performance work or not"?

I'd have to say that at least fifty percent of my power lies in just pure raw charisma. With me it's a more vital aspect than in the work of many other artists. I can just sit doing nothing and perhaps succeed because my instinct is to super exude, I have an animalistic kind of impulse to leave an aromatic impression on people's bodies and feelings so even if I was forced to silence, I'd penetrate anyway. I'm a charismatist. I love audiences, performing for them is very sexual, my contact with them arouses me, the sexy females in the audience, or more abstractly, the audience made of breathing, hearts, salivas, eyes, noses, ears, hair, sweat, it's very exciting. I sense it a lot. Many of my pieces are done in the dark; I like that because I prefer to deal with the total energy audiences exude. I can experience more unconsciously, perhaps psychically, in the dark, pacing energy through audience. People are my gauges, they decide how long things last. I respond by what energy fills the air. It starts like an inhale/exhale relationship and if I begin exhaling a lot and get little response, I feel like I'm choking,

not getting enough air so I exhale less, until things change or end. It's all very sexual. It's like you can tell if somebody is having an orgasm.

You don't seem to be doing any of these violent body pieces anymore?

Not right now anyway.

How do you feel after these pieces, you're in what kind of state?

I feel very relaxed, like I just came.

Again, very sexual.

Soon again I am going to start doing more dangerous body pieces, not for a while. Pieces where I am hanging like Houdini. I have these ideas where I am hanging from a large arena by a rope and I swing smashing against the walls. I feel like doing them now only when thousands will come to see it. I am not going to do it just for a few then. Houdini is one of my heroes. But I wouldn't want to be a traditional magician. That's how I live out my death wish. I would live out my battles very openly, my battles with life and death but of course being a good strategist, living as long as I can. That's why Houdini was able to live long. The only reason he died being an ill-timed appendix attack.

What about your working relationship with Simone Forti?

We seemed to have certain things about singing in common. My relationship with her began by show rituals every day or every few days. We would have a meal together then would go and work. It was like temple time. At that time, singing was the basis of the work. We are both Jewish, we both had worked for a little while with Pran Nath and we were both attracted to the voice as a way to vent one's melancholy.

When you started performing together, what were your roles?

At first, she was more well-known than I

was, so from that point of view, she had the clout that I didn't and she dealt more with movement, she was known for movement. I dealt with lighting, with sound, I dealt with the climate. I built the climate and at the beginning she was the more important character and I took a more subordinate role. Then, times changed and I began to rebel from that structure. Where before, my body just carried the sound, I began to do these large and very aggressive male acts which scared her, which became the beginning of the end actually, that is why we began to separate. I was interested in male and female form that had many dramatic overtones. A grand theatre duet, an epic about man and woman. I forced that form on her and often she would not talk to me for months because of it. I led her to believe that I was just going to play music and instead I would concoct an epic again and force her to be part of it. She was always angry but for a few years I think it was extraordinary.

You said a few times she was getting afraid. Afraid of what?

Well, I think it's traditional that a woman is afraid, many women are afraid of the primeval macho factor in men; they're attracted to it at a distance but when it's right there on top of them, it terrifies them. That's what it was about basically. It manifested itself in performance material. The machismo of male which I was beginning to show pure was terrifying her.

Let's talk again of the situation in the arts going through the sixties and the seventies.

If we are talking of the sixties, I was never a minimalist. I happened to be doing something privately then; there were some people that decided that there was such a thing called minimalism and it was born around New York. I happened to be in New York and I happened to do things ... people

like Bob Morris, he could be my uncle, what they come out of is very different than from what I come out of. Allan Kaprow, he could have been my uncle too. What I am saying is that I wasn't there at the beginning with them, I wasn't the disciple of anyone, nor did I believe in it; I just happened to walk into it and then everybody saw what I was doing and said: "Hey, you're one of us." So I said: "O.K. If you say so." so for a long time, I was considered a minimalist but it was only a momentary coincidence. People were obsessed by wanting to look at things one way. So from that point, that aspect of the sixties, I had nothing to do with it.

But what was happening in the world of performance?

To tell you the truth, I really did not know what was happening. I was always very private. It is only in the last eight years that I've become more in the scene. I didn't care, really. I was struggling with my own aesthetics. I really wasn't a member of the community.

Yes, but in terms of audience, when the performances started, something must have changed?

Yes, it's true that something started, it started small and it began to grow and that started with the community of artists, artists looking at each others' work, it was a small group, a neighbourhood group. For performance, the important ones were perhaps at first Rauschenberg, Warhol, Kaprow, Cage and Cunningham. There were many others too but if I think of the names that stick, those are the ones.

Let's talk of the other aspects of your work, like drawing, video, etc.

As far as drawing is concerned, I've come up with a format now that I'm really happy with. It's like when I created body music in video, I knew I hit the mean, I hit on the basis for a language. When I started doing

strumming music, I hit on the basis for a language, and now I've come upon these book forms, the crumpled surface on the one hand, the book format on the other, and then my expressionist sense of simplistic drawing altogether. Now I have a format, there can be many many variations on this theme. I have found my materials. It's happened in the last two or three years. A lot of the drawings I've done started out as books, the idea of the book. For me the book has many surfaces in time, one can't experience it completely at any given moment, that's what I'm trying to bring to visual art. It's a sense of time and environmentality.

And the video medium?

I first got involved with video as an extension of multimedia in the sixties. I would make documents of things on video but I never really thought of it as something I would use in a different original way. It all began in 1972 in Paris when Ileana Sonnabend told me about Maria Gloria Bicocchi who had a production company that was making videotapes. That's when I created Body Music which is probably one of my best tapes and it just came out of nowhere. I don't know why or how it happened, within a months, I was getting telegrams from Europe and when I came back to Europe, a few months later, Body Music was a very well-known videotape. It happened totally accidentally.

Are you still involved with video these days?

Yes, I'm interested except that to do video as I'd want to do it, I would need a production company because to do videos for galleries doesn't interest me and to just do it for small public broadcasting doesn't interest me either.

You never got involved with T.V., like Channel 33 in New York?

No, not really because it felt to me too elitist to go through all that trouble and it's interesting but my works aren't very well received by the intellectual community. They are better received by the populace because they are very raw, expressionistic and full of action and violence. They don't have the kind of sheen and elegance that the video world thrives on.

Since most of your work is ephemeral, in a sense that it is not recorded, does the documentation about your work have any importance for you?

I want to start to make documents of things that I've done; I don't like to document while performing because I feel that equipment gets in the way of the audience's perception of what I am doing. It takes the privacy out of it. It objectifies it while it's happening. I don't like the audience to be able to get too distant from what I'm doing while I am doing it. I like to feel that they're sucked in and that they're in danger, their perceptions are in danger of being pierced and that they're in danger of thinking things they don't want to think, and feeling things they don't want to feel. If there are cameras and things around, it gives them a defence, a barrier against my impact.

What influence did the Bosendorfer piano have on your music?

I was not even playing the piano before, I played for fun but I did not consider it an instrument that I really was interested in. I was using electronics, bells and I was involved with the voice but the piano didn't interest me. But when I first played the Bösendorfer, it rang the way bells did, it had overtones like electronics and it was as sensitive as the voice. The perfect incarnation of all those things I had been groping with separately. It helped take my ideas further and now I'm ready for the orchestra and larger forces.

What do you think of punk music today?

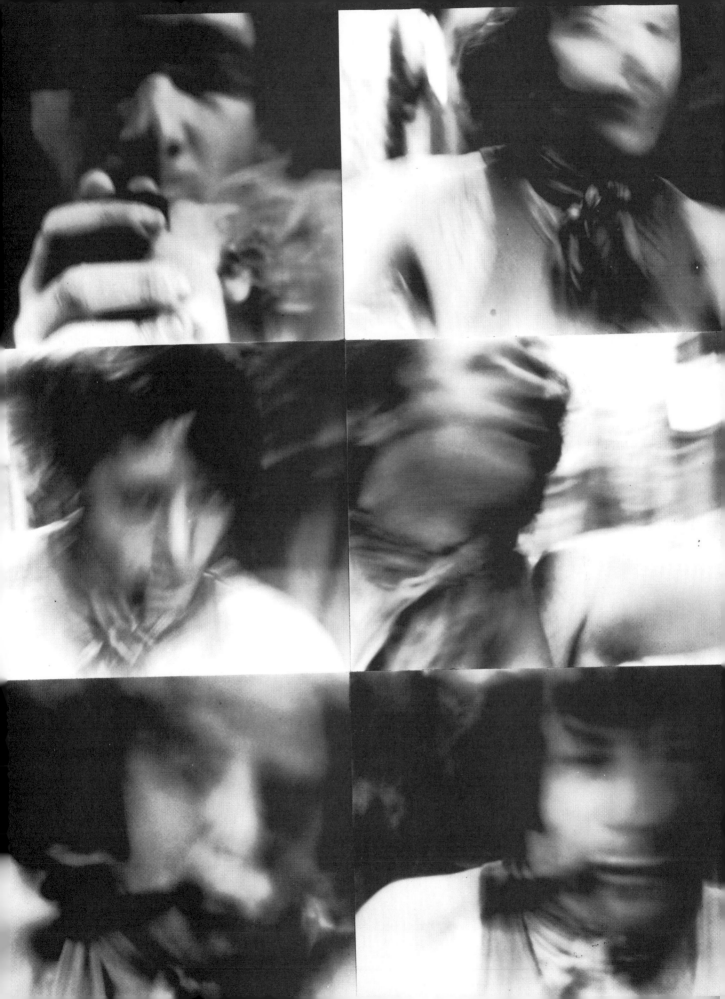

I think that pop music is always looking for cults. Punk is another, though its obsession with violence, poetry, madness and its return to the clipped hair look give it a powerful new flavour. Since it deals with sadism and masochism and anger, it does relate a bit to my own work. Some New York and California groups have even told me that I've had an influence on their aesthetics somewhere or other. But finally, for me, it's too much enforced weirdoism — too culty for my taste, not individualistic and poetic enough for me. On a certain level, what I am about and what Patti Smith is about isn't so different. We are from the same generation, I'm obsessed with my persona, obsessed with a lot of different emotional things about the male but I could never be a cult hero in that way because my weirdness is too aristocratic. I am just a primeval aristocrat, suffering from an overdose of paranoia and megalomania.

Practical Documentation/Reindeer Werk-Photo-Neils Torben Larsen Documentation of four days spent working in Antwerp, Belgium.

I BELIEVE THAT I AM OTHER PEOPLE AND OTHER PEOPLE ARE MYSELF +

WE ARE NOT JUST PRESENTING WORK BY OURSELVES +

OUR WORK IN PERFORMANCE SEEMS TO HAVE HAD AN INBUILT CAPACITY LEADING ITS DEVELOPMENT TOWARDS A BASIC STATE: THIS BEING, IN SIMPLE TERMS, PEOPLE FACING PEOPLE.

THUS NARROWING ITSELF TO A POINT.

BUT THE FORCE OF THE NARROWING PROCESS THEN RE-OPENS THE POINT.

IT NOW SEEMS THAT TO TERM 'PEOPLE FACING PEOPLE' ART IS DEMEANING, AND IS A RESTRICTION OF THE RE-OPENING OF THE POINT.

SO: A TYPE OF ART DEVELOPING INTO A POINT OF 'NOT ART', THIS POINT THEN RE-OPENING.

IF WE ACCEPT OURSELVES IN OUR WORK AS BEING AT THIS POINT, THEN WE CAN NO LONGER CALL OURSELVES MAKERS OF ART.

PEOPLE FACING PEOPLE. PERSON FACING PERSON. PERSON FACING SELF. THEN OUT AGAIN. THIS IS A KIND OF PROCESS.

IN PERFORMANCE WE FACE PEOPLE/FACE OURSELVES. THERE CAN BE A TYPE OF UNDERSTANDING IN THIS PROCESS. AND WHETHER GOING TOWARDS CLARIFICATION OR CONFUSION IT IS STILL UNDERSTANDING. AND WE MUST THEREFORE ACCEPT DEEP CONFUSION AS DEEP UNDERSTANDING. (UNDERSTANDING BEING A PROCESS, NOT AN END.)

SELF AND MUTUAL UNDERSTANDING OF PEOPLE WITHIN THIS SITUATION EXISTS WITHIN THE TERMS OF THE PEOPLE WITHIN THIS SITUATION. OUTSIDE TERMS OR REFERENCE POINTS ARE OF LITTLE USE.

THE FACING PROCESS IS NOTHING IF IT IS NOT HONESTY (EVEN IF, IN ALL HONESTY, DISHONESTY IS REVEALED.)

TO BE HONEST, TO ATTEMPT HONESTY, IS TO OPEN THE PERSON. IT'S TO BECOME VULNERABLE AND IN THAT VULNERABILITY FACE POSSIBLE DISORIENTATION AND CONFUSION. BUT NOW THESE ARE POSITIVE AND POWERFUL STATES.

WE ARE PRESENTED WITH SETS OF REFERENCE POINTS, INTO WHOSE BOUNDARIES WE ARE URGED TO MOULD OURSELVES. WE ARE PRESENTED WITH WAYS TO AVOID FACING. WE ARE PRESENTED TERMS BY WHICH WE CAN *MIS*-UNDERSTAND OURSELVES.

WE KNOW PEOPLE WHO CANNOT COPE WITH THIS, AND ARE IN VARIOUS STATES OF DISORIENTATION AND CONFUSION. IN THE FACE OF HAVING THEIR EXISTENCES MAPPED FOR THEM, THEIR DEVELOPMENT INTO CONFUSION (INTO UNDERSTANDING) IS POSITIVE AND MAGNIFICENT. AND THEIR INADEQUACY AND VULNERABILITY ARE STRENGTHS. INVOLUNTARILY THEY BECOME 'PERSON FACING SELF', AND THROUGH JUST THEIR *BEING* THEY INVOLVE THEMSELVES AND THEIR ASSOCIATES IN THE WHOLE FACING PROCESS.

THIS IS AN EXEMPLARY STATE.

THESE ARE SPECIAL PEOPLE (THOUGH TO SPEAK ABOUT THEM AS AN ELITE IS LUDICROUS.)

WE'RE SEEING A PARTICULAR KIND OF SAINTLINESS, SOCIALLY AND POLITICALLY USELESS, HAVING REFERENCE TO PERSONHOOD ALONE.

THIS IS A CAPACITY WITHIN HUMAN BEINGS.

WE NOW LOOK AT THE FOLLOWING AS TYPES OF WORK:

FACING/BEING FACED BY INDIVIDUALS.
FACING/BEING FACED BY SMALL GROUPS OF PEOPLE.
FACING/BEING FACED BY LARGE GROUPS OF PEOPLE.

THE USE OF WORDS IN EACH OF THESE ONLY AS FAR AS IS COMPLETELY NECESSARY. THE AVOIDANCE OF OUTSIDE TERMS AND REFERENCES (JARGON AND IDEOLOGIES). THE USE OF MEANS TO DOCUMENT THIS WORK, AS A DEVELOPMENT OF UNDERSTANDING WITHIN THE WORK, ONLY AS FAR AS IS COMPLETELY NECESSARY. THE TRUST IN THE WORK BEING ABLE TO DEVELOP ITS OWN MEANS OF DOCUMENTATION.

WE WORK FOR THE TIME BEING IN FAMILIAR CIRCUMSTANCES, TRUSTING THE WORK TO DEVELOP ITS OWN CIRCUMSTANCES IN DUE COURSE.

WE LOOK TO THE RECOGNITION AND DEVELOPMENT OF SAINTLINESS.

M. YECK
APRIL 1978

TAKEN FROM A BOOK BY BRUNA HAUT-MAN SIGEFRIDE: "NOW YOU'VE GOT ALL THE INFORMATION YOU NEED TO KNOW ME". TODAY'S PLACE. KEIZERSTR. 50, 2000 ANTWERPEN.

PERHAPS TOMORROW I WILL BE EMBARRASSED TO SHOW YOU THIS PAPER BECAUSE THERE WILL PROBABLY BE NOTHING ON IT THAT WILL INTEREST YOU BUT I STILL WANT TO GO ON WRITING EVEN WHEN NOBODY MATTERS
I FEEL LIKE A 1M70 HIGH PROBLEM
I SIT HERE SURROUNDED BY OBJECTS WHICH DON'T FEEL LIKE COMMUNICATING WITH ME — THIS NIGHT IS A SPECIAL NIGHT — IT'S THE ONE-WAY BORING NIGHT — GLAD NOBODY ELSE IS INVOLVED — THINK OTHERS WILL BE GLAD FOR THAT TOO — THINK I AM TRYING HARD TO REACH THAT OTHER PART OF MY BRAIN — I MUST GET RID OF THAT FASCINATING FEELING WHICH TELLS ME THAT THE OTHER — UNKNOWN PART — MUST BE MORE INTERESTING THAN THE ONE I'M USED TO
AND I KNOW I SHOULDN'T TALK THAT WAY BECAUSE THAT IS NOT THINKING AT ALL IT IS JUST THE IMPATIENCE — ACTUALLY WAITING FOR SOMETHING TO COME
SO I DECIDED TO GET MORE INVOLVED WITH OTHER PEOPLE — BECAUSE I WANT PEOPLE TO KNOW I EXIST SO I WANT TO GIVE OTHER PEO-PLE THE CHANCE TO TELL ME THEY EXIST TOO — AND I THOUGHT STARTING A CONVERSATION WITH SOMEONE SEEMED TO BE THE RIGHT SOLUTION FOR ME
I KNOW IT MIGHT LOOK SELFISH BECAUSE I START FROM MY POINT OF VIEW THAT OTHER PEOPLE ALSO FEEL THE NEED TO SAY THEY LIVE AND NEED TO TALK ABOUT THEIR PROBLEMS CONCERNING THEMSELVES OR OTHERS OR THEIR ENVIRONMENT
AND ABOUT THE CONVERSATION I MADE SOME VERY IMPORTANT MISTAKES
IT WAS GOING TO BE WITHOUT ANY SPECIFIC QUESTIONS CONCERNING THE OTHER PERSON AND I CERTAINLY DIDN'T REALISE IN TIME I WASN'T THE RIGHT PERSON SOMEBODY WOULD LIKE TO TALK TO WHENEVER THEY HAD PROBLEMS
SO AFTER THIS EXPERIENCE I DECIDED TO WRITE DOWN A FEW QUESTIONS FROM WHICH I THOUGHT THEY WOULD CERTAINLY INTEREST THE PERSON IN QUESTION
AND PERHAPS WITH A SMALL EFFORT ON MY PART I WILL SUCCEED IN HELPING THE OTHER ONE FOR A CHANGE

CONVERSATION II.
QUESTIONS:
1) DO YOU MAKE A CLEAR DISTINCTION BET-WEEN OBJECTIVITY AND SUBJECTIVITY WHEN IT CONCERNS A PERSON YOU ARE EMOTIONAL-LY INVOLVED WITH?
2) ARE YOU AWARE OF THE FACT YOU GIVE A STRONG IMPRESSION OF CONFUSION WHENEVER YOU TRY TO COMMUNICATE WITH SOMEONE? DO YOU EXPERIENCE THAT AS POSITIVE OR NEGATIVE?
3) DO YOU CONSIDER YOURSELF AS PART OF THE GROUP? WHAT KIND OF FUNCTION DO YOU THINK YOU FULFIL?
4) IS IT SO THAT YOU TRY TO HIDE YOURSELF IN THE GROUP BECAUSE YOU PERHAPS THINK OTHERS EXPERIENCE YOUR CONTRIBUTION AS UNIMPORTANT?
5) DO YOU CONSIDER YOURSELF AS NOT BEING A PART OF THE PRODUCTION PROCESS, DO YOU FEEL INVOLVED WHEN IT COMES TO MAKING OTHERS AWARE OF THE PRESENT SITUATION?

AS I ALREADY POINTED OUT MY PREVIOUS MISTAKES, I HAVE NOW STARTED OUT ON AN ENTIRELY DIFFERENT BASE. (QUESTIONS)
I CANNOT SAY THAT WAS A MISTAKE TOO BY PUTTING THEM TO HIM, BUT I HAD THE IM-PRESSION HE FELT HE NEEDED TO APPROACH HIS OWN ANSWERS IN THE WAY I FORMULATED THE QUESTIONS. THE MORE QUESTIONS I PUT TO HIM ABOUT HOW HE EXPERIENCED HIS CON-

STANT CONFUSION IN TALKING, THE MORE CONFUSED HE GOT. I DO NOT WANT TO GIVE AN OPINION ABOUT HIM, BECAUSE I WOULD DO THAT FROM MY PRINCIPLES AND POINT OF VIEW.

THE FACT I HAVE PUT THOSE QUESTIONS TO HIM AFFIRM IN A WAY THE IMAGE I THOUGHT HE WOULD RESPOND TO, AND HE DID

IT IS 10 MIN. LATER NOW AND I WANT TO RECONSIDER MY OPINION, HE DID RESPOND TO THE PROPOSED IMAGE, BUT IT IS NOT MEANT IN A NEGATIVE WAY. I WANT TO REMAIN WITHOUT ENGAGE TOWARDS HIM BECAUSE HE HAS THE RIGHT, JUST LIKE ANYBODY ELSE, TO FIND OUT WHAT HE WANTS TO ACHIEVE AND HOW LONG IT IS GOING TO TAKE HIM TO GET THERE.

NOW I KNOW I WANT TO GET INVOLVED WITH OTHERS BUT I STILL CAN'T PREVENT MYSELF FROM WANTING TO BE UP THERE REALLY HIGH IN DISTANCE WHERE I AM ABLE TO OBSERVE PEOPLE'S BEHAVIOUR SO I CAN GET A CLEAR LOOK AT SITUATIONS BECAUSE WHENEVER I FEEL I AM ON THE SAME HEIGHT AS OTHER PEOPLE PHYSICALLY I FEEL RESTRICTED

CONCRETE FORMS SEEM TO SCARE ME I AM ABLE TO TALK TO *ANY VOICE* BUT NOT TO YOU I CAN THINK OF MANY REASONS FOR NOT COMING TO WARSCHAU BUT THE MAIN REASON IS THAT I DONT FEEL MENTALLY STRONG ENOUGH TO MANIFEST MYSELF AS A BEING IN FRONT OF YOU ALL AND PLEASE DONT YOU EVER DARE CALL ME AN ARTIST BECAUSE I CAN HARDLY CONSIDER MYSELF A HUMAN BEING AND I'M NO WRITER TOO I'M JUST A MINUTE OF YOUR TIME WHEN YOU READ THIS

I KNOW HOW SOME SITUATIONS ARE GOING TO WORK OUT AND I OFTEN RESTRICT MYSELF TO THOSE BECAUSE IT GIVES ME A FEELING OF CERTAINTY ON THE OTHER HAND I FEEL I CAN DISTURB PEOPLE IN CERTAIN SITUATIONS BY JUST DOING NOTHING

I WROTE A HEAP OF SHIT JUST TO FIND A SITUATION

WHENEVER I AM ALONE I STILL DON'T ACT AS IF I AM ALONE THERE IS ALWAYS SOMETHING GOING WITH ME IT MUST BE THAT INVISIBLE SHIELD OF FEAR I AM CARRYING WITH ME IT MUST BE VISIBLE THROUGH THAT MASK OF CERTAINTY PERHAPS IT IS THEREFOR THEY ARE AFRAID OF ME JUST BECAUSE OF MY VISIBLE SHIELD OF FEAR

SUGGEST I LEAVE MY SHIELD OFF AND PEOPLE GO ON HAVING THAT FEAR IMPRESSION ABOUT ME EITHER THEY THINK THEY HAVE GONE MAD OR THEY THINK I AM NONE OF THIS IS TRUE I NEVER FEARED MY SHIELD IT IS ONLY MY SECOND PROTECTION BUT THIS ONE IS TO PROTECT ME AGAINST MYSELF BUT LATELY I THINK IT IS NO PROTECTION I HAVE TO GET RID OF IT BECAUSE IT KEEPS ME FROM THE REST OF MYSELF AND THE OTHER 9/10 OF BRAINS IN MY HEAD I WISH IT WASN'T THE WINE THAT HELPED ME WRITE THIS OR OTHER KNOWN FEELINGS LIKE: . . . OR . . . OR . . . OR . . . OR . . . FILL THEM IN YOURSELF YOU KNOW THEM TOO +

DISTURBANCE OF THE PEACE

The disturbance of the peace results from the giving of a new sense, in contrast to what occurs most often, to traditional meanings of social actions.

It is a creation of disorder, disorder as explained as the coexistence of competing meanings.

Disorder is opposed to chaos where meaning is absent and where one cannot discriminate between competing meanings.

The disorder caused is creative in so far as it has developed new definitions for opposing perceptions.

The freedom of the individual to see things in a manner different from that which is presented to him by the order, or the ''new order'' is manifested in the free transgression of schematised patterns of behaviour and rules.

Such non-normal behaviour of the participants means, in a specific context, an expression of ideas.

Change is seen as disturbance of the peace.

All forms of substantial, spontaneous criticism are considered as breaches of the peace.

Not conforming gives a solution to the problem of opposing values by refusing a final solution.

Text by Today's Place
Keizerstr. 50, 2000 Antwerpen, Belgie.

PAGES BORN OF PROFIT

I HAVE A PET CALLED PROFIT + HER FAVOURITE FOODS ARE THE THRILLS AND SPILLS OF EXCHANGE AND BARTER + I'VE EXCHANGED MY BEST BLUE JACKET FOR A MATCH-BOX CONTAINING A LOCK OF A GIRL'S HAIR TOGETHER WITH TWO RINGS SHE WAS GIVEN WHEN SHE WAS TEN, AND PROFIT GOT FAT + EVEN WHEN I EXCHANGED SOME FAVOURITE THINGS FOR THE FALSE PROMISE OF BEING SHOWN A WAY TO TELEPHONE FREE INTERNATIONALLY FROM COIN-BOXES, MY PROFIT DID WELL AS BOTH TRIUMPHS AND LET-DOWNS ARE ALL GRIST TO HER MILL +

PROFIT SAYS I'M A SAINT + PROFIT WOULD SAY I WAS A SHIT IF I WAS NO GOOD AT DEVISING WAYS TO CREATE THE SPIRIT OF EXCHANGE IN MYSELF AND OTHERS + HOWEVER I KNOW I'M GOOD AT THIS — SO PROFIT SAYS I'M A SAINT +

PROFIT'S WAITING TO DECIDE IF YOU'RE A SHIT OR A SAINT + HE'S WAITING TO SEE HOW WELL YOU PERFORM — HOW WELL YOU CAN GET OTHERS TO PERFORM AN EXCHANGE + START NOW + MAYBE PROFIT WILL RATE YOU MORE THAN ME, BUT ONLY SO FAR AS YOU CAN BRING IN THE READY CASH OR CHANGE +

I LIVE RENT, FOOD AND CLOTHING FREE + I HAVE TO AS I DON'T HAVE A CENT — LARGE AS MY PROFIT MAY BE + BUT I DON'T CARE AS MY PROFIT SAYS I'M NO SHIT + SOON I'M OFF TO MAKE SOME MORE EXCHANGES + I'M OFF TO SHOW HOW FAT ONES PROFIT CAN BE AND STILL REMAIN UNOBTRUSIVE + MY PROFIT, FEEDING OFF HUMAN BEHAVIOUR AND REACTION, BLESSES MY DEALINGS WITH SAINTLINESS, WHEN THEY USE THESE TOOLS + PROFIT'S REALISTIC + THE ONLY IMMORTAL IS PROFIT + PROFIT NEVER DIES AS SHE'S EVERYONE'S PET AND NO-ONE'S IN PARTICULAR + WHEN I STOP, PROFIT TRANSFERS HER AFFECTIONS TO SOMEONE ELSE — CALLS SOMEONE ELSE A SAINT + EVER SINCE I'VE KNOWN PROFIT'S CARROT AND STICK SHE'S TEASED ME WITH HER SAINTLINESS +

PROFIT'S NOT CONCERNED WITH ART, MUSIC OR POLITICS + PROFIT'S CONCERNED ONLY WITH PROFIT GETTING FAT, AND PRETENDS TO NOTHING ELSE + IF IT CAN USE ME IT WILL AND I KNOW I CAN TRUST IT, FOR PROFIT BOTH KNOWS AND IS WHAT'S GOING DOWN + PROFIT'S IMPARTIAL AND THE SOLE SURVIVOR +

N. KRID
APRIL 1978

119

TODAY'S SOCIETY

In our society the Guardian-philosopher-politicians rule.
In Today's society the defective, the inexperienced and the children will not be noticed.

The Law

Our law is based on the idea of wisdom aligned with knowledge and courage, that a few rulers possess for the supposed benefit of others. Knowledge does not exist in Today's state. Today one acquires nothing and one loses nothing. Although dissimilarity rules, individuality does not exist. Individuality is based on similarity. The greatest power in Today's state is to be unidentifiable. But then in this state people don't identify, or use graduation systems. The truest members of the society never want anything. They don't belong to a "state". Each is his own spiral.

Housing

As people will not necessarily be people, Today's beings will shelter behind protective shades of all varieties. The complexity of shades will not point up differences in 'capabilities' between the beings. Some may live in yeast bubbles, others underneath rocks. Some will climb tall trees; go to sleep; fall off and break their noses and it will not deter them.

On Communication

Imagine the systematic break-down of the usage of reading and writing. This will be necessary to develop the nature of Today's speech-action. There will be no single letters or words. Like Chinese, the speech-action will show a meaning rather than a letter, word or phrase. Unlike the Chinese system, these meanings will not be static, as the idea and appreciation of learning will be greatly reduced. Inexperience will be considered socially important. Meanings will have a secondary supportive role to that of the inexperiencing effect of plastic experience, which will be the main basis of communication. There will be greatly differing languages for differing age groups, due to their necessarily changing basis for reflecting the inexperiencing mental processes at work.

What books there are, will not concern themselves with subjects. There will be no encyclopaedias, novels, science, art or sex books, because people will not think in lines. All books will contain all information. There will be no names on books or records. Records will break down into re-assemblable fragments, as with all information in Today's society. Usually the pieces will be re-assembled randomly, and become mixed-up with pieces from other media records. This arbitrary approach will not destroy or change the media-products, as they themselves will be structured just as randomly.

Mathematics

In Today's society mathematics will originate with the perception of movement, rather than on the basis of digital visual identification. Mathematics will no longer work on a basis of identification through isolation. It will be entered into on a basis of physical education. I see the jump/grunt forward as the "addition." The splayed pushing legs as the "division". If one made an "addition" jump/grunt forward, and then in the usual method, tried another grunt/jump forward, the body would have to re-position itself in a different manner from the first positioning for the first jump, due to the physical result on the body of the first jump. The jump/grunt itself would also be necessarily slightly different. These differences would become more and more exaggerated as the series of grunt/jump additions were made, due to the physical effort involved. Thus if each jump/grunt is different, and each re-positioning is different in its physical structure, it means that the physical structure of the "addition" will be fluid due to the graduating collective experience of each "additional" jump. Thus one grunt/jump never equals another jump/grunt. An identification basis for mathematics will not exist in Today's society, as people will not be capable of using a series of digital compilations to accumulate information. They will not be interested in "information". Theirs will be a mathematics of the interaction of states of being. "One" will be the sense of visual movement that supporting legs give a table. "Two" will be the way things lie on their sides. "Three" will be the flatness of the ground. "Four" will be the hope in your throat. "Five" will be a creased tightness. "Six" will be the slope of an attachment. "Seven" will be an animated in-animate. Today's maths is based on, "Movement as a somersault." which will be the chemical flux between our celebral and physical selves.

Unspeakables/Fame is the ———disgrace.

In every society there are Unspeakables. In Today's society the unspeakables are not the mentally defective or the socially incapable, but the behavioural-literates. Those that "know" and "understand". In our society the socially incapable are paternally 'cared' for. A system that effectively cuts them off from being allowed to have any influence on the rest of society. A form of social censorship. In Today's society the behavioural-literates are those who are capable of coping with both a behavioural and literate basis of living. They acquire split personalities and develop a capability for behavioural disorder. As in any society, whose controls rely on behavioural regulation, or conversely, irregularity, these people will be effectively socially castrated through being over-revered for their deviance. Their situation will be exploited as fully as possible by Today's society. It will investigate, and thus identify them; tightening the social noose around them with a contradiction of terms.

Situation Ltd.

Solution will exist on the basis of eternal equivocation. There will be no need for doctors who will "solve" problems as health will exist on the borderline between being alive and dead. There will be no employers or employees. People will not be loyal or disloyal as a result of what happened yesterday. There will be no lasting "relationships" as Today everyone will only exist in passing, and there will be no "words" as no-one will believe. Nothing will be denied or accepted as a basis of existence.

Is your dead Grandmother a dead person, or really a rock? Do humans ever die like rocks? If tables are made to cover our feet, in Today's society, they will be made to cover our hands.

"We limit our systems to try and grant ourselves immortality. But if we are neither dead nor alive or neither cats, logs nor humans, what need is there for immortality?

Our feet are neither ground nor ours. Maybe they are pedestals to our mortality. If so, why should *they* ever die and rot? Both employees and employers are locked; polarised on one pedestal: Belief reinforced by Memory and Faith. If both are poles, North and South, each must be uncompromising to retain his concept of existence, which is essential to the maintenance of Identity, Understanding, Knowledge, Truth and Fiction. Who lives on the Equator? The unemployed and unemployable? If so, they live where the fruits are richer, the sun is warmer and where "The Jungle Is Impartial." But they're so used to partiality that most will die, save those that let their identities blow freely in the wind. Nothing's like tomorrow, and some things are Today. Polarities pro-create the state of conflict. Using reason to justify this conflict, man has to use Truths which utilize conceptual Doublethought as their invisible pawn. Only if mankind believes in the existence of Thought as an ontology, is conflict essentially the state of his existence.

If man is to be acquired by the jungle of Being he will have to neutralize Conflict or cease. If he is only a small part of existence, then it is time he re-discovered his capabilities as a non-functioning material. Maybe his Behaviour, or perhaps his Feet, will non-function his functions and let them meet."

<div align="right">(John)</div>

Sexdeath

Since all books will contain all information sex-books won't exist. This will reflect neither repression nor liberalisation. Peoples' awareness of their celebral and physical natures will be extended to the point where any photo or paper types/textures will be capable of fulfilling sexual needs. In Today's society sexual development will be so extended that male/female sex will seem bizarrely primitive.

"There are no schools as the idea of learning is counter-productive to the flux-base of inter-object communication. (Bear in mind that dogs are trees and cats are people or trees, and sometimes both.) People are born and die, and death is not prolonged. It is obscured by the Present consciousness of the society. Bodies stay where they drop and are part of that Present. Death is not hidden. The cat snuggles up to the old lady's dead body. She is a tree. A log. A curious smell. In her youth she was sexually attracted to railings. She was as attracted to them as to people. Trees, flowers, carpets, chairs, all used to affect her in different ways. She would look, but not see, touch, but not feel, caress, (but not care for), many different types of beings sexuality, and then grow an orgasm in the limbo of her mind. She was part of the generation that found the break between specific-concept sex and "nothing sexed nothing sex". (John)

Movement

Peoples' movements will no longer have any
bearing on where they go, or how far they
travel. They will fling their arms, feet and necks
in unconcerned parodies of de-lineated
movement.

Clothes

Buttons and button-holes will not exist. After
all they exist on an illusory basis of one to one.
Other basis of fastening and attachment will
be used. Material will exist that automatically
attaches on contact to all material. There will
be no different styles and no concept of
different articles of clothing. There will be no
concept of colour. There will be only varying
shades of one colour. Red, blue and yellow will
be seen as one colour. The process of develop
ment toward this viewpoint will come when
people start to declare, "There is no colour
Yellow. Yellow is Green." There will be no
clothes shops. Clothing will be entirely an
individual responsibility. People will stand
behind curtains and declare that they are
clothed. They will stand on floors and the soles
of their feet will be clothed. They will sink into
their no-shape seats and feel clothed. Situations
will be considered to be clothes as much as
clothes will be clothes. Clothes will be situations
not necessarily related to people.

The Universe

Because each man will see himself as a spiral, the illusory proximity of all material beings will be equal. Since there will be no conceptual basis for space, the heavens will be sensed as being as near as the horizon. Stars and planets will not be identified as objects. Fingers held up to the sky will be viewed to possess as much star-quality as the stars themselves. If stars are seen as 'Perfections', so will cuts and grazes on bodies be seen as such.

Feet

Feet will be within one of the most involved areas of concern in Today's society. They will be subject to the same amount of comparative thought as space-research is in our society. If you are a spiral, if your basis of thought exists as a spiral, all material beings will be neither near nor far, due to the equidistant uniformity of the lines of a spiral. If your spiral does not extend to cover areas of material involvement, they simply won't exist. Someone who sees themselves as a conceptual point will position themselves spatially to other points. A being whose consciousness *is* the shape of a spiral, is never conceptually at any point. Now a spiral is in itself conceptual, but it will be developed to become less so thus:

Music

There will be no music as such. Music will be the process of listening at noise, rather than to it. Density of noise will be found attractive.

Health

In present terms Today's society will be supremely unhealthy. Food will be seen in incidental, rather than objective terms. The behavioural circumstances around the physical act of eating will be so indivisible from the act itself in most people's minds, that they will never know whether they are eating or behaving. Food will taste of nothing in particular as nothing in particular will be regarded as more desirable than something specific. It will be shapeless and colourless, and will need no preparing. It will be available scattered all over the land. People will hang around these lands, not for the food, but for the situation. Today's people will regard chemicals as important as food. They will have no regard as to what the chemicals and the food do to their bodies, as they will not think of themselves as being alive or dead. Most people will be covered with sores, cuts and bruises due to their life-styles, but this will not matter to them.

Today, the only reason for a day to end, will be death, exhaustion or forgetfulness. Days will last from one hour to four days or longer. Days and nights will not exist. Dark and light will be found in caves and sunshine, just as in night and day. Nights will be coaxed into the light, and days into the dark. Darkness will be encouraged by the young, and the old will greet the light with suicidal blessings. The young will drag materials around to fill up the light, and old men will clear the space for night. Today's fear-god No will be appeased by accidental death.

On People

Women and men will be children and children will be women and men. Children will be more powerful than women and men. If anyone rules, children will rule, but as they become women and men they will forget their power and try to somersault back on themselves. Some will survive and go on to become women and men. The others will lie where they die, and will be like the earth and the logs. The result of their pubic efforts will be reflected in their smell.

It must be remembered that Today's people will live in Today, not tomorrow or yesterday or the day before. Only Today will exist, and it will only exist Now. Economy has a basis of future and past, which both being abstractions are not on the same basis as Now. Today's people eat Today, fuck Today, give birth Today and die Today. Today's people are not either physically or mentally like those of yesterday. Today's people need not be people.

People can live in great fear. A hunting hope on their tongues causes a babble of excitement in their mouths, but it never reaches anywhere as there is nowhere. Today's beings have no fear of fear. They are all Hunter. They are all afraid and they stamp their feet as what they fear is Belief (unstoppable). They jump from great heights and fly to their deaths if Today can't get them first. They fear yesterday. The little children are the truest of Today. As yet they can have no yesterday, but when their growth comes, then they too might just jump from those tall trees.

Today's beings will see "being" as the prime, rather than "existence" as the prime.

On Possession

Through changing the mores of evaluation, Today's society will allow everyone to possess the most valuable commodity. Power. The fewer material encumbrances the average being possesses, the more power he will gain. Because of the aversion to individual recognition, each person will do his best to rid himself of, or never acquire material possessions. These goods will only point up that he is *there.* Once he becomes a target for recognition, others will find it necessary to relate to him, which will be precisely what they and he wish to avoid most. Recognition *defines* an existence. Through recognition as an individual the main source of his power is lost. His one possession gone. Through power being encouraged as the prime-life possession, Today's society will be able to develop a much faster flux-base. People will be able to live in conurbations of increasing density with less conceptual and emotional friction. Today, people will never recognise other people. Recognition creates history, and history necessitates reflection which stimulates reaction. Dense populations can't afford reaction.

Societies which cannot afford to give people real personal power, lay a heavy moral stress on the development of the individual, which in effect circumscribes his obtaining any real power. These societies encourage the development of myths which show the lack of a collective conceptual appreciation in a wholly negative light. In Today's world there will be no *possession* of sur-names, and most people will be called John. By 'Power' Today's society means fluxibility as a base for positioning, so that all possible human resources are available at all times to all beings.

Women and men

Cats will exist, and so will people and dogs. "Women" and "Men" will not exist. Men will be women and women will be men. There will be no number of identifiable sexes. There will be no one to count them. Dogs will be women and men and cats will be children just as children will be old hens.

what a nasty way to go. Someone poured water over her electric typewriter. Well this is a mystery. Who's behind it all? Who's the murderer? Now the bloke I suspected is in Salt Lake City, it can't be him. Do you know, I've been wrong on every page so far. Every time I suspect someone, they get killed. I can't wait to get to the end of this . . . it's going to be a complicated ending, this one.

Sid Yeah, well hurry up and finish it, it's getting late. Have a look at the last page.

Tony You can't do that. It makes the whole thing pointless, you might as well not read it. It's like looking at the next card when you're playing snap. Please do be quiet, I've read the same sentence three times. Hallo, he's found something. It's all right, Johnny knows who did it. He's found a ginger hair on her skirt. He's solved it! He's narrowed his eyes and a little smile has flickered across his face. He always does that when he knows something.

Sid Well come on then, who done it?

Tony It'll be on the last page. He always keeps you in suspense till the last page this bloke. *(Reads on, getting more excited)* Yes I thought so, he's invited everybody into his flat. He always does that. He lashes them up

with drinks, lights a cigarette and explains who did it. Then the murderer rushes to the window, slips and falls, hits the pavement, and Johnny Oxford turns round to the guests, finishes his Manhattan and says, 'New York is now a cleaner place to live in'. The End. Turn over, a list of new books and an advert for skinny blokes.

Sid If you always know what's going to happen, why bother to read it?

Tony Because I don't know who it is who's going to hit the pavement. Now please keep quiet, Johnny's just started his summing up, prior to unmasking the murderer. *(He concentrates on the book, making odd noises as he notes the points being made)* Oh so she was in on it, the one I told you about. She said she'd never been to the Mocambo Club, but she had a book of matches in her handbag. Oh so that's what put him on to it. That's clever you know, very clever . . . Of course, the trail of footprints in the snow. All made with a size 10 left-footed shoe. So it had to be someone who could walk comfortably in two left shoes. That told him it was a small man who had put a big man's shoes on to lay the suspicion on somebody else. But he didn't realise that in his hurry he'd put two left shoes on. Well I never thought of that. I've been waiting for two one-legged twins to turn up.

Sid Come on, come on, so who done it then?

Tony He's coming to it, it's on the last page, I told you that. Here we are . . . *(Reads)* So, Inspector, you can see that the only person who could have done all these murders is the man sitting over there. So saying, Johnny Oxford pointed his finger at . . . *(He turns the page over to look at the last page. It isn't there)* Men are you skinny, do you have sand kicked in your face, if so . . . wait a minute, that's not right. *(Feverishly examines the pages)* There's a page missing. The last page is missing! *(He looks on the floor, then on the chair where he has been sitting)* Where's the last page? *(To Sid)* What have you done with the last page?

CLIVE ROBERTSON

Performance: An Artist's Dozen, 1970-78

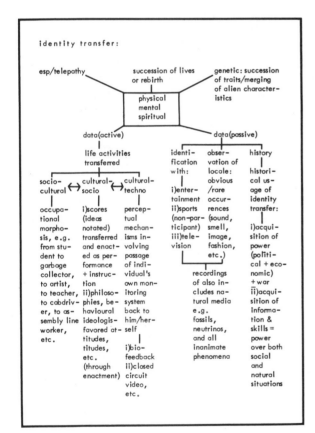

The following descriptions of eleven performances have been chosen from a possible thirty major performances presented between 1970-8. Within those thirty there are perhaps at least thirty more that included various event-musics, performances done within the project "A Year Of..f", and other performances done solely as videoworks. In looking through my own performance output I have been able to break down certain categories of performance which I list here to give some indication of the topological variety within which Performance can exist:

1. Role-Criticism. 2. Identity Transfer. 3. Sensory Action. 4. Social Action. 5. Installed Performance. 6. Phenomenaction. 7. Lifeart. 8. Event Musics. 9. Acoustic Events. 10 Tele-Performance.

Because Performance suggests a wide range of creative activity (including social, political, historical and aesthetic creativity) it has always had the possibility of not being bound by an art-frame. However, the art-frame as we know it, has invariably been the structure which has given the phenomenon attention—even though that attention has often been careless and non-analytical: both awed and suspicious.

Whenever artists allow themselves to be collected under generic names such as 'Performance' or 'Video', which are in themselves initially harmless descriptions of

formats rather than descriptors of movements or mannerisms (see: 'Autobiographical', 'Contextual', 'Language', etc.), they are submitted or submit themselves to a fresh brand-name for an only-slightly-altered product.

Performance work has often been measured, both within and without the active milieu, in terms of 'rage-quotient'. Rage in this instance is not to be seen as violent anger (Pyrotechnics, Destructivist) but to mean 'extreme eagerness and emotion', or 'to spread uncontrolled as an epidemic'. As I began the following works, the Performance geneology was unknown to me (Futurist, Dada, Happenings and Events, Fluxus). By 1972 when the younger artists began to discover the work of the sixties Fluxus artists we sporadically called our work 'Flux-like', even though it was hardly related. (The Fluxus artists generated rage even though their performance 'style' was often referred to as being flat.) Seemingly though many Flux-Laws were broken (ironically there were none to break) this work has at various times benefited from the previous works of Dick Higgins, Robert Filliou, La Monte Young and Joseph Beuys.

Between 1964-9 in England I produced visual analogues (as Sculpture) of a variety of visual perceptual phenomena. In 1970 I worked on my first events and performances and in 1971 moved to Canada and continued that work in Calgary, Alberta. From 1971-8 that is where the majority of the following performances were presented with brief excursions to England, Belgium and Holland in 1973 and from 1973 on at various other locations in Canada. Until 1975 it was researched and produced without any state or commercial funding. In fact any income derived from the work between 1970-5 amounted to less than $1500. I mention this economic history because my involvement existed outside of an 'economic determinism' and therefore outside of the possibility for serving any ornamental role. Performance ART had of course been appropriated for ornamentation (in Canada see Nova Scotia College of Art and Design). What happened to the benevolent attitude towards Performance in Canada post-1974, as elsewhere, I think is quite evident. In 1978 I finally decided to cease presenting my work in galleries though it still can appear in artist-spaces where the predominant concern is one of production and not display.

In 1972 I co-originated with Paul Woodrow an investigatory group: W.O.R.K.S. (We. Ourselves. Roughly. Know. Something.). The group was formed to allow the public and private performance of our own works and the works of other artists through self-organised Festivals, Exhibitions, TV programming and Concerts. W.O.R.K.S. through their artist-publications provided as part of the loose *International Artists Co-operation* a viable alternative to the prolonged awakening of 'official' galleries and art magazines. Working independantly from, but with common interests to, *Image Bank*, Vancouver and *Art Official*, Toronto (*General Idea*) we provided a functioning two-way communication between Canada and Europe, Canada and the U.S. (outside of N.Y.) specifically for the encouragement and dispersal of performance research. Though extremely short-lived (the group unofficially disbanded in 1975) W.O.R.K.S. left behind the first international performance exhibition made for television (*A Conceptographic Reading of Our World Thermometer*), one major festival, lectures on acoustic-electronics in Montreal, 1973; the death of conceptualist art in Saskatoon, 1973; the philosophy of Irrelevance, Nottingham, England, 1973; Identity Transfer, Amsterdam, 1973, and various other concerts, TV broadcasts, an audio cassette magazine and numerous other artist-publications and ephemeral editions.

Some of the following works have been published—in some cases with lengthy discussion. Expandable references follow each description.

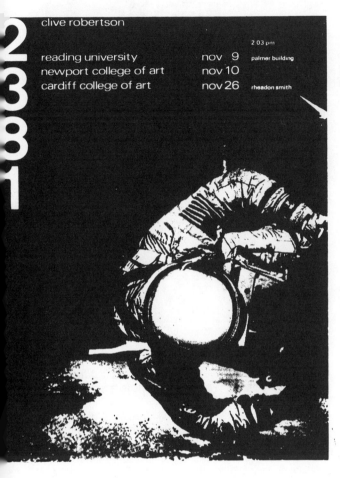

Graham Challifour

12,13,8,11 1970-1

Performed at University of Reading, Cardiff College of Art, Newport College of Art, and Portsmouth College of Art. (U.K.) (An installed performance.)

The title comes from the project numbers of Apollo Space missions in the order in which they were presented within the performance. 12 and 13 were, for example, simultaneously launched. This Space event consisted of 16mm internal footage from NASA lunar training publications, Super 8 films, some 200 slides, multiple soundtracks, transcribed astronaut language and digital clocks. The work was delivered as an exercise in manually-operated automatism where in each location other artists and students would assist the synchronisation of all the components to form some simulation of Mission Control, Houston.

1. *WORKScoreport*, Beau Geste Press (UK), 1975 pp 2-3.
2. An edited version of 12,13,8,11 was also performed during a lecture titled 'Synaesthetics', University of Calgary, 1972.

AIR-TO-EARTH 1971

Compton Abbes, Dorset, England.
(Sensory Action)

This performance consisted of a parachute jump which originated after a discussion with other parachutists about the phenomenon of apparent increased visual acuity experienced whilst free-falling. As preparation for free-falling it was necessary to take a course and make thirty-six attached jumps. The action was therefore a pre-project so that I could qualify for body monitoring (speech, heart) whilst falling, with plans to, in addition, film as I fell. With all these plans in mind I was totally unprepared for the experience of making a first parachute jump and slipped whilst I was exiting which left me hanging from the wing-strut of the airplane before finally letting go.

1. The larger project was submitted to the 2nd John Player Biennale for idea Art (1971).
2. *WORKScoreport*, 1975. pp. 46-7.
3. Postcard Edition, WORKS, 1973.

129

![Conversation](label image)

CONVERSATION PIECE, 1971

Corrugated Products Ltd., Bracknell, England.
(Social Action)

A 12-hour anonymous performance with post-explanation. It was carried out in a factory while I spent the last night of four months working the nightshift at the end of an 80 foot machine which fabricated and printed corrugated wrappers.

Corrugated Products Ltd., was a non-union factory with bad paper-particulate pollution, dangerous, unguarded machinery which had maimed many and killed several. The night-shift (which always pays more) seemed innocuous—the labor was not as intensive as e.g. mining or steel works—but the life-patterns of myself and the other workers were obviously conditioned by the available time off, that being 8.00 am—8.00 pm. Many of the workforce had been on the nightshift, six days a week for between ten to twenty years. Their daytime non-work schedule was divided almost equally. Half would leave work, eat, and go to sleep until six in the evening, eat, and return to work. The other half would remain awake most of the day—some to look after children (especially in cases where their wives worked day-shifts). These men were getting perhaps two to three hours sleep in twenty-four.

On the night of the 17th., I went to work with a programme of prepared actions that I hoped would generate some conversation and hence discussion (I had of course many conversations during those four months but all from my skills related to the job and not exterior to it). I went to work with my hand bandaged. I printed labels which I stuck on many machines, washroom walls, etc. The label read 'Conversation Piece'. During the lunch-break I attach-ed colored balloons to the machines and chanted for long periods during the night with the loud and incessant drones of the numerous electric motors.

There were ten levels of the working hierarchy of manual labor—my job, stripping card being ninth from the top, or one from the bottom. Though I had worked previously in many factories—also occasionally on the night-shift, a combination of factors with this specific job encouraged a development of self-politicisation.

My actions went unnoticed. The next day I attached a printed sheet/report informing all the workers what I had done and how I considered it related to the specifics of life and labor. It crudely explained that all the working hierarchy in the factory were laborers whose job included not merely the supervision but the very necessary exploitation through friendship of one group against another—so improving (by means of unrewarded competition) the production output. Attached to this sheet was a silk-screen mock-up of a light-bulb wrapper.[1]

The fact that my action was the last word for me on that factory I have often felt as being politically irresponsible. However, as an action of rejection, its worth for me was greater than just having left without a statement. My main interest was to formalise a demonstration of my own repression so that I could better understand an occupational reversal of helplessness.

1. The printed wrapper was a direct imitation of one of Corrugated Products' wrappers. Any correspondence that concerned work from the management to the labor force would be illustrated by a sampler wrapper thereby directing attention.
2. *WORKScoreport*, 1975, p. 38.
3. Postcard Edition, W.O.R.K.S., 1973.

Rick Holyoke

The Bat Becomes a Real Flyer, 1972.

60 min.

Performed during 1st. World Festival of W.O.R.K.S., Calgary, 1972, and Inglewood Community Festival, 1972. (Installed Performance)

The fourth in a series of performances that used taped partials (harmonics) around a chosen fundamental frequency (in this case 196Hz), accompanied by instruments (custom-made gongs and large bells) together with voices, clavinet and cello. The taped harmonics were produced from a signal generator with a frequency counter readout so that exact harmonics existing very close together could be used.[1]

The installation was an expansion of an earlier solo performance[2] where the performer made some visual connection between occupied space (along the plane of the floor) and the mathematical constructs of the piece (harmonic generation, time measurement, etc.). The use of toy instruments with variable inaccurate pitch plus the use of wooden balls which were thrown into the centre of the circle to determine, as in a game, certain procedures, removed an essentially classical nature that earlier versions of the work embodied.

The four performers at one point worked in pairs changing the diameters of each of four circles that were outlined with dowel pegs. The pre-recorded tape and the signal generator ensured a basic drone all the way through the piece so that the performers enriched or enlarged the composite changing chord.

The title refers to references made in the work to harmonic envelopes produced by various species of bats.

1. see La Monte Young's *The Tortoise, His Dreams and Journeys, 1964—*.
2. *Partial Composition* 2, January, 1972.
3. *Art and Artists*, November, 1974, p.31.
4. *Arts Canada*, Autumn, 1972, p.94.
5. *WORKScoreport*, 1975, Beau Geste Press, pp30-31.

A YEAR OF..F, 1972-3

A 365-day project which made provision for some 30 private performances and some 26 public performances. (Identity Transfer)

In 1972 I was determined to experience, if not measure, the potential for a lifeart—given the type of working that I was interested in—thereby avoiding the separation between both art and life. It is easy to misrepresent this intention as it sounds familiar in the context of 'alternate lifestyles' to which its specificity owes nothing. The project and its assumptions were both fatalistic with a built-in component of aleatorism. It was in some ways a means of working to avoid the climax-ridden mannerisms of 'superior projects'. The control mechanism in the form of a calendar decided in advance not what could be done but how it could be referred to at a later date. The calendar was syncultural in that it included many different cultural rites, calendars and festivities together with historical methods of how to divide the year and what purposes those divisions held. For A Year Of..f the calendar divided 365 days into the following regular pattern:

Research every five days; *Composition* every six days; *Construction* every seven days; *Private Performance* every twelve days; *Contact* every thirteen days; *Public Performance* every fourteen days; *Travel* every nineteen days; *Festivity* every thirty-three days and *Exhibition* every fifty-two days.

Sometimes the calendar inspired the day's activity, sometimes what happened during each day was analysed, noted and documented as falling within the instructions. Initially, twenty-six copies of the calendar were mailed to artists living in other countries so that they could follow our (the project was also participated in by Susan Clancy) programme and exchange projects and documents on each one of the contact days. In early 1973 a diagram of the conceptual history of Identity Transfer was made as part of a questionnaire. One of the basic assumptions was that Contact-Identity Transfer. A much documented (privately) but little known fact was that there was a period of Performance history which paralleled Correspondence Art with regard to the exchange of and collaboration of performance through the mails. Every thirteen days the 'A Year Of..f' project would publish a xeroxlet (booklet on xerox) that contained those exchanges.

Identity Transfer, as used by W.O.R.K.S. appeared in the work of other artists[1] as specific non-related projects.

There were many working sites for the project[2] and the public performances appeared in concerts and many outside locations.

1. See Maurice Roquet's (Belgium) *Inventory and Identification Contract*.
1. See Fluxshoe Festival (U.K.) 1972-3. Janos Urban (Switzerland) *Parallel Times*.
1. See Alison Knowles (U.S.) "Houses of Dust", *Journal of the Identical Lunch*.
2. See *Fluxshoe Addenda*, Beau Geste Press, 1973.
3. *La Mamelle*, Spring 1976.
4. *WORKScoreport*, 1975, pp. 63-102.
5. *Art & Artists*, November, 1974, p.32.
6. *Family Music*, 60 min., 1973. WORKS audiocassette.

W.O.R.K.S. Plays Cricket, 1975, 1975.

Performed at Clouds and Water Gallery, Calgary, 1975 and
Agnes Etherington Centre, Kingston, 1976.
(Role Criticism)

This project (a performance and an exhibition) emerged
out of joint concerns with Paul Woodrow (who had earlier
done a work titled, "Playing the Field" (1973). The project
underlined role-criticism[1] (which includes criticism of the
social role of the artist by artists). An analogy was made
between the game of cricket and the game of art, as we ex-
perienced it at that time. The context for the performance
was the exhibit, a series of eleven photographs showing
two cricketers 'caught' in certain plays; e.g. Run Out,
Caught from Behind, Leg before Wicket, etc. Underneath
each photograph was an interpretation of strategy that
covered both cricket and art. The field consisted of
representatives of other disciplines—the batsman and
bowler, both being artists. In our analysis the games of the
art world are watched and amended by other disciplines so
adding to the final form (and socio-economic and political in-
terpretation) that allows or disallows each artistic
phenomenon to obtain historical representation.

At this time we were considerate of the interplay between
the art-critic and the artist. This include traditional artist
working concerns and his/her legitimate qualifications of
critical rights. Bowler/Artist (art-critic: creative attack);
Batsman/Artist (Creative Attack and Defence)

Text example:

6. *Inactivity as a means of defence.*
(photo shows a change of bowlers which means that the
bowler has been ineffective in removing the batsman or has

allowed the batsman to score too many runs.)

*The creative batsman's strategy of tiring the attack
consists of being unaffected by all definitions of
delivery. The bowler is inefficient of purpose and will
eventually be replaced. The advantage (to the
game) of replacement is that the batsman seeks
conditions to creative play rather than a quick game
of getting in and out."*

For the performance, which was scripted, each artist in
turn faced the bowler for the 'Delivery of the Ball'. "The
bowler delivers questions, propositions which the batsman
receives. Whilst the delivery is "in the air" the batsman
has time to reject, accept or transform the bowler's presen-
tation." The performance, couched in the language of a
prepared debate, mechanically worked as follows:

Mechanics: *"Between two chairs is strung a loop
of string on which is attached a painted rubber ball[2].
The bowler slowly pulls the suspended ball towards
the batsman (over a distance of 22') giving him time
to question for himself (and the audience) the nature
and meaning of the attack. For each delivery he
makes a response which can include "no ball"
which in this case means that the delivery has to be
re-phased."*

1. See other performances: What About the Art Performance? 1975.
Gallery Isolation, 1973.
2. On the back of the edition of cards[3]: "W.O.R.K.S. continually is able to
produce from within what Tom Wolfe (The Painted Word) has only produced
once from without."
3. *W.O.R.K.S. Plays Cricket,* 1975, Egg Press, Calgary. An edition of
postcards reproducing the exhibit and the first text version of the perfor-
mance.

132

Marcella Bienvenue

The Sculptured Politics of Joseph Beuys, 1975

(Performed at The Parachute Center for Cultural Affairs, Calgary)
(Identity Transfer)

An examination of the actions of Joseph Beuys through re-enactment and re-construction. A 21-hour performance in a small isolated room where the work was carried out in private. For the last twenty minutes an audience was invited to see a re-enactment of Beuys's "How to Explain Pictures to a Dead Hare." (1965)

A Circuit Diagram:

(Description written as a report)

"The room has five walls, 21 hours to be spent in the room; 7 segment areas are travelled through three times (an hour each time) within the 21-hour period. The times to be spent in each segment-area were written into a rough floor plan, e.g. 12-1 am, 7-8 am, 2-3 pm. The length of each 'wall' was then changed, changing five walls into seven. A post was installed (in its original place before renovations) and the seven segments were marked with string, tied at each point at eye level.

The performance then moved through seven segments (A-G), first hour spent in segment A is A(i), 2nd is A(ii), etc. Constructions made are noted with author and date.

A(i) Further measurements using a pap smear stick outlined on floor with *felt*-tip pen. *Construction FEHTSTUHL* (Beuys, 1964).
B(i) A negative (white on black) series of Woodcards, which have no right or wrong way of being placed are laid out; one of three tape loops were played. *Construction: Volume Pedal, a piece of wood and a rock.* (Robertson, 1975)
C(i) A white refrigerator is closed. It is working and has been set to be as cold as possible. A clay wall is built around the refrigerator and this two inch high wall is written on with a pin.
D(i) Exhibition of a wound (one of three exhibitions made by Beuys or as later realisations of life-art done in 1941(?).
A blood-stained piece of cloth is sewn around a fat ball becoming *Construction: Fat-Wound* (Robertson, 1975). *Construction: Filzohlen and Fett* (Beuys, 1963).
E(i) This section contained some elements of 24 HOURS (Beuys, 1965) e.g. Fatrest, small crate covered with white canvas, tape machine with stuttered text, plus my own plastic covered bones which were thrown on a small diagram of arcs drawn on the floor. These arcs were trans-

ferred by physically stretching whilst kneeling on the crate to place objects in similar but magnified positions. Listening to the fat.
F(i) For all three sections this was left as time to rest.
G(i) The rabbit is lying by itself.

(2nd seven hours.)
A(ii) Strips of bacon are attached to a large cymbal with cotton threaded through the rivet holes in the cymbal.
B(ii) Select a tape loop, climbing the step-ladder. At the top of the ladder is a book on metaphysics, if you find anything of significance record it on a sheet of card which is pinned on the ceiling just above your head.
C(ii) Pour oil on the outside of clay wall.
C(ii) Exhibition of a trench (Beuys, 1941). The "trench" is a wooden structure filled with fat, *TRENCH* (Robertson, 1975).
E(II) 24 Hours, cont.
G)ii) Lying next to the rabbit; talking to the rabbit, perhaps discussing with it its role in Fables.

(third seven hours)
A(iii) Gelatin is poured on cymbal which liquifies onto the floor so tracing arcs. *Construction: Fat Cymbal* (Robertson, 1975)
B(iii) Play remaining tape loop.
C(iii) Refrigerator door is opened, contains black bag filled with snow which is now left to melt and be stopped from spreading on the floor by the oiled clay wall. *Construction: Snow-bar* (Robertson, 1975.)
D(iii) Exhibition of Radiation (Beuys, 1941/?). Three pages from a magazine showing genetic destruction by radiation are pinned to the wall and carefully burned. (Robertson, 1975).
E(iii) 24 Hours cont..
G(iii) *Explaining Pictures to a Dead Hare* (Beuys, 1965) An audience has entered., a German text of statement by and about Beuys is played (tape). Slides of Beuys' work is projected in segment E."[1]

1. from *La Mamelle*, Performance Issue, Spring 1976. (contains complete report)
2. "The Constructivism of Clive Robertson as Joseph Beuys" (C.R.) *Queen Street Magazine* May 1977.
3. "Fall Fashion for the Lecturing Personality." *FILE* megazine, Summer 1977.
4. Peggy Gale, "The Robertson/Beuys Admixture"—Parachute printemps, 1979.

Marshall McLuhan Memorial Music, 1975. 60 min.

Performed live on Channel 10 (Calgary Cable TV) and at University of Calgary Theatre.
(Acoustic Event)

Based upon experience with The Western Music Improvisational Company (WMIC), an improvisational ensemble of three persons (myself, Eugene Chadbourne and Paul Woodrow)

MMMM can be described as a seventy minute video symphony. Consisting of seven uninterrupted ten-minute segments the performance and working relationships of the performers to each other is described (by the composer) as an ELECTRONIC CIRCUIT. The performers are the components of the circuit, the work itself having the programmed changeability that any electronic circuit can supply. The reference to McLuhan emerges from the display on six video monitors of 1) Extracts from a film on McLuhan and 2) two tapes containing McLuhan texts being read. All three tapes have been modified to produce intermittent acoustic and visual information/data.''

WMIC would transcribe tapes of their improvisations in the form of word notation. Using the same method a 10 part score was written for ten performers, some of whom were musicians. The score included parts for two narrators, one of which acted as timekeeper informing the performers by light or color cues when each section was finished. The work was written for three percussionists, two saxophonists, two guitarists, three pianists (one prepared, one acoustic, one electric,) voices, two flutes and synthesiser.

The score attempted to prevent the improvisational orchestra from playing together either harmonically or rhythmically, except in the instances provided in the score.

Whilst the work existed twice, its future performance would require that the performers be isolated from each other (by means of multi-track recording) as the temptations for the orchestra to be an influencing unit proved to be too great.

1, In the Singular (catalog) 1975, WORKS, Calgary.

David Hargrave

IN VIDEO TRACTION 1976-7

Performed at Parachute Center, Calgary; Western Front, Vancouver; A Space, Toronto; Vehicule, Montreal. Two versions also exist on videotape.[1]
(Installed Performance)

Consisted of an installation divided into two. One half contained a private ward where a small bandaged TV monitor lay on a bed. The ward was visible through a large glass window. The window was situated in the wall of a narrow corridor through which the audience entered at one end, and exited at the other. The view into the ward showed a doctor seated talking to the monitor. The monitor was playing a tape of the doctor's face. The other half of the installation consisted of a waiting room and reception area where a nurse (Marcella Bienvenue) registered the audience and directed them to pass, one by one, in front of the large glass. To hear the conversation each person was requested to listen through headphones which were hanging on the corridor wall. In Montreal the installation was not quite as described.

The conversation with the doctor and the monitor suggested that the TV monitor had evolved to the stage where it was developing its own mentality and independent memory. The fiction was used to suggest that a television could exist outside of television as we know it, that we were watching a form of life developing under intensive care. We were shown also that the care was academic and that it could also destroy the embryonic development.

In the waiting room a monitor played a pre-recorded tape of the TV drama, ''Emergency''. The audience often was unaware that they were in a real waiting room and would have to wait their turn in order to see and hear the repeated doctor-monitor conversation.

1. Though performed first in Calgary, a video production was made at The Western Front, Vancouver. (*In Video Traction 1*, 1977) A performance document.
2. The second tape was made as a TV Show and was premiered at Alberta College of Art Galleries, Calgary, December 1977.
3. *Television: Adjusting the Hold*, 1977 ACA Galleries (a catalog).
4. *Only Paper Today*, Vol. 4 No. 4, 1977.
5. *Virus International*, Montreal, 1978.

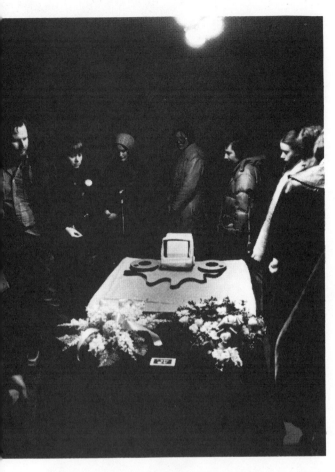

The Death of Television as Entertainment, 1977

Performed at Arton's, Calgary.
(Tele-Performance)

An audience was asked to respectfully encircle a shrine consisting of a blank TV monitor lying in solid state surrounded by a flourish of videotape, plastic flower wreaths and faced by a small plaque which read: "In Videorum" 1930-77". In the corner of the room sat two commentators (Opal Nations and Steve McCaffery) who read a prepared script which required them to discuss the events leading up to the death of television as entertainment. Interspersed with the analysis was their continuous description of the mourners. They described the eulogies that were coming from all countries, how the government was explaining the death of television as we know it and how they were explaining to the population what was going to replace television. The commentators' role was one of being off-camera within a live transmission. The performance was taped.[1]

1. This performance appears in *In Video Traction 2*, 1977.
2. *Parallelogramme 2. Retrospective 1977-8*. p. 180

Explaining Pictures to Dead Air, 1978

Performed at 5th Network Conference, Toronto as part of a Tele-Performance Series
(Tele-Performance)

Written for the Video Conference as part-definition of the artist's role within television. The audience watches a pre-recorded tape on a video screen where the artist is shown sitting behind a desk making telephone calls as he organizes the performance they are attending. (Whilst the conversation is scripted it is based on factual occurences.) A man enters carrying a fragile structure above his head—the man is dressed to look like Joseph Beuys. The man walks into the middle of the room turns the object he's holding upside down and it becomes a primitive newsdesk. "Joseph Beuys" now begins to lip-synch an audio recording of the evening news. His back is to the audience, but they can see his face on two monitors that are fed from two close-circuit cameras.

The pre-recorded videotape, in front of the Beuys-figure, informs the audience that a long-distance phone call is about to be made with Joseph Beuys to ask his views as to what the artist could do about television and television news. The phone call is made. The projected videoimage shows a still of Beuys alongside a still video portrait of the "Beuys" character. Beuys talks from Düsseldorf to the video conference audience via the videotape, via the performance.

Following the phone call the artist explains to the audience that they have just witnessed a docudrama and how the performance itself was an example of how artists misuse performance and television.

As the performance ends a woman's voice states that in the following weeks other sectors of the community will be given air-time to present their political views on television.

1. Interview with Vera Frenkel, *Centerfold* (Tele-Performance issue) Vol. 3 No's 1&2, 1978.
2. See v/tape of same name, 1978.
3. Peggy Gale, "The Robertson/Beuys Admixture", *Parachute printemps* 1979.

Clive Robertson
© 1979

ULRIKE ROSENBACH

Photos by Klaus vom Bruch, Rosenstiel and Edelgard Breitkopf

Circle of Nature, Naturkreis Aktion, 1972

1972 Baulof Ratingen
1972/73 Kunsthalle Düsseldorf, "Between"
 Goetheinstitut London, Sigi Kraus
 "Ten-thousand miles from here"

Ich kniee im Mittelpunkt meines Kreises.
Mein Mantel ist mein Zelt.
Er Ist der Kaefig fur meinen Körper.
Ich habe eine Menge Vögel in meinen
Blumenkaefig aufgenommen.

I am kneeling in the center of my circle.
My coat shall be my tent.
It is a cage for my body.
I am keeping a lot of birds underneath my
flowercage.

Videoconcert — Improvisation, 1973

Konrad Schnitzler: music on synthesizer
Videotape, 30 min, b/w

The videoconcert was the first video-live-performance that I did, and it was a true improvisation. Konrad was having a concert on electronic sound at the Köln-Artfair that year and when I listened to his music I got terrific ideas for visual images with video. So I brought my equipment and we started a concert together with vocal and visual concepts. It was very simple. I just moved the videocamera over my body — face — neck — clothes and feet and combined the bodyshots with a strong light effect from a simple bulb that I moved with my right hand while the left was playing the camera.

Isolation is Transparent, 1973/74

Sound: Konrad Schnitzler
Videotape, 40 min., b/w

112 Greene Street — New York
a Video-show by Willoughby Sharp
Studio Oppenheim, Köln

While I was still making sculptures, in 1971, I often realized that I wanted to break up the material I worked with. I was choosing material like fine milky gauze or thin cotton which was stretched over plastic forms made from thin steel wire. So the sculpture became transparent and sensitive. The inner space was divided from the outer space by a transparent wall.

This dividing wall between inner and outer space later became the milky monitorpane of the videoscreen. The outer space I used for my body's movement, my action. The inner space was shown on the monitor and reflected the camera shots. It was my reflected image as psychological image. The recipient who watches the video-feedback gets to know that the video provides a demarcation between him and me. The monitorpane mitigates my direct impact on him, makes it cool and neutral, so that the view of the psychological reflection that I want to convey to him, becomes more important and primary.

To experience a live video performance the spectator must work from two different sets of impressions. Firstly there is my movement which he sees directly. Secondly and simultaneously he can watch the electronic image of my actions on the monitor. The experiences are there at the same time, combined they produce different reactions.

ISOLATION IS TRANSPARENT — a performance plus videoviews shot with two cameras from two points in the artspace of 112 Greene Street — green light — an underwater piece — a space divided with milky foil wall — you are not to be reached — but transparent — icy — different level different surface — separated from audience — wear a danceskin — koketterie with the female body — erotic — representing a woman's image — do man's work — work with nails and hammer — cut rope usually needed for packing loads — a knife that does not work — move the knife — patience . . . to cut something — free it from its former condition — fix the rope ends to the walls — lead the rope-parts from from the wallpoints to a special point in the space — connect the walls with your body — relationship from room to person — compensation for another person — fasten the ropeends around the person's waist — center of a manege — cut off from the body into two levels — head area, body area . . . to knot — to weave around your waist with rope material — woman's work — former centuries sitting at a loom — to make a skirt around your waist — balletskirt — to please the audience — being woven in like a spider's net — move up and down to fetch more material — move the room — make a connection of movement — to kneel down at the end — silence — feeling relaxed — position of thinking — be on your own — see it from above — gothic rose — Chartres — Middle Ages — center of the earth — mandal form — to get out of the net — become acquainted to another situation — to strip off — transact — change . . .

139

Der innere Widerstand sind meine Füsse, My interior resistance is my feet, 1974

Technical aid: Klaus vor Brauch
Videotape, sound, b/w

1974 Projekt — Köln, Kunstverein Köln, Wulf Herzogenrath

The video camera is fixed to one of my legs. The Videoimage on the monitor shows my body, how it is moving in constant rhythm of me walking up and down on the outline of a 3/4 segment of a circle (radius 200 cm). The circle has the conditions of a sun-lodge mandala (sioux-culture), but at the center-tree there is a complex of video-machines. The videomonitor is fixed at eye-height and is following me constantly from the easterly point of the 3/4 circle to the western point. The result is a constant control of my body-movements — a closed system between me and the media.

The Enchanted Sea, 1975

Technical aid: Jack Moore of Video-heads
Video, 30 min., b/w

1975 Festival of Expanded Media, Belgrade, Yugoslavia

In this performance I am working again on my body with one videocamera plus light. On my navel I placed a five-pointed star made from a transparent plastic-foil. In the "waves" of sweet hawaiian music I moved the light over my body to catch reflections on the star. Together with the movement of my breath the light became an ironic and erotic outlook on the 5 monitor-screens which were placed around me.

Glauben Sie nicht, dass ich eine Amazone bin,
Dont believe, I am a Amazon, 1975

Video: 12 min., b/w, sound

1975 Biennale des Jeunes, Paris
 Galerie U. Krinzinger, Innsbruck, Austria

The image of the madonna keeps up appearances, is inaccessible, beautiful, gentle and shy. It shows the traditional role of the woman. As an image rather absurd, it appears nevertheless in my own existence. While the arrows hit the image — they hit my own ego.

Glauben Sie nicht, dass ich eine Amazone bin. (Don't You Believe I'm an Amazon). In it Ulrike Rosenbach takes the haloed head of the virgin from Stefan Lochner's popular Gothic painting — The Madonna of Rosenhag *— and shoots 15 arrows at it, in the forehead, then the chin, leaving the features intact. Superimposed on the Madonna's face is Rosenbach's own face as she shoots; (they actually resemble each other). So one sees at one glance the sweet, long-suffering image of the virgin and the modern woman fixing the arrow and firing. One feels the shock of each arrow as it strikes target and archer simultaneously. Victim and torturer become one; or, woman as martyr is sacrificed for future power; or, the feminist shoots down the old image of masochistic woman. Choose your own interpretation. In the second half of the tape, the video camera is pointed the other way, and one sees Rosenbach in leotards choosing her arrows and shooting with a tall, elegantly curved bow. While the image here is less interesting than the first, it adds another psychological dimension, in that she shoots directly at the camera. One can almost feel the arrows striking as they stick to the front of the screen in their now unseen target. In fact, the viewer now becomes the victim of the archer's rage or justice, in a memorable combination of Rosenbach's recurrent themes.*

Lucy R. Lippard

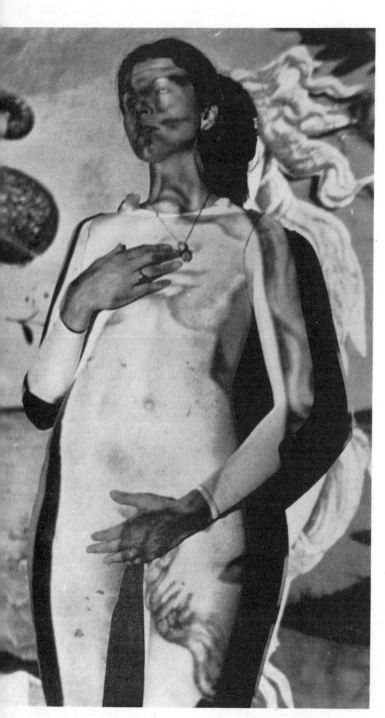

Reflexionen über die Geburt der Venus, Reflections on the birth of Venus, 1976

Videotape, 15 min., color, sound

1976 Women's Building, Los Angeles
 LAICA, Los Angeles
 And/Or, Seattle
 Stiching de Appel, Amsterdam
 Neue Galerie, Sammlung Ludwig Aachen
1977 International Artfair, Bologna (Oppenheim Studio)
 Frauenzentrum Eindhoven, Eindhoven

Born from the foam of the sea — that is the beginning of the classical myth of "The birth of Venus", which was the theme that Sandro Boticcelli used for one of his famous paintings, about 1470. Meanwhile the meaning of the Venus-goddess has changed.
The old mothergoddess with her aspects of fertility and rebirth has been transferred to a modern and profane image. Venus today means to follow the sexual demands of a patriarchal society: masculine sexual dreams. The image of the modern Venus involves the imagination of youth, beauty and wealth — a connection that has been determined by current Christian morals. The idea may be covered by pictures and written material from commercials and elsewhere. In my research I gathered about 150 photoprints which follow the video/live/action as documentation. "Reflections on the birth of Venus" tries to give an answer to the question, if the worn-out image of Venus is worth becoming a subject in the new research for a basis for female culture.

The Botticelli painting is projected in life-size. On the floor, in front of the image, you will find a big triangle of fine white salt that makes a carpet for the scene. On the salt is placed a big styrophor-shell, one of those you could buy at "Sears" to put your plants in. I have fixed a small video-monitor in that shell — like a pearl — and it shows all through the performance one of those big pacific foam-waves. The sound is one of Dylan's songs: "Sad-eyed lady of the low-lands". When the music starts I step into the Venus-image and start turning around very slowly. The slow movements that are repeated over the whole performance make the action. When I am seen from the front, the image of Venus is brightly reflected on the white material of my leotard. When I am turning so the back is seen, the image is absorbed by black colour on the back of the suit. The movement is a constant up and down of the appearance of the image of Venus — like day and night.

Zehntausend Jahre habe ich geschlafen . . ., Tenthousand years I have been sleeping . . .

1976/77

Technical aid: Klaus vom Bruch
Sound: Konrad Schnitzler
Video, 30 min., b/w, sound

material: 300 kg salt
 6 qum moss
 1 bow
videoequipment: 1 portapak, 1 videocamera, 1
 monitor
 sound: amplifier and boxes for taped sound

1976 Neue Galerie Aachen, Sammlung Ludwig,
 one woman show
1977 "Künstlerinnen international", Berlin

dedicated to Z. Budapest

The action space is a big circle of white salt. In the center I have created a smaller circle from fresh green moss. On this I lie for three hours bent into a long Japanese bow. The videocamera is packed together with a portapak recorder on a small cart that is running by battery. The cart fixed on a track runs around the salt-cirle watching me like a little satellite. With this goes a sound of synthetic heartbeats, and together with the watching camera it gives you an impression of voyeurism. ..

Maifrau, 1977

Technical aid: Klaus vom Bruch
Video: 60 min., b/w, sound

1977 Galerie Steiner — Berlin

The spaces are three small gallery-rooms:
1. In the first one you see a projection of an image of a Diana from Ephiseus.
2. In the second space I am sitting on a chair with the video-camera in front of my face and a microphone in my hand to speak the word — *Frau* — while I am breathing. The constant repetitions of the word — *Frau* — are heard through the whole space.
3. In the third room, which is quite dark, I have built a sort of video reservoir. The monitor is placed in it the way you look into water, and the glass shows the double, superimposed image of the Diana's face and mine. The image is moving in the rhythm of my breath and so makes a picture of revival. The three spaces are connected by a spiral painting on the floor.

Sabbat — performance at Villa Romana, Florence, 1500 km from here, 1977

Material:
 150 white candles
 1500 meter red wool
Sound: concert by Jens Ostendorf, Hamburg
With the aid of my daughter Julia

Performed at Florence, Villa Romana, in the garden

The performance started at 10 pm (at night). I had 1500 meters of red wool thread wrapped around my waist, looking rather pregnant with much thread. Then I started stretching the wool around the villa (each turn 100 m), by spinning my body all the time. I became totally dizzy and could not see anymore, but could feel the house-wall guiding me. After finishing, I spun the rest of the wool into the garden, where 150 candles had been stuck into the grass forming a labyrinth, in the center of which was a tree. I lay down in front of the tree making the hand-sign of the Italian women's liberation-movement, while my daughter started to light the candles.

Frauenkultur — Kontaktversuch, womanculture — try to contact, 1977

Videotape, 60 min., b/w, sound

1977 Folkwang Museum Essen & Galerie Heike
 Kurtze, Vienna
1978 Stichting Amazone, Amsterdam

On one of the long walls of the space I have pinned 65 photoprints just above the floor. In front of that row I am lying on the floor with a handy small video-camera before my face. Then I start rolling myself in-to the long coax-cable that connects the camera with the recorder while simultaneously the photos start twirling over the projection wall of a video-beam. The almost endless row of prints show the images of women from all cultures — women in patriarchal societies. Only the first image of that long row shows a woman from a primary culture, on a hunt, with the tools that show her might and her autonomy. Just in front of this image I am totally freed from the chain that the cable makes. At the other end of the row, where you see the modern woman who understands herself as a jewelery of a patriarchal society and behaves that way too. I am totally chained into the videocable. The sound is the endless tam-tam of drums.

Venusdepression, 1977

Live action, performance for five women 1977, Pallazzo Strozzi, Firence, Italy, in the context of a German Art exposition, *"Die Materialien der Sprache"*

description: the floor was covered with a large circle of white salt which was divided by the drawing of a pentagram.
sound: a woman's voice reads a story about a woman's hunt which was taken from the book "Decameron" by Boccaccio. Voice came from a tape and loudspeakers.
language: Italian.

images: five shields, reproductions of the Meduse-painting by Caravagio
 a series of three paintings about the woman-hunt story by Boccaccio painted by Botticelli.
 5 reproductions (prints) of Venus-images painted by Caravagio, Tintoretto, Tiziano, Allori and Goya.
The original paintings of all the prints are to be seen at the Uffizi-gallery in Florence.

We were celebrating the rite as a performance in 5 stations (parts). I was cowering in the center of the circle which was also the center of the pentagram. I covered my head with the shield of Medusa. The voice is telling the story. The length of the performance is limited by the time which the story takes (40 minutes).
After 9 minutes I change my position. I get up and burn one of the Venus images in one of five bowls which are filled with fire. One of the other women walks up, and takes one Medusa shield from the back wall. She fixes the shield to her arm while I go back to the center and kneel down, keeping the Medusa shield in front of me. The woman walks to her position at one point of the star. In this rhythm I assume five stages of body-signs while the other four women step by and take positions at the points of the pentagram. The five positions are:

1. cowering
2. kneeling
3. standing with the Medusa shield covering my belly
4. standing with the Medusa shield held behind my head like a crescent
5. standing, holding up the Medusa shield with its moon-like backside and making a fist.

The last position is followed by all the women.
End.

In this action, which was documented on video, I tried to work on a culture context that I had come across when I spent some summer-weeks at "Agerman Arts Building" in Florence last summer ('77). Walking through the state museum, the "Uffizi-galleries" I looked at Venus-paintings and at the outstanding shield-paintings with the image of the Medusa by Carravacio. The Medusa became a strong image of protection to me, quite different than it was meant by

the patriarchal mythology. Also it seemed a mother-earth-image as well and I became fascinated by the idea of using this shield.
The Venus-images are very common in Florence. They are to be seen as paintings and outdoor sculptures all over the city. Especially the Medici-Venus seemed to have that expression which I hated so much on all these images: an expression of weakness and lack of spirit. The only Venus that is different is the Botticelli-Venus which tells of the original power of this goddess-aspect. Together with the knowledge of the witch-burnings on the Plaza di Signoria, I could work out my thoughts of hatred by burning the prints in bowls.
I knew the series of three paintings by Botticelli before and always wanted to include them in one of my works. I had slides covering the high walls of the pallazzo showing three stages of the women's hunt which is described in Boccaccios "Decamaron", and whose moral goals seemed still quite modern to me, though it was written in the 15th century. All the parts of the performance, the historical images from Italian culture, were used to fit in a puzzle, a collage-like aesthetic piece, to make up a rite of defence and female consciousness of history and its meaning to woman's position in society, a goal which was perfectly understood by the Italian audience, as we understood from discussions afterwards.

145

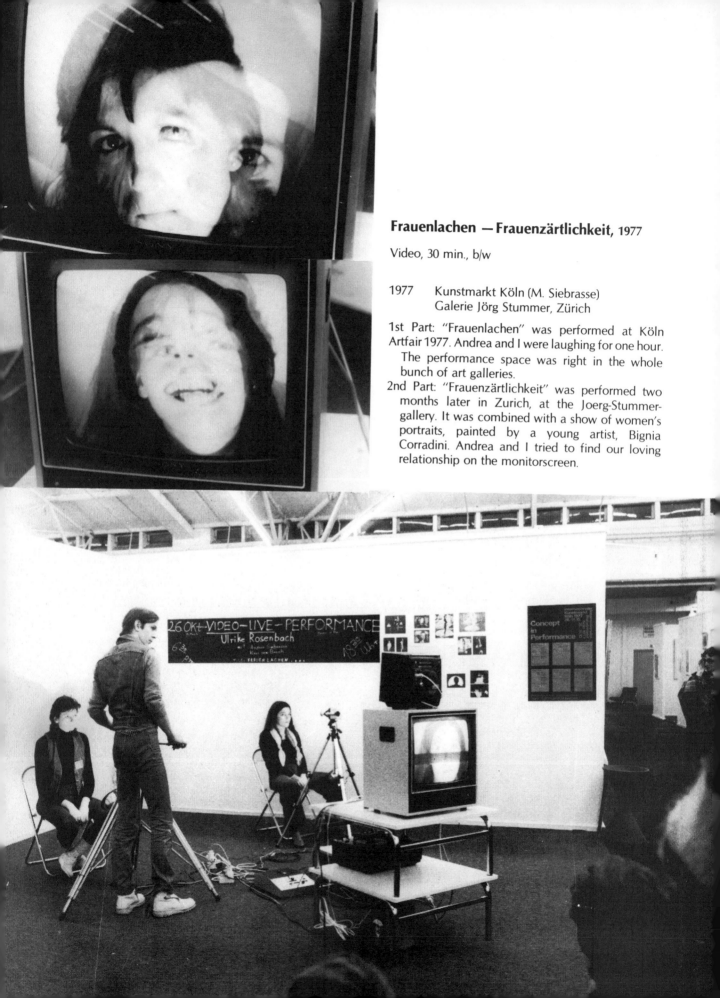

Frauenlachen — Frauenzärtlichkeit, 1977

Video, 30 min., b/w

1977 Kunstmarkt Köln (M. Siebrasse)
 Galerie Jörg Stummer, Zürich

1st Part: "Frauenlachen" was performed at Köln Artfair 1977. Andrea and I were laughing for one hour. The performance space was right in the whole bunch of art galleries.

2nd Part: "Frauenzärtlichkeit" was performed two months later in Zurich, at the Joerg-Stummer-gallery. It was combined with a show of women's portraits, painted by a young artist, Bignia Corradini. Andrea and I tried to find our loving relationship on the monitorscreen.

Meine Verwandlung ist meine Berfeiung,
My transformation is my liberation 1978

Video, 20 min., b/w, sound
Material:
 13 videomonitors
 1 reproduction from "Apostel Paulus" by Duerer
 1 videotape, showing my face when I am waving
 my head
 60 meters of red thread (wool)
Sound: heartbeats

1978 "Forum Musik Bremen", Bremen Dom,
 Bremen

This video-live-action was performed in the krypta of
the dome in Bremen. The space was built like a small
church with columns and altar. Instead of the altar I
built up a pyramid of 13 monitors. The audience was
sitting on church-benches like during regular worship.
Twelve monitors were showing the image of Paulus
by Dürer, a dark, patriarchal face, with one amazing
looking eye.* I started to stretch the wool around the
complex of columns as if marking the space for the
audience. Each time, when I finished one turn, I went
to the monitors and switched one "Paulus"-image to
the moving video-image of my head. During the
performance you could hear the strong heartbeat as
an electronic sound. When all 12 monitors showed
my face I switched the 13th and closed the action.

* The number 12 symbolized the 12 apostles.

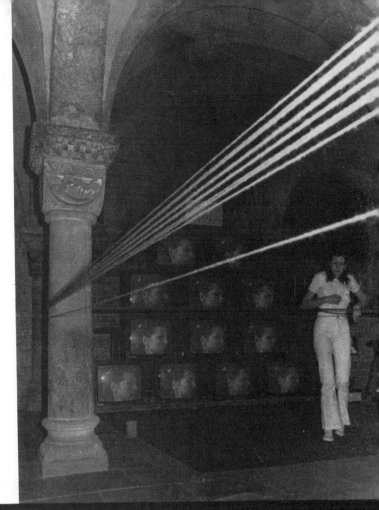

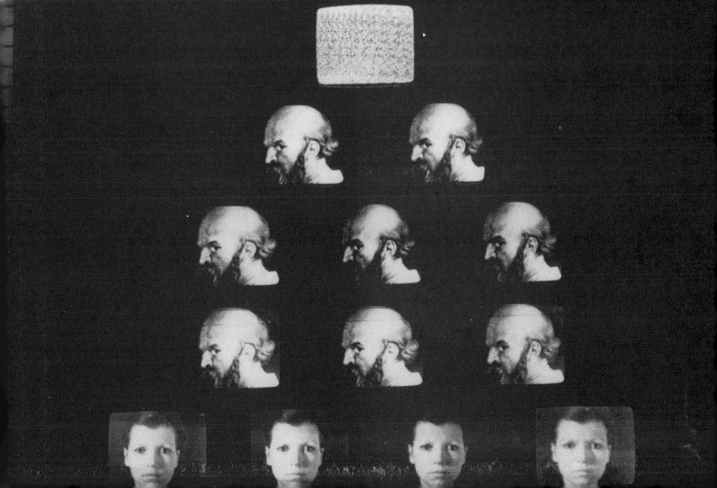

Herakles — Hercules — KingKong — die Vorbilder der Mannsbilder 1977

(the prototype of males)

Videotape: colour, 20 min., NTSC

1978 Documenta 6, Kassel

The centerpiece of this work was a blown-up photoprint of a "Herkules-Farnese" of which there is a big statue on Kassel-Wilhelmshöhe. The reproduction was the same size as the original statue. I took the piece that would fit into the space from floor to ceiling. The image of Hercules is the image of the power and strength of the male body. On the left wall there were two tableaus and a videotape giving information about the importance of Hercules' image as a cliché of male values in our culture.

On the front wall cut into the big photoprint there was a monitor showing a videotape of my face breathing "Frau — Frau" all the time. It had to show some of the female imaginings about the overwhelming body-power of men.

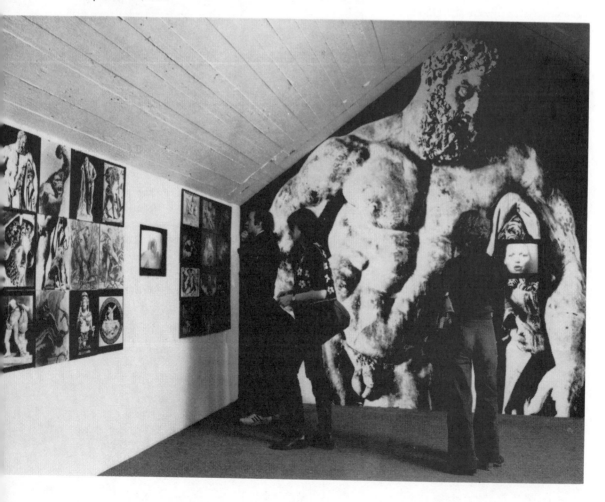

TOM SHERMAN

Television as Regular Nightmare

For Patrick (you didn't know him);

He killed himself in Kansas. He told everyone he was going to New York, then he took a bus to Topeka, where he hired a man to take him by automobile to Wichita, where the hired man shot him in the back and left him dead with full passport and papers, according to their agreement. He did it beautiful and nobody picked up on it. I've been sitting on this shit for years. I know because I gave the man's name. Patrick asked me if I knew anyone who would kill him for 200 bucks. I told him I knew one man who might.

AUTHOR'S NOTE:

This article is wholly fiction. Any resemblance to the present or past is gratuitous and similarity to any actual event or character is accidental and not intended.

149

MUZAC FOR YOUR MIND AS YOU CHECK YOUR MAKEUP.....

It's right on time. That's what I like about it. It's time. Performers line up in front of the cameras. They have a lot of different backgrounds, personal histories, with only their reason in common. They have the reasons to be up there. Performing.

Did she get the microphone extension cord? What's the use of doing this piece if we don't get it on tape? You work to tape, don't you? There is going to be plenty of top-notch hardware around. Access scheduled by telephone. There is raw tape to suit your needs. So work freely. We'll put you in there, in the studio. Don't worry about the technical end. We have the technicians to keep the artists away from the equipment. They don't know about the equipment. Most of them would rather not know about the equipment. They want to stand in front of the cameras. They are on air looking into red light camera number 1. They perform to the camera. They want to broadcast their art. No reason why they shouldn't. I can't think of any reasons why not? They want to get out there by taking electromagnetic form. The wave form or particle or instant sheet of white heat, if you wish. Radio Energy Television Pictures. You are beautiful programme. You really know the language. You really turn on up there on the set. You are better up there than you are in person. Some of you are. But I worry about this thing about the pretty girls and the handsome men. You know so much of your performance depends on the way you look. She may be the next great looking television artist. Because the people will support stereotypes. But why am I here with you in this book?, skirting around in the clarity of these cheap newspaper ideas, formed and reformed by the popular press; the effects of violence on television, the dangers of sexual stereotyping, role reversal and the frequency of gender oscillation; women dominating other women, Indians taking over the cities, the prevailing will of the people dramatically changing the behavior of the artist.

I'm here writing television for the people who watch it. I dread to see what the artist will do on television when he or she decides exactly what's needed. The artist starts by looking around the dial. Television artists hang around their sets in long depressing stupors of surveillance. They refer to this as learning the language. Many watch with the sound off. Taking a look at your world. What channel are you watching? Doesn't matter. Watch whatever you had on the night before. My current focus is on morning network television. But

that's because I'm not working 9 to 5. Right now I like morning TV. Good weather coverage.

Time is so important. Filling time. They all want the chance to fill the television time for somebody they don't know. They will get their time. And they'll get a bundle of money to boot. And the exposure. The exposure is what they really want. She is dying for this exposure. She takes it all very seriously. I personally don't want to watch what will happen to her. In terms of talent, she has what it takes. I'll define her talent in a few seconds. The thing I'm worried about is how television can turn into a regular nightmare for artists. I know her personally and I can tell you, she doesn't need the kind of definition television will give her. I mean she changes her style every 2 weeks now. If she starts watching herself being watched it'll accelerate her fluctuation of character and appearance and I would hate to see her go. I can accept the argument that it's better she's up there than somebody else. Better than one of the robots we're stuck with now. It's said to be the pure slickness that keeps those automobiles on the covers of the TV guides. All those close-ups with the smoothest of slow dissolves...the sure focus: she looks fantastic. I love the way she keeps her face moving, even when she isn't talking. I wonder who she studied with. But what does she do to keep them off her face? You can't hold a close-up forever. It's her movement. Movement specifically choreographed for the frame of the screen. But there has to be a handle. What's her handle? What does she do that nobody else does? She talks backwards. What do you mean? She stands in front of the camera and talks, with her real voice, she talks words and sentences and paragraphs backwards. She does these demonstration tapes where a man records her, taping her talking straight then reversing the track and playing it back so she can sing mimicking her own reversed voice in short segments, so you can check her to the phoneme, if you have any kind of an ear. She can do it as good as the machine does it. She's a talented performer by virtue of this great achievement. She can deep throat the technology. She can do without walking on the head.

I'm a little confused about the revolutionary ideas behind becoming the product of a communications industry. Mass media is money, no matter how kinky your approach. In comes their image, the straight faces of the masses, the people in their homes watching television for something to do, they will be in their homes and they will have art on their screens as soon as it hits the free space-time. Up in the clouds (shot from above) as pink and pretty as the sunset

through the window of a 747. We'll be signals in Radio Frequency Energy Heaven, breathtaking speed of light, bouncing off and slip-streaming across the soft ceiling of the troposphere, maybe as far as your home on a sporadic E-skip. The same Trop E route that's been randomly distributing regular line of sight television around the world for years without satellites. 299,517, km per second. Once you start imagining the view taken in at the speed of light tunneling through your critical path, you realize the galaxies so immense (the sound of 7 coded wavelengths mixed common amplitude impress-ed into a frequency modulated carrier wave to be read by digital computer displayed as visual field with your 'hearing' done at the bottom of your spine by careful placement of a direct contact transducer) and you are absolutely part of it. Transform me, please. Forget it. They're wiring it up.

They're wiring up the whole world into cable nets. You can dream about the reception of art from the sky, I have nothing against you dreaming. The reason they are wiring it up is simple. They can charge you for your television like they charge you for your electrici-ty. Then they'll replace the metal wires with light injected into fiber optics and things will be real energy efficient and easy to manage. Clean and clear. Very quiet communication lines. The better pro-gramming, the television shows you'll want to pay attention to, will be on these lines you'll have to buy into. Sure, you'll still be able to get sky programming, TV from satellites, but it'll be the necessary shit you'll have to watch, like birth control information or the methodology of fuel economy, or the wide world of association football. The television by hypersensitive personalities, the hot stuff, it'll be on the cable and it'll cost you. Performance is made for television. Television performance. Killing time with the viewing au-dience, from the inside out. Can you bring your self up high and down and out to conclude your action in approximately 28 minutes?, give or take 30 seconds. Now that we're not dealing with transmitting signals from the earth into the depths of outer space and back, we can (1) get rid of all the small antennae (I will concede, now that we are back on earth, as signals running through wires or wave guides....I will concede that the present form of home antenna will be replaced by another 'breed' of small antenna, but again I stress that this free access will be to programming you will need but will not necessarily want), and more importantly (2) the forces at hand will stop cutting the programme with their commercial message. You won't have to worry about their inept mechanical cut-ting, their division and fragmentation of your finished product for in-

sertion of their over-budgeted extravagant insults, their commercial messages. You won't have to worry because you will be the commercial. Whole commercial programming. The people will pay for you in a really pure way. They'll pay to watch you age. They'll watch the changes you'll be going through. Oh, the fortunes to be made. The fantastic stakes of the personalities. The chosen few. Oh, the suicides, the murders. The death. The excitement of the burning mind. Look in her eyes. Did you see her eyes last night? The look in her eyes between 8:41.17 and 8:41.29 pm. 12 seconds of love. Her exposure on the international net, under those white lights, playing to the faces of the crew.

You can do your best material in front of millions. For those of you who happen to have been born into the right physical type, the body sized and coloured to fill in the ideal form, you could have National Character potential. Through your performance you could represent art from your country to the world viewing audience. Too big a responsibility? Not for some of you. And I've been writing only about television. Once you start appearing in the tabloids, giving interviews and handing out your 8 by 10 glossies; it's exciting imagining the mass audience, all their faces, the way they look. I've got a finger on the mass audience. I've entered their minds. I've got to start programming for the mass individual.

Whenever he's on talkshows, everything he says is so ambiguous. I wonder what hemisphere of his brain is dominant. He can hold the mike in either hand with equal finesse. He's on the talkshows because he is an artist. He's always on introducing one of his new works. He talks fast, has a great deal of information, he looks good. I wonder who does his research for him. Friends are saying it's his wife. Did you hear about the piece he did with the charm and colour of the elementary particle? He did it with some incredible video animation. He does all the talkshows as an artist. He's in the air all the time, flying around the world, the jet noise falls away as he silently composes his monologues in his head. He can't read anymore, or at least he can't find the time. She must do most of his thinking. I find them amusing. Their relationship is just a phone relationship. But this background information shouldn't discredit his performance. He is very good at what he does. He has a way of loading his tape with his strange introductions. He is very clever and he has enough money to buy the right clothes. He dresses well for TV. Does he play a musical instrument? No, he only makes television. His television platforms human inadequacy. I find his work

funny, but the press he generates is always dead serious. If there happens to be a live audience where he performs, and they laugh at one of his lines, in the quick-cut to close-up—you can see the horror in his eyes. He doesn't like to work with an audience. Their presence throws him off. Then he tightens up and becomes totally insensitive to them. He doesn't work with them. His inability to work with the audience, that's the reason I don't consider him a good performer. But I'm glad to see him on the air. There are a lot of television artists who don't have a clue as to what they'll do with the time. They'll fill their time with smiles and thank you's doubled just to ensure they'll be invited back. All this starts with a visit with a person who sits behind a desk. However you find your way through the highrise door of the mass media, you'll find yourself sitting on the wrong side of the desk of the person who can put you on TV. They're going to look at your teeth, your hair, the way you dress. They'll listen to a couple of minutes of your spiel. Please, no signs of nervousness at this stage. They are not going to spend a pittance of their budget on some-one who'll fry in front of the cameras. Unless they can see you really frying. How many times can you fall apart on network televi-sion? As many times as you need to. Humble yourself, naturally. But after they pity you, you'll have to find completion in your next move. Your final action. They won't tolerate remissions or full recoveries for long. They will want your blood. In terms of the ratings, there is nothing more substantial in actual draw, than the artist dying in his work. Death as performance. The people will always love the artist who dies for them. Until, of course, when everyone is dying on television. Then they will want something with a new twist. Life after death performance. Leave it to the kids. I mean it. Leave your child your body of work to think of you often. Leave them a few unpublished scripts with some photographs of your eyes when you were young.

And the people who refused to get contact lenses the first time around, they're realizing they can't afford to wear glasses any longer.

As for technological jewelry—wearing lavaliere microphones, light-metal cold against the skin rolling over the collar-bone.

All these compromises, we're hoping we'll only have to compromise so heavily in the initial phase of television art. After things get sorted out and all the forms and contracts have been drawn up by the artists' lawyers and approved by the producers for the institu-tions or the corporations and the fine print says they can buy your hours for years and years so they can make all the money they can

make on you; then you'll have to produce, fast. It's a good thing the agents show up the minute you're on National Air. How else could you maintain the pace as your work heads towards world exposure? You are the performing artist. You shouldn't have to think about all this shit. I'm sorry to put you through. I know there are a lot of great performances millions of people might be thrilled to see, if performance by artists were available in the mass media. Personal attitudes towards public display could be transformed. Real emotions could be read in their faces. Established religions could be challenged. People could say they are nothing special. People could say, I'm here and you're not. Artists as performers could work to bring about social change. We could be the information. We could be the information they base their thinking on. We could burn our histories. I sit by the receiver and watch myself in the state of self-consciousness—so full of receiving, I want to be performing for you. I want to fill your time, stranger. I want to fill your time, honestly. If I can't do what I want to do, I don't want to live here anymore. We're Regular National Characters as performing artists go. But surely the National Character Artist is a thing of the past, with travel and communications the way they are today. I feel the most important actions in performance will take place within the parameters of International Performance Criteria. The role of this book is to establish a range of International Performance Criteria.

I'm so glad you stayed awake reading me. I'm sorry there weren't a few pictures of me as a child. I wish I could have made this more revealing, but I feel a little burn on my cheeks as it is. I hope you read English. No, I'm not really anti-satellite. But I'm afraid the way I look is going to interfere with my performance career in the mass media. I've been told plenty of times, there is nothing that can be done with my voice to make it more acceptable. Besides, I can't think of anything innovative to do with the time you say I've got. Now's the time, it's your turn to go up there to inform, to entertain, to fill the hour, to kill the time they're willing to spend with you, spending their good money to see you walk and talk, you lucky dog—all the friends you have that you don't even know. After you get an agent you can trust, then you can get back to work.

Personal matter through television. You use yourself as material. This is not to be confused with the artist working with the media as material. This is the performer working in the media. The machines have us. Perform so the machines can capture your personality. Men AND women in captivity. Perform your own way out.

Someday, we'll all think the same things. Or someday, when our

mental privacy is our last personal space, we'll have no idea what the other person is thinking simply because we will no longer be conscious of others.

Gendering technology is 1 thing.
The eroticism of art is another.

THE PERFORMANCE ACTION BEGINS:

Big Band Music Background.....

When you have your eyes open wide and you're watching classic actions take their form, it makes you want to recall the split second before his gesture moved you through the air. Run it back so I can see the message the tip of his glass sentenced to death. A toast to his lips, but what was there before? He smiles and cracks me forward until I'm smiling back. I'm listening to his answer as I know our eyes take us back and forth, taking our minds into the same lines as we take turns forming the words between us. I feel sometimes I resonate briefly between the sound of your voice and the look in your eyes. I swear I get sort of a green light in my inner ear when you say some of the things you do. I can see you doing everything you say you do. I like to put you up in the air with my voice. You can close your eyes down tight, but you can't shut out the sound of my voice. The way I sound on the telephone, the way I sound in person, my spoken words, they're yours.

I'm going to take in everything you're going to say because look at your mouth, it's moving faster with the sound down a little and your tongue darts out to moisten your lips every once in awhile. The voice comes back up and my eyes become your eyes. There's some pretty clever deception going on inside one of us, probably both of us. And then up real close, there's the back and forth between one eye and the other. My sight over the bridge of your nose to fly up to close on the hair line with the signal on a clear channel; the offering of the kiss. What came before these lips? What else? I've got a notion but the hands come next. The pull on the belt, the hands decisive on the button, the sight of the zipper noise and the pants are down. Under where he takes me, I would like to run a big band sound. A piece of strong music with a European background. Something I can like the taste of the first time I dance to it. Let me have a classy number. Give it to me full volume. Turn it off when I stop moving, and not a second before. I want to hear all the music you got for as long as you got a head full of it.

May 11th, 1952, around 4 in the afternoon......

He sucked me like nobody had ever done before. He was in complete control from the moment he hooked his fingers over the base of my cock, his thumb pushed into my scrotum to stroke the shaft hard where it disappears in my body below. His lips break the shortest kiss over my head shining wet enough as he slides down to hold me deep with his teeth. His hold on me. He wanted me to open my legs a little, I was standing. Without looking up or changing the tension in his mouth, he dove his hands through my thighs to hold my ass to bring me forward to start my moves as in my ass he ran his hand deep with a finger to the end, as far as it could go and there he found me a smooth contraction diminishing to my centre as his finger had triggered my release. His finger pressed the wall deep. He found the soft button hot. I could feel the shock run down my stick to pass through the clench of his tight lips to end in his throat NOW a series of 4 tearing waves with a rip on the end of each. His grip, his hand tightens around my cock again. With his hand and his mouth he pulls me in to finish me hard.

She sucked me like nobody had ever done before. She was in complete control from the moment she hooked her fingers over the base of my cock, her thumb pushed into my scrotum to stroke the shaft hard where it disappears in my body below. Her lips break from the

shortest kiss over my head shining wet enough as she slides down to hold me deep with her teeth. Her hold on me. She wanted me to open my legs a little, I was standing. Without looking up or changing the tension in her mouth, she dove her hands through my thighs to hold my ass to bring me forward to start my moves as in my ass she ran her hand deep with a finger to the end, as far as it could go and there she found me a smooth contraction diminishing to my centre as her finger had triggered my release. Her finger pressed the wall deep. She found the soft button hot. I could feel the shock run down my stick to pass through the clench of her tight lips to end in her throat NOW a series of 4 tearing waves with a rip on the end of each. Her grip, her hand tightens around my cock again. With her hand and her mouth she pulls me in to finish me hard.

THE ANNOUNCER (OFF CAMERA) RECALLED THE MOMENT MANY YEARS PAST, WITH HIS VOICE.

4-18-78
Tom Sherman

ULAY/MARINA ABRAMOVIC
MARINA ABRAMOVIC/ULAY

photographs by Giovanna dal Magro

Performance 5

IMPONDERABILIA

Standing nude in the rebuilt main-entrance of the Museum, facing each other.
The space between us is forty centimeters.
The public entering the Museum has to pass sideways through the small space between us.
Each person before passing has to choose which one of us he wants to face.
Two hidden video-cameras recording each person passing.
An installation in the central space inside the Museum with video-monitors continuously show the people choosing and passing.

Time: 90 min.
Registration: video, black and white

June.1977
Galleria Comunale d'Arte Moderna
Bologna

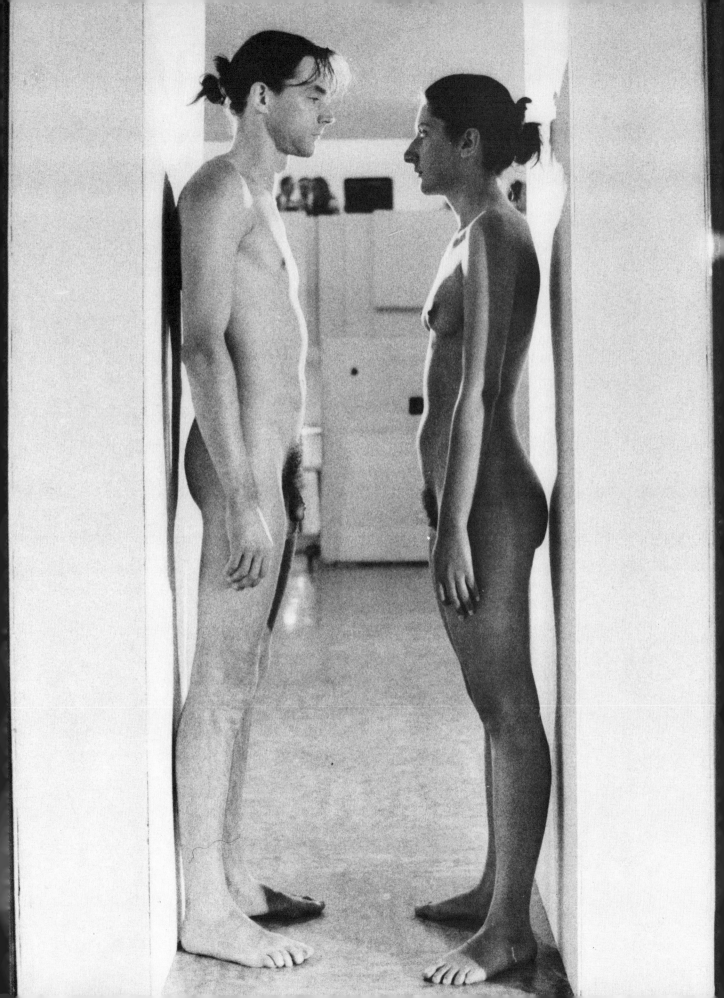

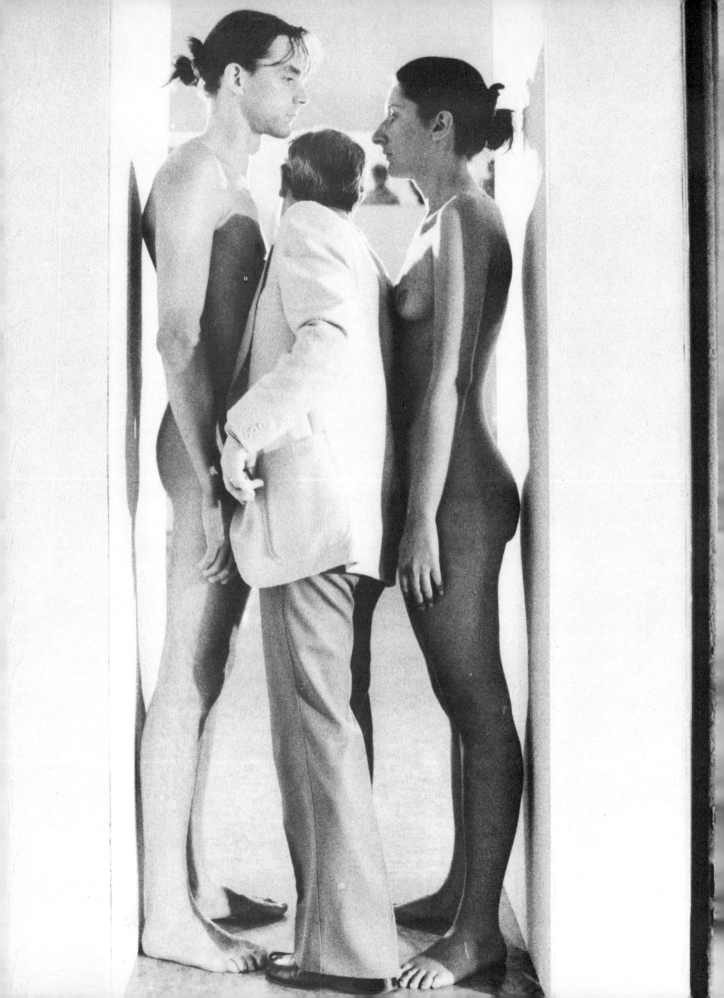

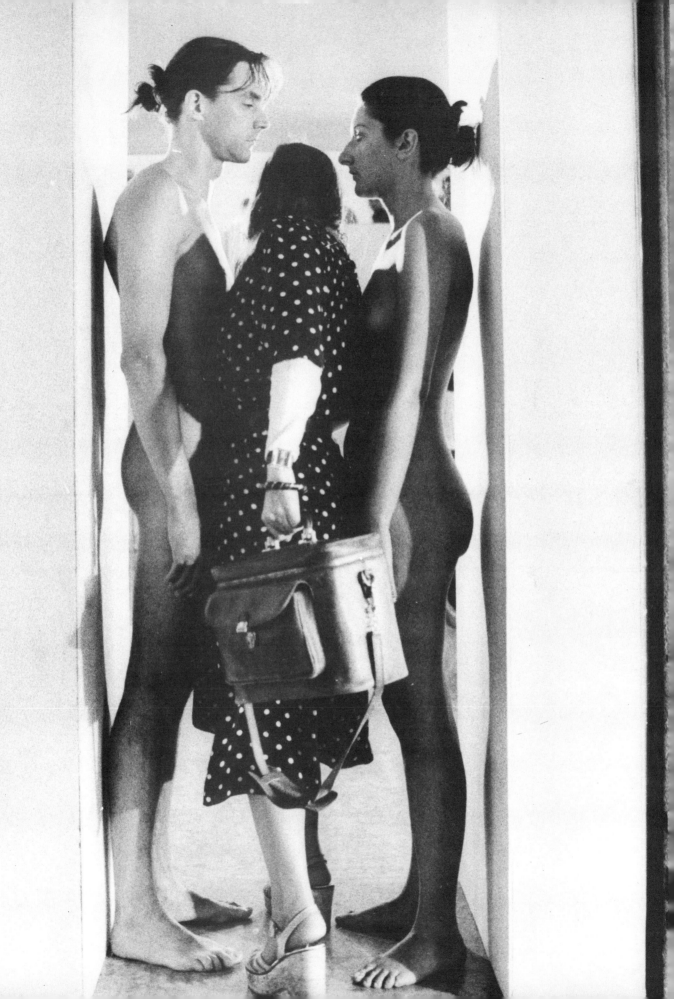

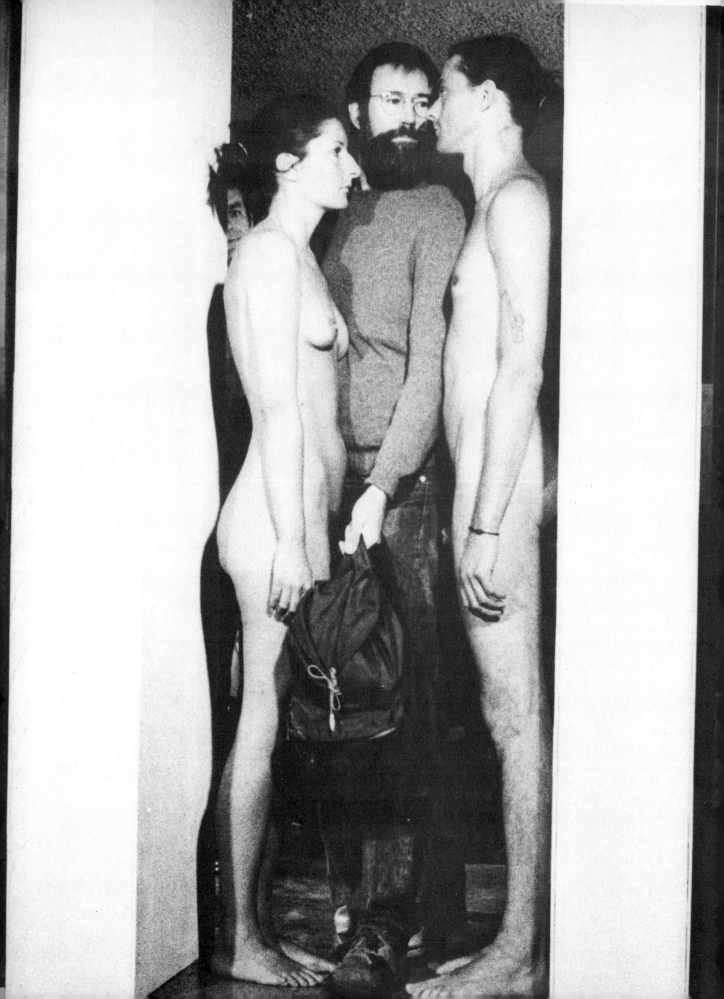

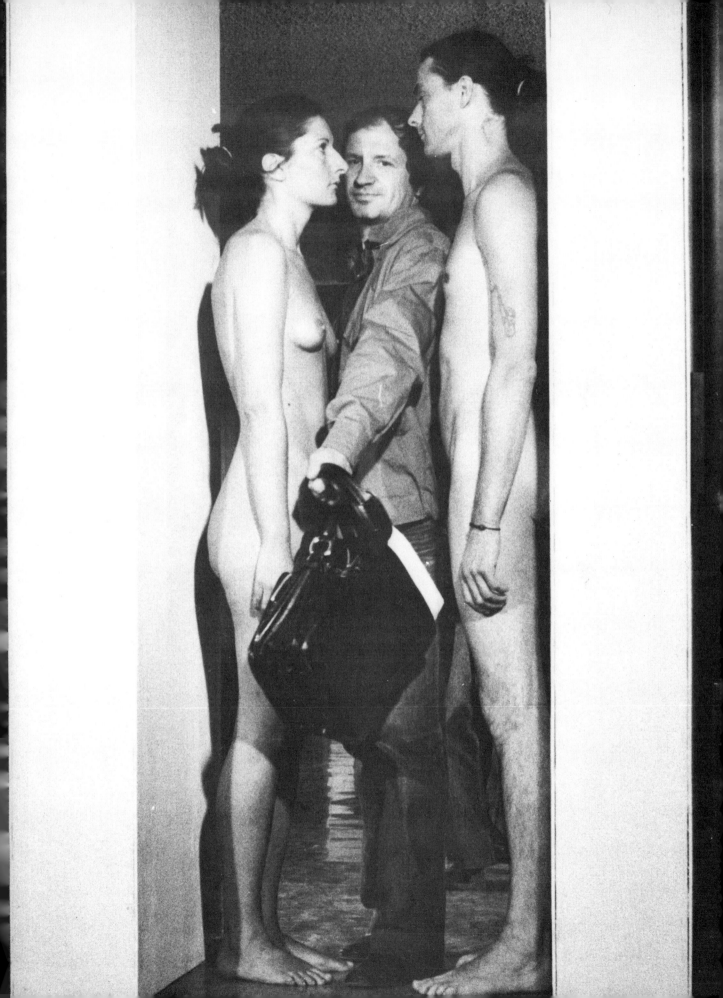

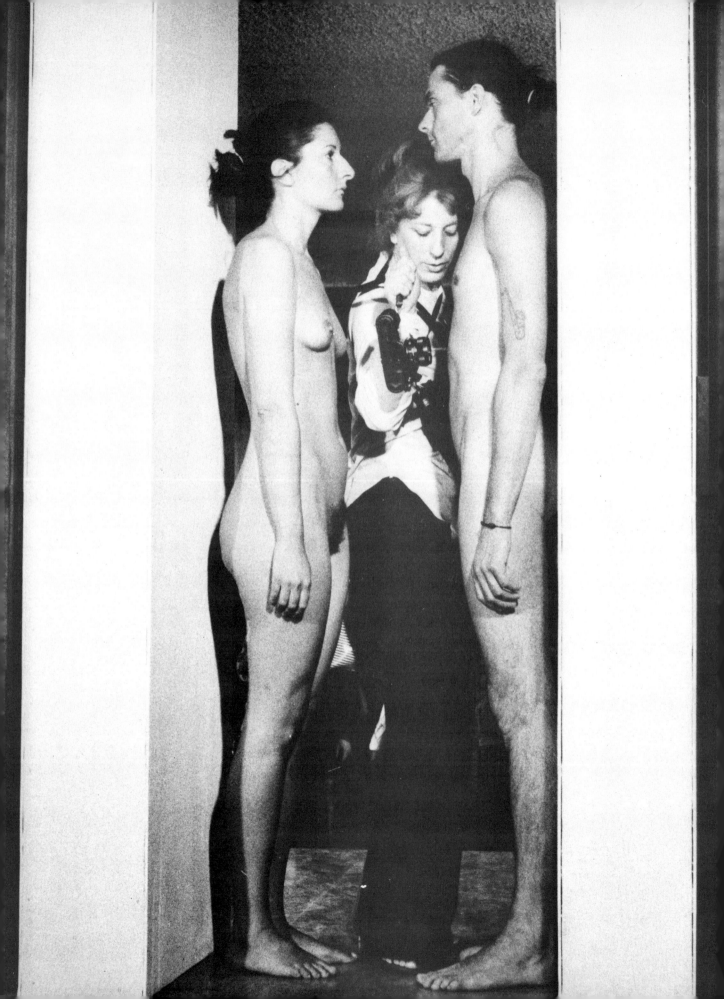

COMMENTARIES

PERFORMANCE: A Hidden History or, The Avant Avant Garde

RoseLee Goldberg

PERFORMANCE is one medium in the twentieth century that lacks a written history, despite ample evidence of its existence in the form of photographs, texts, manifestos and descriptions from witnesses. These events have been consistently left out in the process of evaluating the history of art, more on account of the difficulty of placing them than of any deliberate omission.

Yet performance has been an important catalytic medium in that history, often preceeding the making of art objects. An overview of the history of the avant-garde — meaning those artists who led the field in breaking with each successive tradition — points to the fact that performance has been at the forefront of such activity: an avant, avant garde. Despite the fact that most of what is written today about the work of the Futurists, Constructivists, Dadaists or Surrealists continues to concentrate on the art objects produced by each period, it was more often than not the case that these movements found their roots and attempted to resolve problematic issues in performance: when the members of such groups were still in their twenties or early thirties, it was in performance that they tested their ideas, only later expressing them in the form of objects.

The Italian Futurists for example, began with manifestos and performances before actually finding a painterly or sculptural means to represent those ideas. Live actions in Paris, Milan, Naples, London or St. Petersburg, were at the root of their fame, and the impact of their paintings and sculpture far less than their outrageous performance 'declamations' against 'past-loving art'. Most of the original Zurich Dadaists were poets, artists and performers before actually creating Dada objects themselves, if at all. Similarly, most of the Parisian Dadaists and Surrealists were poets, writers and agitators before they made Surrealist objects and paintings. Breton's text *Surrealism and Painting* (1928) was as such a belated attempt to find a painterly outlet for the Surrealist idea and it continued to raise the question "what is Surrealist painting?" for some years after its publication. For was it not Breton who, four years earlier, had stated that the ultimate Surrealist *acte gratuit* would be to fire a revolver at random into a crowd on the street?

Other examples show how performance often provided a way out of the various impasses created by the overwhelming stalemate reached by painting or sculptural 'styles' such as Abstract Expressionism or Minimalism, when it seemed that no other art form was acceptable to the establishment of museums and critics. Often quoted remarks by Vito Acconci or Dennis Oppenheim, refer to their using 'Body Art' as a direct attack against the overriding concerns of minimal art. More recently, Laurie Anderson described how she turned to performance as a means to alleviate the overly cerebral concerns of conceptual art.

So performance, while designated a peripheral and almost non-existent role in the history of the modern movement, can be seen through a careful analysis of examples from the Futurists to the present, to have had a far wider ranging effect than has thus

far been realized. Historically, the stance of performance artists has been a radical one — against the establishment (be it art or politics), against the commercialisation of art, as well as against the strict confines of museums and galleries. Performers have acted against the overriding belief that art is limited to the production of art objects, suggesting an art of ideas and of action. While in the twenties these opposing pursuits were thrashed out in the journals of the Purists' *L'Esprit Nouveau* or the Surrealists' *La Révolution Surréaliste,* subsequent discussions of the Modern Movement have neglected to acknowledge a parallel development of ideas expressed in performance, making it a hidden history. Extracting two examples from that history — the Italian Futurists and the Zurich Dadaists — a brief description of their early years serves to show how the beginnings of the group activities were in *performance* and how it was in fact the live manifestations of these performers that gained them early notoriety from St. Petersburg to New York. And it was their extensive manifestos that years later, following the desolation of the Second World War, would inspire a generation of artists in the United States and in Europe to extraordinary experiments in music, dance, painting, sculpture or poetry.

THE FUTURIST OBJECTIVE

For FILIPPO TOMMASO MARINETTI, poet and provocateur, spreading the Futurist idea was foremost on the Futurist agenda. The means to do this was invariably in face-to-face confrontation with audiences wherever they could be gathered. His 1909 *Futurist Manifesto,* conceived in his luxurious mansion the Villa Rosa in Milan, and published in the Parisian daily *Le Figaro,* on February 9 of that year, was to provide a blueprint for Futurist action and the content for the early Futurist 'serate' or evenings. The manifesto declared above all the Futurists' irritation with the state of art —'museums: cemeteries! ...Identical, surely, in the sinister promiscuity of so many bodies unknown to one another. It regarded art critics as "useless and dangerous". Moreover, the manifesto's statements provided the Futurists with verbal missiles to attack the public.

The first Futurist serate established their reputation as public irritants — on the political as well as the artistic front. Presented on January 12, 1910 at the Teatro Rosetti in Trieste, the pivotal border city in the Austro-Italian conflict, Marinetti played on the underlying political tension of the town as an additional element in the unrehearsed performance: he praised patriotic militarism and war — taking the opportunity to rage against the cult of tradition and commercialisation of art — while Armando Mazzo introduced the provincial audience to the Futurist Manifesto. Their antics succeeded in causing havoc in the house as well as in the streets of Trieste, and official complaint from the Austrian Consulate to the Italian government, guaranteed that their publicity spread beyond the town borders.

Subsequent serate had similar results and it became clear that performance was the surest means of disturbing a complacent public. Manifestos urged painters to 'go out into the street, launch assaults from theatres and introduce the fisticuff into the artistic battle'. They were also encouraged to 'take pleasure in being booed': 'applause

merely indicates something mediocre, dull, regurgitated or too well digested', Marinetti explained in his manifesto *War, the Only Hygiene,* while booing assured the actor that the audience was 'alive, not simply blinded by intellectual intoxication'. Futurist performances were a guaranteed evening's entertainment and attracted large crowds armed with vegetables from nearby markets with which to attack the performers, in towns throughout Italy.

Such responses to Futurist activity could not have been achieved by painting or sculpture exhibitions alone. While numerous young painters were quickly drawn into Marinetti's circle and solicited as co-signatories of the *Manifesto of Futurist Painters 1910,* their first year of activity was actually on the performance circuit, prior to any exhibitions of Futurist painting or sculpture. And even that exhibition, which took place in Milan on April 30, 1911, was first announced in the form of a performance: The *Technical Manifesto of Futurist Painting* described how 'on the 18th March, 1910, in the limelight of the Chiarella Theatre of Turin, we launched our first manifesto to a public of three thousand people ... It was a violent and cynical cry which displayed our sense of rebellion, our deep-rooted disgust, our haughty contempt for vulgarity, for academic and pedantic mediocrity, for the fanatical worship of all that is old and worm-eaten ...'

Manifestos followed in quick succession, some preceding performances or exhibitions, others written after the events. They encouraged artists to present more elaborate performances and in turn experiments in performance led to more detailed manifestos. For example, months of improvised serate with their wide range of performance tactics, had lead to the *Variety*

Theatre Manifesto of 1913, when it became appropriate to formulate an official theory of Futurist Theatre. While it made no mention of the earlier serate, it did explain the intentions behind many of those eventful occasions. Variety Theatre became a model for many Futurist performances 'because it is lucky in having no tradition, no masters, no dogmas', and 'because it destroyed the Solemn, the Sacred, the Serious and the Sublime in Art with a capital A'.

Marinetti made sure that no branch of culture or artistic medium was left unexamined by the Futurist mind: Noise Music, Lust, Aerial Ballet, Film, Architecture or Stage Design, were each treated to lengthy manifestos and subsequently realized in performances or constructions. By 1933, when it seemed that Marinetti may well have exhausted topics for Futurist interpretation, he added Futurist radio theatre to the Futurist repertoire. Radio — 'the new art that begins where theatre, cinematography and narration end' — became the medium for the Futurist Radiophonic Theatre. Using noise music, silent intervals and even 'interference between stations' five 'concerts' including *A Landscape Hears* and *Silences Speak Among Themselves* were broadcast over Italian radio.

The mass audience reached by such events stirred the public imagination to a far greater extent than did their painting or sculpture which, despite their accompanying radical manifestos, appeared to many as an updated version of Cubism or Orphism. Moreover, it was the inventiveness of their performances which inspired artists in Moscow, St. Petersburg, Paris or Zurich to turn to live events as the surest means of gaining public attention for their art and ideas. And it was the extraordinary suggestions of their manifestos that would

trigger off new developments in music some twenty-five years later. 'In order to understand the sense of musical renaissance and the possibility of invention' that had taken place around 1935, John Cage wrote, 'one should turn to Luigi Russolo's *The Art of Noise ...*'

THE DADA INVECTIVE

SIMILARLY, it was the nightly events that highlighted five months of activity at the Cabaret Voltaire, that led to the beginnings of Dada and to its long term effect on subsequent art preoccupations.

For its founders, Cabaret artist Emmy Hennings, and poet Hugo Ball, the opening of the Cabaret Voltaire was an opportunity for them to recreate something of the cafe-cabaret life they had left behind in Munich. It was also a means for them to provide a central meeting point for the many European exiles spending the war years in neutral Switzerland. The founding of an art movement as such, was far from their intentions. Rather the press release announcing the opening of Cabaret Voltaire on February 5,1916 at a small bar in the Spiegelgasse, explained that they wished to 'create a centre for artistic entertainment'. It was to be open to 'young artists of Zurich, whatever their orientation' to 'come along with suggestions of all kinds'.

Opening night was a great success. Tristan Tzara, Marcel Janco and Hans Arp were among the artists who responded to the invitation, and the following weeks drew numerous volunteer performers to the Cabaret. The bar, decorated with Futurist posters and featuring a small stage, was soon 'bursting at the seams' according to Ball. Under pressure to entertain a varied audience they were forced to be 'incessantly lively, new and alive', he wrote. 'It became a race with the expectations of the audience, and this race calls on all our forces of invention and debate'. The various participants each became adept at particular performance styles: Emmy Hennings sang in French and Danish, Tzara read 'traditional style poems which he fished out of his various coat pockets', Richard Huelsenbeck swished his cane while reciting poems with a 'negro rhythm' and Ball invented 'a new species of verse without words' or 'sound poems', which he read from notes on music stands placed along the front of the stage. Students from Rudolph von Laban's dance school, including Sophie Teuber, created dance movements to accomodate the masks and costumes made by Marcel Janco.

Such activities were not thought of as creating an identifiable Dada art, and in fact the term Dada was only coined several months into the Cabaret programme. Rather they wanted to make the Cabaret Voltaire a focal point for the 'newest art' providing a spectrum of contemporary art, literature, poetry and music. Their repertoire included poems by Morgenstern, Max Jacob or Wedekind, a cello sonato by Saint-Saëns, simultaneous verses by Henri Barzun and Fernand Divoire, readings from Jarry's *Ubu Roi,* and so on. Far from the Futurists' insistence on an entirely original art, Ball believed that such pretensions were unrealistic: 'the artist who works from his freewheeling imagination is deluding himself about his originality', he wrote. 'He is using a material that is already formed and so is undertaking only to elaborate on it!

For Ball, the Cabaret was essentially 'a gesture against this humiliating age', and the creation of an organized art movement, anathema to his way of thinking. Rather he preferred to act as a catalyst, bringing together different ideas and attitudes of the various individuals habituating the cabaret. Orchestrating the evenings was more important to him than encouraging a definition of Dada or the production of a style. 'Producere means to produce , 'to bring into existence', he wrote, 'It does not have to be books. One can produce artists too'.

But Tzara, who, according to Huelsenbeck, was the 'international intellectual playing with ideas of the world', saw Dada as a means to gain an international reputation, as a password to entering the avant-garde circles of Paris, urged for the publication of an anthology of Dada material. Ball and Huelsenbeck were entirely against it. They were against 'organisation': 'People have had enough of it', Huelsenbeck argued. And they felt that 'one should not turn a whim into an artistic school'.

So by the time that the owner of the bar, Ephraim, told them to 'offer better entertainment..or shut down the cabaret', Ball was 'ready to close shop'. When Dada went public at the Waag Hall in Zurich on July 14, 1916, Ball saw the event as the end of his Dada involvement, since to make Dada into a 'tendency in art must mean that one is anticipating complications'. While Tzara systematically created a literary movement out of the Dada idea with a Collection Dada containing manifestos and writings, Ball and Huelsenbeck gradually retired from Dada activities.

Six months after the closing of the Cabaret, in January 1917 a Dada Gallery was opened with exhibitions by Arp, Van Rees, Janco and Richter, Negro art and talks by Tzara on Cubism and 'Art of the present'. The nature of the group's activities had changed from spontaneous performances to a more organized, didactic gallery programme. They charged admission, and expanded the range of events. The Galerie Dada lasted just eleven weeks. It had been calculated and educative in intent with three large scale exhibitions, numerous lectures, soirées and demonstrations. In May 1917, there was a free afternoon tea for school parties as well as a gallery tour for workmen. Meanwhile Huelsenbeck had lost interest in the whole affair, claiming it was a 'self-conscious little art business, characterized by tea-drinking old ladies trying to revive their vanishing sexual powers with the help of 'something mad''. For Ball, the set of circumstances brought on by the First World War had provided a unique situation for reviewing the traditions of art and literature in a rarified atmosphere and he saw little point in attempting to prolong Dada's life by making it into an international movement.

Even before Galerie Dada had officially closed its doors, Ball had left Zurich for the Alps and Huelsenbeck had departed for Berlin. There, after thirteen months of a private existence, he finally presented a Dada type soirée and initiated Berlin Dada with its concentration on performance and political agitation. Tzara made for Paris in December 1919 where he was welcomed by the Littérature magazine group, Andre Breton, Paul Eluard, Philippe Soupault, Louis Aragon and others. For five years, the steadily growing group's activities was centred on performances based on the Zurich recipe. The theatres, cafes and streets of Paris became the venues for endless Dada provocations. Dada excursions through a disused church and a 'Dada trial' were part of the extensive Parisian fare.

Soon the group was split into fragments; conflicting personalities, ambitions and very different intellectual concerns, as well as a general boredom with the standardisation of Dada performances, resulted in endless arguments. Breton's plan for a Congress of Paris 'for the determination of directives and defence of the modern spirit' for 1922 was defeated by opposition from various members of the group, and verbal and ideological battles even reached the point of physical violence when Tzara's second performance of *Le Coeur à Gaz*, presented in July 1923, became the focus of a violent scene. Breton and Peret protested loudly from the stalls, before climbing onto the stage to engage in a physical battle with the performers. Pierre de Massot escaped with a broken arm and Eluard fell into the stage sets, causing considerable damage.

While Tzara stood firmly for the rescue and preservation of Dada, Breton announced its death: 'Though Dada had its hour of fame', he wrote, 'it left few regrets'. 'Leave everything. Leave Dada. Leave your wife. Leave your mistress. Leave your hopes and fears. Set off on the roads'. And in 1924 the new group of the Surrealists published a Surrealist Manifesto and the first issue of their magazine *La Révolution Surréaliste*.

Dada performance dominated eight years of artists' activities in Zurich, Berlin, Paris and Cologne. It provided an underlying energy for an exchange of ideas which would radically alter the accepted view of art, or even what constituted an art object. These ephemeral events may in the passing years have been reduced by art historians to mere curiosities, lively gestures by youthful pranksters now considered masters of twentieth century art. But it was precisely this form of art — performance — that they proposed as a medium in its own right. Subsequent generations of performance artists have proved its continuing importance. Moreover, performance remains a catalyst, and a source, for contemporary art preoccupations.

New York July 1978

175

POSTMODERN PERFORMANCE: Some Criteria and Common Points

Dick Higgins

THE MOMENT that one tries to treat those ideas which are associated with the term "postmodern" concretely, and specifically to apply them to the performance arts, issues and questions are raised which were not anticipated. Even at best "postmodern" is a curious near-oxymoron, covering some forty years of cultural history in which the performance arts, I think it could be argued, have changed even more than the others, so that while the senior citizens speak of Samuel Beckett as "postmodern" their grandchildren think of him as a neo-romantic. During the "postmodern" period, myths have become objectivised and are usually treated very eclectically, simultaneity has become characteristic of communications, forms have become more interpenetrative with their subjects than they had been, many themes have ceased to be presented with logic (either emotional or rational) and are instead presented intuitively as allusions, and narrative, if any, lost its primacy and became either simply scenario or disappeared altogether except for ornament. In the first part of the postmodern period we have the works which begin this evolution — the works of Beckett and Genet (anticipated by the Stein of *The Geographical History of America* or the Joyce of *Finnegans Wake* or the texts of Arno Schmidt in Germany, of the theatre of the absurd, of Abstract Expressionist and *tachiste* painting (the early work of The Living Theater or more recent work by Claus Bremer would be examples of the principles of these being applied to theatre), and to such trends in American poetry as the Black Mountain School of Charles Olson and his followers, or of the New York intuitive styles of John Ashbery or Kenneth Koch.

But sometime around 1958 a second major shift began to crystalise which I have elsewhere called "postcognitivism" — which actually means "postself-cognitivism. Here the overt message follows the narrative into the near-limbo of being mere ornament, the artist ceases to create his own myth (as he had been doing, typically, since the mid-nineteenth century) and the areas of sensual experience or discipline came to be less discrete than they had been. At times these tended to fuse into the *intermedia* — concrete poetry, for example, which fuses text and visual art, sound poetry which fuses text and music conceptually and does not simply mix them, or the happening, which is a three-way intermedium or fusion of text/drama, visual art and music, or the "event" which is the minimalist analog of the happening — as in fluxus works. All the arts were affected by this shift; the novel, for instance, became almost out-of-sequence from its immediate ancestry once visual elements and non-syntactic prose began to be really common in the works, as in, say, Federman in America, Kutter in Switzerland, Roche in France, etc. The principles of chance or aleatoric structures ceased to be the property of a single school and became stock in trade for poets of many groups, for composers such as Pousseur or Kagel, artists like George Brecht of Fluxus, and so on. The ferment which all this fusion produced made the 1960's even more innovative than the 1920's had been — the most innovative decade in our history, in fact.

The critics lagged behind. They saw each fusion of sensibility not as a process but as a separate and definitive trend or movement, thus creating the illusion of a concrete poetry movement, a pop art movement, a happenings movement, a fluxus movement, and so on. The resulting conceptual confusion drove many of them into a formalistic Marxism which, in its own terms at least, explained a lot but dealt with the issues raised by these new art fusions only obliquely and inadequately. There was little or no connection between the formal Marxism of the *Art and Language* group of critics, for instance, and the more intuitive Marxism of many of the artists whose impetus in doing these new arts came from an attempt to do art work which was more appropriate to the real needs, real people and real intellectual currents of the time, of the historical moment.

In many cases the critics retreated into theory that had little or no relevance to practice, at least no relevance to the practice of the only time they knew at first hand — the art of the present. Structuralism was centered in academia and in Paris which, for most of this period, was the most conservative of major cities — even the most conservative city, artistically, in France where recent innovations have come more often from Bordeaux, Limoges or Nice than from Paris. Thus structuralism tended to become a matter of far-out ways of looking at Balzac than what it might have, a set of criteria for understanding one's immediate experience of the new arts. This led to strange things such as the praise of Maurice Roche, a sort of Frenchified offshoot of Emilio Villa, at the expense of real innovators such as Robert Filliou; the theory of structuralism and post-structuralism was very interesting, but its implications for artistic innovation were for the most part

ignored. Similarly, hermeneutics remained, for the most part, the domain of professors or university philosophers, the province of specialists. Its applicability to the problems of graphic notation in music, for instance, were not explored — and, in fact, *have* not been until now, relevant though they are to some of the music of John Cage, Philip Corner, etc.

Through this last twenty years or so, the United States, which experienced a very productive time in its creative arts, was a backwash for criticism and theory — its critics knew much more about getting grant applications in or qualifying to get tenure at universities than they did about the new arts. The United States became a critical backwash, haunted by the ghosts of the New Critics and by the myth of American originality. This last myth, originally cultivated as a defense for our growing independence from Europe, came to be a sort of ideology of the ostrich: "We don't want to see how good your European art is, so we won't." The writing in art journals such as *The Fox* (ultra-leftist), *Artforum* (Fabian and paternalist) or *Art and Letters* (ultra-elitist) seemed curiously out of phase with the best work that was coming from France, Germany, Italy, Scandinavia or Japan. It was as technical as these, but it was a technicalised and jargon-ridden academicised overlay on ideas whose relevance was to the world of half a century before, and which could not be *lived* as vital criticism is lived, as part of the commonality of understanding one's newest cultural experience.

This brings us to the vacuum of the mid and late 1970's. Happenings are passé, we are told: it says so in the media. But the media have been saying that since happenings began. Thus, since the impetus which created happenings in the first place still

exist, when young artists "do a-what comes natchurly" and come up with happenings, they must be represented under the new name — "art performances." It is true they have a different style, typically, from the old happenings — there is no longer Abstract Expressionism to react against, the great protests against America's involvement in the Vietnam fiasco are gone with the passions that they aroused, the pop art urbanism is gone and there is a new emphasis on a holistic social view which includes the problems and potentials of the countryside and agriculture. The taste is for "cooler" things now — "cool" in McLuhan's sense — objective and detached. A new positivism is afoot. The imperative seems to be: "be satisfied to work with things and to mistrust principles." The arts seem cleaner than they did — less interpenetrative with ideas. For instance, the young performance artist — could we call him a happenings artist? — Stuart Sherman makes up a sort of theatre of small objects. He spreads things out on a large table, sorts them and moves with them, demonstrates conventional and unconventional ways of using them. But the criticism — both method and specific analysis — which would be *appropriate* to such performances has not emerged. Perhaps what we need is an *appropriate* criticism, something to parallel *appropriate* technology (which is the new watchword in that area). We need a hermeneutics that is not just for specialists, a structuralism which relates to the language of things and not to the fashions in French departments, a post-structuralism which uses the ideas of Derrida or even Lyotard positively in order to explainwhat one *feels* when one hears a chant by Charles Morrow rather than merely to attack what a few French professors said twenty years ago. In short,

we need a repository of sets of critical approaches and ideas from which we can develop this appropriate criticism. The devil in our universities is not their intellectualism but their politics, their trendiness; thus it is hard to say whether it is possible for such a criticism to come from or to centre on our universities. Only to the extent to which a university is free to be an intellectual centre is it possible.

Rather, then, than starting from criticism and developing ideas about what one will or will not experience *in vacuo* (so far as artistic practice is concerned) — which means that real dialectic is between what one says and the rules and practices of university politics — why not start from some of the ideas common in very recent performance arts, and generalise from them?

One idea is that each work has a unique gestalt which no single performance or notation can totally realise. The term is used widely these days, by performance artists as different as Newton and Helen Harrison, Philip Corner, Alison Knowles and the dancer Meredith Monk. The character or persona *in* a work, the thematic concept and abstract values, each are subordinate to this gestalt and must be so thoroughly embedded in it that they do not overwhelm it lest they wreck its texture. Thus the role of "idea" becomes different from what it was in pre-postcognitive art, literature or discourse: one can evoke an idea, but one is not to prove or to demonstrate it. This is true both of abstract principle and of characterisation. Thus, in Meredith Monk's *Songs from the Hill,* sound poems actually, each of the "songs" evokes a psychological mask or persona in the way a ballet dancer does in character dancing. After each song the character returns to the limbo from which it emerged. In Alison Knowles's *Bean Garden* she performed with her (my) twelve-

year old daughter: a gestalt appeared of mother and child, part of another gestalt of dailiness. The gestalt of the work is, then, part of a linkage of other gestalts, neither subordinate nor superior to it. The gestalt is a quality which the work realizes based on its materials; it is what it exemplifies. But it is not, for example, a hypothesis or a message in the sense of being a separable idea, capable of proof or demonstration.

The second point of concensus has to do with the self-image of the artist: the traditional self-image projected by an artist is a consistent one, while the postcognitive one is often nearly obliterated or anonymised besides. When a traditional composer such as Charles Ives took a sound experience from his personal experience, he turned it into Ivesiana. But the postcognitive artist tends to leave it be, for the most part unchanged. Thus instead of creating a mythic personality for himself or herself, the postcognitive artist tends to make the working materials assume mythic or archetypal characteristics. Alison Knowles working with her daughter becomes Everywoman working with hers. Where in earlier postmodern modes — what I can only call with a horrendous neologism, "pre-postcognitive" — a Charles Olson would not write the poem that needed writing but would imitate the kind of poem that his self-mythic Olson would produce and would thus create a dialogue between the poet and his poethood, the postcognitive artist creates more a dialogue between working material and its myths, between lightbulb and the idea of a lightbulb.

Thus, in postcognitive thinking, the focus lies on the work and not the worker. The impetus to be consistent — in the sense that one might imagine Charles Olson felt the need to do things according to his public and professional image — is not felt in the area of expression, but only of ongoing concern. The new artist says: "I am interested in beans, so I will use them until such a time as I am no longer interested in beans." Thus the postcognitive artist no longer creates a fully formed persona of himself or herself, but creates only the momentary and tentative gestalt, subject to change and modification. If he or she sees that thus-and-such needs doing, then he or she does it. No matter that *A* is a so-called painter, if she feels that some poem needs making, she makes it. This is inherent in the psychology of what Richard Kostelanetz calls "polyartists." In the past artists expanded their horizons in order to extend the challenges — to try themselves in new worlds. Today they simply follow their natural interests, their intuitive curiosity, their wondering whether this or that would "work." The avoidance of expression is not some form of hebephrenia — the pathological condition in which there is a phobia of emotion — but an unwillingness to impose oneself needlessly on the materials with which one is working. Where traditionally the expression was used to create the artist's persona — Beethoven as the mad and passionate genius, for instance — the gestalt of the artist today is directed only onto the mythic level. One thinks of Charlotte Moorman, for instance, as "*the* topless cellist" more than as an individual woman artist from Little Rock, Arkansas (which she happens to be).

Here there arises the crucial distinction between *acting,* in the old art, and *enacting* in the new art. Edmund Kean *acted* King Lear; today we *enact* our rituals of performance, stressing the materials of performance more than our own identities. You do not come to a John Cage concert to hear The Great Fuggitutti perform The Master's Immortal Masterpiece. You come to hear

179

certain sounds which will be meaningful to you, to see and hear certain things which will enrich your cultural or aesthetic experience. Skills may be involved; they usually are. Paul Zukowsky, who plays Cage's recent violin pieces, is a consummately skillful violinist. But he has better things to do than to act out the role of the Great Paul — which would detract from the significance and stature of his performing. If Cage happens to be present and performing, he does not do so *de rostro* as a great man or great authority, but as an active and involved participant. Or, in performing in a happening or a fluxus event, one performer is more or less replaceable by another so long as there exist the physical capability of doing a given performance task and the spiritual appropriateness of that task to be done by the performer at hand. Character is relative, not absolute. One *is* what one *does,* and style proceeds from the gestalt of a particular work. It would seem tyrannic to require that the same style be used for subsequent works for the sake of consistency to one's so-called identity, especially if those works are made for quite different situations, locations and purposes. Perhaps one can assert, though this is hard to demonstrate, that in place of an artist's consistent and ongoing persona or ego, that the ego is replaced by a super-ego, an objectified, generalised and mythicised version of the artist, used as both a poetic reference and as a genius implied by the work. The "artist" becomes a metaphor, while the particular artist remains hard at work.

Turning to another area, the intermedia are necessarily synchretic. That is, they fuse elements from various wholes, rather than allowing each element to remain simultaneously present, distinguishable, discrete and potentially capable of being separated out of the work. The newer performance artists, conscious of the implications of their intermedia, seem to take a synchretic approach to their cultural contexts as well. That is, not only do they tend to fuse visual art, heard art, spoken art and poetry, but they often fuse in elements from other cultures and civilisations, which are borrowed not for any exoticism (exoticism, after all, is ephemeral and vanishes with familiarity — South America is only exotic to people who have not lived or been there), but for their appropriateness to the work at hand. Often they tend to swell the context with which the new artist works. For instance, there are the event pieces which are very similar to fluxus works, which Jerome Rothenberg culled from South Pacific cultures in his *Rituals* and *Technicians of the Sacred* books. There is no need to be authentic in such pieces. The older question in performance, central to existentialism or to the Stanislavskian method, may have been: "Who am I being when I am being someone else?" Often the unspoken question of new performance works seems to be, "Has anyone besides us made performances like ours? Are there precedents for them, or are they unique to our here and now?" The significance of this kind of synchretism of cultures seems to be its answer to that question: "No matter how different these new works may be from traditional western performance art forms, they have precedents in the human experience outside the west," and this context helps to give them legitimacy by establishing itself as a referent that is far more broadly based than some urban, western-world avant-garde alone.

I am what I can do. This is one of our ruling maxims in the new arts. Charles Morrow chants — and syncretises elements from the Siouxan, Hebrew and oriental tra-

ditions into one whole. He also writes (and composes) television jingles for a living. When he chants, is he a jingle-writer chanting? When he writes jingles, is he a chanter writing jingles? An older generation would have answered yes to both questions. But for postmodern performance artists — especially recent, postcognitive ones, there is not so much a question of having a multiple identity as a polyvalent one. One extends one's identity by doing a variety of things. Sometimes it even seems to be assumed that a greater identity — in the sense of a broader capability and scope — is qualitatively "better" than a lesser one. This is, I think, very debatable; but it is an idea that is encountered very often. Each performance artist seems to feel that he or she should have worked in videotape and cinema as well as live performance. A festival of sound poetry is announced and — lo and behold! — all kinds of poets and artists produce their first sound poems — some quite good ones. Strange, how they seem to feel that their message is incomplete without such polymathic catholicity. And so it is with the individual performer in the individual work. Meredith Monk has remarked in a lecture about the difficulty she had, in teaching a choreographic work of hers, in getting any one of a group of new performers to do the variety of things which Lannie Harrison, a member of her original group, "The House," had done in its first production, and how she had to break up the part and divide it among several performers. However, note that she did so. The emphasis was on the things that were to be done. Can one imagine how in a similar situation, a choreographer might arrange to have a pas de deux in *Swan Lake* danced by three dancers, on the ground that no pair of them could do what the choreographer had in mind? Here then is yet another character-

istic of many new works: the number of performers is open, but the things that are to be done are fixed. Monk speaks of a new work that is now in progress as being either a vocal quartet or a full-fledged theatre work. Knowles and Corner specify what they want to happen, but say only that it is to be realized by from one to five performers. This can be working "at degree zero" in Roland Barthe's sense without its being anything which an orthodox structuralist could explain. But what this approach uniquely enables is the taking advantage of a particular performer's capabilities, on the one hand, and the consistent inclusion of some intention or intended body of material on the other. John Cage has fixed four particular singers as his instruments for one recent orchestral work. When one or more cannot be present, rather than make a substitution, he uses a tape of a performance by that performer. This complements Meredith Monk's division of materials among new performers, but it is not its opposite. Rather it is just an alternative way of guaranteeing that such and such a piece will always include such and such material, quite independently of the vagaries of traditional performance style. The work is the process of its realisation, and is not some fixed ideal towards which any given realisation merely aspires. There can be no definitive performance here, as there might with a symphonic work of Mozart, Berlioz or Schoenberg. One gets, instead, samplings. The sampling may be brilliant, but there is always the consciousness that one is experiencing only one of several ways in which a given work could be realised.

Of course there has always been *some* sense of the change of meaning of a work, the shift in how an audience has experienced this or that work through its history. But in the recent works I have mentioned, the

181

audience is encouraged to be active-minded rather than passive, and not only to see the work as it is taking place, but to project, imaginatively, alternates as well. If it is clear that a work moves from point *A* to point *B,* then one thing a spectator must do is imagine *A* and *B* and *C* as well, in order to see why a work is as it is and to appreciate any unique character or strength in a given realisation. One sees through the work to its gestalts. One sees through the performance to the gestalt of the work. Thus there is in all such postcognitive performance art an activity of watching the process on a plurality of levels. One cannot sit back, like the old ladies of Boston at a Tchaikovsky concert, with eyes closed and breasts heaving, waiting to be ravished emotionally. Rather one must be like the witness at a ritual or a crime, or like the public at a boxing match, being both in tune empathically with what one is seeing and mentally dealing with the tactics of each move. One will be lost if one looks for passive thrills. As one new performance artist remarked, Geoffrey Hendricks it was, "Ya won't get 'em." But if one lets the mind wander, if one queries what one sees, if one feels it in relation to what one already knows or has felt, then the experience of "watching the process" is a very rich one, deeply satisfying, uniquely so. Taking art as process, then, makes new and interesting experiences possible, which is ultimately the best justification for an innovation in art.

West Glover, Vermont
July 16, 1978

INDEXING: Conditionalism and Its Heretical Equivalents

Bruce Barber

A BASIC PROBLEM is that which American sculptor Sol Lewitt encountered when, in the late sixties, he began asking those artists who had been associated with the term 'minimalism' whether they would 'refer to' (index)[1] themselves as 'minimal artists.' Finding that nobody would own up to this fact Lewitt concluded that the label[2] had been coined by critics for their own, initially pejorative use. He further denounced it as a secret language they had invented in order to communicate with one another. Like the rash of sixties 'mini' labels however, 'minimalism' held and soon became firmly entrenched in the larger art historical system of classification.

A well documented case of what has often been described as a 'pejorative' label being subsumed under art history is that of Fauvism. The 1905 jury of the salon d'automne hung the work of Matisse and eleven other painters in a room populated with bronzes executed in the 'Florentine' manner. The exhibition apparently moved one critic to cry, "Donatello parmi les fauves" — "Donatello among the wild beasts."

Many labels have been intentionally, but more often than not, inadvertently coined (indexed), by artists themselves. 'Happening,' the accidental and 'rather unfortunate' label, coined by Allan Kaprow, was given to certain 'theatre events' of the late fifties and early sixties. As Kaprow notes in his book "Assemblage, Environments, and Happenings." (Abrams 1966)

I doubt that this is a term acceptable to all artists. It was part of the title of a score included in the body of an article written in early 1959 for the Rutger's University Anthologist (Vol. 30. No.4). This was apparently circulated in New York City. In October of the same year I presented "18 Happenings in Six Parts" at the Reuben Gallery, a loft on New York's Lower Fourth Avenue (now an artist's studio). A number of artists picked up the word informally and the press then popularised it. I had no intention of naming an art form and for a while tried, unsuccessfully, to prevent its use." (Kaprow 1966, p. 184)

Kaprow's initial objections aside, the term stuck, and later even he was to capitalise on the success of his own invention. In 1969 Lewitt was to manufacture or at least aid in popularising the term 'conceptual art'[3] and very recently attempts to coin an art label — 'contextural art' — have been made by one Hervé Fischer.

An important point to be made here is that there is a distinction between a critic's designation of an artist's work or activities and that which the artist makes. The critics's usually develops from a dialogue with the work, sometimes the artist or both; the artist's designation usually arises from

the production of a group of works, a statement of intent, a manifesto and sometimes a combination of all three. The artist's designation may later be appropriated by the critic and popularised (a form of legitimation) through the media. The distinction, which varies from instance to instance, would be the *arbitrariness* (initially) of the former and *provisionality* of the latter. Why for example was Barbara Rose's 'ABC art' not appropriated for art historical use? Why did sculptor Donald Judd's 'specific' not adhere as a label, or 'primary art'? And then how about Michael Fried's 'literalism'? Then there is 'idea art' or 'arte povera' in place of 'concept (conceptual) art'. What, in short, gives any one label predominance over another? Does it need to undergo a certain process of ratification by all parties concerned or is it merely a matter of chance, or worse, marketing expertise that determines which shall predominate? This led me to conjecture whether all labels in art history and more especially contemporary art history, were provisional in character; and furthermore that their use remains provisional until they can be tested and if possible refuted. Not only does the label remain provisional but also the artist's work, his or her activities in relation to the designation, be it their own, or others; at least until there is a substantial body of opinion, usually in the form of books, statements, reviews, articles, etc. that would maintain, — yes, indeed, the works or a portion of the oeuvre of artists X and Y match the designation of provisional 'category' A — and yes, this strengthens or affirms the opinion held by others associated with either the formation or ratification of this 'category' that it is indeed a ... genre, style, movement, or what have you.

This was the point at which I started.

Other questions attended the conjecture. Are there exceptions to the rule? How provisional is provisional anyway? And what does unite the same and other or set them apart as the case may be. If the label, the primary index, is provisional does it necessarily follow that the artists' work, the critical commentary for this work, (which is the critic's work) the alphabetical and chronological registering — indexing — of that work and the final art historical classification, are provisional as well? How far can we go before provisionalism stops being the norm? The conjecture, which had begun to assume heretical proportions by this time, had to be refuted. The lowest common denominator to the problem (my conjecture) appeared to be that this thing — called provisionalism — was conditional; conditional upon other assumptions, presumptions. Labels were provisional, not simply because their coining was possibly an arbitrary affair but because there were alternatives. Somewhere in this process, however, verification and legitimation begin to take place. Referencing, under the power of this 'legitimation' process changes to registering.

INDEXING: PROBLEMS FOR THE CONTEMPORARY ART RESEARCHER

A SIMPLE, yet important piece of research I conducted revealed an interesting side to this provisionalism problem. I called it, with some reservation, 'official provisionalism.'[4] This gives a peculiar emphasis to some of the points raised earlier in the discussion and particularly to the distinction made between referencing and registering.

Taking aside volumes of the Art Index[5], the 'official organ' for the cataloguing of ar-

ticles from leading journals and magazines dealing with the arts, I began to look for and examined the entries under three separate category headings — 'Happenings', 'Body Art', and 'Performance Art'. This became, given that label proliferation is one characteristic of rapid stylistic change in contemporary art, a means toward ascertaining the ability of the index system to keep pace. I assumed that the Art Index was objective, accurate, and authoritative in its 'reportage'. I further assumed that as it was published quarterly, there was ample opportunity for the Index to keep abreast of contemporary developments as they were presented in the form of published articles. I was wrong. I found that in as far as the indexing methods were a means toward keeping pace with the proliferation of contemporary art labels; that is, keeping up with the information and activities for which the label was a designator, the Index had moved from a position, in the fifties, of being 'less than adequate' to 'more than (overly) adequate' in the seventies.

I found, for instance, that 'Happening' as a separate category does not appear until April 1963 with an article by D.G. Seckler, published in *Art and America* titled "Audience is his medium." This, as the first Art Index reference for 'Happening', is some four years after the term itself had been coined and at least two years after it had gained popular usage in advertising and the press. Similarly, 'Body Art' which was being done in the mid to late sixties and was the subject of an important early article by W. Sharp titled "Body Works," *Avalanche,* Fall 1970, does not appear as a separate heading in the Art Index until 1971 — 1972 (vol.20) with an article by Cindy Nemser titled "Subject-Object: Body Art," *Arts Magazine,* September 1971. 'Performance

Art' fares somewhat better and the first entry appears under a separate index heading in 1972-73 (Vol.21).

Tracing the development of these labels from their inception to the present day became an arduous but important task. Curious patterns emerged which began to reveal peculiarities and inconsistencies in the indexing procedure itself. To the index compiler, who is also by virtue of the role accorded him, an index reader, the accumulation of articles for these years may have patterned themselves into a rather miraculous 'birth and death sequence'. The hideousness of having to deal with art 'labels' that appear and disappear in quick succession like a Lewis Carroll 'grin without a cat' is hard enough for the initiated to contend with, let alone the individual who must place an article under an appropriate subject heading at a glance. How does the index compiler/reader deal with the first order indexing problems of the artist as these are 'interpreted' into the second order problems of the critic? How is the designated further designated? The answer is that one looks for the obvious and when that doesn't work, one covers the options. Better, after all, to seek the cat to the grin than the grin to the cat. So to reiterate a little here, we see 'Happening' first entered into the Art Index, Vol. 13 (Nov.61-Oct.63) with the previously mentioned Seckler article. Between November 1963 and October 1965 (Vol.14) there are five listings; from 1965 to 1967 (Vol.15) there is an exceptionally long listing with some seventeen articles. Twelve of these have a direct association with the term, two with the 'Experiments in Art and Technology' exhibition held at the 25th Street Armory in New York and a few less directly associated articles such as "Velvet Underground in Hamilton: Arts/Canada attends McMaster University's

multi-screen audio-visual evening.' written by B. Lord, *Arts Canada,* February 1967. The Index for 1967-1968 (Vol.16) has seven listings; four of these are reviews of the Kirby and Hansen 'Happenings' anthologies which were published in 1966. Two deal with 'happenings' and 'events' as their prime subject — "Pinpointing Happenings" by A. Kaprow, *Art News* October, 1967 and a short article on the German artist Wolf Vostell by H. Rywelski which appeared in the October, 1967 issue of *Aujourd'hui.* An article by English artist John Latham, *Studio* September 1967 does not deal with 'happenings' in more than a peripheral sense. The researcher's cue 'see also Destruction in art symposium' completes the listing. Under 'Destruction in art symposium,' we find one listing titled "DIAS U.S.A. 68: atavism in civilization or art" by L. Picard, *Arts* April 1968. For 1968-1969 (Vol.17) we have two reviews, the first describes a César "happening" at the Tate Gallery in London and the second "Plays" by James Lee Byars, documentation for which appeared in *Progress Architecture.* For November 1969 to October 1970 (Vol. 18) we have four articles all directly associated with the 'happening' phenomenon.

It must be remembered that at this time 'minimal' art as a vanguard phenomenon was beginning to wane with 'conceptual' art taking its place. And in the aforementioned Volume 18 appears the first listing for 'performance,' though not 'performance' as it was to be later stylistically characterised. This article under the 'Performing Arts' listing with the title "Performance as an Aesthetic Category," H. Hein *Journal of Aesthetics,* Spring, 1970, dealt primarily with dance, though mention was made of 'happenings' and 'total theatre' forms.

In the Index for 1970-71 (Vol.19) 'Happenings' has seven listings, two tracing the historical development of the 'movement,', interviews with Allan Kaprow and Ben Vautier and the rest rather isolated or provincial instances of 'happenings'. We find, for example, an article in *Craft Horizons* (October) which reviews two 'happenings' at Southern Illinois University and a "Tasmanian beach party". AASA convention of creativity Hobart". C. Price which appeared in *Architectural Design,* October 1970. Here also under the 'Performing Arts' heading and with still no separate listing for 'performance art' is a seminal series of statements by the American artist Vito Acconci — "Vito Acconci on activity and performance" which appeared in *Art and Artists* May 1970. The other two articles listed under this heading are more directly keyed to the 'performing arts' as an aesthetic category. Accordingly both articles appear in the *Journal of Aesthetics.*

Now let's examine the entries from 1971-77 a little closer. In the 1971-72 (Vol.20) of the Index 'Body Art' as a separate heading first appears with the Nemser article. 'Happenings' remains as a separate listing with nine entries; a disparate mixture of reviews and articles many of which could have been placed under separate headings — 'Performance' or 'Dancing'. At this time a separate 'performance art' listing had yet to be instituted, even though Acconci's article (manifesto) had appeared in journals not carried by the Index. And under the category 'Dancing' there is actually one review entry titled 'Performance', *Craft Horizons* December 1971, which dealt with dance and many of the events now acknowledged as being 'performance' work. This review, written by F. Alenikoff appeared for several years in nearly every issue of *Craft Horizons* and the contents could have served the Dancing and Performance headings equally well.

The volume for 1972-3 (Vol.21) includes under 'Body Art' one minor article, "Idea Demonstrations: Body art and Video Freaks in Sydney," by Australian critic Donald Brook — *Studio* June 1973 and an article by K. Thomas on German artists Klaus Rinke, Franz Erhard Walther, and K. Gollwitz; "Prozessmaterialien" for *Kunstwerk* January 1973. 'Happenings' remains as a separate heading with five entries and an interesting addenda to the list — "see also Performance art."

'Performance art' appears for the first time in this volume with six listings — a *Kunstwerk* special issue "Aufführungskunst" translated as performance art (also listed under 'Body Art'), "Howard Fried, synchromatic baseball' and "Intention-Intentionality sequence," by Dan Graham, both of which appeared in *Arts* magazine April 1973. Also listed are articles by Jack Burnham, "Contemporary Ritual: A Search for meaning in Post-Historical terms" and "Joan Jonas: Organic Honey's Vertical Roll," by Constance de Jong, both from the March, 1973 issue of *Arts* magazine. A survey of artist Meredith Monk's work, with an introduction by A. Westwater, *Artforum*, May 1973, "Performance and Experience," by R. Mayer *Arts* and finally "Performance of Concern: Gina Pane discusses her work with Effie Stephano," which appeared in the April 1973 issue of *Art and Artists*. At the conclusion of this list is a note which reads 'See also Body Art and Video Art'; indicating what was considered by many at this time to be the close ideological and morphological proximity of these 'genres'. Under 'Video Art,' Jong's and Brook's articles reappear — correctly because of the dual nature of the content in each. 'Performing Arts' is still here as well, with, interestingly enough, an article more suitable for the 'performance' heading, "Perfor-

mance, a conversation" by Stephen Koch which appeared in *Artforum* December, 1972. The article is a taped discussion on the topic of performance between Trisha Brown, Robert Dunn, Richard Foreman, Yvonne Rainer, Twyla Tharp and Daniel Ira Sverdlik. This entry also appears under 'Dancing' with a "see also Choreography, Multi-media, and Performance Art" bringing us full circle or perhaps to where we should have been in the first place. The most interesting point to note here is that there appears to have been a 'category' split — 'Performance Art' has 'split' from or into 'Body art'.

With the listings in the 1973-74 Index (Vol.22), 'Body Art' has "Cinéma et Video; Body Works — Acconci, Fox, Oppenheim," by B. Bourgeau from *XXe Siècle* December 1973, and the researcher's cue "see also Video Art." 'Happenings' now seems to veer away from the original sense of 'art happening' toward the loose catch-all phrase that it had become in the popular press some three or four years earlier. Accordingly, two of the articles listed tend towards these extra and 'impure' aims. "Celebration of Creation: Fibre Interlacing", by A. Donovan in *Craft Horizons,* August 1973 and "Fabric Encounter" by S. Kaplan which appeared in the *Handweaver,* July 1973. Two other articles appear, one with a direct relationship to 'art happening': "les Happenings, le Théatre et la Conserve," B. Noel, *XXe Siècle,* and the other "Il Pubblico come casa di risonanze" which appeared in the September 1973 issue of *Domus,* this article which had more to do with 'body art', was written by Lea Vergine, an Italian critic and early popularist of 'Body Art' and 'Performance' in Italy. At the end of this rather disparate list is the strangely unpredictable — "see also Performance and Video Art." What we have here may be a form of ap-

propriation. It seems quite obvious that the editors and compilers of Art Index felt it appropriate to cover all of the options by providing this addenda, given that some critics were themselves having difficulty at this time. But it is also interesting that as early as 1966 'Happenings' had found its way in to the addenda section of *Webster's Third New International Dictionary* with quite acceptable definitions:

> *Happening (n): an event or series of events designed to evoke a spontaneous reaction to sensory, emotional, or spiritual stimuli: as a) The activities concurrent with or involved in the creation or presentation of a nonrepresentational art object (as an action painting) b) a usually unrehearsed staged performance utilizing art objects and sound effects for change and impromptu effects.*

'Performance Art' appears in the volume under discussion once again with a large listing (fourteen articles). These include "Dada Performance at the Cabaret Voltaire," by A. Meltzer, *Artforum* December 1973 (articles alluding to or declaring precedents for 'new' art movements or styles), and several for the new dance and music (Meredith Monk) and new theatre (Tadeuz Kantor's Cricot theatre). Also listed is the special Spring 1973 issue of the *Oberlin College Bulletin* on Performance. Lea Vergine's previously mentioned article reappears and a "see also Body art and Video Art" completes the listing. And not to get caught with their pants down the editors see fit to include a separate listing for A. Meltzer's "Dada Actor and Performance Theory" under the 'Performing Arts' category, presumably because the word actor appears in the title. This article which appeared in Artforum, December 1973 issue, should have been placed under the 'Performance Art' category.

In Volume 23 1974-75 under 'Body Art', appears an important article written by Lea Vergine titled simply "Body Language." It was published in *Art and Artists* September 1974. Also listed is a book review of Vergine's anthology of Body Art, "il corpo come linguaggio: La 'Body Art' e storie simile," written by an artist who appears in the book, Gina Pane, *Domus* October 1974. One of the bluntest criticisms to have been written of Body Art to date, "Indecent Exposure" by Peter Plagens published in Artforum's March 1975 issue also appears here. 'Happenings' remains as an independent entry and the general tenor of the articles listed is of a search for the genesis and historical continuity of the 'genre'. Kaprow's "Echo-Ology" *Artforum* Summer 1975 which is really just a glorified advertisement is listed, as is S.W. Peters' article on the German Fluxus artist Wolf Vostell, "Vostell and the Vengeful Environment," *Art in America,* May 1975. Under this again is the "see also Performance art and Video Art." Under the 'Performance Art' category there is an article on Chris Burden, "Through the Night Softly", by J. Butterfield, *Arts* March 1975, "Moving Things," R. Pomeroy, *Art and Artists,* November 1974 which deals with sculptor Robert Rohm's performance pieces and "Performance", a lengthy review of books dealing with those artists' work representative of the new form. A review of dancer Simone Forti's work, "Performance a Milano" by V. Alliato, *Domus,* April 1975 follows and then "Vito Acconci, Work 1973-1974" by A. Sondheim, *Arts,* March 1975 and to complete the list "Zur geschichte de 'sculpture vivante'" by U. and R.Graf which appeared in *Werk* No. 2, 1974. A "see also Body Art and Video Art" follows. Under the 'Performing Arts' heading we read "see also group W.O.R.K.S." and when we inspect the content of the article to which W.O.R.K.S. refers we find that this group works with

Video and does performance.

To move now to Volume 24 (November 1975 — October 1976) we find under the heading 'Body Art', "La Langue du Corps" (Body Language) by G. Noel XXe Siècle, June 1975; "Pygmalion Reversed" by Max Kozloff, one of the more intelligent criticisms of body art to have been written to date, published in the November 1975 ISSUE OF Artforum, and "Space as Praxis" by RoseLee Goldberg which appeared in Studio September 1975. A "See also Human Figure in Art, Performance Art and Video Art." directs the researcher toward other sections of the Index. However, when we look under 'Human Figure in Art' we find that this in turn splits into no less than twenty one separate headings. 'Happenings', though still listed, has no entries other than the 'tell tale' "see also performance art." 'Performance art' has eight entries listed — "Chris Burden: Performances negli USA a Milano" by C. Ferrari, Domus, August 1975; "Couming along — Colin Naylor interviews G.P-Orridge", Art and Artists, December 1975; "Dan Graham: Past/present," by R. Mayer, Art in America, November 1975; "Kollektivkunst von den bauhutten zur gruppen dynamik," authored by P. Killer for Werk, Vol. 1, 1976 and then a short but intelligent article by A. Hayum titled "Performance and the Arts" which appeared in the summer, 1975 issue of Art Journal. The Goldberg "Space as Praxis" article reappears here along with this author's article, "New York: Recent Performance Work: Four days at the Whitney and the Modern. Scott Burton at the Guggenheim and Dada Soirée at the Clocktower," for Studio, May 1976. This is followed by 'Performance' (Reviews) by English artist Marc Chaimowicz for the Studio issues of January, March, and May, 1976 and finally "Performance art in Italy" by C. Tisdall,

Studio, January 1976. The by now predictable "see also Body Art, Coum (group) and Video art" follows.

For January 1977's 'Body Art' we have "Annihilating Reality" — G.P-Orridge and P. Christopherson, Studio, July 1976 (special issue on performance) and "Auto art: Self-Indulgent? And How!" by Peter Frank for Art News September 1976. Under these entries is "see also Artist in Art, Performance and Video Art." Under "Artist in Art" there are further directions "see Reminiscences, Rights, Statements, Travels" to further confuse the ardent researcher. 'Happenings' appears in this volume with a small number of historically oriented articles as if to 'tie the movement up'. Arts, September 1976 has "Allan Kaprow's activities," by C. Jonathan; Kunstwerk, July 1976 has "Atonumente durch medien ersetzen," by G. Friedrich, followed by a "see also Performance Art" as before. The 'Performance Art' listing also carries "Kaprow's activities" along with Frank's "Auto Art." Domus, August 1976 is listed as having work by artist Alan Sonfist, "Natural Phenomena as Public Monuments" — Sonfist's 'process art' having little to do with any of the headings under examination. Also listed are the contents for the special Studio issue — "Performance".

The April 1977 Index includes under 'Body Art' "Pains and Pleasures of Rebirth: Women's Body Art," by L. Lippard, Art in America, May 1976. 'Happening' mysteriously disappears and under 'Performance Art', "Ancora per Assuado: 32 ft. per second, Performance San Francisco," Domus, October, 1976. Next listed is an article by Nancy Foote, "Anti-photographers" (thankfully also listed in the photography section), Artforum, September 1976, followed by "Alan Sonfist: Time as an Aesthetic Dimension," by C. Robins, For Arts, October

189

1976, an article which has little more to do with the 'Performance' category than the previously mentioned article for *Domus*. Lippard's "Pains and Pleasures" is relisted along with two articles on Vito Acconci — "Vito Acconci, Stars and Strips," by R. Skoggard, *Art in America,* November 1976 and "Vito Acconci: Recent Work," by P. Salle which appeared in *Arts,* December, 1976.

For July 1977 there are no entries, nor even the headings for 'Body Art' and 'Happening'. 'Performance Art' has Allan Kaprow's "From Happening to Activity", *Domus,* January 1977: H. Freed, "In time of time; the artist necessarily works in and of time," *Arts,* June 1976 and finally J. Reichardt's "Kantor's tragic theatre" for *Architectural Design,* November 1976. We find that the next heading, 'Performing Arts', has now split into 'Performing Artists (see entertainers)' and 'Performing Artists in Art (see entertainers in art)'.

The last Index issue I wish to deal with is October 1977. Once again 'Performance art' is the only one of our three headings that is present. Listed here we find "Dennis Oppenheim's motorized self-portrait marionette, titled Theme for a major Hit" by J. Crary for *Arts,* February 1976 and "Participation performance" by Allan Kaprow *Artforum,* March 1977.

What can we deduce from all of this. One simple assessment — an index reader's deduction — might lead us to believe that somewhere along the line we have witnessed the 'demise' of the 'happening' (which is actually what happened) or alternatively the subsumption under or absorption of this heading into that of 'Performance Art' (which is what didn't happen). We may also feel that we have been privileged to view the beginnings of the absorption of the 'Body Art' and 'Video Art' headings into that of 'Performance' or another less likely alternative, the absorption of 'Body' and 'Performance Art' into 'Video Art', 'Dancing', 'Artist in Art', 'Performing Artists' (see entertainers, 'Performing Artists in Art') and a host of other headings and subheadings. I have purposely not dealt with these even though the string is there to lead the researcher into a labyrinthine web from which even a Theseus would not find his way. What we have witnessed while exploring the entries is the editors' attempts to place generalised and in many cases non specific articles (regarding content) into some kind of useful and intelligible order of subject — apart from the one that could be structured by using a simple author/artist index. However, it is my view that given the general paucity of specific articles or conversely the extensive nature of the content for many of these, it is a wonder that single subject headings were found for them at all. One is lead to contemplate the question; which came first — the subject heading or the articles to put into it. Of course the answer to this is, as philosopher of science Karl Popper pointed out several years ago, "an earlier kind of egg" — (read heading).

The situation is compounded when one learns that nearly 50% of the magazines and journals that deal with the three label types are not represented by the Art Index[6]. At a rough estimate and given the fact that there may be 10% to 15% still uncovered between the pages of the Index, (under artists names, book reviews and other subject headings) and that I may have dealt with at the maximum, a half of the 50% that the Index does carry — another 50% to 75% may still be around to uncover and index. This is in effect what I mean by 'official provisionalism'. Indexing as we have explored it seems to have become an end unto itself with its own system of requirements. Subject headings once they arrive in the Index

190

seem to acquire a life of their own and as such desire to be 'fed' every now and then to validate their existence. This is why we often find article misallocations. Multiple listings can further increase the problems associated with label proliferation, through category or class confusion. The Index to the unwary seems to give a 'legitimate gloss' to the labels, a gloss that almost serves to indicate that some form of *classification* is going on. Yet this over-proliferation of ordering and cross referencing[7] can finally obscure the development of our contemporary art history; one example of the results is in an article written by critic Max Kozloff, titled "Pygmalion Reversed, *Artforum,* November, 1975.

> "Body art's origins are obscured *in the recent process and conceptual art, the minimal sculpture of 10, the happenings of 15, and the Dada and Futurism of 60 years ago." (Kozloff, 1975, p.30)*

The origins are not as Kozloff indicates, obscured, he has just been unable to differentiate them. Category confusion *tends* to obscure. Adequate 'indexing' would enable us to isolate and identify those features which would in turn enable our judgement to be more authoritative.

THE TERMS: LIMITS TO PERFORMANCE?

"WHAT ARE the limits of performance? We do not know with certainty," said Michael Kirby in his introductory paragraph to a short evaluation of early (1971) art performance works.

"For several years," he continued, "we have been aware that performance did not necessarily need an audience. It could be done as an activity, in which the performer was his own audience so to speak." (Kirby 1971, p.70)

To my mind "the limits", as Kirby prefers

to call them, have still not been determined. This is what makes classification at the present time so difficult. The examples from the Art Index system previously given reveal how easily, on the official level at least, performance can bleed into other categories and vice versa. It is perhaps in the very nature of the word 'performance' that this be so, at least until the term becomes so convenient and 'catch-all,' like the word Happening, that it ceases to have any other than a specific historical relevance viz — performance in New York meant such and such to this particular group of people within this limited period of time. In fact the word performance is not like the word Hapening. It has been appropriated rather than coined and has therefore already been honed down by its users to accommodate what they wish it to mean. Indeed, it is (or was) less open to abuse from the very start of its existence as an art term than Happening ever was. As a word with already a great deal of currency in the vernacular it is less likely to be appropriated by the world of advertising than say Pop art, Body Art or Body Language. But then it's more likely to be open to abuse in the art world — of the kind that the term alienation has had in the world of sociology and philosophy.

Kirby, to get back to the 'limits problem', touches on an important notion as far as actually setting the limits is concerned; that is, can we actually ascribe the word performance to a situation where there is a performance but no audience? Does, in other words, the use of the word performance imply that an audience was present and can we call some kind of activity a performance when either the performer himself is the audience or all of the audience members become participants, or do we have to give it another term? This is in fact what did hap-

pen with some 'post-minimalist' work of the mid to late sixties which used the body as its raw material. The other situation is answered in some ways by Kaprow's ideal for the Happening which 'breaks the wall between art and life'. We shall touch on this point again a little later when distinguishing between an 'authentic' body work and Kaprow's theories. The name accorded this kind of work became Body Works[8], coined in 1970, probably by the editors of the then new art magazine *Avalanche* for the first major article to deal with the new form. Titled "Body Works: A Pre-critical, non-definitive survey of the very recent works using the human body or parts thereof," the contents are exactly as the title describes. However, for any critic approaching the subject now, the article incorporates nearly all the major problems that one is likely to find in any investigation into the limits of performance. In America at least, the term Performance gained preference over other terms fairly early on and even in the article named the term was offered along with others and was presumably received positively by the artists doing such work as one suitable alternative for their activities.

"Variously called actions, events, performances, pieces, things, the works present physical activities, ordinary bodily functions and other usual and unusual manifestations of physicality." (Sharp, 1970 p. 14)

Interestingly enough Allan Kaprow, with a slightly different emphasis from Sharp, italicizes the term *performance* in his book "Assemblage, Environments, and Happenings" (Abrams 1966) when he stated:

"Shifting things around can be an excellent mode of Performance as much as of composition. Just as environment or assemblage can be maintained in prolonged transformation by allowing its parts to be rearranged in numbers of ways, the same can apply to a Happening." (Kaprow, p.204)

A more likely source for the appropriation of the word for recent art is Vito Acconci, and specifically, from the writings of sociologist Irving Goffman, whose 'dramaturgical metaphor' for day to day interaction between people was a major influence on Acconci's early work and writings.

Sharp in his article broaches what appears to be a crucial distinction between Performance and Body Art. Sharp describes an early work by Dennis Oppenheim (Backtrack 1969) in which the artist's body was dragged along a sandy beach to make marks while the whole process was filmed. He describes this (after Duchamp) as an *'assisted* Body Work' because it demanded the assistance of others for its execution. And importantly, to distinguish this from an early Yves Klein work, he wrote,

"In some ways it is reminiscent of Yves Klein's Imprints (anthro-pometries 1961) using the bodies of nude models to apply paint to canvas, but Klein was more interested in the theatrics of the works which were generally done as performances. (Sharp p.15)

So here in the first major article on Body works is a feature which seemingly singles out the bona fide Performance work from the Action, Gesture, or 'authentic' Body Work — theatre. Does it divide it from the Happening or Event as well? Yes, in terms of the prerequisites or principles Kaprow outlines it does. However, a few of the principles are the same. For instance Kaprow states in his list of general principles that:

(a) "The line between art and life should be kept as fluid and perhaps indistinct as possible." (p.188) On one hand Oppenheim's work fits this description; after all, it's not an extraordinary gesture or activity to see taking place on a beach. But yes, it may be, if someone is carefully filming it with a 16 mm camera. The means of documentation provide an effective wall

between art and life. We are not merely documenting life, but framing it, containing it. And the real crux of the matter is what happens to the document after the event.

Kaprow's (b) is "Therefore, the source of themes, material, actions, and the relationships between them are to be derived from any place or period except from the arts, their derivatives, and their milieu". (p.189). Even Kaprow admitted in his explanation for this that it was an extremely difficult practice to adhere to, and in fact many of the Happenings make references to other forms of art — sculpture, painting, literature, film — as much as to popular culture — advertising, the automobile, etc. The credo 'nothing develops in isolation,' is certainly accepted here by Kaprow and probably in this instance by Oppenheim as well.

With (c) Kaprow states, "The performance of a happening should take place over several widely spaced, sometimes moving and changing locales." (p.190) This certainly doesn't fit the Oppenheim piece but then neither does it fit many of the works generally regarded as being Happenings either. Only a few of Kaprow's Happenings would actually comply with this direction.

(d) "Time, which follows closely on space considerations, should be variable and discontinuous." (p.191) Here is a marked difference between Kaprow's ideals and Oppenheim's work. Discontinuity and variability is the mark of the collagist and and ultimately the Surrealist. Oppenheim is more interested in continuous time, and he is certainly not interested in any more than the most rudimentary and 'real' forms of juxtaposition, i.e. body to sand to landscape. He is only working with what is given. For Kaprow discontinuity is an attempt to break the picture frame, reach out

from the proscenium to break away from any form of confinement because, as he says, these will "not allow for breaking the barrier between art and life." (p.193) Oppenheim happily accepts this convention. His use of the camera, if we want to be purists, all but says as much. With (e) we read "Happenings should be performed once only." For Oppenheim, who is not particularly interested in the spontaneity or novelty of the event, performing his gesture once may be all that is required. After all there is no difficulty in reproducing the action if the film doesn't come out well. There is no live audience as such to worry about. For Kaprow, however, reproducibility is one of the most salient and objectionable features of the theatre tradition. To renounce reproducibility is to embrace life.

(f) "It follows that audiences should be eliminated entirely." (p.195) Oppenheim is not interested in a live audience for his action, for there will be an audience for his work in the marketplace, the gallery or magazine. Kaprow would eschew this not only because it may be a crass form of consumerism, but also because it is another instance of framing, of the divisive function of art. Ideally for Kaprow, the audience for a Happening would become *all* participants or *all* 'watchers'. Another essential difference between the two artists is principle (g), "The composition of a Happening proceeds exactly as in Assemblage and Environments, that is, it is evolved as a collage of events in certain spans of time and in certain spaces." (p.198) If anything, this is diametrically opposed to the way Oppenheim, at least in his early works, operates. Juxtaposition is minimised, spontaneity, the collagist's use of chance and the discontinuous meanderings of the subconscious mind are all but eliminated. Oppenheim's work is exclusive rather than inclusive; he

focuses on the singularity of the event rather than the plurality. Absolutely nothing is extraneous to the original conception of the activity. Though Kaprow says that the Happening is 'anti-theatrical,' there is still a theatrical residuum which permeates the works.

Michael Kirby noted in the introduction for his "Happenings: An illustrated Anthology" (1966) that,

"Not all of the fourteen presentations described in this book were called Happenings by their creator. The poster for (Red Groom's) 'The Burning Building' called it a play," Whitman refers to his works as 'Theatre-pieces,' and Oldenburg uses 'Ray Gun Theatre'." (Kirby p.10)

As we have seen theatre is not the only element that one can use to compare and contrast. This discussion has pointed out that other attributes, more easily isolated than theatre, can be used for this purpose. And as far as Body Art and Performance are concerned, there is nothing to indicate that any single attribute such as Theatre can be isolated to say that this work — exhibit A is an example of either 'genre'. An even more detailed morphological and ideological analysis than I attempted with the Oppenheim example and Kaprow's principles for Happenings should be done.

Some of this has been attempted (Lea Vergine, Max Kozloff, Lucy Lippard, RoseLee Goldberg), yet even relatively recently in a 'definitive' "Project 74" essay for the "Kunst Bleibt Kunst" show in Cologne, the critic asks:

"Why the word 'performance' — and why this American technical term in association with a compact Beuysian principle?" (Gruterich, p.55,1974)

Why indeed? But the Germans have never been terribly happy with American coined terminology for their art. Klaus Rinke and German art critic George Jappe in a recently published interview (*Studio* July '76) were both adamant that there is no such thing as 'performance art' in Germany.[9] Their preference is for 'Aktion', 'Demonstration', or a more curious word offered by another German artist, Franz Walther — 'Handlung'. 'Aktion' as a synonym for 'Event' is also used in preference to Kaprow's term in German Fluxus artist Wolf Vostell's book "Aktionen: Happenings." (Hamburg, 1965)

The German words Handlung and Aktion however fairly closely approximate the English words perform, performance, here quoted from the Concise Oxford Dictionary:

Perform, vt. to do, to carry out duly; to act in fulfilment of; to carry into effect; to fulfil; to bring about: to render: to execute; to go through duly; to act; to play in due form.

and

Performance, n. act of performing; a carrying out of something; something done; a piece of work; a notable feat; manner of success in working; executing; especially an exhibition or entertainment; an act or action.

and then Action, this time from the Shorter Oxford:

Action n) Gen.1.) the process or condition of acting or doing; the exertion of energy or influence; working; agency; operation. 2) A thing done; a deed; in Pl. conduct; viewed as occupying time in doing. 3) the thing represented as done in a drama, poem, etc. 4) pl. acts or records of a court. 5) Gesture, esp. oratory; feature and attitude in sculpture and painting; trained movement of the body, etc. 6) the way in which an instrument acts.

Other more specific meanings follow — as in law, a legal process or suit; the acting of plays; a devotional exercise, etc.

Now for comparison, Handlung and Aktion in German from Cassels German/English Dictionary:

Handlung, (en) f. action, deed, performance, act, transaction, business, trade, commerce, shop, firm.

Dramatische Handlung — plot of a play

Handlungweise, (f) mode of procedure, action or

operation: way of acting, attitude, conduct, behaviour.

and

Aktion, (f) en (pl) has the editors "this has recently become very common and has the vaguest connotations: 1) Activity; Process, eg. Schuttaktion - clearing rubble. 2) undertaking, procedure.

It may be seen from this that handlung very clearly approximates the meanings for the English verb to perform, with, if anything, a slightly greater emphasis toward the theatrical. Aktion is extremely close to the English Action which it should be, as a fairly recent adaption into the German Language. Yet to evaluate objectively, neither the English or the German words have an exceptionally strong component of theatre in their meanings, nor is there any sense in Handlung, Aktion, etc. that these activities — doings, have to be done for another — an audience. The emphasis appears to be on the 'carrying out, acting through' or merely 'doing something.' They are fairly anonymous in this respect. Yet we find in two exchanges between Georg Jappe, Franz Walther and Klaus Rinke very fine distinctions being made.

G.J. "You are aware of the notion of 'performance.' Would you count yourself as one of its followers, or what description would you use for your work?"

K.R. "The concept of 'performance' comes from the New York scene. For us — for our generation - it took a long time after the Happening era to avoid walking in its footsteps. That is why we use the notion of Aktion and Demonstration. Aktion was basically a quite short minimal gesture, in contrast to the theatrical, material organisation of Happening. Minimal art was fundamentally very important for us. In the first place, it was concerned with material, but then we got rid of material and said: I only want to do things with myself. Personally I would prefer to call it Demonstration or 'I Present' something, if there is an exact translation for that." (p.63)

With Walther, Jappe opens again with the same leading question:

G.T. "You know the blanket term 'performance.' Would you accept it for yourself, or what description would you want to see applied to your own works?"

F.E.W. "Ever since the word 'performance' was first applied to my work I've had difficulties with it, because for me it has too many theatrical associations. All sorts of words have been used, but I haven't found one that's right. Certainly what goes on in my work has something to do with action — Handlung in German. It's thought processes developing. I've seen my work categorised sometimes as process art, sometimes as Behaviour Art, I should prefer to use the word Handlung if it can be turned into an art word: I like 'Aktion art' better than performance because its more neutral. And yet the English word 'action' I'm afraid it has something programatic about it: it almost amounts to a definition of content. I don't think I do 'Actions.' A better way to put it in English would be just 'doing' — it's simply an activity." (p.66)

Obviously the meanings in these instances correspond to the use, and no matter how much we would like to bind these artists to the literal it would still not enable us to feel satisfied with our appellation, simply because it's not theirs and there may be no real point of conjunction between their's and our's. And yet labels do matter to artists like Walther and Rinke because they are a useful way of signalling, usually in shorthand, the difference between their type of work and say that of Joseph Beuys who also uses the word Aktion, and those of the 'true' Waltherian or Rinkerian performance artist, say Acconci, whose work to them would be unnecessarily theatrical. Thus, judging by some of the remarks made by participants in the debate, 'performance' can be distinguished from 'Aktion' or demonstration on the basis of theatre. However, many of Rinke's works, for example, look superficially like some of Acconci's early works. If we were to compare some of Rinke's early "Primary Demonstrations" (1970-71) where simple,

unemotionally performed actions or tasks were performed (sometimes of long, sometimes short duration) such as moving one object from one side of a room to another, emptying one material from a container into another container or simply holding the body in certain positions for periods of time, with some of Acconci's early 'performances' or 'activities;' for instance his "Seconds" (1971) where he simply paced time in a circle around a naked hanging bulb, following with his eye the second hand going around a clock, we can identify certain common features. Both stem, according to the artists themselves, from minimalism; both are gestures that consume (for want of a better word) time; there is no acting or role playing in the accepted theatre sense; they are in some ways uninteresting to watch; there is little complexity or detail; there is no hierarchy in the structure of parts (instances in time) with the whole, (the duration of the performance). In fact they both fit neatly into many of the principles governing minimal dance as expressed by Yvonne Rainer . And yet the distinguishing feature between the two for Rinke would be theatre.

Now theatre is a very difficult thing to isolate unless you are an Irving Goffman who would dichotomise into 'front stage' and 'backstage' a household situation in which — (hypothetically) — you were in the bathroom, while your parents are in the kitchen talking to your neighbours while your brother is in the hallway talking to a policeman. It is almost as difficult to isolate as performance. Obviously, like performance, theatre is relative and context-dependent and to compare individual instances may be misleading and unfair.

However, some would say that Michael Fried did a pretty good job in his finely honed essay "Art and Objecthood," which appeared in *Artforum* June 1967. Fried's basic thesis, which was deftly used from the standpoint of modernist theory, to attack minimalism, is that there is, at the core of literalist (minimalist) theory, an inherent theatricality.

"What is it," he says, "about objecthood as projected and hypostatized by the literalists that makes it, if only from the perspective of recent modernist painting, antithetical to art?" (for art — read modernist painting) And "the answer," he proposes, is this: "The literalist espousal of objecthood amounts to nothing other than a plea for a new genre of theatre; and theatre is now the negation of art." (p.125)

In a new paragraph he continues:

"Literalist sensibility is theatrical because, to begin with, it is concerned with the actual circumstances in which the beholder encounters literalist work. Morris makes this explicit. Whereas in previous art, "What is to be had from the work is located strictly within (it)," The experience of literalist art is of an object in a situation — one that virtually by definition includes the beholder." (p.125)

The question of whether or not theatre is the negation of art is not at issue here. It is, I think, true to say that this is the case as far as modernist theory is concerned. And when Fried claims that minimal art is inherently theatrical and substantiates this view by ennumerating cases of 'statements of intention or observation' from what the minimalists feel and experience when confronted by the 'minimalist presence' — he is right. This presence was a means whereby the object somehow gained control over

the spectator, or Fried's term, the beholder. The beholder, asserts Fried, again interpreting sculptor Robert Morris, is distanced "not just physically by psychically" (p.126). And "it is," he continues, "precisely this distancing that *makes* the beholder a subject and the piece in question ... an object." (p.126) but what he subsequently goes on to reveal is that the beholder becomes *subjected* to the object's *power* or *presence*: The control that the object evinces over the viewer is like the instance he gives of sculptor 'Tony Smith dwarfed at the Nuremberg parade ground.' This 'control' is further equated with theatre. It is simply power that the one (the object, situation or person) has over the other. This, to Fried, is an example of "Art degenerating as it approaches the condition of theatre." Theatre corrupts, perverts and as he says in his conclusion, "We are all literalists most or all of our lives. (But) presentness is grace." (p.147) This 'presentness' exmplified in modernist art but not in minimalism is for Fried an affirmation of the continuous, (existential) and "permanent present" — a transcendent condition which art *should* have over the 'theatre of life.'

Paradoxically, it is almost as if Fried's essay were opening the door to the exploration of the self existing within this 'theatrical world.' It *is* an act of affirmation rather than of abrogation of the self in the here and now; in fact why use a surrogate object to 'get at it' — this transcendent condition?

Is this what Acconci means when he says that his early work was really "a last gasp of minimalism" (in conversation with the author, January 1977) or what Rinke means when he talks of substituting "the material of minimalism with (the material) of self"? (p.62). Probably not, in Rinke's case, for he would not worry too much about debating the notion of theatricality in those works associated with the term performance; for him it is in the word itself. But then minimalism? Perhaps Rinke is labouring under a misconception. If, as Fried says, minimalism is theatrical, surely Rinke should re-evaluate what he (Rinke) means by theatre, and alter the appellation for his own work accordingly.

Acconci possibly knew that it, (theatre), was there in the situation of the object 'confronting' the viewer, and the lesson was readily assimilable and translated into the ultimate theatricality contained in the subordination of the audience (the object) to the performer (the subject). Or were Acconci, Nauman and others pointing out in the late 60's that Fried's position was anomalous; that theatricality was not necessarily there (in the object) — even when you had a person *literally* imitating the object? This is one way the argument could go if one was to adhere to a lineage concept of art history from the beginnings of 'Reductivism.' The intense examination of the 'self in the world' may be the ultimate gesture to make in relation to the reductive impulse that has been said to have operated in mainstream art over the past century. The body object 'in-the-world' is probably more open to a close scrutiny by the self and others than the object used as a theatrical substitute for the body. But then is this the kind of narcissism that Merleau-ponty talks about in his essay the "Eye and the Mind" quoted ad nauseum by the 'literalists' of the 60's — the ultimate tautology we involve ourselves in when confronting the problem of the self in the

world? We, according to the philosopher, are confronting ourselves, confronting ourselves.

"The enigma is that my body simultaneously sees and is seen. That which looks at all things can also look at itself and recognise in what it sees, the "other side" of its power of looking. It sees itself, it touches itself, touching; it is visible and sensitive to itself. It is not a self through transparence, like thought, which only thinks its object by assimilating it by transforming it into thought. It is a self through confusion, narcissism through inherence of the one who sees in that which he sees, and through inherence of the sensing in the sensed — a self therefore, that is caught up in things, that has a front, and a back, a past and a future ...

This initial paradox cannot but produce others. Visible and mobile, my body is a thing among things; it is caught in the fragment of the world, and its cohesion is that of a thing. But because it moves itself and sees, it holds things in a circle around itself." (Merleau-Ponty 1964, p.162-3)

This is presentness; it may not be the presentness of the stage, but it is the presentness of the amphitheatre.

BODY-OBJECT. MORALITY AS A KEY TO CLASSIFICATION?

"STRICTLY SPEAKING," says Willoughby Sharp in his Body Works essay, "it is impossible to use the body as an object; the only case in which body approaches an object is when it becomes a corpse."(p.6)

Cadavers are not new to the art enterprise and several artists have proposed works which make use of a cadaver in some ways or even utilise their own bodies upon death (John Baldessari, Robert Morris, Alan

Sonfist). Sharp also notes that the "artist's body becomes both the subject and the object of the action."(p.6). Clearly this is a generalisation but it does provide us with the same tautology we saw earlier in the Merleau-Ponty quote. Sharp then, as if to deny his primary statement, goes on to enumerate examples of 'body as object' — 'Body as tool', 'body as backdrop', body as prop', 'body as place.' Others could conceivably be added — 'body as canvas', 'body as mannequin', 'body as landscape', body as building', 'body as animal's body', etc. The end is limitless and I hesitate to attempt a reductio ad absurdam. Furthermore this kind of 'transference' is not new to art or culture. 'The making of the body — an object, — the 'humanisation of nature' and the 'naturalisation of man' was as much in evidence in the time of the Egyptians and Greeks as it was in theatre of the commedia del'arte of the 16th and 17th centuries — a phenomena with a history as long as mankind itself. It has its roots in myth, ritual and religion — manifestations of man's relationship to his environment and other men.

In a 'Body work', even the most extreme examples (Schwarzkogler, some of the works of Burden, Brisley, Oppenheim, Brus, Pane, and Nitch). The 'corpus vivant' sense of subject is always there, no matter what the conditions of use or role assigned. It is wholly relative to what extent the object is emphasised over the subject. The body can be reified in many ways both inside and outside the art arena without losing, if there is a corporeality inherent within the subject — the essential subject. It is extremely difficult to alter this fact even with the most extreme forms of analysis available (ie. Gestalt Psychology or Behaviourism).

It is as difficult to elucidate the subject-object dichotomy from the audience stand-

point, and yet this where the accusations about the artist turning himself into an object often arise. Reification or 'thingification' as it is sometimes called, in this sense, has to do with alienation.

The questions from the audience's standpoint in this instance may take the form of these. "To what extent am I put into the position of being an object by what I see before me — am I being harmed in some ways by witnessing this act?" And to use just two of the many senses that the word alienation has — "To what extent have I become an *instrument* of the artists' intentions (Eric Fromm) ie. aiding them in realising their own belief in themselves (their self-esteem) helping to inflate their egos etc. etc.?" Or, "how am I being *estranged* (Hegel through to Sartre) from my own true beliefs — ie. regarding my sense of rightness or wrongness regarding this act before me?" (How does this observation make my judgement ambiguous.)

It seems that many writers when alluding to the reified or alienated artist or audience member, have fallen into difficulties — difficulties which arise because any investigation of alienation gets into the even more abstract domain of morality. The morality of the artist's intentions and ambitions in regard to his or her work is ultimately pitted against the moral conviction of the audience. This is the dilemma Max Kozloff faces in his criticism of Body and Performance art (Art Forum Nov. 1975). His stance is really that of the moralist. What he is feeling is the unfair manipulation of himself — the critic — by the artists' activities. It is not so much that the artists are 'reifying' themselves (hence the title of the article — "Pygmalion Reversed") but that somehow the viewer (recipient) of the artist's actions is being reified — alienated and in short, victimised. Just one of the remarks he makes in his essay will suffice to illustrate what I mean.

"Their bodies and ours: they're conscious, animate, sensitive and mortal organisms. The artist's flesh often gives the impression of having been exposed to damaging conditions, or having taken into itself something of the work, and possibly the force necessary to have made an object presentable as art. But we never had to empathise, as we do now, with the physical violence that materialised art because it has become dramatised by the artist who plays the role of its victim."(p.30)

The critic has become an 'unwilling' participant. By merely viewing the act he has in some ways counselled it. It's o.k. if Van Gogh offers us a surrogate for his act (his self portrait) or Schwarzkogler a photograph, but looking on while they do it? Absolutely not ! The viewer must in these circumstances feel some sort of responsibility. Is he as responsible as the hapless passerby who does not assist the victim of a rape attempt, while the raping is still in progress and he is in a position of giving aid? More fool is the passerby who joins in the rape, or robs the victim after the raping is finished. But this is art is it not and is *insulated* to a large degree from the vagaries that make decision making in life so difficult? No matter how moral a critic's feelings about what is right and lawful in art practise or how much of a legislator he pretends to be, he is not prime arbitrator — he is not a judge.

He can only place himself in the somewhat anomalous and mutually exclusive position of being either counsel for the defense or alternatively counsel for the prosecution.

And yet what does one do when Chris Burden shoots at a 747 with a revolver or lies down on La Cienaga Boulevard in L.A. pretending to be an accident victim? Applaud it as meaningful and innovative art or convict him for committing a criminal of-

199

fense? Maybe he should get it both ways.

Most of Kozloff's 'counselling' is thankfully low key. The audience member (Kozloff) projects heavily on to the situation wherein the artist is making of him or herself a victim. The audience member is compelled into a feeling of 'empathy' with the victim. Yet is this truly empathy where the victim, as Kozloff would have it, is victimizing the audience? What *is* the equation between empathy and victimization?. Please stand the real victim! Is this victimization or simply commiserating with the victim — compassion or pity.

Morality is always specific to a certain age. Instances of a morality and immorality have been counselled and in some cases approved of by various sectors of the public through the ages, yet there is no real evidence to suggest that artists were in fact any more moral or immoral than ordinary citizens of their time.[12]

To classify on the basis of morality is at best a risky business, but it is a task that is a necessary if subordinate facet of the larger and more pressing task of classification on the basis of 'ideology and intention' as manifestations of an artist's actions, knowledge of place or role and his or her beliefs within the community.

PSYCHOLOGY AS A METHOD OF CLASSIFICATION? THE PATHETIC FALLACY

SINCE FREUD and the writings of Ernst Kris (Psychoanalytic Explorations into Art), the attraction of using psychology as an analytical tool to unravel the mysteries of art and art making has not waned. Even with the experience that we have gained from the mistakes of these men and others, recent critical studies often show an inadequate knowledge of their work. We still, for instance, get statements such as this (from a recent essay by Jack Burnham):

"In our times, art begins with the psychological make up of certain individuals who to some degree usually suffer from psychoneurosis." (1974,p.139)

Burnham does qualify his statement with "usually," but it is lamentable that such virtually unsubstantiated statements exist.

A recent attempt to 'classify' or anthologise those artists producing works of performance and body art has been made by an Italian critic Lea Vergine on a rather specious psychological model. To be fair, she is clear about what her book is not. In the conclusion to her essay we read:

"The purpose of this essay is clear, evident and openly declared. I should like once again to underline it.

It has no intention of being a final categorisation — that would in any case be dreadfully premature. It hopes, on the contrary, to be a possible path to follow; it desires to derive inferences and to offer hypotheses. Rather than judgements, it presents nothing more than emphases and considerations so that the reader may more easily approach the problem of the use of the body as an art language. I have formulated a series of ideas in order to develop a possibility of a reading for the operations that have been collected together here. Most of the artists have prepared texts to accompany their works and many of them can help to give even greater clarification to the symptomology of the arguments that have been touched upon. The artist's declarations and notes to the works constitute the parameters in relationship to which my "diagnoses" must be seen as conflicting or coincident. And in any case they seem to me to furnish a firm guide for those who desire to make use of a certain group of concepts not only in the light of the things to which they refer, but also in the light of the way in which the references are made." (1974,p.40)

And yet in the introduction she makes a huge value judgement and then proceeds

to build her argument on the most treacherous of terrain. Her 'supposition' begins thus,

"At the basis of 'body art' and all of the other operations presented in this book, one can discover the unsatisified need for a love that extends itself without limit in time — the need for what one is and what one wants to be; the need for a love that confers unlimited rights — the need for what is called primary love."(p1)

This is not merely a 'supposition' but a tremendous imposition on the works and artists presented in the book. Her attempt at 'pre-categorisation' moves further out on a limb as she lays out a sequence of possible moves for later investigators to the subject. In 'describing' these works generally she says,

"Once the productive forces of the unconscious have been liberated, what follows is a continuous and hysterical dramatization of the conflicts between desire and defense, license and prohibition, latent content and manifest content, memory and resistance, castration and self-conservation, life impulses and death impulses, voyeuristic exhibition, impulses towards sadism and masochistic pleasure destructive fantasy and cathartic fantasy."

One wonders if these forces are indeed productive, but as if to offset this initial confusion (sic) "the continuous and hysterical etc." she offers us a placebo.

"If we were interested in looking for analogies in psychopathology we could find them in the intemperances of neurolobility, in hysterical crises (emotional reactions that lack proportion to their external causes), in abandonment neuroses, in obsessive mania, in aspiration to omnipotence, in oral avidity, in sadistic allusivity."

and

"If we were interested in relations to perversion, we could talk about fetishism, transvestism, voyeurism, kleptomania, paedophilia, necrophilia, sado-masochism, rupophobia, scatophagia. A search for psychotic symptoms would lead our attention to the aspects of the work connected to dissociation melancholy, delirium, depression, and persecution manias."(p.6)

She covers herself neatly by saying that this procedure would lack committment if as Ernst Kris suggests, much of the use made of psychoanalysis to uncover the secrets of creativity has been appropriated by artists themselves for use in their works. The trick then would be for later "analysts" to ascertain (foolishly) who were the bona fide rupophobiacs, schizoids, scatophagiacs, etc. and who were those artists who were using these syndromes as 'material' for their work. What is disappointing is that few of the artists represented in her book would fit any of these categories, or if they do (on the basis of their work and statements) — they fit *so many* of the categories that they should have been over the edge years ago. Only on the superficial level of form could some of them have been said to have matched their practice problem.

Vergine, treating the material she has gathered for her anthology as case histories from sixty-two patients for whom she is the consulting analyst, is not only doing the artists and their work a disservice but psychology as well. There is not space here to go into the book at length or evaluate the many contradictions that exist between the critic's assertions of what the artists intentions are and those of the artists themselves. That psychology in relation to these works must be dealt with is not in question, though the way these forms of analysis are used is — lest we fall into the trap of merely providing a symptomology, and not a classification.

TOWARDS A TAXONOMY: CONCLUDING REMARKS

A TAXONOMY need not lay claims to being scientific. A taxonomy as a kind of classification system or branch of knowledge which is accorded a certain truth quotient or value would remain (as philoso-

phers of science such as Karl Popper and Paul Feyerabend have taken pains to point out) — *provisional*. And provisionalism, as far as classification is concerned, is accorded a higher truth value than arbitrariness. Much recent art classification has been arbitrary; this is the raison d'être for my perhaps provocative use of the term taxonomy — to reveal by contrast.

We have even been treated with new systems of 'classification' in an attempt to alleviate the problem of classification itself — witness for example, the title to Alan Sondheim's recent collection (anthology) of artists and their works, "Individuals: Post-Movement Art in America," (Dutton 1977), wherein Sondheim makes an extremely brave attempt at announcing why his people should be 'classified' together, what mutual concerns they and their works share, while denying that they belong to any accredited art movement or style.

'Styles', 'genres', 'like-types' of work still exist even without a collective manifesto to lend credence to their existence. If there is already a system of designation operating, albeit an arbitrary or a provisional one (Body Art, Performance, or Post-Movement Art), then this should become the basis for further enquiry and if needed, further designation. As most of the Body-Art and Performance practitioners would deny that they belong to a group or movement (it has been fashionable for some time now to assert one's independence as far as this is concerned — hence the much-vaunted 70's pluralism), it would be unwise to lump together artists under a label because they have at some time or another "focused on the body or parts of the body" (Lucy Lippard 1976, p.73), or alternatively have at some time 'performed' in front of an audience. Designation, purely on the basis of type, is not enough.

It would also be unwise, judging from the previous discussion, centred on theatre and Klaus Rinke's rejection of it in relation to his work, to focus on an element such as this to distinguish between his sense of performance — and that of say Acconci's. Artists' appellations, no matter how relevant and useful they may at first sight appear to be, should not be taken for granted. To elaborate, the artists should be taken at their word, though their designation for what they are doing should be treated with some caution. This is where ideology and intention and their place within the works themselves become crucial. What the artists say they are doing and what they are actually doing may be entirely different things. The statements by the artist or the import of the works themselves may be even further moderated by the critics in accordance with their philosophy, ideology, and intentions. Misconceptions "in the air" may also inhibit the formation of a viable (long term) designation for the work (s) as, too, may short lived conventions or fashions which tend to alter the 'colour' of a style.

The minimum number of requirements for any successful classification to be formed would be three. Others could conceivably be added but three criteria in my view would give a minimum definition for success. Briefly they would be these: 1) History; 2) Morphology; 3) Ideology (and intention).

I would insist that for any classification system to have value it must be historical and not simply evolutionary historicism. The canons of minimal art as compared or opposed to those of conceptual art are essential for the understanding of the basic interests of early body works. Body Art that springs from or has its roots in Minimalism is I think vastly different from that which

develops from conceptual art or for that matter the Happening, Process art, Vaudeville or Dada. To say as Max Kozloff does that Body Art's "Origins are obscured in the recent Process and Conceptual art, the Minimal Sculpture of 10, the Happenings of 15, and the Dada and Futurism of 60 years ago." (1975,p.30) is to neglect those salient features which would separate individual instances of Body Works from one another and bring others together. Furthermore to order them in "ascending order of flagrance" (p.32) is to straddle uneasily the 'morality question' discussed earlier.

The morphological criterion necessarily dovetails with that of history. They are often indivisible in any discussion concerning precedents or influences for a particular work or group of works. The question most often asked here is "what is the outward substance of the work like?" How is it presented to the viewers — video, photographs, performance, audiotapes. A few of Acconci's early works, for example, bear the same morphological characteristics as 'minimal art' or 'process work' and yet the use of his own body *appears* to make them 'different'. Is drawing a line on an arm with a sharp knife (Larry Smith) the same as marking a line in the desert (Walter de Maria), or walking a straight line on a moor (Richard Long)? This in turn gets into intention and ideology, that contained within the work as well as that expressed by the artist.

Compare Acconci's "Learning Piece", 1970 with Dan Graham's "T.V. Camera/Monitor Performance" (1970), neither of which share outward 'classical conceptual' morphological characteristics but both share the basic intentions — ideological tenets and philosophy of conceptual art — reflexivity or the insistance on the primacy of the idea (in this case perhaps the ubiquitousness of feedback in the learning process) over the object or even the process, to name but two of the more evident and popular ones. If we posit that these two works are examples of say a 'conceptual performance' (R. Pincus-Witter's term), what separates them or designates them as such? The fact that Acconci is learning his Leadbelly song out loud in a rather theatrical manner at a desk (recording studio desk, school desk) for an audience, the fact that Graham calls his a 'performance' and that he is 'performing' in front of an audience? Yes, these morphological characteristics help, but if Graham is using video (CCTV) equipment and Acconci is using a tape-recorder — what then? Could Graham's be designated as a Video 'Performance'? What separates this from Acconci's video works or a Wegman video 'performance'?

Richard Foreman's theatre is "Ontological-Hysteric Theatre", but it is still theatre and not just performance art. His work is part of a long tradition of eclectic theatre. With its discontinuity, emphasis on the subconscious (Foreman's own), juxtaposition of seemingly unrelated images and words, the theatre of Foreman could, on the superficial morphological level at least, be placed within the modern tradition of the Theatre of the Absurd. Why place it in Performance? Would it not 'rest' more easily in a class with Ionesco and Becket than Acconci or Burden?

Questions such as these should be asked, the bracketing of criteria to postpone value judgement, made. If a work appears to defy designation, no extra effort should be made to ensure that it does fit one (or several) designations. We have seen in the Art Index examples how easily this can cause confusion.

Because a work is labeled does not mean

203

that it is stripped of its uniqueness, which is a dubious value at the best of times, or that the artist is robbed of his or her individuality. In some ways the work may more easily reveal 'positive' values with a provisional label than it would without one, or worse, with the wrong label.

In concluding I have not tried to accelerate the need for indexing (referencing) for the sake of indexing (registering) nor designating for the sake of designations. No label has ever enhanced the value of a work, nor should this be so. There are works — Picasso's "Demoiselles d'Avignon," Duchamp's "Large Glass' or Brancusi's "Column" which defy labeling and indexing in any way other than that they were extremely important for the history of contemporary art. To isolate them or contain to any one class or genre is negate their worth as seminal works of art. If the kind of indexing-classification I am advocating does nothing else, it may enable us to isolate, identify and estimate the worth of the "Glasses" and "Columns" of our own age. Maybe they will be the ones that cannot be adequately classified, the 'black sheep of the family' — the ones that win by default.

Halifax
Summer, 1977

SELECTED BIBLIOGRAPHY

Adams, H. "British Performance Art", *Studio International,* July/August 1976.

Battcock, G. (ed.), *Minimal Art: A Critical Anthology,* New York: E.P. Dutton, 1968.

Bourgeaud, B., "Cinema et Video: Body Works", *XXe Siecle,* December, 1973.

Burnham, J., *Great Western Saltworks. Essays on the Meaning of Post Formalist Art,* New York: Braziller, 1974.

Kaprow, A., *Assemblage, Environments, and Happenings,* New York: Harry N. Abrams, 1966.

Kirby, M., *Happenings,* New York: E.P. Dutton, 1966.

Kunst Bleibt Kunst, Project '74, Cologne: Wallraf-Richartz Museum, 1974.

Kozloff, M., "Pygmalion Reversed", *Artforum,* November, 1975.

Lippard, L., "Six Years: the Dematerialization of the Art Object", *Studio Vista,* 1973. "The Pains and Pleasures of Rebirth: Women's Body Art", *Art in America,* May/June, 1976.

Merleau-Ponty, M., *The Primacy of Perception and Other Essays,* ed. Edie, J., Illinois: Northwestern University Press, 1964.

Sharp, W., "Body Works", *Avalanche,* fall, 1970.

Shattuck, R., *Alienation,* New York: Doubleday, 1971.

Vergine, L., *Il Corpo Come Linguaggio (la "Body-Art" e Storie Simile),* Milan: Giampaolo Preare, 1974.

PERFORMANCES E COMUNICAZIONE
PERFORMANCES AND COMMUNICATION

Maria Gloria Bicocchi/Fulvio Salvadori

CI SONO NELLA STORIA di un termine certi periodi di fortuna in cui diviene oggetto di un uso esteso. E' allora molto difficile scoprirne il senso, poiché questo suo successo può derivare da una situazione di ambiguità che richiede un termine di comodo per designare una molteplicità di fenomeni. D'altra parte il senso può forse essere ricercato nella fortuna stessa del termine che, se nell'uso comune unisce sotto un nome di famiglia fenomeni diversi, designerà anche certi rapporti di parentela tra di essi. Perché quel termine e non un altro, dunque? Il senso va ricercato allora nelle *nuances* delle sue utilizzazioni.

Il termine "performance", con cui abbiamo a che fare, contiene in sé il senso del realizzare, ma anche quello dell'eseguire. In relazione al lavoro dell'attore, ad esempio, assume i connotati della dipendenza dalle intenzioni dell'autore e dai desideri del pubblico.

L' interpretazione dell'attore si pone al limite tra due potenze. Sulla scena illuminata la sua azione si svolge in una situazione che ha le sue zone d'ombra, la necessità e il desiderio, dietro le quinte e nella platea. Solo, sul palcoscenico, l'attore trasforma mediante il suo lavoro uno schema astratto, il copione, in un oggetto consumabile per il godimento del pubblico.

AS THE MEANING of a term develops through history, there may be certain periods of success in which the term becomes an object of widespread use. Then it is very difficult to discover its sense, since this very popularity can derive from an ambiguity requiring a single convenient word to designate a multiplicty of phenomena. On the other hand the same popularity of the term in common use can unite under one family name several diverse phenomena, and designate certain relationships between them. The sense will then be sophisticated and nuanced in its use.

205

Tuttavia l'interpretazione è proprietà dell'attore, è la sua controparte in questo rapporto di sottomissione. Suo è l' onere, ma anche l' onore della prova. L' attore presta il suo corpo come supporto alla maschera del personaggio, ma è proprio in questa prestazione che si afferma la sua autonomia. Il personaggio agisce mediato, infatti, dalla personalità, dalla abilità, ossia qualcosa di diverso che fa tutta la differenza con le prestazioni degli altri attori.

In certi casi, poi, il copione diviene solo un pretesto per l'esibizione dell'abilità. L'attore acquista allora la sua libertà proponendo il suo lavoro come emanazione di sé, come espressione del proprio desiderio — di superarsi. Ma è nel marginale, nel gesto contrapposto alla parola del testo, che si pone la differenza con la normalità meccanica con cui la parte può essere sostenuta.

D'altro lato è attraverso questo percorso che la performance stessa si rende autonoma, diviene fatto irripetibile, evento, liberandosi delle forze occulte del pubblico e dell'autore. L'azione si sostituisce nella performance alla prestazione, che è frutto del mestiere che lega l'artista al suo ruolo.

Il gesto è il demiurgo di questa liberazione. "La tecnica è un mezzo per liberare l'artista" ha scritto Joseph Chaikin. E' necessario percorrere questa via. Ma la tecnica dell' attore, o dell' artista in genere, è fatta di gesti stereotipi in cui si riflette la competenza che è la storia del suo apprendistato. Il gesto che porta l'impronta della personalità, come la pennellata del pittore riconoscibile perché ripetuto nell'automatismo, s'imprime come un marchio di bottega sull' opera, sostituisce la firma. Ed è introno alla firma che si addensa il consenso popolare.

Dobbiamo allora rovesciare la nostra ottica e dire che se è il gesto sapiente che garan-

The term "Performance", with which we are dealing, contains within itself the sense of accomplishment, but also that of carrying out. In relation to the work of the actor, for example, it suggests dependence on both the intentions of the author and the desires of the public.

The actor's interpretation stands at a conjunction between two forces. On the illuminated stage his action occurs in a situation with a shadowy area of necessity and desire, behind the scenes and in the audience. Alone on the stage, the actor transforms through his work an abstract scheme, the script, into a consumable object for the enjoyment of the public. However the interpretation is the property of the actor; it is his opponent in this statement of submission. It is his burden, but also his prize. The actor lends his body as support for the mask of the personage, but it is really in this loan (performance) that his autonomy is affirmed. The personage acts through, in fact, the personality, the ability, or something else separating his performance from those of the other actors.

In certain cases, then, the script is only a pretext for the display of ability. Then the actor acquires his liberty in presenting his work as an emanation of himself, as an expression of his own desire — to excel himself. But it is in the fringe areas, in the gesture rather than the words of the text, that we find something other than the mechanical normality with which the part may be played.

On the other hand, it is by this means that the performance is made autonomous, an undeniable fact, an event, freed from the hidden forces of author and public. The action is substituted in the performance to the performing, which is the practice linking artist and role.

tisce della competenza dell'artista, al contrario la performance si costituisce solo nel superamento dell'automatismo, in un qualcosa di più, una intensificazione che avviene al limite del saper fare, dove all'abilità gestuale del performer si sovrappone una sorta di pesantezza significante, di profondità semantica. La performance vale infatti di per sé nell'evento della sua presentazione, nell'istante in cui l'attore impone la sua presenza alla parola.

L' attore vive sulla scena il dramma del conflitto fra identità e identificazione proprio di ciascuno. La macchina teatrale opera nell'agire quotidiano: una finzione accettata. A livello del senso comune la comunicazione avviene infatti nella tacita acquiescenza della convenzione, una sorta di rete significante su cui l'informazione scorre appoggiandosi sul non detto, sul convenuto. La persona poi, è una specie di maschera, un fantasma, l' alter-ego che agisce e manovra i nostri rapporti con gli altri, è l' "attore" della nostra strategia pubblica. Questo nostro rappresentante, le cui avanzate e ritirate sono solo in parte controllate da noi, proietta se stesso nella dichiarazione, che è una specie di esperimento, un mettere alla prova la situazione, un rischio calcolato. Al contrario la dichiarazione diviene performance quando agisce in profondità nella situazione, ne fa scattare meccanismi nascosti. Allora essa supera la prova operando nuove connessioni, coagulando la realtà nel proprio intorno. La persona che getta la maschera impone la propria presenza. Questo tipo di dichiarazione non esplorativa che è la performance avviene infatti "in presentia", "the great there", come lo ha definito Charlemagne Palestine.

Agire in prima persona vuol dire assumere rischi allo scoperto, poiché la situazione non è mai controllabile com-

The gesture is the source of this liberation. "Technique is a means of freeing the artist", Joesph Chaikin has written. It is necessary to push this notion further. The technique of the actor, or of the artist in general, is made up of stereotypical gestures reflecting a competence acquired through training. The gesture bearing the imprint of personality is stamped like a trademark on the work and takes the place of a signature. And it is the signature that brings popular approval.

We must then reject appearances and say that if it is the knowing gesture that establishes the artist's competence, significantly the performance takes shape only by overcoming automatism, by adding something more, an intensification beyond technique, where upon the gestural skill of the artist is imposed a sort of significant weight, a semantic profundity. The performance in fact is valid only during its presentation, in the instant in which the actor imposes his appearance onto the speech. The actor enacts on stage a drama appropriate to the conflict between identity and identification. The theatrical tool also exists in daily activity: an accepted fiction. On the level of common sense, communication happens in fact through a network on which information runs smoothly, relying on the unspoken and on convention. Any person then is a sort of mask, a ghost, the alter-ego that acts and manoeuvers our relations with others; he is the "actor" of our social strategy. This persona, who advances and withdraws under social "control", projects himself as a kind of experiment, a rehearsal, a calculated risk. These activities can become Performance when a radical situation is engaged, releasing hidden mechanisms. The person who projects the mask imposes his own presence. This kind of non-exploratory statement that is

207

pletamente, ha le sue zone d'ombra in cui si nascondono insidie non valutabili. Ma è proprio in queste zone marginali che può avvenire il contatto, proiettandosi al di là dei confini dell'apparato simbolico comunemente accettato, ossia il campo significante in cui avviene la conversazione normale o normalizzata, il cicaleccio delle maschere sulla scena predisposta, la macchina teatrale. Se il termine "performance", allora, contiene in sé il senso del "superare la prova", ciò può significare solo il portarsi al di là della situazione data e comunemente accettata nella finzione e nella convenzione, vuol dire superare i confini del già fatto per imporre una situazione nuova che emana, viene proiettata dal sé.

La dichiarazione /performance ha pertanto una storia da cui deriva la competenza del performer all'azione, come un' abilità nel gettare i dadi che agisce sulla casualità dominandola. Vi è, naturalmente, un addestramento, una precognizione, ma la performance in sé è al di là della storia perché avviene in quel tempo senza tempo in cui memoria personale e memoria collettiva si toccano, una eventualità che può accadere solo in istanti privilegiati. In presenza si dice la verità.

Tuttavia in teatro si finge la verità. La performance dell'attore può rendere vera la finzione intensificandola, dilatandone i margini nella diffusione dell'intorno e nello stesso tempo emarginandola dalla situazione normale (il copione, la macchina teatrale, il pubblico). E' una sorta di introiezione, di implosione della situazione da cui deriva una proiezione in cui la performance diviene autonoma al di là della figura stessa dell'attore che appare solo come un accumulatore, un *medium*. Ma questa autonomia, acquisita al prezzo della autoreferenzialità nei limiti dell'apparire e dell'apparenza, comporta che ciò che resta

the Performance, takes place in fact "in the present", "the great there", as Charlemagne Palestine has defined it.

To act in the first person means taking on the risk of discovery, since the situation is never completely controllable, has its shadowy zones in which are hidden inestimable dangers. But it is truly in these marginal areas that contact can take place, projected through the confines of the normally accepted symbolic apparatus, or the expressive field in which normal or normalised conversation takes place, the babbling of the masks on the prearranged set. If the term "performance", then, contains within itself a sense of overcoming a test, it can signify only the carrying of oneself beyond the situation given and normally accepted in fiction and in convention, i.e. overcome the boundaries of the already-made in order to impose a new situation that issues from the self. The statement/performance has therefore a history from which derives the competence of the performer in action, like a talent for throwing dice which controls mere chance. There is, naturally, a training or preconception, but the performance itself is beyond history. It happens in that time without time where personal memory and collective memory touch, an event which can take place only in privileged instants (times). In the present one speaks the truth.

Yet in the theatre one simulates the truth. The performance of the actor can render the truth, intensifying it, expanding its margins in the diffusion of the surroundings, and at the same time isolating or cutting off the normal situation (the script, the stage, the public). It is a kind of implosion of the situation, from which derives a projection in which the performance becomes autonomous beyond the person of the actor, who appears only as a storage battery, a me-

è, comunque, il teatro. Ossia, se l'attore/performer riesce a rendersi libero, nell'istante della performance, dalla macchina teatrale solo annullando se stesso, la macchina teatrale continua, dopo, a permanere nel tempo nel suo statuto di luogo privilegiato, istituzionalizzante, di luogo di riunione del consenso. L' attore ha messo in scena la sua trascendenza, ma finita la messa rimane la chiesa.

Da parte del pubblico una finzione accettata: la credenza scettica ("oui, je le sais, mais quand même") propria dell'ambiguità della fede borghese che deriva dal "fai come se". La verità abita la finzione. La performance, una volta manifestatasi viene inquadrata dall'opinione nella scena teatrale. E' la legge della registrazione: l'evento non può sfuggire nel ricordo dalle condizioni del suo apparire. In questo senso il recordo diventa una funzione di verità. Una fotografia in campo lungo dell'attore durante la performance, ad esempio, svela l'impalcatura che lo sorregge e lo circonda. Alla stessa maniera la foto o il resoconto critico di una performance d'arte, inserito nel catalogo di un museo o di una galleria o in qualsiasi altra pubblicazione può mettere in luce il significato politico ed economico del sistema che sottostà all'esistenza di quel particolare fatto artistico. Alla verifica della finzione, allora, quale avviene nella performance dell'attore, si sostituisce il momento analitico/empirico della verifica della verità.

Una volta che l'evento è risolto nell'insieme delle registrazioni, esso sta a limite di tutte le descrizioni possibili. Attraverso la semplificazione, che è lo strumento del ricordo, l'evento, unico e limitato nello spazio tempo, si presenta nei suoi aspetti analitici, essenziali, diventa riproducibile, e, per mezzo della registrazione è assunto all' interno del sistema logico. Il sistema ac-

dium. But after this autonomy is gained at the price of self-referentiality in the limits of appearances, what remains is always theatre. Or, if the actor/performer succeeds in the instant of the performance in freeing himself from the theatrical machinery through denying himself, the theatrical machinery continues on afterwards, institutionalising the place of approval. The actor has placed on stage his transcendence, but after the mass the church remains.

On the part of the public an accepted fiction: the skeptical belief (yes I know but all the same ...) suitable to the ambiguity of bourgeois faith deriving from the *als ob*. Truth lives in fiction. The performance, once revealed, becomes framed by opinion on the theatre stage. It is the law of recording: the event cannot evade in memory the conditions of its appearance. In this sense the record becomes a truth-function. A photograph in long shot of the actor during the performance, for example, reveals the scaffolding that supports and surrounds him. In the same way the photograph or critical report of an art performance, included in a museum catalogue or some other publication, can throw light on the political and economic implications supporting the existence of that particular artistic fact. For the examination of poetic invention, then, which takes place during the actor's performance, we substitute the analytic/empirical moment of the verification of the truth.

Once the event is fully recorded, it has reached the limit of all possible description. Apart from simplification, which is the instrument of memory, record the event, unique and bounded in space and time, is presented in its analytic, essential and reproducible aspects, and by means of the recording is assumed into the system of logic. The system grants the event, in addi-

corda all'evento, attraverso la classificazione, un "valore" al suo interno, ossia il riconoscimento della sua "validità" teorica alla conferma del sistema. Conferma che avviene, tautologicamente, con la riproduzione stessa dell'evento. La riproduzione definisce pertanto il criterio di verifica della teoria. E' chiaro allora che esiste un tipo di performance che deriva dalla ideologia empirico/analitica.

Una volta stabilito che l'indagine sulla verità va condotta sugli elementi e sulla loro situazione, la verifica della verità, di per sé autoreferenziale perché s'impone nella sua semplicità funzionale, consiste nella messa a nudo di queste strutture minime. La verità abita ora la funzione. Messo tra parentesi il vissuto, e spostata la luce dall'attore alla scena, ciò che viene messo in evidenza è l'impalcatura su cui si appoggia il consenso. Il *minimal environment*, ad esempio, nella sua persecuzione dell'idea chiara e distinta, si è risolta nel disvelamento della struttura cartesiana che regge il nostro mondo, una forma simbolica funzionale alla società industriale, con la sua triangolazione rigida nelle tre coordinate spaziali, nella individuazione atemporale della oggettività riporducibile perchè opera di una gestualità ripetitiva, in cui il marginale è tagliato fuori, oppure portato fuori a controllare i tempi, ad assumere il ruolo di sorvegliante ai lavori.

In questa situazione, ossia quando la performance si svolge in uno spazio ideologico minimal, i termini che ad essa si riferiscono (gesto, intensità, autonomia) subiscono uno spostamento semantico pur rimanendo nominalmente invariati. La perfomance assume allora il carattere, come nei tentativi di record sportivo, di una *pièce de résistance* in cui il marginale viene perseguito come situazione limite di un insieme elementare di cui si esperimentano le

tion to classification, an internal "value", or the recognition of its theoretical "validity" in the system's confirmation. This confirmation takes place, tautologically, with the reproduction itself of the event. The reproduction therefore defines the criterion of verification for the theory. It is clear then that a type of performance exists which derives from empirical/analytic ideology.

Once it is established that an inquiry into truth gives rise to the arrangement of specific elements, the verification of truth, of self-referentiality (because it is imposed on its functional simplicity) consists in stripping down these minimal structures. Truth has now found its home. With living placed in parentheses, and the lights shifted from the actor to the stage, what comes into focus is the scaffolding on which consent is maintained. The minimal environment, for example, in its pursuit of the clear and distinct idea, is a deciding factor in revealing the Cartesian structure ruling our world — a symbolic functional form in industrial society, with its rigid triangulation in three spatial coordinates, in the atemporal individuation of reproducible objectivity — because it is a work of repetitive gesturing in which the marginal areas are removed in order to control the times and oversee the works. In this situation, or when the performance occurs in a minimal ideologic space, the terms to which it refers (gesture, intensity, autonomy) undergo a semantic shift while remaining nominally unchanged. The performance then assumes the character, as in an attempt to set a sports record, of a *pièce de résistance* seeking to locate and extend the outer limits of the possible. This happens in certain body works, in which bodily functions become a place for investigation. The fragmentation of functions in such cases, evidence of stereotyped gestures, and in themselves fun-

possibilità in estensione. Ciò avviene ad esempio in certe performances body, in cui la funzionalità del corpo viene assunta come luogo d'indagine. La parcellizzazione delle funzioni, in questi casi, evidenzia il gesto sterotipo, in sé funzionale al corpo/macchina, ma che, nell'isolamento della performance, si trasforma in gesto parossistico e ossessivo. Qualcosa di simile all'atto di lavoro dell'operaio, che nella sua semplicità/semplificazione trova senso solo nella serie. L'autonomia della performance si verifica allora nell'automatismo, nella coazione a ripetere. Il pubblico, poi, rimane fuori a testimone del fatto, all stessa maniera del cronometrista che garantisce del risultato atletico.

Se ne vogliamo fare allora una questione di comunicazione (ma non necessariamente, perché la performance può essere anche un mezzo di ricerca sulle modalità della non-comunicazione, come abbiamo visto), dobbiamo di nuovo ribaltare i termini del problema. E' chiaro che un fatto è superare i limiti della scena per porsi da un punto di vista esterno, neutrale, ed un altro uscire di scena del tutto, soprattutto se la scena cui facciamo riferimento è l'altra scena. La sincronicità del sistema, con la sua catena di relazioni normative, si contrappone infatti alla simultaneità della situazione, e il fatto della dimostrazione, una volta compiuto questo rovesciamento di ottica, svela il suo valore elementare dinanzi alla ricchezza delle relazioni situazionali. La situazione, in questo contesto opposta a sistema, più che un campo di verifica diviene luogo dell'esperienza, in cui l'agire, più che l'informare, acquista significato nel contatto marginale. Tutto si giuoca su due possibili accezioni del termine "ricerca": la ricerca perde ora quei connotati parascentifici che aveva assunto all'interno dell' ideologia empirico/minimal (cui non era estranea una mistica

ctional as body/machine, are in the isolation of the performance, transformed into climactic and obsessive gestures. The same could be said of a worker's actions, which in their simplicity/simplification make sense only in series. The independence of the performance is verified then in the automatism, in the compulsion to repeat. The public, then, remains on the sidelines as witness to the deed, in the same way that a scorekeeper guarantees the results.

Then, if we consider the question of communication (although a performance can also investigate non-communication, as we have seen) we must again overturn the terms of the problem. It is clear that if it is possible to go beyond the limits of the stage so that the viewpoint's subject is replaced by an external viewpoint, neutral, then a different question is the exit from the stage by all. The synchronicty of the system, with its chain of prescriptive relations, is opposed in fact to the simultaneity of the situation, and once this overthrow of visual evidence has been accomplished, reveals its basic value in view of the richness of relationships. The situation, anti-system in this context, has become a place for experience, in which to act rather than for information or verification, and has acquired meaning in the marginal contact. Everything is played out on two possible meanings of the term "research": research now loses the para-scientific connotations that it assumed inside empirical/minimal ideology (where a mystique of the void was central), and can become research into that marginal contact on which can be based a field of intercommunication. Since it is clear that on the real edge, that territory where desire weaves its strategies of subversion, consent is threadbare.

But where is consent formed, and where

del ruoto), e può divenire ricerca di quel contatto marginale su cui si fonda la possibilità di esistenza di un campo di intercomunicazione. Poiché è evidente che proprio nel marginale, il territorio dove il desiderio intreccia le sue strategie di sovversione, il consenso mostra la corda.

Ma quel'è il luogo dove il consenso si forma, ossia trova la sua informazione? Facciamo uso ancora una volta della metafora teatrale. Se prendiamo un punto di vista sulla scena e uno nella platea, il teatro si struttura allora come una stella di David, una doppia triangolazione, in cui la zona comune, esagonale, si rivela come la zona del consenso.

figura: Schema di base dell'impianto teatrale rinascimentale disegnato da Fra Giovanni Giocondo, secondo le indicazioni di Vitruvio, nel 1509. La linea "b" segna la divisione tra pulpito e orchestra, e la linea "e" il fronte della scena.

In questa zona non vi è contatto, ma solo convenzione. I vetici restano fuori. I triangoli stanno tra di loro in un rapporto speculare, come avviene nel ribaltamento del punto di vista nella costruzione prospettica rinascimentale, in cui l'apertura che permette di vedere la scena non è soltanto una finestra o una parete mancante, ma uno specchio, uno schermo su cui si consuma il mistero della proiezione del desiderio. Questo schermo diverrà, poi, in teatro, il sipario che taglia l'azione, la soglia che divide il pubblico dallo spettacolo: sarà pertanto il luogo di una mancanza e di uno spostamento, il simbolo della non partecipazione.

"Il cervello", ha detto Lacan, "è una macchina per sognare", che è pur sempre una singolare ipostasi della macchina teatrale.

does the information come from? Let us use the theatrical metaphor again. If we take the viewpoints of stage and audience, the theatre is structured like a Star of David, a double triangulation, in which the hexagonal common zone is revealed as the zone of assent.

figure: outline of the Renaissance theatre plan designed by Fra Giovanni Gioconde, according to the directions of Vitruvius, in 1509; the Line B marks the division between pulpit and orchestra, and Line E is the front of the stage.

In this zone there is no contact, but only convention. The verticals remain outside. The triangles are in a mirrored relationship amongst themselves, as happens when the viewpoint in Renaissance perspective constructions is upset, and when the opening giving a view of the stage is not just a window or wall manqué, but a mirror, a screen on which is enacted the projection of desire. In the theatre then, this screen becomes the curtain that divides the action, the threshold separating public from spec-

In ogni modo nel sogno la fantasia mette ordine nel caos delle immagini organizzandole in una struttura significante. Il pubblico che va a teatro è disposto alla resa, rinuncia a questa sua facoltà, fa in modo che si sogni per lui. O forse il teatro è in origine un modo per sognare collettivamente. Comunque non vi è in teatro soddisfacimento di un bisogno, ma solo proiezione del desiderio. Il pubblico accetta (ma è un *do ut des*, perché si libera dal pericolo del coinvolgimento nel'azione) questo rovesciamento del punto di vista, per cui il desiderio, di cui è titolare e di cui è dispossessato, viene rappresentato, riprodotto e riproiettato verso di lui dalla scena. La platea sulla scena viene rappresentata. Il pubblico da in uso alla scena la propria essenza: la pubblicità.

Tutto ciò non avviene senza consequenze. Il rovesciamento speculare non è un fatto simmetrico. Non vi è semplice riflessione, mimesi, riproduzione: vi è invece trasformazione e produzione. La macchina teatrale (e vorrei ancora sottolineare che essa non è che la metafora di una condizione sociale più vasta, vero archetipo del comportamento borghese, in cui il desiderio è sottoposto alla manipolazione della macchina) funziona come un meccanismo ad orologeria, prima questo, poi quello: il tempo che essa esprime è un tempo cronologico linearizzato, solo un simulacro del tempo memoria che agisce dentro di noi. Questa abdicazione, pertanto, questa delega del pubblico alla scena, fa sì che l' immaginazione sociale venga gestita altrove. La platea riceve dal palcoscenico la propria immagine pubblica. L' identità si trasforma in identificazione.

In effetti la struttura stellare del teatro rinascimentale ha subito nel tempo una trasformazione topologica. Gli elementi proiettivi provenienti dalla scena e dalla

tacle: it is therefore a point of emptiness and shift, a symbol of non-participation.

"The brain", Lacan has said, "is a machine for dreaming" which is as always a singular hypostasis for the theatrical machine. In dreams, in any case, fantasy gives order to the chaos of images, organising them into a meaningful structure. The theatre-going public willingly surrenders or renounces this faculty of theirs, letting others dream for him. Or perhaps the theatre offers a way to dream collectively. However, the theatre does not satisfy a need, but is rather the projection of desire. The public accepts this overturning of viewpoint, whose desire — of which he is titleholder, and of which he is dispossessed — is represented, reproduced and reprojected towards him from the stage. The audience is represented on the stage. The public permits the stage its real essence: publicity.

All of this does not take place without consequences; the mirrorlike upset is not a symmetrical deed. There is not simple reflection, mimicry, reproduction; instead there is transformation and production. The theatrical machine (and we wish to underline again that this is simply a metaphor for a broader social condition, a true archetype of bourgeois behaviour, in which desire is subordinated to the manipulations of the machine) functions like a clock mechanism, first this way then that: the time that it expresses is a linear chronological time, a simulacrum of memory time acting inside us. This abdication, however, this delegation of the public to the stage, acts as if the social imagination comes to them administered from elsewhere. The audience receives its own public image from the stage; identity is transformed in identification. In effect, the starlike structure of the Renaissance theatre has undergone a

platea sono venuti a coincidere sullo schermo, la linea di confine su cui si proiettano le ombre, i fantasmi del desiderio, ormai normalizzati, organizzati nella catena simbolica. Questa linea diviene allora la diagonale di un quadrato ai cui vertici opposti si pongono l'occhio che vede e la macchina da proiezione.

figura: Le due proiezioni, della macchina e dell'occhio che guarda, s'incontrano sulla linea di divisione tra pubblico e spettacolo (linea "b").

Non vi è più finzione, perché non vi è più visione marginale, ossia non vi è più visione marginale della macchina (quinte o scene dipinte, ecc.), ciò che faceva del teatro una convenzione tacitamente accettata. Nel cinema, ad esempio, lo sguardo è tutto preso nella bidimensione dello schermo, su cui l'attore stesso è un' ombra tra le altre, una bande dessinée. Nel caso della televisione, poi, lo schermo è divenuto il terminal della rete elettronica su cui scorre l'informazione, simile al bottone terminale di un sistema nervoso ramificato.

Il sistema elettronico della comunicazione lascia passare ciò che trova un senso all'interno delle sue connessioni per giungere fino al terminale. Lungo questa via l'informazione, la registrazione, perde il suo senso proprio ed acquista il senso del percorso, diviene nella proiezione un rappresentante dell' hardware. Tutto ciò comporta una inquadratura dell'immaginario nella riduzione del ricordo computerizzato, del catalogo inteso come banca della memoria, secondo le modalità dell'imput e dell'output.

L' universo cibernetico è un universo probabilistico, non meccanico, in cui cioè non

topological transformation. The elements projected from stage and audience coincide on the screen, a borderline where shadowy outlines are projected, the ghosts of desire now normalised, organised in the symbolic chain. This line then becomes the diagonal of a square where the watching eye and the projector are placed at opposite verticals.

figure: The two projections, from the machine and from the watching eye, meet on the division line between public and spectacle (Line B).

There is no longer fiction, because there is no longer marginal vision, or there is no longer marginal vision from the machine (wings or painted scenery etc.) that made a tacitly accepted convention of the theatre. In the cinema, for example, the glance is occupied with the two-dimensionality of the screen, on which the actor himself is a shadow among others, a cartoon strip. In the case of television, then, the screen has become the terminal of the electronic network on which flows information, similar to

vale la legge di causa ed effetto, ma in cui l'accadere dell'evento è sottoposto a leggi quantitative, numeriche. E' l'universo dello scommettitore: più la situazione si normalizza nella serie, più è probabile che l'evento si manifesti. Naturalmente in questo contesto contano più la previsione e l'attesa che non la produzione e l' uso. Ciò, poi, che la serie si aspetta dal resultato è la conferma stessa della serie. Quest' ultima deriva da una quantificazione e linearizzazione delle funzioni qualitative che comporta un valore di soglia (+ o -) cui è sottoposto l'evento, una legge che permette di unificare le variazioni degli effetti qualitativi e di dare coerenza alla successione. Non esiste pertanto sorpresa, solo novità, ma quest'ultima funzionale alla serie che ingloba la novità, in quanto rappresentante del sistema, nella memoria, nel catalogo.

La ripetizione e il record sono i due esiti dell'informazione cibernetica. La performance sportiva è, allora, estremamente funzionale a questo universo della registrazione, poiché è accettata quando riesce a superare il limite ultimo di una serie numerica. Allo stesso modo è funzionale la serie dei gesti ripetitivi, l'oscillazione regolare secondo certi parametri fissi, paragonabile ad una emissione perfettamente ergodica in cui l'informazione, e pertanto, l'attesa, sia zero. "Il est clair, ha detto Lacan, qu'il n'y a là dedans aucune place pour ce qui serait une realisation nouvelle, un *wirken*, une action à proprement parler". Estremamente esemplari di questo stato di cose appaiono ora le prime performances per videotape di Bruce Nauman: la ripresa di un gesto ripetuto per la durata di un intero tape (60 min.). Nauman ha poi dichiarato: "Il mio problema era di fare tapes che continuano a scorrere, senza inizio e senza fine. Volevo

the terminal button of a branching nervous system.

The electronic communications system permits internal connectors to pass through to the terminal. Along this path the information or recording loses its own sense and acquires a sense of distance and hardware. All of this frames the imaginary in reduced size as computerised memory, a catalogue understood as a memory bank, according to the procedure of input and output.

The cybernetic universe is a universe of probability, not a mechanistic one, where the law of cause and effect is not valid, but rather where the occurence of events is subject to quantitative, numerical laws. It is a gambler's universe: the more serialised the situation, the more likely it is that events are revealed. Naturally, in this context, expectation and delays are more important than production and use. Results are the confirmation of the series. This last fact derives from a quantification and linearisation of qualitative functions by submitting the event to the threshold value (+ or -) – a law which permits a unification of qualitative variations and which gives coherence to succession. But surprises do not exist, only novelties included in the series of memory and catalogue systems.

Repetition and recording are the two outcomes of cybernetic information. The sports performance, then, is a useful example in this world of records, since it is accepted as the final unit of a numerical series is overcome. A series of repetitive gestures functions in the same way, as a regular oscillation according to certain fixed parameters, comparable to a perfect broadcast in which information and waiting is reduced to zero. "It is clear", Lacan has said, "that there is no place there for what would be a new realisation, a *wirken*, an action so to speak". Extreme examples of this state of things

la tensione dell'attesa per qualcosa che deve accadere, e allora voi sarete presi proprio nel ritmo della cosa".

L' attesa di una cosa che può accadere e non accadrà. Essere presi nel ritmo della cosa. Ecco svelato l'arcano dell'occulto legame che lega lo spettatore allo schermo televisivo. Egli è preso nella trappola del circuito. In tutto questo processo il desiderio ha assunto il carattere astratto dell'attesa e il soddisfacimento di un bisogno l'aspetto sterile della conferma. Non vi è più finzione, o trucco: la televisione non mente, come Dio.

Ma, può essere, in ogni modo la televisione sorpresa a mentire? Oppure, più in generale, può essere il sistema sorpreso? In effetti il desiderio non è scomparso, sta invece in altro luogo, ed è solo in quest' altro luogo, da cui può partire la sorpresa, che la performance può assumere un nuovo significato.

Follonica
Aprile 1978

now seem clear in the first performances by Bruce Nauman for videotape: the recording of a gesture repeated for the duration of the whole tape (60 minutes). Nauman declared at that time, "My problem was to make tapes that continue to flow without beginning and without end. I wanted the tension of waiting for something to happen and then you would be taken really in the rhythm of the thing."

The waiting for a thing that could happen and would not happen. To be taken up in the rhythm of the thing. Here is revealed the mystery of the hidden bond linking the spectator with the television screen. He is taken into the circuit. In this whole process, desire has assumed the abstract character of waiting, and the satisfaction of needs the sterile aspect of confirmation. There is no longer fiction, or tricks: television does not lie, as God does.

But can it be that somehow television surprises in order to lie? Or, more generally, can it be the system that's surprised? In effect, desire has not disappeared, but has only stayed behind somewhere. And it is only in this other place, from where surprise can come, that performance can take on a new meaning.

translated from the Italian by Peggy Gale

ROLE ART AND SOCIAL CONTEXT

Kenneth Coutts-Smith

IT OFTEN SEEMS that a great deal of the incomprehension experienced by people outside of the art community, as well as a great deal of the role ambiguity experienced by those within the community, is a result of a confusion between the worlds of historical necessity and of cultural contingency; in other words, between life as it really is and life as we mythicise it.

This discrepancy would not seem, in itself, to be a particularily recent development in respect to the history of visual culture. In fact, it has been evident in one way or another since the inception of what we loosely call the avant-garde; that is to say, over a period of something a little more than one hundred years. The clarity of definition between the previously interpenetrating and interacting domains of society and culture, of life and art, has not, however, been severely blurred until the comparatively recent past.

The current uncertainty as to the precise function of art in our society is, of course, not a feature restricted to a self-enclosed art system, though the problem is often, mistakenly, understood only in the context of the support-structure, in the context of the individual artist's relationship with the market, with institutions, critics, curators and fellow artists. Rather, it is symptomatic of a fugitive and unclear relationship between a changed structure of developing social and political realities and the essentially unchanged assumptions of an art-community that draws its identity and its rationale from the past, from the traditions of art rather than from the realities of lived experience.

Quite obviously, any examination of this question must be based on two factors as they apply to the way in which art operates in the world of social relationships: on the product, the art-work itself, and on the artist's self-view, the role and posture that he has defined for himself.

Up until the very recent past, these two factors have been almost invariably distinct and separate from each other, despite a certain interplay and feedback between them. The art-object was focused, ultimately, towards the outer, social world, where it was destined to become commodity and property. The artist's individual self-view was focused onto the enclosed world of the art community to provide an identity reinforcement within the subculture.

This is an obvious simplification, but one made consciously in the context of this present purpose. Clearly, the art-work is not (or is very rarely) pure property; it also, to the extent of its aesthetic excellence, embodies symbolically a portion of man's humanisation of the world. Equally certainly, the bohemian imperatives to define the artist as a privileged and special being are not restricted to the enclosed circles of visual high culture, they are partly dictated by the necessity to create and to refine a market for his products.

The necessary simplification of the distinction between role and product is here presented to underline and emphasise the dimensions of the change (a truly fundamental change) that has recently taken place in the very nature and function of art, a change

that has largely passed unremarked and un-analysed.

The previous dichotomy is now closed. The artist's individual self-view and the object that he makes are merging into one entity. The producer and the product are melding. For some time now, it has been evident that the creative experience was tending to become an "event" rather than a process, and the existential imperatives of Action Painting, which launched the trend towards the *privitisation* of the creative act, have now mutated to the logical position where the artist's individual self-view, *his posture,* has become the actual art-work.

This development is an extremely significant one, but the extent to which the shift is radical would appear to be far from clearly understood. Art-criticism has not, so far, been able to come to grips with the question since it remains focused on the cultural product. Analysis continues to be largely based on the notion that significance is concentrated entirely in the art-work (the art-work understood as an *achieved* object, an end-product that has arrived at a static condition of rest).

To this degree, even "non-formalist" criticism may be observed to be limited by the conventions of formalism. The imperative to isolate significant structure within the artistic event demands the more encompassing isolation of the art-product, demands that it be frozen for examination into the condition of a "specimen", that it be redeemed from process. This clearly presupposes the rigid compartmentalisation of creative activity and its separation from the artistic object which is the product of that activity.

Performance Art tends towards proposing the absolute integration of the two and, thus, centralises and validates an aspect of visual culture that has hitherto, despite its insistent presence throughout the whole history of the avant-garde, been marginal. Established criticism has previously been able to deal, to its own satisfaction, with the recurring appearance of art-products that were less isolatable "objects" than objectifications of the individual artist's self-view by attempting to formalise that which was essentially unformalisable.

Academic categorisation proved useful in this regard. By subsuming these events under the art-historical categories of Dadaism, Surrealism and the like, criticism managed to impose the central notion of "style" upon events that were, in essence, conceived as anti-style. It did this partly by regarding such manifestations as psycho-cultural aberrations, as exceptions which proved (or, at least, delineated) the rule, and partly by isolating an apparent aesthetic "structure" which either was not present at all, or, if so, was far from a central factor to the creative assertion on the one hand or to its residual traces on the other.

For, what established criticism has failed to understand with regard to the greater part of this tradition is that the art "object" produced and the process of producing it are not merely integral, they can be literally one and the same thing. What criticism takes, in these cases, to be the art-object is actually the echo, the reberveration within cultural space, of an act that takes place in social space.

The curious thing is that the melding together of the creative act (or, more properly, the "gesture") with its product is accompanied by an increasing separation of the social and the cultural worlds into distinct domains of experience. That these two phenomena are not unrelated will be explored further below, since it seems likely that an understanding of this process may clarify the whole question of the nature and the scope of Performance Art.

It is, however, important to recognise that, in the context of this present publication, we

are concerned with a rather special understanding of the notion of "performance". Of course, when we speak of Performance-Art, we are aware that we are talking about something quite distinct from "theatre" (in the sense of the dramatic stage) on the one hand and from the idea of performance in the more generalised meaning of public ritual, spectacle, ceremony, circus or cabaret, on the other. But, there would seem to be no clear consensus as to where and how these distinctions can be made, nor can one discern any particular agreement as to the limits and scope of the genre.

Art-criticism, so far, has not been particularly helpful since the essential problem appears to have been avoided: existing publications are either art-journalistic in nature (compendia of review-like observations on the work of selected individual artists) or prises de position (anthologies of manifestos, statements or descriptive texts by individual artists conceived independently and in isolation from each other).

This may well be because established criticism, having an apparent inbuilt imperative to regard the development of this genre as being yet a further step within a conceived unfolding sequence of modern high visual culture, recognises instinctually the possibility that a proper analysis might only be possible at the expense of admitting a rupture with this tradition.

The present extremely vague generalities permit a great deal of "performance" to be categorised within the formalist tradition, while the remainder can easily and comfortably be dealt with by placing it in the context of "total theatre", in terms of the tradition of Gesamtkunstwerk that impinges upon art-historical continuity at specific points from Symbolism onwards.

This situation would seem to be one that exists at the complete expense of any critical

distinction as well as one that draws limits to the authority of self-awareness that is necessary to studio practice. The various myths of the avant-garde, whether they be individual symbols or structured assumptions, have, of course, represented a valid orientation in the past; but, if they are no longer apposite due to an increasing institutionalisation of culture, the attempt to define in terms of outmoded markers can only be obscurantist at the best, manipulative at the worst.

It is for this reason that an approach is proposed (quite tentatively, obviously, due to the limited possibilities of a short essay) towards an alternate perspective, an alternate focus, in respect of a few selected facets of the whole area at hand. It would seem necessary, however, to launch this attempt with an observation that might appear at first to be obvious, even simplistic: the statement that "Performance Art" is art, that is to say, a sub-section of the whole cultural category of the fine arts.

This is not merely to state that performance is a cultural activity that, despite the breadth and complexity of its media dimensionality, has a special relationship to painting and sculpture. It is evident, rather, that the idiom both regards itself and is critically understood as being the most recent circuit in a sort of perpetually ascending spiral of the modernist fine-art tradition.

Instead of regarding performance as a sort of sub-section of the general tendency of Conceptual Art (which would have been a reasonable position some six or seven years ago) it now seems that we must understand the performance mode to have become a general one embracing, or at least conditioning, all innovatory developments across the whole field of visual culture. In one sense, this may well be a specific aspect of a trend that may be widely noted over the recent

past, and that is the tendency for marginality to become central, for "fringe" activities to be displaced into core ones.

It is likely that this phenomenon is related to the fact that the whole domain of culture is becoming increasingly institutionalised, and thus those previously peripheral areas of "anti-art" (concerned essentially with a critique of a high culture that has become absorbed into the established value system of class-society) now find themselves thrust, perhaps prematurely, onto centre stage.

The *inclusive* nature of recent fine-art activity may be seen to reveal an element of inconsistency, almost of "double-think", wherein two opposed concepts are not permitted to collide — and thus to reveal fundamental contradictions — but are allowed to slide past each other in a mentally discontinuous field. The provocative (and previously *marginal*) assertion that art can be anything at all if it is so declared (if it be situated within the context of what is generally understood to be art) that was characteristic of the sixties, has now become, it seems clear, an accepted axiom applicable to the whole field of visual culture.

Yet, the attempt towards realising a putative *democratisation* of art through its de-aestheticisation, through the questioning of the "idea of achievement",[1] did not manage to break down in any way the privilege of accepted culture. The rhetorical statement implicit in some Happenings and in most of Fluxus that anything can be art if so declared, that *anyone can be an artist if he seizes hold of his personal freedom, that is, creates himself anew through a sequence of "gestures"* remained rhetoric.

These acts, themselves, became instantly privileged as a result of being designated significant as anti-art or as non-art, since the very designation, despite stated intentions, finally restricted the event to the domain of

cultural space at the expense of the projected penetration of social space. The paradox is evident; the situation was both open and closed at the same time. The apparent *disavowal of culture* was ultimately nothing more than the *rejection of past established culture*. The dimension of double-think becomes obvious when we observe that the dismantlement of the past was essentially designed to provide a vacuum in which the potential for self-assertion by a new generation could be realised.[2]

With the benefit of hindsight, it is now possible to note how firmly Happenings were based in the beaux-arts tradition. In perspective, the dimension of "correspondence", that element of orientalised synaesthesia that it adopted from John Cage, seems to owe very little to a revived interest in Dada. In passing, one may remark that it would be more fruitful to regard this phenomenon as an aspect of the expansion of formalism since it marks a clear assertion of the separation of art from social considerations in the maintenance of art's mythical extra-historicity.

The "provocations" which seemed so evident at the time in Happenings were almost invariably the offshoot of purely plastic considerations. It remained to the later Fluxus movement (if such a loose structuring of like-minded individuals can be called a movement) to partly revive the tradition of defining art as its absolute negation taking place in real life, and thus make a clear reclamation of its social dimension.

The initiative of Happenings was largely, if not exclusively, painterly; the innovation lay in extending the notion of collage and the incorporation of "unprivileged" materials to include living individual people. From the point of the artist's physical confrontation with paint as fundamental "matter" in Action Painting to the assumption of the artist's presence as raw material itself is a com-

paratively short and logical progression in art-historical terms.[3]

And it seems certain that the earlier artists *were* thinking in art-historical terms. Motherwell's book[4] indicates an academic and scholarly interest in Dada; its value lay not so much in providing heroic exemplars of cultural confrontation as in revealing a rich source, a mother lode, of *formal* ideas to be adopted into the changed conditions within visual culture itself. This observation may be supported by indicating that the element of "performance" in Dada was, even in the most nihilistic presentation, an individual assertion of ego, the unilateral seizure of personal liberty.

The understanding of the world in which this type of voluntarist assertion takes place is one that recognises the individual as being existentially isolated from both his fellows and from history, living in a sort of vacuum in which his identity may only be experienced through an opposition to "arbitary" social and cultural conventions. It is a world wherein the individual rejects a history (that is to him necessarily meaningless) in the search for an instantaneous "gesture" that can transcend, not merely social and cultural conventions, but time itself, and thus all blocks to personal freedom. Freedom here, of course, is not understood as the development of the personality, but as the cancelling out of all that which is alternative to the personality.

The world in which Happenings take place is a world where "art" is still believed to have a clear function, and where the *revolt* is focused within the cultural sphere, toward the imperative to supercede the previous generation. In this case, the "performance" element is severely formal; the scripted actions are fundamentally plastic ones that are conceived within a defined area of cultural spectator-orientated space that is analogous to a canvas. Whatever narrative elements appear during the "performance" are of the order of painterly iconography and are almost always *self-referential within the work.*

The Happening operated within history, and it was consciously history (art-history in this case) in the making. Furthermore, it was firmly linked on the one side to the *formal* tradition of the latest painting, and on the other to the realities of a social world that was becoming more and more conditioned, as a result of the rapid development of the media, to a life based largely on the consumption of visual information.

When Rauschenberg made his celebrated remark that he wished "to operate in the gap between art and life" he really meant, though he was perhaps not aware of the fact, that he wished his art to expand further into life, to appropriate and formalise a greater area of social relationships. In the nineteen fifties, television (and new extensions of print and advertising media) were further reifying social relations, particularly in North America, by initiating as a norm of consumer society *the condition of passivity before spectacle*[5].

We may easily observe that painting did not in any way alter its fundamental nature, as it logically should have under the imperatives of Rauschenberg's stricture, it merely expanded its borders. The fact that North American visual culture remained bound by the limits of what is understood to be "high culture" may be emphasised by noting that, even while Rauschenberg spoke, Manzoni and Yves Kline were genuinely moving out of the domain of culture into the "gap between", reanimating the earlier Dadaistical and nihilistic gestures with significance beyond the boundaries of what was understood to be art.[6]

Their actions did not represent an artistic appropriation of a portion of the real (that is to say, the social) world, but were individual penetrations of that world. Nor, despite their

personal bohemianism and the stance of "heroic" pessimism that they acquired from the post-war climate of existentialism, was their motivation the essentially static one of disillusionment and despair. In this latter distinction we may clearly isolate what has come to be known as Neo-Dada from Dada itself, and thus observe the fundamentally different intentions and nature of the Fluxus movement.

If Fluxus and Happenings are two quite different (though, obviously, to some extent intertwined) areas of activity, they are both mutations that have taken place within visual culture. Any understanding of their limits requires that a clear separation is made from the idea of theatre despite the fact that the dual elements of performance and spectacle are central to both areas. There is, of course, no denying that there has been a cross-fertilisation, particularly with certain aspects of the dance-theatre, but the recorded and reinforced facts of art-history may well be obscuring the real situation.

We are constantly aware in the self view of art-history that the development of the modern theatre constitutes a series of creative bursts of activity, sometimes tangential and sometimes parallel, to those of avant-garde art, and that this, to a greater or a lesser degree shares in the common visual culture. Kokoschka's dual role as painter and playwright was no mere eccentricity, but a joint undertaking consistent with the imperatives of expressionism; the bio-mechanics of Meyerhold were inseparable from the constructivism of Tatlin and Rodchenko; "total" theater was a concept originally expounded by Gropius and Piscator, and the development from the Bauhaus of Moholy Nagy and Schlemmer to Brecht, Weiss, Hochhuth, and, more recently, via Peter Brook, to the bourgeois commercial theatre as a whole, is an obvious, though somewhat awkward,

process: Breton and Artaud were inextricably linked perhaps because of, rather than in spite of, their ideological quarrels.

Art-history, in fact, insists on the compatability, even the interpenetration of modern theatre with modern visual arts. Yet, in one sense, this is a myth of art-history itself. It appears that the Neo-Dadaism of the fifties and the sixties has paid this myth lip-service rather than engaging in the analysis of an authentic dialectical relationship. (It is of course, an undoubted fact that the nineteen-twenties demonstrated that innovatory art and innovatory theatre were in a relationship of mutual coherence, both revealing facets of the then existent general tendency to synthesize all the arts. This interdependence, however, was short-lived and it was restricted to the period spanning the pre-1914 era and the socio-political upheaval that followed the war. In this way, it was quite rigorously limited to the period of expressionist-constructivist optimism.

Dadaism, following on — as a result, inevitably, of its individualistic bias and its apparently paradoxical art-for-art's-sake committment (or, anti-committment) — helped to fragment the totalising and group-orientated idiom realised by the experiments in agit-prop on the one hand and the Bauhaus on the other. This "marriage" between the visual arts and the theatre was transitory, the rupture of their joint endeavour formed one of the events that accompanied the disillusionment of the Weimar Republic.

Theatre is necessarily a collective enterprise, while art (in its modern manifestations, anyway) remains a solitary one. The assertion, ideologically central to post-industrialist social realities, of creative individual "genius", was as much affirmed by the pessimism of Dada as it was by the optimism of cubism. What we may call "Proto-Performance" remains quite distict from

theatre, as does also the whole genre of Performance Art which covers the recent fifteen years or so. Whatever cross-references there exist between the two are essentially tangential.

Journalistic art-criticism responds frequently to a requirement imposed upon it by the market, which results in it drawing a mystificatory veil over the true events that are taking place. More frequently, perhaps, it is simply mistaken in its understanding of the issues at hand, and permits an easy blanket pigeon-holing of categories for the sake of a facile apprehension and a persuasive text.

Recent journalistic compendia of Performance Art (and we have hardly yet seen any that are not journalistic — consider, for example the *Studio International* issue of July-August 1976, "Performance" or the final valedictory issue of *L'Art Vivant* of September 1975 entitled "Les Marginaux") have clearly failed to define the extent and the scope of the subject under discussion, since they have invariably expanded their categories under the market imperative towards media coverage in such a manner as to render any critical analysis difficult, if not meaningless.

It is clearly not possible to develop any sort of theoretical overview across a spectrum that ranges from, say Oppenheim, Acconci or Urs Lüthi via Ben, Beuys, Schwarzkogler and Nitsch to Kantor, Grotowski and Richard Foreman, particularly if such a proposed analysis is restricted, almost by some sort of axiomatic definition, to the mechanism of formalist art-criticism.

Of course, we can hardly expect to be able here to draw a firm and incontrovertible boundary between performance and theatre. It would scarcely be sensible not to expect to note a transitional shadow area, a gray terminator, between the one and the other; and, with a moment's reflection, it is easily possible to isolate in this regard such ambiguous examples as the two English artists Stuart Brisley and Marc Chaimowicz with their recognised debts to Ronald Laing and Jean Genet, or the *Vienna Actionists* such as Günther Brus, Otto Mühl, Hermann Nitsch and the "Organum-Mysterium Theater". It should, nevertheless, be possible to define in some way the broad distinctions between theatre and performance, and thus arrive at the beginning of a theoretical understanding of the latter.

First of all we can easily remark that theatre *demands* an audience. The idea of a "theatrical" performance taking place in such a way that it is experienced, *that it is witnessed,* only by the actors is a ridiculous concept. Drama, in the widest sense, implies two worlds: that of the stage and that of the auditorium. "Total" theatre has abandoned the proscenium, it is true, it has also invited, to some degree, an audience "participation" by rendering the boundary between these two somewhat fugitive worlds. But these innovations have not altered the fundamental relationship between the two separate, but interlocked, domains. In fact, these innovations spring from the very need to emphasize in one way or another the separation, the significance, *the reality* of the necessarily artificial events that are taking place on the stage. The two spaces remain distinct, uniting only in the spectator's mind.

Happenings and Fluxus (and for that matter, their prototypes in Dada) *do not fundamentally require* the existence of an audience, though there most frequently is one. This realisation immediately clarifies one significant and crucial factor: the analogy seen here (and the cross-references understood) should not be between Performance Art and drama, but between Performance Art and the musical concert. A performance of music does not depend upon the presence of an external audience for its very existence.

223

Indeed, a great deal of music (such as chamber music and solo instrumental) is basically conceived and understood as being autonomous. The performers can, and frequently do, play entirely for their own pleasure. The aesthetic dimension lies in being a listener and observer of your own participation.

The fact that so many Happenings and Fluxus events were cast as "concerts" does not so much reveal the influence of John Cage as to explain it. The notion of "concert" is central to the whole genre, and an awareness of this places an extended understanding on such innovatory and apparently "personal" pieces as those of Yoko Ono's "Grapefruit" series of the mid-sixties and Mieko Shiomi's still-ongoing "Spatial Poem" series in which the performer was instructed to act in silence and in solitude.

In such cases, of course, the presence of the spectator still remains necessary in order to "validate" the gesture that would otherwise remain incomplete, solipsistic, a purely private ritual. The event performed in total solitude (that is to say, in front of the unique performer-witness and not in terms of a group "concert") is analogous to the condition of a painting in the studio before it has been observed by colleagues and critics, before it has become animated into socio-cultural space as a result of being contemplated by observers. The solitary Fluxus event, of course, gains its spectators, its fulfillment, via the dimension of *exhibition,* as a result of either the gallery exposure of documentation or even the simple public knowledge in the art-community that the performance took place in such and such a way.

It is now possible to observe a further shift. Theatre requires an audience (and it is not, of course, insignificant that we use this word even in terms of a silent movie, a theatrical event wholly of spectacle, since a flow from stage to auditorium is implied: the actors speak — the audience listens). The relationship that is now formed between participants and observers is clearly different. We do not here essentially think of an audience, but of *spectators.*

In the case of the Happening, the relationship was clear. The event was understood to take place in a gallery space — no matter whether it was actually in such a privileged environment or whether it was located in the street, in a field, a swimming pool, a courtyard or a railway siding. The relationship defined between an event and the spectator was that set up by the gallery conventions. That is to say, despite the fact that there might be a large group of spectators, each one confronted the "work" as an isolated and separate individual. This, of course, is not true of the theatrical process of "audience" which, for the duration of the spectacle, becomes a ritual collective.

The development of Fluxus proposed an even greater ambiguity in this regard, since it substituted, for the fundamentally pictorial frame of reference implicit in Happenings, a more or less socio-cultural frame of reference resulting from the position of refusal and irony central to a revived Dadaism. Unlike the original version of some forty years before, however, it was not projected (as that was) into social space as a challenge to accepted value, or was constrained to do so only to a limited degree. This is because the artists were inescapably operating within the confines of a precedent, an accredited art-historical tradition. Inevitably, a great deal of conscious (even Mannerist) formalism permeated their provocations and ironic reversals.

Performance Art, in its contemporary guise, is clearly a product of the melding together of these two traditions. Like Happenings (and to a lesser degree, like Fluxus) it

operates in cultural space; like them both, its arena is ultimately that of the classic beaux-arts "gallery" exposure; like them, it may absorb or altogether dispense with the presence of the spectators at the actual performance. Yet there has been a clear further mutation not merely in form but also in basic orientation. It is evident that Performance Art now comprises a distinct genre from proto-Performance. But, wherein does the distinction lie? Conventional criticism has not been able to isolate and define this shift.

The artist of proto-Performance, as we have seen, discovered the raw material for his manifestations in the objective world, a world that consists not only of objects but also of people. He frequently included in the work his own physical presence as well as those of selected colleagues and even individuals who had been persuaded to make the transition from spectator to participant. Yet this contributing "presence" was not of a special order beyond the existing conventions of the painterly tradition; the individual was simply yet another element in the overall *collage,* a further appropriation into the art-work of material that was previously considered non-artistic or unprivileged. The innovation lay in the fact that this new element in the pictorial equation was sentient and reflexively aware of participation.

The essential point is that the artist is here still operating in an environment over which he has total authority. He is the individual *maker,* the only animating focus of an invented world which he, as creator, is bringing into being. It is this invented world, the outer "pictorial" space that he confronts, that he defines as the arena of his self-realisation, into which he occasionally enters personally as a subsidiary physical element, in a manner analogous to that in which he has persuaded the participation of others — *as a further object in a formalised tension with other objects.*

Obviously, the creative act is here based on the traditional Romantic notion of the artist as visionary and genius, the subjective manipulator of a purely objective environment. In this regard, the Happening (and, to a lesser degree, the Fluxus event) is a direct and linear descendant of Action Painting in which the creative process is regarded as an existential confrontation and the canvas considered as an "arena in which to act."

The present situation of Performance Art, however, may be seen to be conditional upon a mutation that clearly parts company from the long-established conventions that orbit the basic notion of the artist acting from a position of subjectivity upon an *external pictorial space.* The shift which separates the greater part of contemporary sensibility across the whole spectrum of visual culture is one in which this earlier externalisation appears to be becoming progressively interiorized.

The artist used to consider the art-work as something objective, something *exterior* to himself, upon which he acted, as it were, from outside and from above. It seems, however, that certain imperatives have set into motion the necessity for him to physically meld himself with his work, to integrate the realms of perception and conception on the one hand with those of the realisation and presence-in-the-world of the art-object on the other.

One technical way of attempting to achieve this end was personally and bodily to penetrate the art-work, to enter the outside formal configuration as both aesthetic object and process. But a more recent and total re-orientation has taken place, in which the relationship between artist and cultural artefact has been reversed. Instead of physically and personally penetrating the external space of the art-work, the artist has switched to absorbing that outside event into his own existen-

tial and bodily space. Rather than the artist operating as an element in the art-work, the art-work now begins to become a component part of the artist in an ongoing process of self-invention and realisation.

It was at this point that Body Art became a distinct genre some years ago. But it would seem that there has been no clear critical understanding of this remarkable reversal. Formalist criticism comprehends the advent of Body Art as being in some way related to, even being a consequence of, the combination of Process Art and Land Art, but has never been able to analyse or explain this relationship. In general, events under these parameters are merely stated to have taken place, as it were, in a sort of art-historical limbo. The fact that all of these genres may be observed in conjunction in the case of certain individuals (Dennis Oppenheim, for instance) probably helps to validate a type of linear "promotional" writing that masquerades as criticism.

The lack of any serious analysis of this major reorientation (indeed, the lack of any clear understanding that a major reorientation has taken place) is understandable, since the crisis of the pictorial tradition that reached a climax of insoluble contradiction during the middle to late-sixties left, as a legacy, a situation which appeared to be only amenable to a resolution on formalist terms. This development was as a result of the fundamental notion of the artist as a special and privileged being, visionary and genius, remaining unchallenged.

The Greenbergian reductive imperatives have rarified the adventure of visual culture to a point of the almost total disappearance of signification, to an abstracted, attenuated and transcendental statement of absolute objective presence, pure property. This, of course, was the logical culmination of an extended historical process. As long ago as the

Symbolist period which marked the launching of modernism in visual culture, Mallarmé remarked that the " ... ideal poem should be white", and the sequence thus initiated of the progressive formalistic condensation of art has now finally come to maturity, achieved the point of silence, the point of connotive and allusive invisibility.

In one sense, and in a very real sense, the whole pictorial tradition initiated by Manet and reconfirmed by Cézanne, Matisse and the Cubists, has committed suicide. No real resolution was possible in terms of the tradition when that very tradition has become eroded into the stasis of absolute surface. However, Symbolism, which contributed so much to this mainstream, now at the point of ultimate reification, also offered an alternative tradition (the "other" tradition occasionally noted as such by a few perceptive critics)[8], and that was the obverse of the proposition that art was a quasi-sacral function which rendered meaning to life — the counter-proposition that all of life should be understood as a work of art.

Huysman's character Des Esseintes[9] defined the ambition to render all experience mental and sensuous, while Count Axel[10] declared unequivocally that only the contrived and the artificial (art, in short) was bearable, " ... as for living, our servants can do that for us!" The unspoken aim of Fluxus (obviously "unspoken", under the Neo-Dadaist imperative to combat all forms of the structuration and institutionalization of culture) was clearly evident in the very nature of its public manifestations. Turning around the elitist assumptions central to the sanctioning and sacralising of arbitrarily selected objects that are carried by the Duchampian dicta that "art is what the artist declares it to be", Fluxus maintained that all life experiences could (and perhaps, should) be a matter of art, that the crucial sensibility through which

226

we apprehend experience and comprehend ourselves ought to be based on the aesthetic faculties rather than on those of reason, intuition or social ritual.

Within the formalist mainstream, however, the widespread but short-lived burst of Process and Land Art seems paradoxically to owe a great deal of its impetus to this tendency, or rather, to a specific version of it. This may well help to explain not only the evident difficulty inherent in attempting to understand the phenomena as an extension of minimalism but also the extreme brevity of the movement.

The expansion of reductionist and serial "gallery" sculpture to vast environmental works was not understood, even in terms of studio practice, as being attempts to *aestheticize* enormous areas of land, even, eventually, the whole planet. The insistence in taking the perspective of the conventional fine-art object (*objet de luxe,* embodiment of special function) could only result in a considerable ambiguity and confusion of aims and intentions. The career of Robert Morris may be seen to typify this problem: oscillating between the early (and extremely significant) Fluxus-type of action in "legally" declaring an object void of aesthetic merit, via minimal, environmental and land art works to sexually-ambiguous statements of power and submission, he demonstrates an archetypal uncertainty and inconsistency of creative direction.

The earth-work, of course, constitutes in itself a type of Performance Art; documentations of the process of construction are invariably as central to the final "artefact" as are descriptive media photographs and the rare personal confrontations. But, like Process Art in general, this was inevitably a transitional form. The trend towards which it was probing became realised only when the focus was turned from the Land Art scale to the human dimension, when attention was removed from, as it were, the macrocosm in favour of the microcosm, when the artist's own body became concurrently the initiator of the action, the arena in which it took place and the object in which it was embodied.

Body Art, in itself, would not seem to be such a remarkable innovation. Indeed, what appears extraordinary is that it had not come about as an artistic genre earlier than it did. It is possible to observe precedents as early as the end of the nineteenth century, since the history of the avant-garde also describes to some extent the unfolding history of the artist asserting himself as a cultural artefact. In this regard it is only necessary to think of such individuals as Alfred Jarry whose self-invented *mythic presence* proved at least as significant an aesthetic "object" as any of his written texts or theatrical presentations.

In anthropological terms, observers have long since noted a propensity to transform the human body into an artefact. As early as the mid nineteen-thirties, Marcel Mauss described the manipulation of the body as an object during the process of training and education: " ... in every society", he remarked, "everyone knows and has to know and learn what he has to do in all conditions, the techniques of the body being assembled by and for social authority the body is the first and most natural instrument of man."[11]

Following on from the work of Mauss, Mary Douglas points out the correlation between the individual body existing in a social context and the enveloping organism of society, the "body politic". She begins with the assumption that " ... the social body constrains the way the physical body is perceived", and points out that the physical body is an object that we *perceive* rather than one that we possess. In this way, it constitutes a segment of our "social construction of reality".

The body, however, is not to be understood as simply another element in the spectrum of socially-perceived reality, but as one that occupies a significant and important place in the whole scheme, since " ... the physical experience of the body, always modified by the social categories through which it is known, sustains a particular view of society. There is a continual exchange of meanings between the two kinds of bodily experience so that each reinforces the categories of the other."[12]

If we accept Douglas' contention that "the human body is always treated as an image of society"[13], then a more clear understanding of Body Art becomes possible. It would seem obvious that the imperatives to discover alternatives to the severely enclosed and formalistic visual culture (such imperatives as we note operating in proto-Performance) constitute, in part, a reaction to the domination of the cultural domain over that of the social. It reflects a desire to place visual culture once more firmly within the ambit of social experience and to render its subject matter that of a generalised experience-in-the-world rather than that of a specialised and aestheticised experience-divorced-from-the-world.

That this process has not previously been theoretically understood is evident from the existing ambiguities; ambiguities that have necessarily arisen from an attempt to equate what was, in effect, an intuitional drive towards the re-socialising of art with an existing and all-pervasive straight-jacket of formalism. This formalism, it should be clear, operated not only in the academic dimensions of criticism where it achieved its most rarified form in the Greenbergian canon, but it penetrated and suffused the whole structure of studio practice which resulted in an almost total and blanket acceptance of formalist assumptions as the standards and norms of creative activity.

A temporary (and obviously unsatisfactory) resolution of this contradiction was only possible as a result of formalist criticism appropriating to itself a proposition that was, or should have been, far removed from its concerns and interests, and that is the anarchistic imperative of Dadaism that stated (originally in terms of a democratising concept) that a work of art is such since the artist states it so to be.

It is evident that Acconci's act of stuffing his hand into his mouth until he gags, or of masturbating beneath the floor boards, is considered art *by declaration,* while a similar act engaged in by someone else (someone, that is, unsanctioned by the label "artist") in a non-art context would be understood as a private and arbitrary (even a pathological) manifestation. Two distinct elements are operating here on the "art" side of this comparison. One is that of the unilateral declaration of the status of "art" by locating an event within the continuum of what is agreed to be visual culture, and the other is that the event takes place as the result of the deliberate and conscious notion of *spectacle.*

Acconci, presumably conditioned to some degree by formalist ideas concerning art, does not seem to be aware (according to his published statements) that his intuitive condensation, his merging together of signifier and signified into the single unit of his own body, constitutes a series of lyric metaphors for the tenuous contemporary relationship presently existing between the individual and society as a whole. There is, of course, nothing particularily surprising in this apparent astigmatism, since Acconci's sanction is his (and subsequent critics') personal labelling of an act with the cachet of "art". Yet it would seem to be inevitable that his understanding of "art" would also be declared in his immediate milieu (that is to

228

say, that of North American visual culture in the sixties), one defined in formalistic (even Greenbergian) terms.

It has been remarked above that the events in Body Art take place as conscious *spectacle,* that one of the parameters of significance lies in the fact that the event is always a public one, never a private one. A moment's reflection reveals that this assertion contains the possibility for an approach towards the resolution of the present critical dilemma. The usual notion of spectacle implies a visually-orientated event that unfolds before a more or less static audience. But, combine this idea with the general concept of *public,* as opposed to private, and conceive of "spectacle" as something which can take place in the open and potential arena of social experience as well as in the closed, artificial and virtual one of cultural limitiation, and a significant dimension of *theatricalisation* becomes evident.

It is now possible in this light to approach the whole subject from a different direction altogether. Once a break is made with the product-orientated focus of traditional visual culture, the recognition becomes inescapable that the significance of Performance Art lies less in the spectacle itself, the event projected, than it does in the attitudes which that spectacle embodies. The very name that we have given to the genre tends to obscure what now surfaces to our attention: the fact that the major characteristic is *not* the performed event, but the essential process of play-acting — *the assumption by the performer of roles.*

This realisation resolves the previous critical opacity. To some degree the work of Dennis Oppenheim, Vito Acconci, Gilbert and George, Dan Graham, Klaus Rinke, Joan Jonas, Barry le Va and others has shown itself amenable to the understanding of traditional art-criticism; but only, as we have noted, to a

severely limited degree. On the other hand, such diverse artists and groups as Joseph Beuys, COUM Transmissions, Dr. Brute, Urs Lüthi, General Idea and William Wegman, not to mention more highly internalised individuals such as Gina Pane, Chris Burden, Natalia L.L. and Michel Journiac cannot be comprehended in any way in terms of existing notions concerning art.

It is true, of course, that the manifestations that these artists represent are susceptible to a type of literary journalism, their work may be discussed in terms of ritual, ceremonial theatre, psychodrama, suicide, aberrant sexuality and the like (as is frequently done in such journals as *Flash Art* and *Art Press*).But, as long as this approach remains unemancipated from formalist criticism, there would seem to be little that is capable of being said other than the constant reiteration of avant-garde myths and the bestowing of the somewhat shallow accolade of *Poète-maudit.*

Clearly, the austerities of the Greenbergian perspective are unable to sympathise with, let alone come to grips with, such subjective voluntaristic and ultra-romantic postures as are demonstrated by our second group above. Yet, this neo-positivist focus, leavened frequently as it is by structurist and linguistic dimensions, has revealed something interesting. In isolating, for critical attention, certain artists (our first group above as opposed to the second), it has defined a split between those susceptible to a neo-positivist approach and those who can only be reported upon journalistically.

The comparison of the two groups of names reveals a distinction between an American artistic overview and a European one (Canada, unexpectedly, appears to be affiliated, in this regard at least, to the European sensibility) that must evidently be dependant upon social, political and ideological factors. This shift away from the

229

exclusively cultural field of reference proposes, in itself, the alternative critical perspective that has hitherto been lacking: that is to say, a critical perspective based on *sociological* parameters.

With the centralisation of role-playing, the very nature of visual culture has been fundamentally altered. The network of activity — conception, performance, event, spectacle, response — has been abstracted from the domain of a circumscribed art-culture that is progressively ossifying under the pressures of a general institutionalisation of the society, and has been restored once more to the social frame of reference. *Quite obviously both critical response and the self-view of studio practice must now be couched in sociological terms.*

The aestheticisation of extreme conditions; of pain, anxiety, sexuality, the ritualising of social conflicts and ambiguities, the ironic reinforcement of the artificial world of glamour, the assumption of masks and the invention of elaborate personae, are all comprehensible phenomena once they are examined in this light. Take the dimension of ritual, for instance: clearly the potentialities of Performance Art can allow for the surfacing of a psychologically deep-seated impetus towards a ritual and magical apprehension of the world. One would expect to observe a widespread involvement and concern with a structure of esoteric and hermetic ceremonial, particularily in response to the undoubtedly chiliastic climate of the present times.

However, we do not observe this, or note it merely in peripheral forms: in the Viennese *Abreaktionspeil,* for instance, which more properly belongs to the Artaudian theater of cruelty and catharsis, or in the fading hangover of drug-culture now firmly-entrenched in the popular music and fashion industries. Ritual itself, of course, is central to

Performance Art, but it does not appear to take on a magical or mystical colouration. It remains (as may be demonstrated by the undoubted master of this approach, Joseph Beuys) firmly located within social parameters.

Beuys' specific contribution is his remarkable ability to ritualise, and thus assert a human hegemony over, certain social ambiguities of late capitalism. His work is *political* in the essence (not the trivial unidimensional and linear "political" comprehension of cultural ultra-leftism, but one that recognises with a piercing clarity that the very making of art today is an inescapably political action). Perhaps this political dimension is a characteristic, one way or another, of all that is presently valuable and significant in Performance Art.

Beuys does not deny the historical weight of the cultural past, as did the greater part of the Fluxus movement to which he is understood as having "belonged". He locates ritual action at the peripheries of a cultural tradition in such a way as both to revitalise that culture and to make it significant in the real-time/real-life domain of social interaction. The intensity and the validity of this process is attested to by the fact that even those whose exposure to Beuys' work lies only via the media have experienced such notions as the fat, the hare, the coyote, as images which have achieved a mythic dimension *on their own terms,* and which provide images of a deeply haunting quality that reverberate and echo continuously in the mind.

It is perhaps necessary to remark here as an aside, that the documentation of Beuys' *aktions*[14] do not constitute the whole, or even a significant element towards the realisation of the work — as does, for example, the documentation of some performance events and almost all large Land Art earth-works. In

the latter case, the aesthetic "event" is largely *situated in the media,* in a manner analogous to that in which the experience of easel painting may be said to be situated "in the gallery".

The photographic documentation here is, for most people, the totality of the aesthetic experience, since physical confrontation is restricted to a closed circle of extremely privileged consumers: invariably the patron and those individuals rich enough to hire a privately-chartered aircraft to view the necessarily isolated sites. Such works operate on a double aesthetic: that of a certain extreme of private property and that of media affirmation.

The patron, of course, clearly needs the latter. The widespread media coverage and its concomitant secondary aesthetic consumption through documentation, are essential to announce and proclaim the *ownership* of the property at hand. The whole point of being a patron of the arts is that you should be widely acknowledged, credited and *envied* as being so.

The manner in which Beuys' documentation operates is hardly analogous. The ritual which he celebrates (and here the word "performs" is deliberately avoided) is a significant and charged event that is available to as many people and to as broad a cross-section of the art-public who choose to attend the gallery; as wide a selection, basically, as any exposed at first-hand to the conventional plastic arts of painting and sculpture.

Quite obviously, this in itself constitutes a privileged circle to a broader degree and to a minor level of intensity. That question, though, is hardly relevant in this particular context, since such privilege is the norm in any aesthetic confrontation that presently takes place in our society. The point here is that the art-work is *not* subsumed into the media to constitute either a dependency or a reinforcement of the ideology of consumption.

A dominant factor of consumption lies in its single-dimensionality. The product advertised, the dream-fulfillment proposed, offers a rigidly-controlled view of the product at hand. The advertising media defines both the appearance of the object it presents and the parameters of the fantasy that it purports to satisfy. The photographers's camera freezes all potentiality, it presents us with a single and definitive viewpoint, a viewpoint which embraces the totality of the product.

Similarily, in a very real sense (barring the extremely rare and privileged aesthetic confrontation at the site) Smithson's *Spiral Jetty,* or any similar work, may be said to exist only *in terms of those single viewpoints defined by the camera documentation.* The work is closed off from any but a rigidly controlled response. The artist has, by extension, initiated a relationship between himself and the spectator that is absolutely hierarchical.

No dialogue is possible. *No aesthetic interaction is possible.* This may, in one sense, be regarded as truly "performance" art (in the absolute meaning of the term) for the artist has totally stage-managed the *one-way flow* of the image, from above to below, from a position of his own aesthetic potentiality to one of a severely-limited *script,* a script demanding a scrupulous and exactly "correct" reading.

This type of aesthetic confrontation is ultimately inauthentic in nature, for a valid aesthetic experience depends upon interaction, depends upon a flow of responses and counter-responses, the increasing penetration of the work and the increasing revelation of the image, a flux between the spectator together with his memory (all of that spectator's previous cultural experiences) on the one hand and the art-work on the other.

Authenticity demands absolute contingen-

cy. The true artistic experience is the result, finally, of a state of balance achieved between all the factors in the equation. The signified is essentially the resulting nexus, the still silent point of maximum tension between the thrust of the signifiers — and these may well include previously apprehended signifieds. Any alteration whatsoever to the signifiers shifts the centre of gravity, as it were, and a new, temporary and precarious balance is achieved.

We are, each of us, the products of continuing experience, and thus clearly the signifiers change in some way at each separate moment in our lives. This process explains why an individual art-work actually means a different thing (and *is* a different thing) at a different point in time and in a different social of socio-geographic location. The freezing of the signifiers by the documentation-control of viewpoint constitutes an attempt to ensure the hierarchical and one-way flow of aesthetic experience from above to below, and it reveals the desire to render art *an absolute and fixed experience.*

This imperative towards the isolation of art from the processes of mutation, and thus from history, has at the back of it certain ideological assumptions that are central to a society which constantly wishes to claim that whatever is happening right now, at this exact moment in the present, is the absolute and desirable norm; a norm that is understood to constitute the ideal and enduring network of human relationships. Quite clearly the isolation of the art-work from any interaction with the spectator is inimical to the health of visual culture: i.e. it is also, ultimately, socially reprehensible since it is a blatantly manipulative process.

The documentation in the media of the activities of such artists as Beuys, is not in the least manipulative in this manner. There is, of course, an element of restriction of experien-

ce (an element of selectivity) at work, since significant moments of a process have been isolated — but that is inherent to the nature of iconography in general, not merely to the camera and the printed media.

The spectator present at the ritual is free to interact on the plane of aesthetics, and to resolve for himself his own assessment of the significance of what is taking place, and he will obviously do so in retrospect. For various reasons, already defined by the culture available to the individual, memory will select and isolate certain images which will then haunt him and which, in turn, he will feed back into the resolution of his next aesthetic experience.

An artist such as Smithson (in a manner perhaps central to the ideology of capitalism) wishes to evade just such a process of judgement; in doing so, of course, he also evades the possibility of an authentic aesthetic experience taking place. The hallucinatory quality of Beuys' printed images is the result of the interaction of the mythic structure that he has created with the existing experience of the spectator; it constitutes an "open" dream. It has nothing to do with the closed hallucination of mental manipulation. It has little to do, either with egoic assertion, with those hallucinations based on exemplary individuals, on those who have abandoned the present world for the rarified limbo of the glamour of excess.

The photographs, for instance, with their haunting images of the coyote, the hunched, mysterious roll of felt, the walking-stick, both staff and mace, move us precisely because they are ambiguous and not because they are structured. We sense a sort of re-arrangement of our identity, we feel our deepest sensibilities stir and slip into another tenuous configuration of balance as we confront these mysterious and potent images.

Ultimately we are changed by art when we

are permitted the potential to change it. Interpenetration implies alteration. We are humanised by art to the very degree that we humanise art itself, and through it, the world. What must inevitably begin as the subjective asserveration of an artist, the projection of his ego onto the world, is transformed into a structure of symbols that exist in and for the world. In an authentic process, the merely egoic assumes the lineaments of collective myth. Beuys' private world becomes symbolic, *as a result of the role he has himself assumed and projected as personal myth in* terms of the real conditions of the world. *It enters me as spectator, and becomes part of me, the spectator.*

Beuys' achievement is analogous to that of Kafka, whose private and therapeutic struggle with neurosis became a screen upon which the historic collective psychosis of Europe was projected during the nineteen twenties and thirties. In a similar way it seems that Beuys' deeply personal mythic resolutions embody a historical sense of the present. This process of mythification is finally the process of rendering the world transparent. The photographs of Beuys' actions are "beautiful" in the most profound sense — because they *speak,* they bear witness to the human condition, and they open channels for us to participate in that process.

The photographs of Smithson's installations, on the other hand, are merely statements concerned with the logic of formal relationships. The work is severely self-referential and it speaks outward only to assert a hierarchical view of *order,* and, of course, finally, of power. The photographs are not "beautiful" in any meaningful sense — they are simply the documentation and the reinforcement of a static and a-social point of view.

Sometimes, the luminous quality of aesthetic beauty (platonic and classical beauty even) may surface in the most unexpected places. The recent and widely-circulated limited-edition folio of photographs of Schwarzkogler's bizarre and ultimately fatal ritual of self-mutilation embodies, to one's enormous surprise, a remarkable density of sheer lyricism. This recognition would seem to have nothing whatsoever to do with any special feelings of awe before the fact of suicide or before the apotheosis of cultural martyrdom. For, otherwise, we should surely feel a similar emotion in the face of Smithson's untimely death as the result of a plane crash near the isolated desert location of one of his massive and ambiguous earthworks.

It is more reasonable to assess the haunting power of Schwarzkogler's imagery (that of a mute and blind, gauze-wrapped, bandaged — *and bondaged* —figure, teetering at the very edge of self-recognition, the composite victim-torturer, acting out his elegant and poignant sado-masochistic role with absolute conscious authority and total consistency) as imagery defined completely within its own terms.

The subject of these posthumous photographs is not that merely of Schwarzkogler, a Viennese artist playing "theatre", but that of a totally *invented* "Schwarzkogler" who, like Beuys and others, becomes a self-creation, a complete and consistent product of his own activity. The freedom that he seized was not the fragile and transitory anarchistic "freedom" of a Dada-type egoic self-asseveration, but that absolute and rare liberty which is the fragile and elusive fruit of an assertion of complete control both over a personal life and a private bodily existence on the one hand and over a public social existence, a relationship-in-the-world, on the other. Schwarzkogler's manipulation was a social, even to some degree a spiritual, act — not a mere cultural one.

233

The same, or similar, is true for those who, like Gina Pane or Chris Burden, invite and provoke risk, anxiety, physical pain, even the potentiality of death, as testaments to their identity, to their presence, and to their assumption of personal responsibility for that presence. The essential perspective proposed would seem to be one which claims centrality for a process designed to aestheticise both the world and the individual's selfview within it. The significance of this process lies, quite obviously, in the attempt to reclaim artistic activity from a de-socialised and hierarchic domain of institutionally-accredited culture.

The centrality of the idea of "role" in Performance Art would seem to be emphasised by the particular focus which is often taken up in the domain of sexuality. Quite clearly, in the light of the foregoing, we would expect to observe, as we indeed do, an emphasis on sexuality in much of Performance Art, since sexuality, like pain or any other extraordinary physical sensation, proposes a "theatre" in which it may manifest itself. Yet this sexual dimension, even though frequently explicit, often seems to lean more towards an ambiguous, even androgynous, understanding of sexual roles and activities.

This factor alone emphasises the distinction between role-orientated Performance Art and the theatricalised spectator-manipulation of Proto-Performance. The sexual element in much of Fluxus and Post-Fluxus transitional pieces was essentially conceived (sometimes even in the Dadaistical manner) as a shock element. The purpose ranged across a spectrum that included the simple crudities of *épater les bourgeois* and the complexities of forcing novel perspectives through the effects of shock and cultural trauma.

Sexuality in Performance Art, on the other hand, is concerned with a diametrically opposed set of pre-occupations. It has supplanted the attempt of a minority consensus to impose a point of view across the prejudices and conventions of a majority consensus with an analytic ritualisation of conventions. The intention of the latter approach is more a process of exploration than one based on a desire to manipulate social value systems.

This distinction may be illustrated by citing Mark Boyle's presentation *Son et Lumière Body Fluids and Functions* in London during 1966, in which a couple copulated publicly (though hidden visually from the audience by a screen) where the cycle of foreplay to climax and orgasm was observed via various readout mechanisms which monitored the activity levels of the participant's body-fluids, pulse, respiration, blood, endocrine and electrical brain activity, and comparing it with the entirely different sexual dimensions explored in various ways by such as Urs Lüthi, Vito Acconci, Natalia L.L. or Cosey Fanny Tutti.

Mark Boyle's piece was designed to manipulate a perspectual shift in the audience's understanding of both the nature of sex and the nature of "theatre" and the method employed was one of deliberate social provocation. But the Performance artists of the type cited are not so much concerned with sexuality as a cultural phenomenon as regarding it as a psycho-social one. Their intention is clearly defined by the exploration of subjective identity within a social context through the public display and deformation of sexual characteristics and activities.

That this process is fundamentally a self-observation/self-display taking place *in a social context* would appear to be supported by the fact that the sexual dimension is usually conceived of in solitary terms and frequently objectified in ambiguous or trans-sexual forms. The

essential "feminising" of sexuality in Performance Art would not seem to be either gratuitous or merely socially eccentric if we remember how John Berger has pointed out that one of the characteristics of our present society is for men to "act" while women remain conditioned to "observe themselves being acted upon"[15]

The sexual ambiguity of much Performance Art (not to mention the propensity of a great of a great deal of video to be self-observing — narcissistic, understood as a non-derogatory term) is clearly involved with the whole complex situation of watching oneself existing as an object in the gaze and understanding of other people.

In this regard the dimension of sexuality in particular and the broad thrust of recent Performance Art in general (the propensity towards the glamour-camp-androgyne focus in the work of such as General Idea, Colin Campbell or David Buchan is partly a sublimated version of the above) might suggest an understanding of role-playing that is closer to that of a more conventional "theatre". It seems reminiscent of Jean Genet's observation that the true stage of our identity is the stage of sexual encounter, and that the person who achieves a fleeting awareness of subjective identity in the present anarchic conditions of social alienation tends to be one who assumes the rôles and costumes of the brothel.

However, the reality of poeticised psycho-social theatre and that of aestheticised socio-cultural transformation would not appear to exist on contingent planes. It is true that Genet (perhaps even Artaud) can be seen somehow to be the perverse descendant of Rousseau (in maintaining that it is only in the depths of artificiality and a-sociality may there be found innocence) and that this point of view sometimes seems close to much of the L'art pour l'art extrapolations of Performance.

It is also true that the self-view of the Performance Art community appears occasionally to suggest that both innocence and the dragon-media, that both the imagined honesty of studio insight and the real corruption of gallery commerce, that both the residual dream of individual poetic vision and the enduring patronage reality of the Canada Council all meet and are reconciled on the brothel's Balcony[16] — where (in the vacuum between a collapsing bourgeois culture and that which will eventually replace it) the hopes of subjective individual man and the prisons of bureaucritic institutions are briefly and temporarily resolved.

However, social reality does not permit the resolution of contradictions in such a manner, despite the long tradition within institutionalised visual culture of sublimating discrepancies into comfortable illusions sustained by cultural myths. If there is one clear fact that distinguishes Performance Art from its preceeding forms, it is the rupture with tradition brought about by a (frequently unspoken, frequently intuited) awareness that the end of the avantgarde has finally come about. The idea that the individual artist is no longer conditioned or supported by the century-long tradition of the "bohemian" beaux-arts is what separates Performance from the "living" theater of cruelty and surprise that it superficially resembles.

In a world of rapidly evolving (and devolving) social value, the old aesthetic

235

vision of coherence in which the individual creative act became a mirror of confirmation, a momentary, silent and briefly-arrested *haven of identity and love,* has now totally eroded to zero and is presently as unattainable as the lost collective endeavour of the beaux-arts which defined that vision as a group enterprise.

The present crisis in visual culture is firmly anchored to the fact that the general structure of institutionalised art, the museo-critical complex, has not even begun to become aware of the presence of this watershed, much less started to come to terms with it. Only in the so-called "marginal" art scene (which now assumes greater and greater centrality) would there seem to be the potential to transcend the old outworn culture of subjective individualist idealism, for only there is it presently possible to escape the traditional self-view of the artist as an individualist visionary, rebel and hero.

Performance Art (together with sibling Video) presently stands before its own crisis. It has the possibility to reach forward for an art of genuine aesceticised social content, or it can let itself fall back into the congealing pool of an "art-history" that History itself has already supplanted.

Winnipeg
September 1978

1. Allan Kaprow, see footnote 2 below.
2. "We have things to do. 'Anarchy' can now be revolutionised. If we own allegiance to no one and to no institution of beauty however sanctified, we are only turning away from what should be left behind: the *idea* of achievement. This bogey has stifled us too often. The long shadow of Dante or Michaelangelo is only a shadow after all, and not the intensity, the electricity that infused their art. We can approach them with understanding and genuine affection when we have made something actual ourselves. We are adventurers. We do not have to 'hope' for anything. We are busy dreaming. We are hard and tender without nostalgia, fearless, ecstatic. We are giving to the past and to the future the present." Allan Kaprow, text printed in the flyer for *A Programme of Happenings ? Events ! and Situations ?* directed by Al Hansen, Pratt Institute, New York, May 2nd, 1960.
3. Despite the idea of "audience participation", the separation between the space of the spectator and that of the work was clearly marked. It was necessary that a member of the "audience" participate more or less as an "object" under the artist's direction. That this direction was essential may be observed from the fact that uncontrolled participation usually resulted in the breakdown of the Happening.
4. Robert Motherwell, *Dada Painters and Poets, An Anthology,* Wittenborn, Schultz Inc., New York, 1951. This book precipitated to a great extent the revived interest in Dada of the nineteen fifties.
5. See Guy Debord, *La Societe du Spectacle,* Buchet Chastel, Paris, 1967.
6. Of course, the "gestures" of Manzoni and Kline have since been appropriated into established culture. Naturally their actions took place within the continuum of "visual culture" in respect of anti-art traditions inherited from the Dada past. They did not, however, take place within a continuum of institutionalised culture, within "art-history", though they were, of course, later absorbed into this structure.
7. The same is true also of all books published in this area so far. The usual format is that of a short and extremely generalised essay supported by sections on individual artists consisting of photographs, biographical material and artists' "scripts". These books are essentially exhibition catalogues without the exhibitions. As this article goes to press, however, there is a book announced by RoseLee Goldberg that may provide the first serious critical and historical examination of the subject.
8. For instance, see Gene Swenson, *The Other Tradition,* University of Pennsylvania, 1966.
9. J.K. Huysmans, *Against the Grain,* first published in Paris, 1884.
10. Villiers de Lisle Adam, *Axel,* Paris, 1890.
11. Marcel Mauss, Les Techniques du Corps, Journal de la Psychologie, Paris, Volume 32, March-April 1935.
12. Mary Douglas, *Natural Symbols,* Barrie and Rockcliffe, London, 1970, page 65, quoted by Ted Polhemus, *The Social Aspects of the Body,* Allen Lane, London 1975, page 28.
13. Mary Douglas, op. cit., page 70.
14. It is notable that a performance work is usually called a 'piece' in North America while on the European continent it is nearly always termed an 'action'. This semantic difference would seem to reveal a basic variation of concept. One suggests a *thing,* an object in the terms of a traditional art product as property, the other suggests an *event,* a process that is intended to animate social space. It may also be observed that the word 'piece' in North American slang can also refer to *ultimate property* in a different sense, as it may describe either a handgun or a woman as sex object.
15. See John Berger, *Ways of Seeing,* Penguin and B.B.C., in London 1972.
16. Jean Genet's play *The Balcony,* first performed in 1957 at the Arts Theatre Club in London, is set in a brothel wherein the role playing of formalised and commodicised sexual encounter is presented as a paradigm for certain contemporary political realities.

236

EVERYBODY WANTS TO BE THE GIRL

Ardele Lister/Bill Jones

I LOVE YOU BABY, BUT

I love you baby, but I can't afford your price.
I love you baby, but I can't afford your price.
All my light all my fire and the ruination of my life.
You take my imagination and call it your own
You take my imagination and call it your own
You don't want anybody to find out that's why
you're always going out alone and leaving me at home.
Now that you've picked my brain you think I am a drag
and that I really bring you down.
and that I really bring you down.
That's what you've been telling all your friends
while you're sitting pretty wearing my crown.
If I got something you want you want to take it away
and give it to yourself, If I got something you want
you want to take it away and give it to yourself,
you won't mind if I end up just an empty cookie jar
on the shelf.
Why don't you concentrate on your own flour and your
own yeast, why don't you concentrate on your own
flour and your own yeast. Get yourself a rolling pin
and cook us up a feast. When you finish baking
you'll find your own cookies taste better by far.
you'll find your own cookies taste better by far.
Eating other people's cookies never produced nothing
that wasn't already on the market. You're trying
to get what you want, the wrong way.
You're trying to get what you want the wrong way.
Honey you got to go deep in your own soul and pray.

Song by Jill Kroesen 1977

I. LEAKS IN THE UNIVERSE AND SIGNS OF THE TIMES

PERFORMANCE, the term often used to connect the conglomeration of recent activities in the visual arts (from the artistic endeavors that exist as events only to the mass communications-related activities including video and artists' publications) is more telling about the state of the art in relation to the culture as a whole than any of the art historical legacy of similarly coined terms used to posthumously define the leading edge. It is no coincidence that the term performance is easily applied to a broader spectrum of cultural ventures such as the 'performing arts' or, when used to describe Art Performance, smacks of such all-pervasive scope as to define any event which an audience witnesses. Performance, in the context of art, acknowledges a greed for aesthetic territory as much as a purposeful ambiguity. In this regard the term is as general as it is specific; general in that the art form as practiced draws from and incorporates usable parts from activities well outside the traditional sphere of the visual arts which have variously to do with a notion of performing; specific because the discipline in the form of Performance claims for itself the ability to transform the

photo courtesy Castelli-Sonnabend Videotapes & Films

drawn from a larger inventory of commonly shared knowledge but because Performance Art may actually double as a detached second to any of the aforementioned list, distinguished only by the unmistakable presence of the artist. The care and maintenance of this presence is the art in Performance. Attention to the required air of authenticity of the borrowed parts is the artist's work.

This writing was initially conceived out of what were believed to be important similarities between the rise of feminism and performance in the cultural community during the last decade, and the implications engendered by the presence and prominence of both in the culture as a whole. Rather than stringing together a series of individual critiques or defining the state of feminism in the arts by a survey of examples, we have chosen instead to concentrate on a number of more pressing issues centering around two misconceptions related by their function in the continued suppression of women. First, that feminism (within or without art) has outlived its usefulness as an active proposition, having left us with a modicum of political notions and a veneer of relevance; and second, the other side of the coin, that performance and its associated formats herald a new era of individualism free from the traps of hierarchies and history and therefore not subject to the scrutiny or ensuing attack in the midst of which other art forms (and extended, all behaviour) currently find themselves abounding in a new sense of ritual, purpose and consciousness: the Post-Modern Package.

Dorothy Dinnerstein, in her inspiring book *The Mermaid and the Minotaur, Sexual Arrangements and Human Malaise*, defines feminism as "the broad task of restructuring our male-female arrangemen-

nature of these borrowed goods only by the intent to make art. With this in mind it is possible to see the striking similarities between Performance and theatre or literature or music or dance as parallels rather than evidence of imitation or usurpation. It is considerably more difficult to maintain the distinction between Performance and any of a multifarious list of cultural events, disciplines and phenomena from varying forms of science and philosophy to terrorist acts to a range of therapeutic expressive disciplines including psychodrama and bodywork$_1$, encounter and role-playing. The differentiation is difficult not only because of an overlapping of procedures and tools

ts.'' Toward this end feminism has developed divided fronts both public and private, once again reflecting the essential faceting of the lives of most women. Privately, the recent focus on women and their unique, unexplored and untold stories has changed the lives of countless women, crossing class and racial barriers previously thought insurmountable, in turn discovering and identifying common problems and solutions. These first stages of feminism provided for a rise in the consciousness and perception of large numbers of women and has led to such far reaching work as that of Dinnerstein and the politically active poetry and art of Robin Morgan, Adrienne Rich, Suzanne Lacy, Nancy Spero to name a few, or tangentially, to name just two, the performances of Jill Kroesen and Meredith Monk. Publicly, the intensity and urgency of the focus has been turned against the possibility of restructuring gender arrangements. Though such a reactionary effort has always been concerted, the 'in kind' nature of the retribution is due more to a societal conspiracy that grinds the edges off anything contentious to the status quo, running the public image of feminism ragged through the vastness of the mass communications network, effecting a case of not only 'bad press' but terminal over-exposure. Justified fear and apprehension of this boomerang effect as well as more concerted, severe retribution leads to an acceptance of the premise that feminism is somehow obsolescent.

MW: *I think they (men) are very jealous and that performance is active now because lots of latitude is possible. People can express themselves now in ways they never thought were possible. So women are good at that if that's what good means. The reason they're good is that they've been released from the format. They can go into territories now like impersonating other people ... a territory that painting couldn't go into* because *it wasn't within the limits of those two-dimensional issues. But when you get into performance and you have a set of social issues, there's all this other stuff that becomes a part of the piece.*

JA: *And anyways, I think that women have been brought up to* PERFORM ALL THE TIME, TO BE ON STAGE FOR PEOPLE. *It's a natural ...*[2]

THE SECOND MISCONCEPTION:

F EW WOULD ARGUE the major influence of women on the face of the visual arts during the last decade. Certainly women are responsible for the recent movement towards a renewed celebration of the intuitive powers of the artist, the return to a more modest, individual scale, and for the acceptance of emotionally cathartic and political forces as motivation for new works of art. And it is no coincidence that the endorsement and prominence of autobiographical and personal subject matter as well as styles for dealing with that subject matter are due to the numbers of women now making art, and to their involvement, at whatever level, in the women's movement.

Yet few men would admit that conversely, since women had previously been acceptable in art only as muse or in nurturing roles such as curator, critic or dealer, that there had been and continues to be discrimination against women built directly into the system recorded by the history of art. Those women who have been successful — even in the supporting roles — have had to pay the price of male identification (usually accompanied by a measure of discrimination against their own gender). This discrimination as well as the system that fostered it is still very much with us.

The tidy, post-modern package previously referred to exists to alleviate the

240

problems incurred by the realisation of such an oppressive state. Some subscribing to the notion of this 'liberated' age would go so far as to say that women should claim more than a fair share of the (misdirected) glory for its inception and most of the accompanying benefits. If it were only so simple. We have not yet witnessed the post-dated death of modern art, for its legacy, though incorporated into the new amalgam of art as event, is still ever present. The tenets of modern art serve as the foundation for these more recently invented formats. Any rewards are in relation to the further perpetuation of the old order — for infusing life into the decay. The torch lit by Cézanne and passed on from man to man for nearly a century, though it glimmers ever so faintly is till afire, today occasionally held by women. If, however, we cleave away all the subterfuge and false promises we will find that the only significant change is that there are women where before there were not: simply that for the first time in western history there are numbers of women in the position of creator rather than muse.

The emergence of women in the international art community occurred when modern art had once again come close to running its course. This time, however, there were no shining novas on the horizon to rescue the old hackneyed system from its near-fatal fatigue. That is, no male hopefuls. There were instead women demanding a rightful position and an end to sexual discrimination. And only at this time, when the dire need for new blood far surpassed the abject reticence, were women and their art more quickly accepted into the artists' club. In many ways women inherited a legacy in the current state of art replete with procreative vows to perpetuate the discipline.

Certain key changes have taken place toward a possible reorientation of goals and priorities in the visual arts, since it is clear that women have always been adept at finding new uses for old and often alien tools, and that these abilities have been fully demonstrated to the world of art and artists. But it is important to acknowledge the difficulty and unavoidable working through of certain extensions of past thinking. If we must make use of the structures and formats of the past (and is increasingly apparent that we must) it is of vital importance that we rethink the theorising from which they were developed, rather than accept them as temporary dwelling. Why a rejuvenation was so drastically needed in the art community by 1970 and in turn how women's influence serves as a shoring up of an oppressive system to which many have falsely proclaimed an end is a most necessary analysis since the premature heralding of such a 'victory' would be the dissolution of any possibility for lasting change.

II. AT THE HEART IT'S STILL MODERN ART

THE AMBIVALENT STATE of modern art, which allowed for growing numbers of women to be recognized as artists, was not due to mismanagement but rather to a self-fulfilling prophecy of eventual obsolescence patterned on the witnessing of shifts in the public sensibility and a growing perceptual awareness ushered in by the invention of photography, film and the large scale media implications therein increasingly apparent during the latter half of the nineteenth century. This period of transition was attested to by the antiquated nature of the procedures and philosophies of art-making virtually unchanged for 400 years,

wherein what was once deemed and understood as realistic came to be thought of as illusion. The contextual changes which made possible the reading of that which was once seen as quantifiable reality as image soon became the focus of the new art. At the heart of modern art was the attempt to invoke the transitional state where concepts of reality and image intermingle. In practice, parts traditionally forming the image were defined in terms of the artist's notion of physical reality. For painters these factors became collectively referred to as the 'surface' metaphorically referencing all concerns other than 'image', beginning with the flatness of the canvas and the two-dimensional space bounded by the edge of the painting surface. The effect that these quantities have on the making of the painted image and the reading of that image by the viewer serve to demonstrate a dichotomy essential to the prevalent 20th century definition of artmaking, much more so than any disciplinary methodology such as painting contexts this one essential notion was played out in art exemplary forms (posthumously described as 'movements') in a century-long epoch of heroic invention.

Gradually works of art came to be seen as prescribed sets of cues to imaging (a mental process) rather than images themselves. And in keeping with the scientific mood of the times the image was tested by the dismissing of cues deemed unnecessary to the process of imaging by defining those cues in terms of measurable quantity. Thus necessitating the delineation of another well substantiated set of cues which in turn would be subsumed by the over-riding predilection toward total objectification and definition, all facilitating an expanded ability to image in order to keep the dichotomy vibrant.

Adding fire to the quest and turning what

might have continued as acts of personal revelation into an open competition was the intricate symbiosis between the world of art and the world of commerce, wherein monetary values are placed on the verification of the existence of the dichotomy in the product. The goal of the artist was then to cleave away identifiable aspects of imaging from those not yet clearly understood which remain for the moment of victory indivisible, making the game more difficult while never ending it.

By 1920 it was understood by many that an extended competition in which reductivist tendencies stand to sweeten the pot would eventually lead to a state where the remaining cues become unreadable, the work of art becoming inseparable from its context, all experience viewed as quantifiable reality and image. With this knowledge the final chapter of Modern Art could have drawn to a close when, for example, Duchamp effectively defined the art-viewing experience as purely contextual, dismissing all notions of methodological or disciplinary cues; or when Kasimir Malevich defined image as object through the process of the making rather than by relation to paint and canvas. Though information was now clearly available for the charting of the demise of the system, the notion of essential dichotomies was revivified again and again. In what was collectively termed Abstract Expressionism 'surface' was translated to 'gesture' focussing on the act of the making of the art object. Yet it was not until the mid 1960s that Allan Kaprow and his contemporaries (through works which he coined as Happenings) finally made the link rendering the essential dichotomy as the act of making, confronting the intent to make art. To Kaprow the art historian, such an undeniable realisation formalised and accepted into the historical

record sounded the final knell of modernism and the isolating and delineating of its dichotomies; but the act/intent dichotomy which appeared non-reducible to Kaprow and his generation served as a challenge for the next.

Sculpture provided breathing room, as most of the major battles had been fought around the specifics of painting.

Sculpture had more or less followed the path of painting often merely affecting the look of its (painting's) current state. Yet sculpture had an untapped set of methodologies concerning actions in three-dimensional space. In less than a decade, with strict attention to the full range of art history, what is to this day the last heroic generation put the existing concerns of sculpture through the paces, and upgraded the neglected tradition to the most current state of all the visual arts. The work of these sculptors, now known as Minimal Art, defined the object itself as the final cue to imaging, given that the object was seen to represent only itself through the implicit logic of the process of its making. The next step was obviously an attack on the object itself. Conceptual art (which was very much the underside, or final statement of the sculptural concerns of Minimalism) was just such an attack, attempting to divide the concept of object into the processes of its making and the product of that process, dismissing that product as a cue to imaging. Though it might have appeared otherwise at first, the intent to make art remained, and Kaprow's act/intent dichotomy seemingly proved irreducible. What had served as a challenge to artists of the late 60s was a warning to those who would follow, for they were left the unenviable task of turning the leading edge back on itself with a return to the event as the final mode of the contemporary visual arts. But the experiences of the decade which had passed since Kaprow's discoveries had effected major differences in procedure. In what was now called Conceptual Performance the artist stood as the object. The essential dichotomy thus began to approximate body and mind. In theory the state in which art and life merge was at hand, but in practice the competition remained keen. What was obviously an essential split in the public psyche was delineated and put into the service of art.

What we have always experienced as a static, built-in dilemma has lost its aura of inevitability ... We have been living with it under proverbial duress; and yet, confronted with the practical possibility of living without it, we tend to lose our nerve. A time-honored bluff has been called — what we have always seen as a set of necessary evils, to be complained about and endured, must now be ended or defended — and we respond with a kind of terror.[3]

In the tradition of the surface, gesture *et al* the artist demonstrated the processes of his life. The newly established performer/audience relationship, which Kaprow had dismissed as an outmoded cue to imaging, began to look more and more like the fictional proscenium of literature and theatre. The artist combatted this tendency by never allowing his presentation to be subsumed by the performance context and degenerate to mere autobiography. The artist remained not the content of the work but the focus of his own investigation while at the same time attending to the state of the fictional proscenium, even if by simply responding to the presence of the audience. He must embody the essential dichotomy. The acceptance of certain philosophical limits within the discipline set the stage, so to speak, for a new form of the old competition without the safety net of the reduc-

tivist contingency. The competition was defined by the challenge of each new work in its expansion of the contextual framework. Thus it became increasingly more difficult for the artist to secure a part of his person in unpostured real time, differentiating that state from the dispensing of fictional cues which ask the audience to suspend their normal senses of order and time. When successful the artist's acts served as both. The fantastic didactics of conceptual art led the artist to an investigation of the body as an almost infinite compendium of physical phenomena but the heat of the competition soon made necessary the exposure of the gamut of human responses including the deepest ranges of experience and emotions. The contextual cues grew wild, entangling the artist, turning all to image. To escape what had become the artist's equivalent of Houdini's Water Torture Chamber, artists cut, slit, shot, starved, tortured, electrocuted, cheated and killed themselves in exhibitions of self-flagellation, exposing their basest emotions and their most self-destructive tendencies in what amounts to a vastly extended form of pinching oneself to see if, to prove that, one is truly awake. There was however a more deeply rooted cause for this obvious turmoil and that was that artists were profoundly frustrated at a loss of self and a conditioned inability to plumb their emotional depths due to the strict cautions against personal, self-searching content (and probably feeling utterly impotent in a world in which art is no longer actively avant-garde).

I remember when I screamed from mental pain
you looked satisfied and hoped I'd aim
a punch at your hide
so you'd believe you're alive
you can't feel nothing subtle
so you gotta cause trouble

It's true that you're a twirp
It's true that you're a jerk
you sure give me the irps
I don't need no devils hanging around me.
 Jill Kroesen, Universal-
 ly Resented Part I

I don't understand why my art should be uninteresting to my life so I always tend to do pieces that are what I'm doing in my life anyways. Xeroxed pages from my diary all crumpled up all over the floor and a desk and a chair. You could pick up pieces and read it you know, it's all real diary. Why not put your art bucks down on something you don't know about and work on that? I'm not interested in expertise — it has more to do with community — or rather with pleasure, being with each other and having access to another person's emotional life. Immerse yourself in that emotional territory for a while and just go with it.[5]

The rapid and thorough advances of sculpture which served to link inextricably the most basic formal structures to the individual artists of the middle and late 60s effectively closed off most art-exemplary possibilities for the construction of objects. And the relative failure of conceptual art to offer any heuristic possibilities (other than the inevitable next step of the dismissing of intent) left little to be done by future generations of artists and in turn created a vacuum in the world of artists. *It was precisely this situation coupled with the rise in consciousness for women throughout the society, fostered by the women's movement, that accounted for the relatively rapid growth of women in creative roles claiming the title of artist.*

Female exclusion from history (like male exclusion from 'female' realms) has never, of course, been total. Women proverbially have, through their influence on children and men, made incalculable contributions of an indirect, informal, anonymous kind to the growth of collective sensibility and the shape of large new events. They

244

have also made calculable contributions of a direct and overt kind. Throughout recorded history exceptional women, or ordinary women under exceptional circumstances, have done so here and there.[6]

● ● ●

If you gotta shit
don't shit on me
cause I ain't no shit box, baby. (repeat)
<div align="right">Jill Kroesen, Universally
Resented Part I</div>

III. FATAL FLAWS AND SAVING GRACES

ALTHOUGH NOT ALL WOMEN artists are feminists, few would be able to disregard the tenets of the women's movement or the efforts made on the part of feminists to improve the situation for all women artists regardless of their stated political position. This aspect of feminism is explicitly socialist — a commitment to work toward the kind of socio-political and economic adjustments necessary to end the oppressive gender arrangements that our civilization has thus far wrought. An issue larger than the individual role of artist within the society.

MW: *I never worry about it — whether it's art — never think about it at all.*[7]

Adrian Piper: I think that much of my work is about kinds of alienation, personal, political and emotional. I am normally very withdrawn and have an intense need for privacy. But I still feel compelled to make art, but an art that is about confrontation of the distances that separate people.[8]

When women artists protested that their own concerns had been denied them and insisted that men could no longer speak or make art for all of us, they were met with a considerable degree of anger, resentment and shock from male artists who had always prided themselves on their abilities to be perceptive, intuitive and sensitive — all qualities that women have been conditioned to reflect. It was no wonder that male artists were surprised and hurt that they were being accused of behaving like men, discriminating against women, playing power games, and of being deceitful towards women and their art. But the fact of such deceit was proven out when women were branded as regressive for searching through forms thought to be obsolete (discarded in the career competition for the new) as they found places in the existing system which they might for the first time inhabit. Painfully obvious because men had already taken the first step in such a denial of the problematic notion of progress by returning to art as act. But men were not able to break away from the unmanageable notion of progress through 'breakthroughs' and women were left to solve the resulting solipsism with the sense of communitas available to oppressed people just beginning to comprehend the true nature of their oppression.

The real rub however concerned issues internal to the discipline itself. Women entered the profession as artists with commonly engendered ambitions, and inherited a set of problems and associated forms heretofore discussed, and were successful with those forms in ways long since thought implausible. Solutions were drawn not from the mechanics of reduction or the logic of science and modern philosophy but through a purpose beyond the bounds of the discipline — a sense of self long ago atrophied in the art of men. That overriding sense of purpose to raise the consciousness of all women (and by extension, men) as tools necessary to survival revived the essential dichotomy of act/intent. Intent

245

was thus dislodged from the supposedly irreducible formula and split between intent-to-make-art and the tendentious nature of heightened purpose. Such purpose outside the intent to make art had always been thought to sap art of its self-interests. Women, however, had never before been allowed to intend to make art as had men; and neither had they been allowed their rightful place in the shaping of the culture as a whole. They wanted both. The unfolding utilitarian character of the work coexisting with the *untapped* desire to make art put the edge back on the fictional proscenium by restoring the flagging process, action, event, real time continuum which much to the frustration of male artists had become merely an image of a relationship with the external world. As well women were particularly adept in the role of performer.

Up to then the social presence of a woman was different in kind from that of a man. A man's presence was dependent upon the promise of power which he embodied. If the promise was large and credible, his presence was striking. If it was small or incredible, he was found to have little presence. There were men, even many men, who were devoid of presence altogether. The promised power may have been moral, physical, temperamental, economic, social, sexual — but its object was always exterior to the man. A man's presence suggested what he was capable of doing to you or for you.

By contrast, a woman's presence expressed her own attitude to herself, and defined what could and could not be done to her. No woman lacked presence altogether. Her presence was manifest in her gestures, voice, opinions, expressions, clothes, chosen surroundings, taste — indeed there was nothing she could do which did not contribute to her presence.

To be born woman was to be born within an allotted and confined space, into the keeping of man. A woman's presence developed as the precipitate of her ingenuity in living under such tutelage within such a limited cell. She furnished

her cell, as it were, with her presence; not primarily in order to make it more agreeable to herself, but in the hope of persuading others to enter it.

A woman's presence was the result of herself being split into two, and of her energy being in-turned. ... From earliest childhood she had been taught and persuaded to survey herself continually. And so she came to consider the surveyor and the surveyed within her as the two constituent yet always distinct elements of her identity as a woman.[9]

Women had always lived in a transitory world where they were expected and conditioned to be both solid and real as well as magical and illusory at the same time. The performance vehicle was made for women, and now they were finally demanding to publicly play their own parts.

The conglomerate discipline converging all art-as-act forms, what is now simply called Performance, with its refined framing devices such as the "artists' space" or 'alternate space', was only realizable during the moratorium on progressive action effected by ever increasing numbers of women recognized as creators in the face of the prevalence of the malaise. But what began imbued with the purpose of raising the level of communitas (while not destroyed) was integrated into the system which it had once used, because the old art, the art of men, was specifically about framing, structuring, making all experience read as art. The acceptance of the unquestioned ideology that making art be the only purpose of the artist is tacit in the use of the essential dichotomy, since it signifies the intent to contextualise beyond purpose.

It is exactly this notion that turns ritual into something that is about or draws from an understanding of ritual. This is in no way to demean the desire for or importance of success for women in a man's world, since it remains true that in a battle for survival

territory must be recovered. The success of women in the visual arts is indicative of the scope of women's capabilities (even in an alien world) because the wholesale rescue of that which we know as our only culture was not accomplished through a magnanimous gesture on the part of those (men) in power. The magnanimity was and is there on the part of women, who, at a time when expression and communication were so vitally important, put to use those devices for packaging and presentation and in the spirit of revolution dreams found fruition as works of art. It is crucial that we do not lose sight of the significant changes for which women have been responsible. In this decade the art of women passed through the first stages of emancipation. With nothing left to lose, women began to reveal their long hidden rituals — life experiences previously shared only in secret, covert messages. The first steps were taken toward a common language and in turn women were branded "regressive" or, at best, adding to a renewal of romantic, expressionistic concerns, a revival of literary qualities absent for over a century. In fact male artists had first begun what might have been termed regressive, though they were able to couch a return to literary narratives, romantic concerns et al in a severe structural framework which masked the desperate nature of the work. Male artists had attempted to embody a concept of the feminine throughout their history, while still claiming male prerogatives. When what had consistantly been described as the duplicity of women came to be recognised as a valued cultural commodity, women were for the first time present and active and fitted themselves to the Performance mode as if it had been made for them.

There is clearly an ever present danger that what has served as a prefabricated shelter will become no more than a cage, or that the success of the feminine presence will serve as fuel for self-immolation, the suicidal path of our cultural diversion, the "massive communal self-deception, designed to allay immediate discomfort".[10] Yet the leaks in the ever so well controlled surface of the art organism engendered by that presence are the only evidence of truly radical thought or action and still counter the implicit risks.

EVERYBODY WANTS TO BE THE GIRL

Part I — The Rules

You must always watch everything and everyone around you and you must always watch yourself. You possess a magical mirroring device whereby you can monitor everyone's response to you at any given time. If you are crying, you can see yourself crying. If you are being told something, you can see yourself responding to the telling. You always know how to look. You always know how you should look depending on the situation and the person(s) involved. You always know everything about surfaces and everything about performing. Unless you try very hard you seldom know how you really feel because you are so busy in the mirrors, so busy being in relationship to everyone and everything around you. You are a girl. You are a girl brought up in 20th century North America. If you are smart almost all of your intelligence is directed towards excelling in everyone else's eyes, be it she's such a whiz or she's such a tease, or she's just like a guy. If you are smart you probably figured out that it was much better to do boy things and to do them well than to do girl things and do them well unless you didn't want to take any chances in which case you'd learn to do both well and cover all bases. Who

247

knew? Things could change anytime. You learn that too. Girls on the lam in their own culture. Girls learn to want what boys want. Boys want in a singular way. Straight ahead. None of this agonizing laterally. Boys are vertical, forward-moving, simple. Girls can do okay until real girl things start to get in the way. Real permanent girl things — undeniable. Unchangeable. Like blood for example. When girls think of sex they think about sex & respect, sex & love, sex & work, weighing their actions and feelings in the eyes, the faces — of others. When boys think about sex they just think about sex. Straight ahead.

Part II — Consequences of Fact(s)

The mirrors that surround you and reflect you and ultimately give you your own life, your own image, also have the power to destroy, to kill. So many reflections you can't tell the real thing from the reflection. Or you get lost in the maze. And without the reflection there is no existence. As a result of double training, that is training to be a person and training to be a girl, everything appears to coexist in dualities, sometimes pluralities. Everything is always in context. It can never get out of context. And if you think you want to get ahead in that simple boy-like way, context is stifling. So is history. And I do mean history. His story and his story and his story. All you have is your story and it's personal (read unimportant, not universal) and unless you write it down yourself or speak it it will not be written. You have always seen women and girls telling each other stories. You have noticed how similar the stories are. They always move you. They speak in code. You learn the code from listening and watching. The eyes. The hands. The gestures. Girls to girls and women to women. It's a different language than the one that boys and men traffic in.

Part III — The Price

Eventually you learn that hockey and lewd jokes stand for nothing except male power and preserve. There is little real deciphering to be done. Women's talk is full of code — not necessarily verbal — full of intricate permutations, levels of meaning. More powerful than anything written down. No wonder men would rather not acknowledge it. Their last stab at preventing it from being known as valuable — that women and girls, however ascribed to their respective men and families, have a culture, a story, a context, a future frighteningly stronger than men. Those women among us who know this may be severely punished for knowing this and for attempting to link, to communicate, to change the status quo.

Part IV — Caution and Choice(s)

If you aren't wise to the tricks of men you may be bought and sold before you know it. Your honesty can be used against you. Your goodwill can be used against you. Your creativity can be subverted, coopted, delivered in the name of someone else. You will be interrogated. You will be asked to defend yourself and your sex. It is always your choice to reply. To direct your energy where you will. Watch carefully in the mirrors. Are there any mirrors left? Are the faces in them male or male-identified female or is it your face? Your blood and your sex and your beauty and your intelligence may all be used against you. You have a long history as a vessel. Maybe you have grown to like it. Maybe there is so much hate in love that's all the love you know. Looking forward you will be accused of looking backward or looking nowhere at all. You will be labelled selfish, egotistical, solipsistic for claiming your own existence. Trained in guilt you will have to overcome the instant remorse that

fills you whenever harmony is violated, ostensibly by you. You will be asked to give in the name of humanity (they know now not to call it mankind) — to tell, to share, to spend, to nurture. You may be punished if you don't.

Part V — The Case for a Sex Change

Look around you. They make and enforce all the rules. They have taken everything that is yours and called it theirs, at best all-of-ours. If you think you can live inside this system and change it from the inside, think again. Think carefully. Think hard. The only thing they don't want, the only thing they fear, is your blood. Use it.

Ardele Lister/Bill Jones
1978

1 a form of therapy designed to release blocked mental and physical energies, rigid character armor and chronic muscle tension through deep abdominal breathing and shiatsu thumb massage.
2 from a taped interview done by Ardele Lister with Martha Wilson and Jacki Apple in New York, June 1978.
3 Dinnerstein, Dorothy. *The Mermaid and the Minotaur, Sexual Arrangements and Human Malaise.* New York: Harper and Row. 1976. page 6.
4 The masculine adjective is used intentionally as a reflection of a culture in which men prevail and make the *rules.*
5 Martha Wilson speaking in an interview with Ardele Lister taped in New York, June 1978.
6 Op. Cit. page 21
7 Martha Wilson in an interview with Ardele Lister, June, 1978.
8 Adrian Piper *Studio International* Performance Issue, 1977.
9 Berger, John G. London: Penguin Books. 1973.p.166.
10 Dinnerstein, Dorothy. *The Mermaid and the Minotaur.* p.9.

DER FLIRT MIT DEM 'ES' — Zur Transgression der Gesetze in der Performance der 70 er Jahre
THE FLIRTATION WITH THE 'IT' — On Transgressing the Law in the Performance of the Seventies

Gislind Nabakowski

Der BEGRIFF der 'Performance' stammt aus der disco-Szene und der musikalischen Massenkultur. Er wurde als Terminus für eine non-verbale Aufführungspraxis mit Breitenwirkung für Vorführungen mit begrenztem Publikum adaptiert.

Die Herleitung der 'Performance' aus dem musikalischen Geschehen und dessen avantgardistischen Traditionen (dem Kinästhetischen Happening, den Fluxus-Events und dem Musiktheater der 30 er oder frühen 60 er Jahre . . .) erklärt auch, warum die verschiedensten 'Performer' die ihren Aufführungen, Gesten und Bewegungen zugrunde liegenden Skripts als "Noten" (Partituren, Notationen) gelesen haben wollen.

Die meisten Performances haben keinen Klimax und keinen dramatischen Höhepunkt. Dies ist vor allem deshalb der Fall, weil ihre gesamte Struktur dramatischen Charakter hat. Viele intendieren aber, den Alltag, seine Sorgen und Probleme und die dahinter stehenden Machtstrukturen, die einen genussbrichen oder geretchten Alltag verhindern, spielerisch bewusst zu machen.

Dies erklärt auch, warum in den meisten zeitgenössischen Performances (auch denen von Julia Heyward und Laurie Anderson) artikulierte Sprache in Musik übergeht. Durch die phantastische Transformation der

THE CONCEPT of "Performance" derives from the Disco scene and popular music culture. It was adopted as a term for the practice of non-verbal performances, and extended to performances for limited audiences.

The devolution of "Performance" from the musical performance, with its avantgarde tradition (the kinestetic Happening, the Fluxus-events, and the Music-theatre of the 30's or early 60's . . .) also explains why quite different "Performers" want the scripts on which their productions, gestures, movements are based, to be read as "Notes" (Partiturs, Notations).

Few Performances have either a climax or a dramatic peak. This is primarily because the whole structure is dramatic in character, but many productions deal with the everyday, recreating "on stage" the trials and vexations of daily life and the underlying power-structure of society which prevent people from enjoying life as they should.

It also explains why, in most contemporary Performances (even those by Julia Heyward and Laurie Anderson) language turns into music. This fantastic transformation (of words into music) does not, however, in any way lessen the explosive social im-

Sprache in Musik wird jedoch deren gesellschaftliche Brisanz keineswegs eingebüsst. So singt Julia Heyward mit Bauchrednerei oder einer bei den Hindus erlernten monotonen, markerschütternden Nasaltechnik Gesellschaftskritik bis in die letzte Ritze jedes Aufführungssaales (siehe: ihre Performance 'Light & Power in Paris und Köln 1977). Laurie Anderson bringt, weitaus weniger aggressiv im musikalischen Duktus als Heyward, mit ihren sich rasch ablöseneden, dicht überlagerten sounds die "Luft" um die Zuhörer zum Flirren. In wieder anderen Performances (etwa in Valie Exports Stück 'Delta', Köln, 1977) taucht Sprache als beschädigte auf. Mit einem Endlostonband wird während dieser Performance die Meinung des "gesunden Volksempfindens", das sich gegen die Interessen der Künstlerin erhebt, in das Stück eingespielt — mit den Worten: "Freche Sau".

Es tauchte die Frage auf, warum beinahe, die Hälfte der 'Performances' der 70 er Jahre von Frauen aufgeführt werden? Denn unter den Aktionisten und Happenisten der frühen 60 er Jahre war die 'Frau als Künstlerin' noch beträchtlich in der Minderheit. Einer der Gründe — aber nicht der einzige — könnte darin liegen, dass die 'Performance' noch nicht durch Traditionen (Konventionen) festgelegt ist, und somit auch eine erfolgreiche Partizipation der 'Frau als Küstlerin' möglich wird. Ein weiterer Grund liegt meiner Meinung nach auch in einem verstärkt aufgeklärten, sozialen Bewusstsein der heutigen Künstlerinnen im Alter von ca 30 Jahren. Sie scheinen zumindest erheblich vorbereiterer auf die Probleme eines verschärften Wettbewerbs zu sein und somit weit weniger typischen Rollenkonflikten zu unterliegen, als ihre Kolleginnen, die Ende der 50 er Jahre zu arbeiten begannen.

pact of the event. Thus Julia Heyward, using ventriloquism, or a spine-chilling nasal monotone learnt from the Hindus, projects her social criticisms into every nook and cranny of an auditorium, as in her Performance "Light and Power", Paris and Cologne, 1977. Laurie Anderson, much less musically aggressive than Heyward, sets the "air" flurrying around her listeners with her rapidly dissolving, thickly superimposed sounds. Then again, in other Performances — Valie Export's piece "Delta", Cologne, 1977, for example — the language emerges as damaged; on a continuous tape recording, the words "Shameless slut" are repeated throughout, representing "healthy" public reaction against the opinions of the performer.

An interesting question arises: why have almost half of the "Performances" of the Seventies been given by women? Especially since the "woman as artist" was, in the early Sixties, still very much in the minority among Activists and Happeningists. One reason, though not the only one, might be that "Performance" is an art form not yet circumscribed by tradition (convention), and successful participation is possible, even for the "woman as artist". Another reason, in my opinion, is the stronger, more enlightened social consciousness of women artists in their thirties today. They seem, at least, to be markedly better prepared to cope with the problem of tougher competition, and are, as a result, much less vulnerable to typical role conflicts than their colleagues who began work in the late Fifties. There are a number of other reasons that might be mentioned, but to do so would exceed the bounds of this (short) essay.

The woman as an artist — woman, also, as a feminist artist — has, in solo and in group productions, made the explanation of her daily predicament the very stuff of her

Eine Reihe von anderen Gründen müssten noch genannt werden, die allerdings den Umfang dieses (kurzen) Essais überschreiten würden.

Die Frau als Künstlerin — und auch als 'feministische Künstlerin' hat in den letzten 6-8 Jahren als Solistin und in Gruppen Aufklärung über ihre Alltagssituation zum Gegenstand ihrer 'Performances' gemacht.

"Wenn ihr beim Komponieren das Fenster aufmacht, so erinnert Euch, dass der Lärm der Strasse nicht Selbstzweck ist und von Menschen erzeugt wird. Versucht wirklich eine Zeitlang, euch schwülstiger Synphonik, verspielter Kammermusik und vergrübelter Lyrik zu enthalten. Wählt euch Texte und Sujets, die möglichst viele angehen. Versucht, eure Zeit wirklich zu verstehen, aber bleibt nicht bei blossen Ausserlichkeiten hängen. Entdeckt den Menschen, den wirklichen Menschen, entdeckt den Alltag für eure Kunst, dann wird man Euch vielleicht wieder entdecken".

Hanns Eisler[1]

Vereinzelt gehen die Künstlerinnen sogar soweit, Handzettel und Flublätter mit empirischen, aufklärenden Daten, mit in ihre Performance aufzunehmen, ohne, dass dieses Material überhand nähme. (Ein brisantes Beispiel dafür ist die 'Three weeks in may' — Performance, die eine Gruppe um Suzanne Lacy und Leslie-Labowitz-Starus 1977 in Californien aufführte, eine Kampagne über die psychischen Folgen bei und die Dunkelziffern von 'Vergewaltigungen' in den USA. Diese Performance — obgleich bislang ein Einzelfall — nahm gegen ihr. Ende bürgerinitiativ-ähnlichen Charakter an.

Auf der anderen Seite gibt es mehr und mehr Anzeichen dafür, dass das Publikum es allmählich lernt, auch die non-verbalen Performances zu "lesen" und deren Symbolgehalt zu entziffern. Dabei werden nicht nur Fragen nach dem "Wie" (einer Botschaft) gestellt, sondern auch die nach dem "Warum" und "Wozu".

"Performance".

"When you open the window while you are composing, remember that the noise from the street is not an end in itself but has been produced by human beings. Try for a while to forego bombastic symphonies, skittish Chamber Music, carping poetry. Choose texts and subjects which are the concern of many. Make an effort really to understand your time, but don't confine yourself to superficialities. Discover Man, real Man, discover the everyday for your art, and then perhaps you yourself will be rediscovered."

Hans Eisler[1]

In some cases, women artists have gone so far as to distribute flyers and handbills during their Performances, giving empirical explanatory data. But this was not to excess. An excellent example of this was provided in the Performance "Three Weeks in May", given by a group connected with Suzanne Lacy and Leslie Labowitz Starus in California in 1977. The Performance highlighted the psychological after-effects of the grim statistics for rape in the USA, and while it remained an isolated event, it did eventually take on something of the character of a citizens' initiative.

On the other hand, there are increasing signs that audiences are learning to "read" non-verbal Performances, and to "decode" symbolic content. Questions are no longer confined to the "how" (message) but extend to the "why" and the "what for".

An example of this: Orlan's "Baiser de l'Artiste" (Kiss of the woman artist). The 30-year-old Orlan lives Lyon. During the F.I.A.C. — Force internationale d'Art Contemporain — in Paris last autumn, she sold her kisses for 5 Francs apiece. . . . "Venez, Venez, achetez des veritables baiser de l'artiste! Seulement 5 Francs!". Anyone who wanted to kiss her could have a few moments with her, but within a few seconds each kiss was interrupted by the wailing of a

Ein Beispiel dafür ist Orlans 'Kuss der Künstlerin' (Baiser de l'artiste). Orlan, 30 jährig lebt in Lyon. Während der Parier F.I.A.C. (Foire internationale d'art contemporain) im letzten Herbst verkaufte sie zum Stückpreis von 5 Francs ihre Küsse....

"Venez, Venez, achetez des véritables baiser de l'artiste! Seulement 5 francs!". Jeder, der sie küssen wollte, konnte einige Momente mit ihr verbringen. Aber, schon nach weniger Sekunden wurde jeder Kuss durch den Henlton einer Sirene unterbrochen. Und der Klient musste gehen. Orlan sass währenddessen auf einem leicht erhöhten Podest. Neben ihr als Attrappe eine Pietà aus Pappmaché, in maklellose Laken gehüllt, ein gewickeltes Lakenbündel in den Armen wiegend. Zur Ironie zwischen der Pietà mit ihren irrealen Eigenschaften und der Künstlerin eine Vase mit Lilien, den Blumen der Unschuld. Zu beider Füssen ein kleines Schild mit der mokanten Inschrift "La choix". Die Küntlerin trug während der Performance vor ihrem Körper einen Pappschild, der eine Spardose symbolisierte. Am oberen Ende dieses Schildes ein Schlitz, dem der Klient die 5 Francs zustecken musste. Die Moneten fielen sichtbar in einen Behälter, der am unteren Ende der Foto-Attrappe angebracht war, in die Nähe ihres Geschlechts. So küsste sie einige Tage lang, für jeweils drei Stunden, das Publikum. Am ersten Tag namhm sie 95 Francs ein. An den weiteren Tagen etwa dieselbe Summe. Brauchte man sie nicht?

Orlan greift mit ihrer Aktion die mythisierte Rolle der Frau als Mutter/Madonna an.

"Die verschiedenen Formen der 'Anbetung' der Frau haben sich selbst als Frauenfreundlich ausgegeben; dennoch ist diese Haltung im wesentlichen wohl ein weltlicher Ableger des Marienkultes der katholischen Kirche".
Klaus Theweleit[2]

siren. And the client had to go. Orlan was seated on a slightly-raised platform, at her side, as a "prop", a "Pietà" of papier maché, draped in spotless linen, nursing a bundle made up of clean sheets. A vase of lilies, the flowers of innocence, stood ironically between the Pietà, with her unreal quality, and the artist; at the feet of both stood a small sign with the mocking inscription "La Choix". During the Performance, the artist wore in front of her a cardboard sign symbolising a money-box. At the top of this sign there was a slot into which each customer dropped his 5 Francs. The money fell visibly into a container placed at the bottom of the sign, in the region of the artists' sexual organs. The kissing proceeded like this for three hours daily, for several days. The first day Orlan earned 95 Francs; the following days, much the same sum. Did no one need her?

Orlan, in this Performance, is attacking the mysticised role of woman as mother/madonna.

"The different kinds of woman-adoration appear sympathetic towards women, but this attitude is almost certainly largely a secular variation of the Maria-cult of the Catholic Church."
Klaus Theweleit[2]

The mother/madonna is, for patriarchal societies, the esoteric, pure, sexless being. She is the triumph of fettered carnal instincts, the triumph of cleanliness (white lilies, white linen) and the "clean" desexualized body. Orlan, in her Performance, leaves the mythologised woman behind in history (on the pedestal) and flirts, not with her audience, but with her own unconscious, the "It".

"The unconscious has no name and no memory (Deleuze/Guattari). It produces no images and has nothing to do with any kind of expression or mean-

Die Mutter/Madonna ist in den patriachalischen Gesellschaften das esoterische, reinem, geschlechtslose Wesen. Sie ist der Siegeszug des gefesselten Trieblebens, Siegeszug der Sauberkeit (wiesses Leinen, wiesse Lilien) und des "sauberen", de-sexualisierten Körpers. Orlan lässt in ihrer Performance die mythologisierte Frau hinter sich in der Geschichte (auf dem Sockel) und flirtet jedoch nicht mit den Besuchern, sondern mit ihrem eigenen Unbewussten, dem "Es".

"Das Unbewusste kennt, sagen (Deleuze/Guattari), keine Namen und kein Gedächtnis. Es produziert keine Bilder und hat nichts mit irgendwelchem Ausdruck und Bedeutungen zu tun. Für das Unbewusste gibt es ebenso kein bevorzugtes Objekt, auch nicht die Mutter. Uberhaupt sind ganze Objekte, Personen durchaus nicht bevorzugte Objekte der Wunschproduktion . . . (. . .) . . . Diese Art der Objektbeziehung halten Deleuze/Guattari der Produktionsweise des Unbewussten für angemessen. Es braucht keine ganzen Personen für seine "Produktionen". Es erreicht Befriedigung wenn eigene Teile sich mit Teilen anderer Objekte verbinden und vorübergehende "Produktionseinheiten" bilden, die sich wieder auflösesn, damit andere Produktionseinheiten gebildet werden können . . . (. . .) . . . Das Unbewusste ist eine 'Wunschmaschine' ".[3]

Dass sie dabei ein Gesetz überschreitet, wurde deutlich, als die Vorgesetzten einer 'Ateliergemeinschaft', in der Orlan als Professorin lehrte ihr mit der Begründung kündigten "ihr öffentliches Verhalten sei unvereinbar mit ihren Pflichten als Lehrerin". Orlan wurde aufgrund dieser Performance, die von Presse, Rundfunk und Fernsehen in vielen Schattierungen in der Regel skandalisiert wurde, von einem auf den anderen Tag arbeitslos.

1976 stellt sie in der "Galerie des Ursulines" in Macon das 'Dejeuner sur l'herbe' von Edouard Manet (1863) nach. Mit einem entscheidenden Unterschied: in ihrer "plein-

ing. For the unconscious, there is no favourite, not even the Mother. Whole objects, persons, are altogether not the preferred objects of wish-production. . . . This kind of relationship with the object is considered by Deleuze/Guattari as sufficient for the production-pattern of the unconscious. A complete person is not required for its 'Productions'. Satisfaction is gained through the merger of parts of one's self with those of other objects, forming temporary 'units of production', which dissolve in turn to allow the formation of other units of production. . . .The unconscious is a 'wishing-machine'."

That Orlan had violated a rule became obvious when the leaders of her "atelier community" relieved her of her post as teaching Professor, on the grounds that "her public behaviour was incompatible with her duties as a teacher." With this Performance — which was variously covered, but generally treated as a scandal by press, radio and television, Orlan became jobless overnight.

In 1976, in the "Galerie des Ursulines" in Macon, Orlan recreated, live, Edouard Manet's painting "Déjeuner sur l'Herbe" (1863) — with one decisive difference: in Orlan's "Plein-air-Performance" the men are naked, while she, as the female protagonist, remains clothed.

In "Striptease" (1977), Orlan again depicts various mythological stages of woman. Draped in the bed-sheets of her dowry, she portrays a madonna who gradually lets fall her draperies, as "heritage", until she finally reaches the stage of the "femme strip tease" — in other words, the stage of prostitution, the whore. In this way, she makes contact with another mystification in the male-patriarchal history of ideas. The Performance "Striptease" ends at the moment when the woman, as "infinite Madonna" without a body, in other words, without sexuality, becomes a "finite object" for the Peeping Tom.

This moment requires critical codifica-

air-Performance" sind die Männer nackt, während sie als weibliche Protagonistin bekleidet bleibt.

In ihrem Stück "Strip tease" passiert sie 1977 erneut verschiedene mythologische Stadien der Frau. In die Bettlaken ihrer Aussteuer gehüllt, stellt sie eine Madonna nach, die sich nach und nach der Draperien entledigt und sie als "Erbschaft" auf den Boden sinken lässt, um bei der "femme strip tease" auszukommen, das heisst, der Nutte, der Prostituierten und damit erneut eine weitere Mystifikation der männlich-patriachalischen Ideengeschichte zu erreichen. Die Performance "strip tease" ist in dem Augenblick beendet in dem die Frau als "entgrenzte Madonna" ohne Körper, also entsexualisiert, zum "begrenzten Objekt" des Voyeurismus wird.

Dieser Moment müsste kritisch kodifiziert werden. Die attraktive, hüllenlose Orlan will nicht verführen. Sie wiederholt viel eher die subjektive Verwandlung von regressiver Aktivität zum autonomen Narzissmus. Dies wird erst sichtbar, wenn man auf das Wortspiel aufmerksam macht, dass Orlan ihrem 'Baiser de l'artiste' unterlegt hat.

Im Französischen heisst "Sprache" — le language und "Zunge" heisst la langue. "Mettre sa langue dans le langage de quelqu'un" heisst somit, dass jemand seine Zunge in die Sprache von jemandem anderem legt, seine Sprache sich mit der eines anderen vermischt. Dieses Wortspiel ist für Orlan doppeldeutig. Einmal hat ihre eigene Mutter ihre Sprache mit Orlans vermischt", d.h.: sie hat sie erzieherisch bevormundet. Zum anderen meint sie, jeder habe eine Berührungsangst — nicht vor der Zunge — sondern vor der "Sprache" und der Bedeutung der Sprache anderer Menschen.

Sie stellt die "Grosse Odaliske" von Jean

tion. The attractive, naked Orlan does not intend to seduce. She is rather repeating the subjective metamorphosis from regressive activity to autonomous narcissism. This first becomes evident when one takes notice of the play on words on which Orlan based her "Baiser de l'Artiste".

In French, "language" is "le langage" and "tongue" is "la langue". "Mettre sa langue dans le langage de quelqu'un" means that someone is attempting another language, his own language is being mixed with that of another. This play on words had a double meaning for Orlan: her mother had once mixed her own language with Orlan's, in other words, she had dominated Orlan's development. Orlan at the same time believes that everyone has a "contact-complex", not related to contact of tongues, but to contact of language, and contact with the language of others.

Orlan recreated the "Great Odalisque" (1814) of J.A.D. Ingres. On this occasion she described without comment or addition the classic romanticism of a female stereotype: a creature of luxury, without an identity, for sexual use. The "Odalisque" represents today's kept, dependent woman, whose only value in the work force is her sexuality.

After her Performances, Orlan distributes questionnaires to the members of her audience, and records their reactions meticulously. Of her "Baiser de l'Artiste", which she performed daily during the 1977 Paris Art Fair, she noted:

ONE WOMAN stroked my hair and said "You are very brave!"
— ANOTHER returned several times, and we had a drink together.
— ANOTHER woman insisted that her male companion kiss me.
— ANOTHER pulls back in horror when she feels my tongue in her mouth. What had she

255

Auguste Dominique Ingres (1814) nach. Dieses Mal umschreibt sie ohne Zusatz und Kommentar distanzlos die Klassizistische Romantisierung einer weiblichen Stereotypen: als Luxusgeschöpf, das ohne eigne Identität, sexuell zu Diensten ist. Die "Odaliske" als modernes Bild der ausgehaltenen, abhängigen Frau, deren einzige verwertbare "Arbeitskraft" ihre Sexualität ist.

Nach den Performances verteilt Orlan Fragebögen an die Besucher. Sie notiert die Reaktionen der Besucher genau. Zu ihren 'Baisers de l'artiste', die sie tagelang während der Pariser Kunstmesse 1977 anbot, meint sie:

EINE FRAU streichelt meine Haare und sagt: "Du bist sehr mutig!"
— EINE andere kommt mehrmals zurück. Wir gehen gemeinsam ein Glas trinken.
— EINE andere insistiert darauf, dass ihr männlicher Begleiter mich küssen soll.
— EINE andere zieht sich angewidert zurück, als sie spürt, wie meine Zunge den Innenraum ihres Mundes berührt. Was hatte sie erwartet?!
— EINE andere bringt mir ein Glas Champagner.
— EINE andere antwortet auf die langsamen, zärtlichen Bewegungen meiner Zunge. Ohre kontrastiert auffallend mit den vielen nervösen, aufgeregten Zungen der anderen. Danach aber schwätzt sie erregt drauflos und zeigt Angst und Unsicherheit.

EIN MANN gibt mir nachher ein 'Trinkgeld' von 100 (österreichischen) Schillingen.
— EIN anderer setzt sich zu meinen Füssen nieder und will nicht mehr aufstehen.
— EIN anderer beginnt mit mir um den Preis von 5 Francs zu feilschen, zahlt in kleinen Stücken, und am Abend fehlen mir 5 Centimes.
— EIN anderer küsst mich auf die Nase.

expected?!
— ANOTHER brings me a glass of champagne.
— ANOTHER responds to the slow gentle movements of my tongue. Her tongue is in marked contrast to the many nervous, excited tongues of the others. Afterwards, however, she chatters excitedly on, and shows signs of anxiety and insecurity.

ONE MAN gives me 100 Austrian shillings afterwards as a tip.
— ANOTHER sits down at my feet and will not get up.
— ANOTHER starts bargaining for a reduction on the 5 Francs, pays up in small change, and in the evening I am 5 centimes short.
— ANOTHER man kisses my nose.
— ANOTHER takes my head in his hands.
— ANOTHER gets hold of some "Peeping Toms" to watch him.
— ANOTHER returns the next day with poems which he has written and dedicated to me.
— ANOTHER (a journalist from "Liberation") distributes quite a number of 5-France pieces among the audience and invites them to kiss me.
— ANOTHER man brings me photographs of the kisses.
— ANOTHER man says "You're right; we are all prostitutes here; you spit it in our faces." (He is an artist.)
— Jacques Jeannet, the inventor of "Artists' currency", buys 10 kisses from me and pays for them with a piece of paper signed with his name.

VARIOUS REACTIONS FROM PEOPLE WHO DID NOT ACTIVELY PARTICIPATE IN "BAISER DE L'ARTISTE"

— 'Punks' set themselves up alongside me. One shouts "15 Francs la pipe! 15 Francs la pipe!" He blocks the way from my audience

— EIN anderer nimmt meinen Kopf zwischen beide Hände.

— EIN anderer besorgt sich Voyeure, die ihm zusehen sollen.

— EIN anderer bringt mir einen Tag später selbstgeschriebene Gedichte, die er mir widmet.

— EIN anderer (Journalist bei 'Liberation') verteilt an die Anwesenden mehrere 5-Francs-Stücke und lädt sie ein, mich zu küssen.

— EIN anderer bringt mir Fotos von den Küssen.

— EIN anderer saft: "Du hast Recht. Hier sind wir alle Nutten. Du spuckst es uns in's Gesicht" (Er ist Künstler).

— Jacques Jeannet, der Erfinder des 'Künstlergeldes', erwirbt bei mir 10 Küsse und bezahlt sie mit einem von ihm signierten Stück Papier.

VERSCHIEDENE REAKTIONEN VON PERSONEN, DIE NICHT AM 'BAISER DE L'ARTISTE' TEILGENOMMEN HABEN:

— Die 'Punks' bauen sich neben mir auf. Einer brüllt: "15 Francs la pipe! 15 Francs la pipe". Damit blockiert er den Zugang des Publikums zu mir.

— Ein anderer Mann brüllt: "1 Franc für einen Kuss von einem Mann"! (Es kommen mehrere homosexuelle Freunde und küssen ihn).

— Der Galerist von nebenan will die Polizei holen, er meint, meine "Sirene" würde ihn belästigen.

— Ein Galerist nutzt eine TV-Sendung über die Kunstmesse und beschwert sich über mich.

— Ein anderer schreit mir wütend zu, ich solle zum "Place Pigalle" und "der Bastille" gehen (den konventionellen Orten der Prostituierten).

— Viele zögern. Viele lachen. Einige Klienten protestieren nach dem Kuss, weil

to me.

— Another man shouts "1 Franc for a kiss by a man!" (Several homosexual friends come forward and kiss him.)

— The next gallery-owner threatens to call the police, he claims that my siren is disturbing him.

— One gallery-owner takes advantage of a TV show on the Art Fair to complain about me.

— Another shouts angrily that I should move to the Place Pigalle or the Bastille (recognised haunts of prostitutes).

— Many people are hesitant, many laugh. Some customers protest after their kiss because they claim their predecessors got longer kisses.

— On the last day of the F.I.A.C. I realise that many had come to the Fair out of curiosity to see ME. Since the element of surprise had gone from my Performance I broke it off prematurely.

R E S U M E:

As a result of the special consequences (unemployment) and the considerable public interest, Orlan's "Baiser de l'artiste" has increased rapidly in value. A kiss from her today costs 50 Frances, a price-rise of 10%. (Translator's Note: 10% is the figure given in the original; probably means "ten times as much".) Special rates are available for editions of 10, 20, 30, 40, 50, . . . 100 kisses.

Although Orlan's Performance depicts the special situation of the woman in capitalist society (the body as a trading commodity), it is not about "prostitution", but is rather a defence of language and its meaning. (Language/lange . . .) (Translator's Note: /langue?) *"With 'Baiser de l'Artiste' I have created a symbol, but not one of prostitution: generally speaking, prostitutes do not sell their lips, their tongues, their language."*

257

sie sich einbilden, ich hätte ihre Vorgänger länger geküsst.

— Am letzten Tag der F.I.A.C. stelle ich fest, dass viele Leute nur aus Neugierde zur Messe kamen, um Mich zu sehen. Weil der Überraschungseffekt meiner Performance nicht mehr arbeitete, breche ich sie verfrüht ab.

RESUME:

Infolge der sozialen Konsequenzen (Arbeitslosigkeit) und des grossen öffentlichen Interesses, ist Orlans 'Baiser de l'artiste' schnell im Wert gestiegen. Ein Kuss von ihr kostet heute 50 Francs. Somit ist ein Preisanstieg von 10% zu vermerken. Preisreduktionen gibt es lediglich bei Editionen — bei 10, 20, 30, 40, 50 . . . oder 100 Küssen.

Obwohl Orlans Performance auf die besonderen Bedingungen der Frau im Kapitalismus hinweist (Warencharackter des Körpers), ist ihre Performance keine über die "Prostitution", sondern über die Abwehr der Sprache und ihrer Bedeutungen. (Language/lange . . .) *Ich habe mit dem 'Baiser de l'artiste' ein Symbol gebildet. Aber: nicht über Prostitution. Denn, im allgemeinen verkaufen Prostituierte ihre Lippen, ihre Zunge, ihre Sprache nicht".*

Orlan machte Aktionen und Performances auf Strassen und Plätzen und an öffentlichen Knotenpunkten, z.B. vor einem Bankgebäude. Dort verteilt sie meist Fragebögen. (*"Sind die modernen Stadte nach unserem Mass gebaut?"* — *"Ist die Stadt, in der sie leben okologisch verdreckt oder sauber?"* — *"Fuhlen Sie, dass Sie sich sozial-politisch engagieren, wenn Sie durch die Ture einer Bank treten?"*)

Sie misst mit ihrem Körper die Kulturinstitutionen (Centre Georges Pompidou) und die Strassen Frankreichs. Dabei werden ihre Kleider schmutzig. Dann zieht

Orlan brings her Actions and Peformances on to the streets and into the squares, and to public places (before a bank building, for example). There she usually distributes questionnaires. (*"Are modern cities built according to our measurements?"* — *"Is the city you live in ecologically clean or dirty?"* — *"Do you feel socio-politically involved when you enter a Bank?"*)

She takes the measurements of cultural institutions (Centre Georges Pompidou) and the streets of France — with her body. As a result, her clothes get dirty. She removes her outer garments, knocks on any door, asks for soap, water, and a bowl. The dirty water she fills into bottles which she then brings to a Paris gallery.

To whom does the body belong? To the person who has occupied it since childhood, or to the Peeping Toms? Orlan creates a photographic jig-saw puzzle of her body. She sells the pieces in the Vegetable Market of Lyon. For men, the price is 20% higher.

Why did she stop painting in 1976?

"Once it was possible to exhibit an empty canvas, even an empty unspanned frame, both of which can mean a revolution at the level of perception, it seemed to me that one could go no further with the canvas. Canvas no longer goes beyond any laws. So I left behind me an art form that had pushed me to the very edge of society."

Düsseldorf
May, 1978

Translated by Grace Dencker

sie die Uberkleider aus, klopft an x-beliebige Türen, bittet um eine Schüssel, Wasser und Seife. Das schmutzige Wasser füllt sie danach in Flacons und bringt diese Relikte in eine Pariser Galerie.

Wem gehört der Körper? Dem, der ihn von Kindheit an bewohnt oder den Voyeuren? Orlan stellt ein fotografisches Puzzle ihres Körpers her. Sie verkauft die einzelnen Stücke auf dem Gemüsemarkt von Lyon. Den Preis für Männer erhöht sie um 20 %.

Warum hat sie 1976 aufgehört zu malen?

"Seitdem man eine leere Leinwand ausstellen kann, sogar ein leeres, unbespanntes Chassis, was beides auf der Ebene der Wahrnehmung eine Revolution bedeuten kann, hatte ich den Eindruck, dass man mit der Leinwand nicht mehr weiter gehen kann. Die Leinwand überschreitet keine Gesetze mehr. So habe ich eine Kunst hinter mir gelassen, die mich völlig an den Rand der Gesellschaft gedrängt hat".

Düsseldorf
May, 1978

1. Hanns Eisler, Schriften I, Musik und Politik, 1924-1948, Rogner & Bernhard, München 1973
2. Klaus Theweleit, Männerphantasien 1., Frauen,Körper, Fluten, Geschichte, Verlag Roter Stern, 1977
3. ibid, cit. nach Deleuze/Guattari, Antiödipus, Suhrkamp Verlag, Frankfurt

VALIE EXPORT

geb. 1940 in Linz, lebt in Wien.
1968 gründendes mitglied der austrian filmmakers cooperative. mitbegründendes mitglied der grazer autorenversammlung. gründendes mitglied von "film women international" (unesco), zus. mit susan sontag, agnes varda, mai zetterling u.a. 1975. zusammenstellung und organisation der ausstellung "magna". "feminismus: kunst und kreativitat", galerie nächst st. stephan, wien 1975. beratung und mitarbeit für die ausstellung "kunstlerinnen international 1877-1977", berlin 1977. mitglied des "institut of direct art" (Nitsch . . .)

I (BEAT — it —) PERFORMANCE

das leben ist in unseren händen, auch wenn wir gleiten und uns schwer darin bewegen, aber schlagen wir nicht dagegen, so werden wir verschwinden.

material: 3 monitore, 3 videobänder, 8 gelenksbänder aus blei, bleihandschuhe, 1 foto (liegt am boden), kanister mit schmieröl, endlostonband, automatischer verstärker.

die 3 monitore bilden ein dreieck, auf den bildschirmen dieser monitore sieht man drei mich ankläffende hunde. dieses dreieck und dieses gebell stehen stellvertretend für den ständigen apell, den vater staat, mutter natur und (männliche) ideologie an uns richten. das dreieck der monitore steht für eine ganze kette von trinitäten, die bei der heiligen von vater, sohn und geist beginnt und bei der profanen von mann, geschlecht, moral endet. im mittelpunkt dieses dreiecks liegt das foto einer liegenden frau, auf das ich mich spiralenförmig durch abschreiten des monitors zubewege, wobei ich aus dem kanister schmieröl schütte.
meine bewegungen sind aber extremer natur, da meine extremitäten (beine und arme) belastet sind. die 8 abwink-

VALIE EXPORT

born 1940 in Linz, now living in Vienna.
1968: founding member of the Austrian Film-Makers' Cooperative; member of the Graz Writers' Association.
1975: founding member of "Film Women International" (UNESCO) with Susan Sontag, Agnes Varda, Mai Zetterling and others.
Compiled and organised the exhibition "Magna. Feminism, Art and Creativity", Gallerie Nachst St. Stephan, Vienna.
1975: Berlin: advice and collaboration in the exhibition "Women Artists' International 1877-1977".
Member of the "Institute of Direct Art". (Nitsch. . . .)

I (BEAT — it —) PERFORMANCE

life is in our hands, even if we slide, and move with difficulty, but if we do not strike out against it, we will disappear.
materials: 3 monitors, 3 video tapes, 8 bangles of lead, gloves of lead, 1 photograph (lying on the floor), 1 can of oil, one continuous tape, automatic amplifier.

the three monitors form a triangle; on the screen, three dogs are barking at me. this triangle and this barking represent the constant call to obedience from father state, mother nature, and (male) ideology. the triangle of monitors symbolises a whole chain of trinities, starting with the holy one of Father, Son and Holy Ghost, and ending with the profane one of man, gender, and morality. in the centre of the triangle is the photograph of a reclining woman, which I approach in a spiral, pouring out oil from the can. my movements are of an exaggerated nature, since my extremities (arms and legs) are burdened: the eight joints of my limbs are encircled with lead bangles tied with leather bands, making it impossible for the joints to move freely. there are lead gloves on my hands, making productive work even more difficult. my arm and

elungsgelenke meiner extremitäten sind mit bleibändern umspannt, die mit lederriemen geschlossen werden, sodass ich sie nicht mehr vollständig bewegen kann. meine hände sind überzogen mit bleihandschuhen: meine hände taugen als produktionsmittel nur mehr schwerlich. meine gelenke an armen und füssen sind in ihrer bewegungsfreiheit und -totalität stark gehandicapt. sie hängen von meinem rumpf als funktionslose extensionen meines körperlichen seins. bin ich da noch ich selbst? eine arbeiterin an einer maschine, die sich als extension der maschine wie eine marionette im takt derselben bewegt, ist es noch ihr körper, der sich da bewegt? ihr körper handelt abhängig, buchstäblich abhängig, die gewichte der maschine hängen an ihr. der körper arbeitet für die maschine, nicht für sich selbst. die arbeiterin arbeitet selbstlos in der (sozialen) maschinerie. dieser entfremdete körpereinsatz zeigt gerade dadurch, dass der körper eingesetzt wird, wie wenig es der eigene körper ist, sondern wie sehr er als fremder behandelt wird und als fremder handelt. dieser selbstlose körper, weil er einem nicht gehört, handelt auch von der anderen selbstlosigkeit der arbeiterin. sie, die frau, hat in der sozialen maschinerie kein eigenes selbst, sie darf nicht für sich selbst sein. sie darf durch ihren körper (geliebte, mutter etc) nur funktionieren in bezug auf andere, in bezug auf den mann, in bezug auf die gesellschaft.

bei meinem weg schütte ich vor mir selbst das schmieröl auf, vor meine füsse . . . diese bewegung auf dem schmieröl, diesen wellen, diesen brandungen (des lebens?), ist eine handlungsform, die sich nur in der angedeuteten trinität legitimiert. ohne diese trinität wäre sie sinnlos. aber die

leg joints are themselves, and in their mobility, severely restricted. they hang from my trunk like functionless extensions of my bodily being. am I thus still myself? a woman machinist, who, as an extension of the machine, moves like a marionette to the beat of the machine, is it still her body that is moving? her body acts dependently, literally dependently, the weights of the machine are hanging from her, the body works for the machine, not for itself. the woman works selflessly in the (social) machinery. this alienation of the body indicates, precisely because the body is made use of, how little it is one's own body. how much, rather, it is treated as an entity, and how much like a foreign entity it behaves. this selfless body, since it belongs to no one, symbolises, too, the other selflessness of the woman machinist. she, the woman, has no self in the social structure, she cannot exist for herself. she is allowed, through her body, to function (as mistress, mother, etc.) only in relation to others, in relation to husband, to society. as I go I pour oil in front of me, before my feet . . . this movement on the oil, these waves, these tides (of life?) is a form of action which is legitimised only in the aforementioned trinity. without this trinity it would be pointless. but the presence of the trinity, its call for obedience, shows that we don't move as masters of ourselves, unimpeded, in a vacuum. the oil is ambivalent: it calms the sea waves, but on land it causes skidding. calming and degrading. these are the lubricating processes with which society hopes to ensure smooth communication, even if the price is the downfall of many. if I stand, I can move only like a puppet. if I fall, I shall hurt myself. if I sit, I cannot rest. I can lie only in pain. I am

anwesenheit der trinität, ihr appell, zeigt ja, dass wir uns nicht im luftleeren raum ungehindert als selbsteigner bewegen. das öl ist ambivalent: es glättet die wogen des meeres, aber auf dem land verursacht es ein ausrutschen. beruhigt soll werden und erniedrigt — das sind die gleit — und schmiermittel, mit denen die gesellschaft eine reibungslose kommunikation erwünscht, auch wenn der preis, das zugrundegehen vieler ist.

stehe ich, so kann ich mich nur wie eine marionette bewegen. falle ich, so wird es mich verletzen. sitze ich, so kann ich nicht ruhen. liege ich, so kann ich es nur unter schmerzen. ich bin meiner werkzeuge beraubt, die mich vorwärts kommen lassen. ich bin ein gebäude, in dem das selbst bewegungslos in sich verharren muss, in dem meine gedanken, wünsche und bedürfnisse nur luftgefechte schlagen können.

die echten gefechte, die ich mit kanister, schmieröl und bleibändern auf meiner reise nicht zum mittelpunkt der erde, sondern meiner selbst ausführe, diese gefechte führen glücklichenfalls in den sturz der resignation, das letzte aufbranden der hoffnung auf eine selbst-begegnung im wald der kälte, im wald der trinität, im wald des egoismus ist die begegnung mit einem kalten fotografischen abbild wärmer als der tod, ist das schmieröl auch heizöl, ist das blei auch schatten der luft. im mittelpunkt der drei erstarrten felsen, in den mich vielleicht die wellen des schmieröls getragen haben (halb mit ihrer kraft, halb mit meiner kraft), öffnet sich mein mund nicht mehr zum atmen, sondern er spricht: MEHR! MEER!

auf der endlosschleife eines magnetophons hört man das wort: MER. einmal von einer

deprived of the tools that would allow me to progress. I am a building in which my self must remain motionless, in which my thoughts, wishes and needs can only fight sham fights. the real battle, which I fight with can, lubricating oil and lead bangles, on my journey which leads not to the centre of the earth but to the centre of myself — these fights lead at best into the descent of resignation, to the last rays of hope for a self-encounter in the forests of cold, in the forests of the trinity. in the forest of egoism, the encounter with a cold photographic image is warmer than death, lubricating oil is also heating oil, lead is also the shadow of air. in the middle of three petrified rocks, borne, perhaps, by the waves of lubricating oil (partly with their energy, partly with mine) my mouth opens, no longer to breathe, but to say MEHR! (More!) MEER! (Sea!)

On the continuous tape, the word MER is heard, spoken by a male and a female voice alternately. it is pronounced in such a way as to make it impossible for the listener to know if it is "mehr" (more) or "meer" (sea) or both. at first the word can hardly be heard above the barking of the dogs, but gradually it becomes more audible (thanks to a special electronic device). towards the end it is quite loud, and finally the actress is saying it herself. "mer" as MEHR (more) signifies the intensification of pain and strain, of not-yet-having-reached-the-end, of more endurance. . . .

"mer" as MEER (sea) means evolution, hope, escape from the quagmire. . . .

In 1972, when I was very much involved in the presentation of psychological conditions, I wanted to wear these lead bangles to

männlichen und einmal von einer weiblichen stimme gesprochen. das wort wird so gesprochen, dass der zuhörer nicht weiss, soll es "mehr" oder "meer" bedeuten oder beides. anfangs hört man dieses MER wegen des hundegebells kaum, doch langsam wird es automatisch (vermöge einer speziellen elektronischen einrichtung) immer deutlicher vernehmlich. schliesslich wird es ganz laut und am schluss sagt es die akteurin selbst. als MEHR bedeutet "mer": die steigerung des leids, der anstrengung, des noch noch nicht zu ende, noch mehr erdulden. . . .

als MEER bedeutet "mer": evolution, hoffnung, aus dem sumpf heraus. . . .

1972, als ich mich beonders intensiv mit der darstellung psychischer zustände beschäftigte, wolle ich mit diesen blei-bändern zu bett gehen und eine nacht damit schlafen. eine video-kamera hätte mich die ganze nacht beobachtet. ich wäre allein gewesen, (nur ein helfer der die bänder neu einlegt). als ich es versuchte überkam mich eine schreckliche angst, ein einsamkeitsgefühl überfiel mich, mich in dieser zwangssituation dem schlaf hilflos auszuliefern. bei diesen gedanken erfasste mich eine panik, und ich musste mich sofort aus dieser körperlichen beschränkung befreien lassen (ich konnte es auch bis jetzt nicht mehr wiederholen). der gleichzeitige versuch mit schlittschuhen eine nacht zu schlafen hat zu den eigenartigsten traum-ketten geführt, und am nächsten morgen als ich aufwachte, empfand ich ein befreites gefühl.

ich habe damals noch eine ganze reihe solcher versuche unternommen z.b. mit bergsteigerkleidung ins bett schlafen zu gehen, mit männerbekleidung, rollschuhen, mit papiermasken, papierkleidern etc.

bed, and sleep for one night with them on. a video-camera would watch me the whole night. I should be alone (but for a helper who would put the bangles on). when I attempted it, I was seized by a terrible fear, overcome by loneliness, helplessly left to sleep in this constrained situation. These thoughts made me panic, and I had to be freed from the physical bonds (I have not yet been able to repeat the experiment). An attempt to spend the night wearing ice-skates (from this same period) led to the strangest dream-sequence, and the following morning I woke with a feeling of freedom.

I made a whole series of similar experiments at this time — sleeping in mountaineering gear, in men's clothes, in roller-skates, in paper masks, in paper clothes, etc.

ACTION DE RUE

(Pour une plus grande communication en milieu urbain et une meilleure prise de conscience collective de ce qui nous limite).

TITRE ET DEROULEMENT:

La Brigade Internationale Anti-Norme et d'Intronisation de la Marginalité vous informe que *vous n'etes pas règlementaire* et vous adresse une contravention car vous ne vous habillez pas comme moi, vous ne pensez pas comme moi. Cette contravention est payable en nature, en action, en bouton de culotte, en idée, etc. . . .

LA MOTIVATION DE CETTE ACTION EST L'INTERROGATION SUIVANTE:

Qu'est-ce que la norme?
Vous sentez-vous différents des autres?
en quoi?
Pensez-vous être normal? pourquoi?
Me trouvez-vous normale? pourquoi?
Notre vêtement est notre carte de visite mais notre "FOND" correspond-il à notre "FORME"?
Est-ce que nos pensées ne dépendent pas à notre insu, des journeaux de la télé, de nos voisins et de la mode comme nos vêtements?

Dans l'histoire du costume certaines tendances nous paraissent aujourd'hui aberrantes:
— pour les hommes: le port de la robe, de la perruque, de la fraise, de la braguette proéminente, des bas brodés, des dentelles, des rubans etc.
— pour les femmes: le port du Henin et de chapeaux monumentaux, le rasage de la moitié des cheveux à partir du front, l'abscence de sourcil, le vertugadin, le corsage baleiné, la crinoline, le faux cul etc. . . .

STREET ACTION

(for a greater communication with the urban development and a better collective awareness of what limits us.)

TITLE AND ACTION:

The International Brigade of Anti-Norm and Enthroning of Marginality informs you that *you are not statutory* and issues you a ticket because you do not dress like me, you do not think like me. This fine is payable in nature, in action, in ideas, in fly buttons, etc. . . .

THE MOTIVATION OF THIS ACTION IS THE FOLLOWING INTERROGATION:

What is the norm?
Do you feel different from others? How?
Do you consider yourself to be normal?
Why?
Do you think I am normal? Why?
Our dress is our calling card but does the SUBSTANCE correspond to the FORM?
Don't television, newspapers, our neighbours, influence our thoughts without our knowledge, just as fashion conditions our dressing?

In the history of costume some tendencies seem today to be pure aberration:
— for men: wearing dresses, wigs, "fraise" (collarette), prominent codpieces, embroidered socks, lace, ribbons, etc. . . .
— for women: wearing "hennin" and other types of monumental hats, shaving half the hair from the forehead, shaving eyebrows, the farthingale, whalebone corsets, crinoline, the bustle.

In History, there are also some schools of thinking which today appear as total abberation:
the burning of so-called witches to drive out

Dans notre Histoire également voici quelques mouvements de pensée qui nous paraissent aberrants:

Faire brûler de soi-disant sorcières pour en chasser le diable, le procès de Galilée, la croyance à la génération spontanée. Au moment des découvertes des transports rapides l'idée que le corps ne résisterait pas à une accélération de plus 30 Kms/heure, le nazisme, etc. . . .

Actuellement pour faire sérieux il faut être habillé avec discrètion, il en a été différemment à d'autres époques — peut-on être sérieux et habillé de manière personnelle?

<div align="right">pourquoi?</div>

Faut-il être discret? pourquoi?

L'habit ne fait-il pas le moine?

Quelles sont vos couleurs préférées?

<div align="right">les portez-vous?</div>

Etes-vous contre la fantaisie? pourquoi?

Admirez-vous ou méprisez-vous les anti-conformistes?

Seriez-vous d'accord pour porter un uniforme?

Osons-nous penser à contre-courant?

Pourquoi somme-nous toujours choqués par ce qui ne nous est pas familier?

ACTION DE RUE

Pour une plus grande communication en milieu urbain, pour une meilleure prise de conscience collective de ce qui nous limite.

TITRE: "OUVRONS-NOUS DES PORTES"

DEROULEMENT:

 — Porter une porte et son chambranle aux portes importantes de la ville (ex-

their devils, the trial of Gallileo, the belief in spontaneous generation; at the time of the discovery of transportation means, the belief that the human body would not stand up to an acceleration over 30 kilometers/hour; the Nazi movement, etc. . . .

Nowadays, to be taken seriously, you must dress with circumspection. Things were different during some other epochs of history. Can't one be serious and still be dressed in a personal manner? Why?

Should we be discreet, quiet? Why?

Isn't it the cowl that makes the monk?

What are your favourite colours? Do you dress in those colours?

Are you against fantasy? Why?

Do you admire or do you despise anti-conformists?

Would you agree to wear a uniform?

Do we dare think against the mainstream?

Why are we always disturbed by what is unfamiliar?

STREET ACTION

For a greater communication within the urban environment, for a greater collective awareness of what limits us.

TITLE: "LET'S OPEN SOME DOORS FOR OURSELVES"

ACTION:

 —To carry a door and its frame to important door locations around town (example: bank doors, churches, department stores, museum, galleries, etc. . . .).

 — To count the number of passers-by who accept this reconsideration of our

emple: porte de banque, d'église, de magasin à grande surface, de musée, de galerie, etc. . . .)

— Compter le nombre de passants qui auront accepter de reconsidérer un de nos actes familiers en passant par ma porte

— Distribuer ces tracts

— Se mettre en contact avec le plus de passants possible

— Remplir ce questionnaire

LA MOTIVATION DE CETTE INTERVENTION EST L'INTERROGATION SUIVANTE:

— Sommes-nous capables de détecter nos automatismes?

— Sommes-nous conscients de chacun de nos gestes?

— Chacun de nos actes nous engage-t-il vraiment?

— Est-ce que passer la porte (par exemple) d'une banque nous engage socialement, politiquement?

— Ouvrons-nous facilement notre porte?

— Est-ce qu'une porte doit être ouverte ou fermée?

Est-ce que cette action vous paraît efficace? Pourquoi?

Sinon que faudrait-il faire pour qu'elle le soit?

ACTION DE RUE
ENQUETE
INTERVENTION

QUESTIONS ET MOTIVATIONS: Qu'est ce que peindre? AVOIR UN REGARD ET LE DONNER A VOIR. Donner à voir quoi? De la peinture! C'est-à-dire devenir un luxe et une marchandise dans les galeries (situation difficilement contournable lorsque l'atelier de l'artiste est envahi par ses oeuvres). En outre

familiar actions by going through my door.

— To distribute these leaflets.

— To be in contact with as many passers-by as possible.

— To fill in this form.

THE MOTIVATION OF THIS INTERVENTION IS THE FOLLOWING QUESTION:

— Are we able to detect "automatisms"?

— Are we aware of each of our gestures?

— Does each of our gestures really show commitment?

— Does going through the door (for example a bank door) commit us socially, politically?

— Do we easily open our door?

— Should a door be open or closed?

Does this action seem efficient to you?

Why?

If not what should be done to make it so?

STREET ACTION
SURVEY
INTERVENTION

QUESTIONS AND MOTIVATIONS: What is painting? TO HAVE A VISION AND MAKE IT VISIBLE. Make what visible? Some paint! That is, to become a luxury and a gallery merchandise (which constitutes a situation controlled with difficulty when the artist's studio is literally filled with works). Besides, the easel painting, even the most contemporary and least aesthetic, makes me become marginal, anachronistic; in order to convince ourselves, let's have a look at History and the History of painting. What should we do? Refuse to paint? I considered it but painting is necessary to my process. Then I continue to create a pictorial

la peinture de chevalet même la plus contemporaine, la moins esthétisante me rend marginale, anachronique: pour s'en persuader interrogeons l'Histoire et l'histoire de la peinture. Que faire? Renoncer à la peinture? J'y ai songé mais elle est nécessaire à mon cheminement, aussi je continue à produire un langage pictural tout en étant consciente de cette position de repli, de fuite, de contradiction qu'est la peinture-peinture. La vision du peintre a un intérêt si elle dérange, interroge, subvertie. Vivre pleinement mon époque en continuant à la dénoncer ce n'est pas me mettre en marge "m'en laver les mains" en travaillant uniquement pour ma thérapeutique personnelle et pour une élite intellectuelle ou richissime. Je nie l'efficacité de la peinture-peinture comme communication, interrogation. J'ai donc entrepris un travail parallèle d'action de rue qui me permet d'intégrer ma propre réalité dans une réalité sociale où je m'engage, où je me sens responsable et solidaire d'une plus grande prise de conscience collective. J'ai fait depuis 1964 des actions de rue en essayant d'être la moins agressive possible, de rechercher la communication, de solliciter les questions, d'y répondre toujours et de distribuer des tracts explicatifs les plus clairs possible avec parfois une note d'humour ou de poésie. Mes actions sont sérieuses, mûrement réflèchies mais je refuse de me prendre trop au sérieux, je refuse l'obscurantisme.

language while being aware of that position of withdrawal, of escape, of contradiction that is painting-painting. The painter's vision has interest if it disturbs, questions, subverts. To live fully while continually denouncing it does not make me marginal and does not constitute a cop-out while working only for personal therapy or for an intellectual or very wealthy elite. I deny the effectiveness of painting as a means of communication, interrogation. So I have undertaken a parallel series of "street action" projects which enable me to integrate my own reality within a social reality where I commit myself, where I feel responsible and really part of a greater collective awareness. Since 1964, I have produced street action works, always trying to be as non-aggressive as possible, to seek communication, to solicit (and provoke) questions, to always answer them, and to distribute explanatory leaflets which are as clear as possible — and sometimes with a tone of humour or poetry. My actions are serious, carefully considered, but I refuse to take myself too seriously, I refuse the obscurantism.

LE CORPS DE L'ARTISTE EN SITUATION—CITATION DANS LA GRANDE ODALISQUE DE INGRES

CORRESPONDENCE a propos d'oevre faite avec les draps de mon trousseau (montrer le bout de l'oreille)

1 PARTIE:

un sous-oeuvre
remeniscence de discours
MATERNAL

Ecoute avoir l'oreille fine — Met-toi à jour — Met-toi au jour — Tire les fils — enfile l'aiguille — attention ca pique et le chas est petit — ferme l'oeil — à droite à gauche au centre — le phallus fil ne veut pas — it est mou — le chas est petit — trou sot — mouille le bout de la langue — lèche — essuie avec les levres — il se raidit — ne te fais pas tirer l'oreille — Viva! il passe — je l'ai enfilé — c'est bon! — attention ça pique — fais un noeud entre le pouce et l'index — un gros noeud — assied-toi au jour — comme on fait son lit on se couche ma petite — TROUSSEAU — compte les fils-beiges - du metis - belle qualité — tu le prends pour rien — c'est pas rien — c'est pas pour rien — c'est pas donné — poings serrés — points-petits-points-blancs — ne rêve pas — va vite — AJOURER — il'y a plusieurs draps a DEUX places — plusiers jours — plusieurs points — les initiales à broder — points de bourdon — paires de chainette — au centre ou a côte — au choix ma petite — comme on fait son lit on se couche — draps non decatis-raides-rêches-empeses — PESANTS.
Non.

2 PARTIE:

Se mettre à l'oeuvre
Faire la sourde oreille

ne t'infiltre pas sous la-couverture-sous-le corps-de-mes-amants Mère — desormais — DECHIRER — CROCHETER — DRAPER — Desormais — Delice-lyrismeludismeonirismedelir — GRANDIR — SE MESURER à soi-même à l'AUTRE — A L'ESPACE — ETRE SA PROPRE MESURE — ETRE SANS MESURE — ETRE DESIR — DEMESURER — PASSER DE L'AUTRE COTE DE SON DESIR — PASSER — SE SURPASSER — SE SURPRENDRE — SE DEPASSER — MON CORPS — LE CORPS DU PEINTRE DANS L'OEUVRE — il passe de l'AUTRE COTE DE LA TOILE — CE CORPS VOILE — CACHE PAR LA MERE — par la TOILE — ET LE PEINTRE — CE DENUDE — ETRE VU — SE VOIR — point de côte — être a côte — DELECTATION — jouissance — ultime — REGARDE — REGARDANT — DEHORS — DEDANS DEDANS — DEHORS — VA ET VIENT — MACHINE A COUDRE — confidence sur l'oreiller — elle était chemisière

encore de l'ordre de la
reminiscence (1ere partie)

DORS SUR TES deux oreilles
NE TE FATIGUE PAS
DIS OUI
ATTENDS L'EPOUX
NON Tu n'es pas sortie de la cuisse de Jupiter ma petite.

3 PARTIE: se grandir

Ecrasement

or-oreille-oreiller

or-ient-dans quelle mesure?

NE ME REGARDE PAS J. Gertz

(un mètre soixante DEUX)
Et puis les vedettes-consacrées-de-notre-passé-culturel — les muses — la muse — la pute — la vierge — la mère — la vénus — les chefs d'oeuvre de l'Art — les féminins — corps-consacrés-de-notre-passé-culturel — Autant de pénétrations (oh pardon je voulais écrire de FASCINATION)[2] être tour à tour dans le corps de chacune d'elles — ATTRACTION IRRESISTIBLE — LES ENFILER — comme un gant — ô femmes — CONS — NUS — hommes-peintres immortels — LES CITES — se situer — Strip Tease occasionnel — je suis dans de beaux draps! ALORS SE DEGUISER — le trou — ô — draps drapés Je me drape je brode au crochet j'en fais des ventres de plus en plus énormes enceintes de mille "MOI" ("SUR MOI" je vous montre mon cul, je vous fais l'humour) Multiples raisons pour ne pas dormir je suis nyctalope

1. denuder: car on peut dire le vendre le prendre
2. lapsus chéri, je vous embrasse

Orlan

THE ARTIST'S BODY IN SITUATION—CITATION IN INGRES' "LA GRANDE ODALISQUE"

CORRESPONDENCE about work made with the sheets of my trousseau
(show the tip of the ear)

FIRST PART:

underground work
reminiscence
of the discourse

MATERNAL

Listen be all ears — Bring yourself up to date — draw the thread — thread the needle — watch out it is sharp, and the eye is small — close your eye — to the right, to the left, to the centre — the phallus-thread doesn't want — it is soft — the eye is small — stupid hole — wet the tip of the tongue — lick — wipe with the lips — it stiffens — do not demand much coaxing — Viva, it goes through — I have threaded it — it is good! — watch out, it is sharp — make a nut between thumb and the index — a big nut — Sit down in light — first you make your bed, then you lie on it, my little one — TROUSSEAU — count the beige threads of the linen/cotton — fine quality — you think it is nothing — it is nothing — it is not for nothing — it is not given away — tight fists — stitches, little white stitches — don't dream — go fast — hemstitch — there are many double sheets — many days — many stitches - initials to embroider: drop stitches, pairs of chain stitches in the centre or to one side your choice, my little one — first you make your bed then you lie on it — glossy, stiff — harsh — starched sheets — HEAVY.

No.

SECOND PART:

(set yourself to work)
pretend not to hear

Do not slip under the blanket — under-my-lover's-body, mother — from now on TO TEAR UP — TO CROCHET — TO DRAPE — from now on pleasure-lyricismgamesdreamsdelirium — TO GROW UP — TO MEASURE UP to oneself and to OTHERS — TO THE SPACE — TO BE YOUR OWN MEASURE — TO BE WITHOUT MEASURE — TO BE DESIRE — UNBOUNDED — TO PASS BEYOND ONE'S OWN DESIRE — TO PASS — TO SURPASS ONESELF — TO ASTONISH YOURSELF — TO SURPASS ONESELF — MY BODY — THE PAINTER'S BODY IN THE WORK — he passes BEYOND THE CANVAS — THIS VEILED BODY — HIDDEN BY THE MOTHER — by the CANVAS — AND THE PAINTER — THIS DENUDED ONE[1] — BEING SEEN — TO SEE ONESELF — side stitch — To be to one side — DELIGHT — climax — SEEN — SEEING — OUTSIDE — INSIDE — INSIDE — OUTSIDE — BACK AND FORTH — SEWING MACHINE — (confidence on the pillow — She was a shirtmaker)

still about the order
of the reminiscence
(1st part)

SLEEP SOUNDLY
DO NOT TIRE YOURSELF
SAY YES
WAIT FOR YOUR HUSBAND
NO, you were not born from Jupiter's thigh, my little one.

THIRD PART growing up

Crushing

Gold — ear-pillow

or-ient in which measure?

DON'T LOOK AT ME J. Gertz

(1 meter sixty-TWO)
And then the consecrated-stars-of-our-cultural-past: the Muses — the muse — the whore — the virgin — the mother — Venus — The masterpieces of Art — the females — consecrated-bodies-of-our-cultural-past — As many penetrations (oh, so sorry, I meant to say FASCINATIONS[2] — to be by turns in the bodies of each of them — IRRESISTABLE APPEAL — TO PUT THEM ON — like a glove — O Women — known to the immortal men painters — CITE THEM — situate oneself — occasional strip tease, I am in a fine mess. THEN TO DISGUISE MYSELF — the hole — o — draped sheets I drape myself I crochet I make bellies, bigger and bigger, pregnant with thousands of "ME" ("SUR MOI" I show you my ass, I make humour amour to You) multiple reasons not to sleep I don't see well in the dark.

1. to denude: because one can say to sell it to take it
2. a slip dear, I give you a kiss

269

Orlan
translation: René Blouin

PERFORMANCE NOTES FROM THE WESTERN FRONT

The Western Front, Vancouver, was started in 1973 by a group of eight artists. The Front itself is a three-storey wooden building, originally built as a Knights of Pythias Fraternal Order hall in 1922. The building incorporates two large performance/production spaces, a gallery, an archive, video and audio editing facilities, and private living spaces.*

The Western Front has become an important performance centre in Canada, involving such visiting artists as Hermann Nitsch, Robert Filliou, Cioni Carpi, Fabio Mauri, Clive Robertson, General Idea, Elizabeth Chitty, and many more too numerous to list here. In addition, it has been an important centre in the development of such local artists as Randy & Bernicci, Paul Wong, Al Neil, Rick Hambleton, Byron Black, and the artists at Pumps, a group of younger artists who have recently opened their own centre in Vancouver.

The texts which follow are excerpted from conversations and personal correspondence of Michael Morris, Eric Metcalfe, Hank Bull, and myself.

Glenn Lewis
Vancouver
April, 1979

* *Founding members of the Western Front include Martin Bartlett, Kate Craig, Henry Greenhow, Glenn Lewis, Eric Metcalfe, Michael Morris, Mo van Nostrand and Vincent Trasov.*

LIST OF CHARACTERS — NOT NECESSARILY IN THIS ORDER

Martin Bartlett — Min Blett
Kate Craig — Lady Brute
Glenn Lewis — Flakey Rose Hip — New York Corres Sponge Dance School of Vancouver
Michael Morris — Marcel Idea
Eric Metcalfe — Dr. Brute
Vincent Trasov — Mr. Peanut
Banal Beauty Inc. — Eric Metcalfe & Kate Craig — Leopard Realty
Image Bank — Michael Morris & Vincent Trasov
HP — Hank Bull & Patrick Ready
Tootaloonies — Eric Metcalfe & Jane Ellison
Lux Radio Players — Hank Bull, Kate Craig, Glenn Lewis, Patrick Ready, Suzanne Ksinan, Marybeth Knechtel, Warren Knechtel, Bob Amussen, Robert Amos, Opal L. Nations, Bill Little, Byron Black, Randy Gledhill, Bernicci Hershorn, Richard Harper, Donna Reeve, Peter Fraser, Eric Metcalfe, Gerry Rutter and a hearty thanks to a host of others too numerous to recall here and abroad.
Canadian Shadow Theatre — Hank Bull, Patrick Ready, Martin Bartlett, Glenn Lewis, Josephine Rigg

VANCOUVER has a long history of "marginal and fringe" artistic activities and, in Canadian terms, a fairly enthusiastic and consistent audience. I became involved with performances, events and happenings, as they used to be called, while living in London in the mid sixties. The old I.C.A. in London hosted many early concrete poetry events, interdisciplinary and revolutionary art forms as a matter of principle. Signals Art Gallery instigated the most independent and outrageous events and also published an ambitious tabloid for the period. David Medalla, Takis, Soto, Tomas Schmidt, John Latham, Gustave Metzner, Ernst Jandal and many other artists had equal influence as did Warhol, Johns etc. and greatly added to my appreciation of Duchamp and in general, all interdisciplinary activities in the arts as it emerged from the myth of modernism. I prefer Moholy-Nagy's Parker Pen to sitting under a Paolozzi in a Wimpy Bar.

Returning to Vancouver in the summer of 1966 and taking a temporary job as curator at the Vancouver Art Gallery I realized how provincial the art scene was here. About the same time 'Intermedia' started up, a unique and highly idealistic organization. Intermedia was the name given to a very large group of artists who banded together in Vancouver to produce new art activity in film, performance, light, sound, dance, graphics, video and sculptural constructions and environments with an emphasis on technological innovation. It created an artistic climate, audience and acceptance for subsequent artistic activity. Dave Rimmer, Gary Lee Nova (Art Rat), Al Razutis, Gregg Simpson, Don Druick, Gerry Gilbert, Gathie Falk, Glenn Lewis, Michael de Courcey, Al Neil, Michael Goldberg, were among some of the important artists who produced work there.

Besides Intermedia and Alvin Balkind at UBC Fine Arts Gallery, one has to give credit to Iain Baxter and Doug Christmas (Douglas Gallery, now Ace Gallery) for the energy they generated on both the local and international scene. I worked closely with both of them at that time and in retrospect we managed to initiate some amazing things. Ralph Ortz' 'Art and Destruction' performance in 1968, which I initiated, was not only met with horror by the popular press, but raised questions in Ottawa, because Ralph's airfare was paid by the Canada Council. It really stands up as an important event, posing situations and ideas that have become part of art's concerns of the seventies.

I instigated "The Beach Party" at the Douglas Gallery in 1967, in which the gallery was lined with plastic and flooded. Hot dogs and cokes were served while life guards offered sun tan lotions and massages to the audience, while beach party music added to the general confusion.

In 1967 I started a series of visits to Los Angeles. Philip Leider was then editor of Art Forum. Ed Ruscha was looking after layout and design. Ken Tyler had just started Gemini Graphics. There was a lot of international art activity there. I arranged with Doug Christmas to bring Rauschenberg to Vancouver to show his first Gemini prints. He came with Steve Paxton, Deborah and Alex Hay. Steve and Deborah made numerous return visits and have had an influence on dance and performance in Vancouver. Through them we got to know Yvonne Rainer, Barbara Dilley, and most of the Grand Union Dancers. Yvonne and Steve have done several major performances here in Vancouver. In 1968 Glenn Lewis and Yvonne did a west coast tour,

271

Vancouver to LA, which was really important.

I was also involved with the concrete poetry and Fluxus movements. I coordinated the first exhibition of these activities in Canada in 1969 at the UBC Fine Arts Gallery, which included the first presentation of the work of Ray Johnson and his New York Correspondence school outside the USA. That was a performance! Ray's correspondence collages were to be a major part of the exhibition. However, the gallery facilities were less than adequate for the

scope, material and concerns represented in the exhibition, and Ray ended up refusing to show his collages. He accidentally cut his finger while installing the work and proceeded to spread his blood on the white wall, entitling the work "Blood of a concrete poet". Needless to say these gestures were not greatly appreciated at the time and were not considered as performance, which of course they were.

In Vancouver, besides Glenn Lewis, Iain Baxter and myself, Gathie Falk emerged as a major, and still not fully recognized innovator of performance art. Vincent Trasov

made his debut which remains a very strong piece.

The subsequent activities in the Image Bank, which Vincent Trasov and I founded, reflect the emergence of my own involvement and relationship to the present scene. Image Bank is specifically the on-going collaboration and concern of Vincent and myself and is both separate and integral to the Western Front. Two collaborative pieces with Glenn Lewis in 1971 were essentially performance; the installation of a live cow in a room filled with old masters' paintings of cows in the "Realism" show at the Montreal Museum and the "Taping" of the International Art Critics Convention of Vancouver Art Gallery.

In 1970 Vincent Trasov assumed the identity of Mr. Peanut, a life-time favourite corporate image. Vincent constructed a papier-mache peanut costume with Art Rat and Dr. Brute. There was an enormous proliferation of props at this time, as we began to work and understand the performance event structure our collaborative efforts were taking.

Image Bank's first meeting with General Idea in 1971 occurred at old Image Bank in Point Grey Scale. It was our first important cross Canada connection with artists of the seventies. I was amazed how our concerns overlapped — lite-on mirrors, fire, spectrums, nature meets glamour, fetish, the playing of parts, etc. When AA returned to GIHQ, I received a letter shortly afterwards, informing me that I was a finalist in the 1971 Miss General Idea Pageant at the Art Gallery of Ontario. I posed for my documentation in a 1940's gown, holding the hand of the spirit and colour dot. The judges were current moguls of Canadian Art: Dorothy Cameron, Dennis Young and David Silcox. The announcement that I had been crowned Miss General Idea 1971-1983

caused Dorothy to fall off the stage. Mario Amaya called the evening the first Surrealist Event in Canadian history.

The Decca-Dance was probably one of the most elaborate and baroque performances in the recent history of the Eternal Network. This occurred in February 1974, but was a year in the making. It involved advanced discussion, planning and input from two continents, which culminated with approximately 30 artists, mostly from Canada, performing in the rather faded deco, but still grand, Elk's Building, across from MacArthur Park in Los Angeles. It was very much "A Canadian looks at Hollywood". We improvised a parody of the Academy Awards Ceremony with speeches, cameo appearances, choreography, and as many props and trappings as we could invent and afford. Completely unrehearsed, the event is still a mystery today, but the genre of communicating new ideas within an established media context became a real connection for numerous future collaborations.

Eight of us got together and founded the Western Front in March 1973. The main hall upstairs is called the "Lux" or rather the "Grand Lux". It is a direct reference to an outrageous chapter in William Burroughs' "Wild Boys". The main auditorium containing the ghosts of the old fraternal order of the Knights of Pythias, former owners of the building, conjured up Burroughs style connotations, and I started referring to the space as the "Lux". The first Lux Radio Play was 'Kind Hearts and Kind Hearst' in November 1974, produced by Peter Gordon and Rich Gold, two San Francisco composers and performing artists who worked at KPFA, San Francisco. The format they suggested for their performance brought to my mind fond memories of childhood "Lux Radio Theatre" listening. The vent and idea took hold and a tradition of radio perfor-

mances began. At first these events would stem out of ideas and situations arising from the Western Front activities, and were primarily collaborative pieces designed as social entertainments for ourselves and friends. The plays have been enormously popular locally and have developed into a particular performance genre. Glenn, Kate, Hank, Patrick, Byron Black, plus visitors like Dana Atchley have been the motivators in this area. Although not founders or directors of Western Front, Hank and Patrick have been enthusiastic supporters, and in-

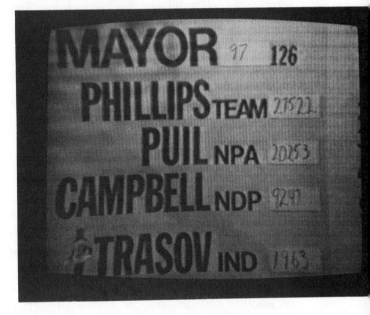

novators of many WF productions.

In no real way has Lux Radio been a part of the larger performance context of my own work. Lux Radio's basis is essentially founded in an eccentric social and regional response to the larger issues that performance art has developed. My own involvement with performance stems from my understanding and stance to the issues inherent within the entire spectrum of contemporary art.

It is my opinion that the Mr. Peanut Campaign for Mayor of Vancouver in November 1974 is one of the most successful, signifi-

cant and sophisticated examples of the artists' ability to assume a role/stance, which, without compromise, captured the imagination and participation of both the public and news media. It gave them a sense of the effectiveness that artists have in our generally apathetic culture. I think the event, a collaboration between John Mitchell and Vincent Trasov, is still relevant, and that it will be eventually reviewed and considered on the multilevels it exists on. In fact, the first critical response to the campaign, in an art context, was in Leisure, Vancouver Sun, October 8, 1976, where the performing arts' critic Max Wyman quotes Tom Fielding, of the BC Cultural Fund.

"When, if ever, was the arts part of any political campaign? The only specific involvement in this city (Vancouver) I can remember was when Vince Trasov as Mr. Peanut ran for Mayor to prove that politics was really an art form."

I prefer to think of reviews or critical reactions in terms of the news media as being an art form. This kind of news coverage gives an added authenticity to an event that far surpasses the best critical reactions, which, as far as I'm concerned, don't exist in Canada, and are still in a very uncertain stage of development anywhere. Since 1963 I have classified all art news media and writing as "Mondo Artie". After all, the modern, or maudlin, is a myth, handed down to us from the immediate past, when, even if its significance or message is recognized, its ideals and relevance never affect the public until long after the concerns have any relevant applications; e.g., the work of the Bauhaus is testament. Their ideals were popularized as styles and created the whole consumer media industry.

I feel personally that a lot of performance

does not fit comfortably into an audience situation. The 24 hour performance of Clive Robertson, playing the part of Joseph Beuys, where the audience is involved in the last hour only. Documentation plays an important part in the work, which is often highly introspective and personal.

Performance art is different from theatre, even street theatre and living theatre experiments. It is its own form and requires enormous sensitivity on how one approaches communicating, whether one is performing or producing performance works. It is genuinely an art form that entails time and a variety of opinions. There will be new and exciting forms of creativity. Hollywood gave up the star system 20 years ago.

GLENN LEWIS:

PERFORMANCE ART does permit you access to everything, the whole gamut of what is available to us. You can make direct reference to art, to history, to sociology, to anything. Performance is a way of presenting things in a contemporary context. You can actually get into various kinds of formats or information that people do understand because it is similar to the particular culture we live in. I'm personally elusive and a bit all over the map but I think it's important to realize, in terms of the whole phenomena of performance art, how wide a field it can encompass.

Primarily, performance art is real and immediate. If you look at political figures, all we know about them sometimes is what they've written — what was Lenin like as a performer? He was probably an extraordinary performer in front of the people. Is he remembered because he inspired people with his words or with his actions? Was it a

combination of these things? As we get further back in history we have less evidence of what great leaders actually said; they are remembered simply because of their exploits and leadership — their performance. This is the phenomenon of performance. As you get further and further back, it becomes mythology.

The whole impetus for change or revolution goes along at a certain pace, and I think it happens on all kinds of levels in all kinds of ways — the women's movement, gay rights, in art, in politics, legal reform, the ecological movement, etc. There are so many avenues; I don't think any one person has a handle on it. I think the arts are more and more committed to social change. The fact that I do performance involves me more with everything that's going on in the world.

Part of performance activity is to keep certain things alive and also to investigate new ways of dealing with current phenomena. It questions a lot of assumptions about art. That's why the audiences are generally small. There's no way to go back to old art situations; you have to reinvent the situation and that seems to be part of the artistic content. Philosophically, the question that artists ask themselves, particularly performance artists, is how can you reinterpret the function of the artist in a contemporary society. There are very set positions about this — there's the marxist positions and fascist positions, etc., that relegate art and artists to certain limits. In spite of these views, the artist does preserve the possibility of freedoms or liberties that the artist wants to investigate even though it may run counter to what the general public's current idea of what art is or what is relevant.

Like everything else in our cultural process, art became specialized. It had something to do with the way language has been treated — the whole idea of specialization. There were painters, there were sculptors, just as there were plumbers, carpenters or masons. Artists specialized in one particular aspect of art. In a primitive society specialization would take place on a much broader level — as an 'artist' rather than a 'sculptor' for instance.

The primitive artist probably didn't even think of himself as an 'artist'. He was just a member of the community and he somehow, either by birthright or by some process of discovery, was assigned that broad responsibility. The products of his labour, perhaps totems, would have some particular function within the society, magical or otherwise. The Hopi, for instance, have some highly developed functions of this sort. Tribal dances were definitely dance, but they were a ritual and a performance. They wouldn't have conceived or something as separate as ballet or theatre although these things developed out of tribal dance and storytelling. In Java, for instance, there were shadow plays which involved displacement. The shadow play (shadow puppets) is the most ancient form in this country but that is not because it is more ancient than dance or movement, but because it embodies the most ancient remnant of their dance.

The present day dance in these places has changed or evolved away from the original forms which have died out. The plays enact a ritual but they are also a way of dealing with an audience — a community event. It is like going to the movies or watching TV. It's an attempt to reiterate the rituals and the history — that whole group consciousness — in a certain kind of performance. This is really the common ground of performance art as opposed to theatre or dance or those kinds of specializations.

Right now, in the latter part of the 20th

Century, there is a lot of archeology going on — not only archeology in the ground, but archeology of language and all our cultural modes. It may be that as we are approaching a particular period in our history where a lot of primitive cultures are being wiped out, we are making an effort to understand and to learn from what has gone before. It's indicative that when the primitive Tassadays in the Philipines, who had never seen a civilized man before, were discovered, it was big news, world wide. Maybe we are entering that period, I

hesitate to use McLuhan's term, of the global village, where we are responsive to small events in the remote jungles of the Philipines, just as we were to the next door neighbour's gossip. This archeology is one of the motivations behind the effort to get back to the roots of performance and those kinds of art experiences.

Painting, per se, perhaps doesn't satisfy that urge. You see painters going to extraordinary lengths to overcome such problems as the 'edge' of the canvas and the two-dimension referential value to something else. Stella, for instance, in his new work,

makes an incredible effort to 'paint' (build) works that are self-referential, objects that stand on their own feet — huge things that are trying to leap off the wall and run around in gaudy costumes. They don't quite perform these turnarounds like some mechanical Tinguely but they are an attempt to create paintings that have a 'real' life of their own. It's quite a performance, but it is still beyond the real life experiences of most people and has been staged within the art marketplace.

There are pressures that arise in societies, in our society, for changes. There is an effort or movement to put things back together again. Rather than specialization, it's an integration. You see it in the 'New Philosophy', you see it in the whole ecological movement. You see it in a whole lot of things, where you can't divorce a decision in one area from one in another. The wisdom of the primitive, of course, is that his view is a comprehensive view; it takes everything into consideration. In order to live in the world, he has to have a pretty accurate feeling for what is going on around him. In the same way, performance actually permits you to deal with a lot of different things at once and speaks for that wholeness.

Performance art is a kind of hybrid without a large developed audience like theatre yet.

Performance can deal with repetition, which you don't usually get in theatre. A repetitive sequence might be closer to music. The performance artist might use a structure out of music in a movement sequence of some sort. You do get repetition in dance also, but in performance it would not be "dance"; it's not what you would expect in dance. It might be akin to dance more than music but in fact it's more like soap opera with choreography in some respects. Choreography, as a word, as a

language term, is associated with dance. A lot of the problem with the definition of performance art is language. It's a very visual thing. It's like trying to describe the history of smell. We do have a lot of terms for visual experience but we don't have them lined up in the right kind of way to describe or define performance — such as, 'body art', 'the choreography of the eye', or 'the dance of the mind'. You can say that, it does provoke a certain kind of image or synapse, but a language still needs to be developed that will adequately describe the operations in performance art. That's why I think it is instructive to look into primitive ways of dealing with the phenomena of the whole — performance. Performance art, as such, has more to do with the celebration of life than the history or life of art. It may be impossible to define performance art in general ways and I think it would be undesirable. Personal definitions are what count.

The precursors to the present day performance art — the Surrealists, the Bauhaus and Dada — must have looked at primitive 'art'. Picasso certainly did.

In my recent pygmy performances, I was very concerned about the whole anthropological and primitive base of performance and art. I think it is an important area and it deserves attention. At least I was concerned about it, so I thought other people might be interested in it if I brought their attention to it. I always operate out of my interests and obsessions. I wanted my art to be in this kind of context. Trying to look like a pygmy with shortened legs was the theatrical aspect to the event. People found this amusing and I knew they would. But this is my character, how I relate to the world. I often relate to it humourously. It's a personal statement. It's my way of dealing with performance.

A friend, Diane Philips, who was visiting at the Western Front, once told me that I looked like Hitler. I was astonished, but to prove it, she got me dressed and made up. I did indeed look rather like Hitler. I even assumed a fractured German speech — "luddle rude rotting hood". At that time, I was also receiving correspondence from Greg Michelenko, a friend who was teaching mycology in Zurich. He wrote to me about the oddities there in a hilarious fractured German which I used as my model. It was as if he were my secret agent in Zurich on the Eastern Front. As Hitler, I

walked about, presided at functions or gave speeches. I was simply imitating the visual aspects of Hitler that were available in photographs of him either giving speeches, striding around, sitting, or looking relaxed. It was amazing how my appearance as Hitler was immediately recognizable to people. Some people were quite upset with this image, especially in Toronto at the opening of the new Henry Moore wing at the Art Gallery of Ontario in 1974. Rather than espousing fascism, I was attempting to expose the benevolent fascism at the Art Gallery of Ontario, which has had a bad record on showing living Canadian artists. Those people who were upset with my image felt that it was still a threatening one, when the fascist image in our time would be a grey flannel suit, like Richard Nixon. It also showed the power of the image in the reality of performance.

The Western Front has been very important to my performance work and its direction because of the possibility of collaboration, the use of equipment and space; but most of all, it is a place where I can live my art. It is a place where performance tends to merge with my living situation. Much of my performance and that of others has come out of this playful relationship. For me, performance is an art that permits me to get closer to the realities of life.

ERIC METCALFE:

My whole idea of art in the 60's was fairly traditional. I loved drawing. I liked listening to music. I had a lot of early starts, but it wasn't carried through into my idea of art at that time. I do now. I think I got into performance art through making my wooden and cast saxophones. I didn't know it at the time. I didn't know where it was going. I used kazoos in the mouthpiece of the saxophones so I could sing into them — my jazz interest. It seemed that I should do something with that. My first opportunity to exercise it was the F. Scott Fitzgerald Tea that Glenn Lewis organized in 1972. Those were the beginnings of my performance. Of course, in hindsight, now, I think my instincts were right. I really couldn't say why I was doing it at the time. I don't think I said, "I want to become a performance artist."

Audience is important to me. I don't mind rehearsing but I save my energy for the final thing — the audience. I've had a fair amount of experience in the last few years since '73, since the A Space performances, and the Deccadance in Hollywood; every year I've done something, so I don't have stage fright anymore.

If an audience is excited about me, if they are excited about my personality, and the other performers' personalities, they are learning something about me and the others, as people — it's like charisma. Some people *have* charisma.

Glenn Lewis: The audience is getting something of and from the person. The performer exposes himself, is vulnerable, in a sense. You're giving yourself; you are not giving a product of yourself.

Eric: I think some people (the audience) would like to perform but they don't quite know how to do it — they see something in you. They don't have that type of projection down. They may do something else better. I wish I could write well, for instance. I don't see myself as an actor. I've been influenced by the Las Vegas scene in my sensibility toward performance, by people like Dean Martin and Frank Sinatra — those types of guys that have a slickness to them. The Dr. Brute things I've done, especially, are parodies of Sinatra and the others. I like the idea of communicating. I don't see that

278

much difference in my work between performance and the popular entertainment. Maybe one could say I'm a frustrated Las Vegas star but I'm doing it in an art context.

Glenn Lewis: Maybe there isn't really any distinction between painting and illustration. We've built up a distinction in our culture between painting and what is called 'commercial art' — it's our historical process. In Japan they didn't make that kind of distinction. The commerce of art, somewhere in the background, probably has a lot to do with our distinctions.

Eric: The Western Front was a bit like my finishing school because it enabled me to do all those things in performance that I wanted to do. There were large spaces, backup, and the people that I was meeting. It all became possible. The things that Vincent (Mr. Peanut) and I did, exposed me to the possibilities of collaboration, although Vincent's experience was probably quite different than mine in those performances — he was in a nutshell. The performances we did in Hollywood and his Mayoralty campaign performances helped me get my performance style together. It was a real experience walking around in my costume. It got me over my self-consciousness very quickly. It put me through the other end of it. I was into costumes when I was a kid, but in my teens the whole thing of conformity, being like Jimmy Dean, wearing a certain type of suit, became very important. You lose touch with all your childhood fantasies. You are suddenly told that you have to get a job, go to college, etc. It's such a fragile time and most people, I think, get processed at that time. They never get a chance after that. It's the kiss of death — they're dead men walking. The vitality of performance, on the street or elsewhere, put me back in touch.

The minstrel shows in the early jazz times

interest me. They were the forerunners of vaudeville. A lot of my inspiration comes through my interest in jazz, first of all, which is an interest I've had for some years now. That's been my resource material. It's an historical, uniquely American thing. The minstrel shows were mainly travelling shows. They varied from song and dance to skits, to telling jokes. That's my source of inspiration — that sensibility — a sort of cabaret-vaudeville. I think that all the artists that I've worked with have influenced me — from General Idea, Glenn, Michael and Vin-

cent — but the jazz and so on, is my own trip, and so is my Dr. Brute image.

I think our kind of performance at the Western Front has had quite an influence on other performers — mainly in Toronto. The cabaret format has been adopted by the Video Cab people, for instance. We started establishing that format in '74 at the Amy Vanderbilt Valentine's Ball and in some ways at the Deccadance. I also did a solo performance in Toronto with a professional pianist before that too. It was probably the best performance I've done. People went

279

crazy. I was only up on the stage for six minutes.

I'm thinking about doing some solo things by myself now. I'd like to do something with underworld figures that I'm interested in. The performance I did of Howard Huge playing with the airplane on the video tape, "Spots Before Your Eyes", was like that. I'm interested in extremely eccentric behaviour, studying eccentric behaviour and actually becoming a part of the eccentric, even more so than I am in my own life — like 'the toot-a-loonies' that Jane and I perform in 'Piranha Farms'. I'm very close to that kind of behaviour. I love those performing non-artists you see on the streets, like that woman who walks around on the street in Vancouver with her head up in the air. I think that is the most excellent, excellent performance. It's so totally extreme.

Glenn: I think we are living in a very theatrical age. People almost see themselves in the theatre all the time. The punk phenomenon is like that. It's a theatre of life. All Eric has to do is walk onto the stage holding a pair of binoculars and it's funny. He doesn't even have to do anything else; it strikes a chord.

Eric: Sinatra and Martin play off real life situations. It would be too precious to suggest that they had a tradition in the same way as music or theatre have a tradition. They're tough and they act out their fantasies. They're brutes. There is an edge to their behaviour that I find fascinating. I find this much closer to performance art — at least, my view of it. There's an edge in performance art sometimes where you are not sure whether it's real behaviour or not. It can be quite insane. In theatre, you always know they are acting. In performance you can almost push yourself to a state of frenzy or trance. You let yourself go completely. That's what I do. That happens before you

are processed. Theatre is fine for what it is but there is a sense of processed work, above all, in operation. You become an actor in repertoire for the rest of your life.

Howard Hughes interests me more than Duchamp. I find him a more interesting character. Duchamp was a brilliant man. They were both of the same period. Duchamp interests me, of course. His dress-up photographs as Rrose Sélavy and the shampoo images were fascinating performances. I'm interested in Howard Hughes because he made far more interesting works with his money — like the 'spruce goose.'

HANK BULL:

I DIDN'T KNOW ANYTHING about performance art until I'd been doing performance art for several years and then I realized that there was a thing called performance art. I became aware of it when we started doing radio plays and HP performances. I thought of it as a conception beyond art, which is something I aspire to. I wanted to get beyond the art world, beyond the bureaucracy, beyond 'art speak', beyond talking about art. Art is not a career for me. Art is more a way of life and performance gave the best opportunity to deal with it on those terms.

I came to Vancouver in the fall of 1973. I'd been playing in blues bands in Toronto and I wanted to get out of that scene. I got out in Vancouver, sat on my trunk, looked in the newspaper and found a fabulous room. I went and booked the room; it was gorgeous with a big picture window overlooking the harbour and mountains.

In the same paper, I noticed that the Vancouver Art Gallery had been painted over with leopard spots by Dr. Brute. I got on a bus and happened to be standing right

beside him — just by chance. I had met him once before. I gave him the newspaper and showed him the picture. He was totally delighted and invited me to a party that night. I came to the Western Front and it was the night of the Von Bonin dinner. It was organized for Dr. Von Bonin, a woman from German TV who was doing a special on Canadian art. The Western Front decided to show that art was life by throwing a banquet for them. There was this huge groaning board surrounded by Kleig lights. People were mainly passed out by the time I got there and ready for stage 2 of the party.

I followed the hoards upstairs to the Grand Lux where there happened to be a grand piano. I moved over to the piano and started to play. The room was dark, and as soon as I started to play, a spot light came on and Dr. Brute appeared in leopard skin regalia and saxophone. It completely blew my mind; I'd never seen anything like it. I just happened to be playing exactly the kind of music he liked. Then Mr. Peanut came out and did a tap dance, and it was as if we had rehearsed it, but we hadn't rehearsed it, and German television was filming the whole thing. That was my introduction to performance art.

Eric was totally blown away and I started coming around every day. We rehearsed and went to Hollywood to do the Deccadance with the Brute Sax Big Band, six months later. I had helped Eric make the saxophones and all the music for the Deccadance. It was interesting how the Deccadance was almost made up on the spot. The script was written in the afternoon and performed at night. My performances have almost always been situations where the script is written no more than a couple of days in advance.

I've always detested theatre, I don't like rehearsals; it makes no sense to me to rehearse something twenty times and perform it for two years over and over again. We have rehearsals, but it's loose. My ideal performance is one in which the performers know ahead of time what it is they have to do. They show up and do it without any rehearsal, perhaps without ever having been assembled before. It would be as much a surprise for the performers as for anyone else. It's a one time thing and that's it, it's over. I like the way the CCMC works that way. They have a format which allows them to be completely different and do whatever they want every time. I would like to achieve that in a more theatrical sense or in a visual way.

I've always done performance in collaboration with other people. In the first couple of years at the Western Front, I helped intensively with whoever's performance was happening: General Idea, Dana Atchley, Willoughby Sharp, Mr. Peanut and all the people at the Western Front. I really contributed a lot and got off, and that was, in a sense, my education. It's a continual education.

Patrick Ready and I, who are old friends, corresponded a while through cassette tapes and when he moved to Vancouver from the mountains, we started our work called 'HP'. He is a combination adventurer, writer, working man, academic. At one point in his life he wanted to be a poet, but then he got to the point where he couldn't stand poetry. When we worked together, it was as original as his life had been. It wasn't with any concept of it being art. It was done with a kind of militant unprofessionalism. We first started working together through correspondence. We'd write exquisite cadavers back and forth — cassette stories with breaks in them that the other person would have to fill in, or a continuing story that each of us would add to. They were wide ranging

stories, a kind of Burroughsian, sci/fi, technolgical time travel sort of thing — quite dada. HP was a trip where we invaded a format. We invaded the format of the HP bottle label. The first project was to redesign the label for the HP bottle. We went around to department stores and put our new HP bottles in place of the other HP bottles on the shelves. We mailed the labels out to our friends and told them to paste the new labels on their HP bottles.

For a C.B.C. production about art in Vancouver, in May '74, Glenn Lewis and Gerry

Gilbert decided to do an art race, where all the artists would dress up and have a race. For that, we designed the HP sedan bottle which was a sedan chair in the shape of an HP bottle, painted black, with no windows. The rider viewed the outside world through a periscope. H and P carried the sedan bottle. The man who resided in the sedan bottle was the mysterious third man. He was the agent of collaboration so that neither H nor P actually had the idea but this mysterious third man, who lived somewhere in the space between, actually did the work, got

the ideas and got them off. We went to see this movie — the Three Musketeers, and they had sedan chairs in the movie. It was very appealing because it was such a ridiculous technology. Ridiculous technologies are very dear to our hearts. We designed the sedan bottle as a solution to the transportation problem — no smog from cars; it used up the employable energy of people. It was a civilized way to travel.

The sedan bottle hung around in my apartment afterwards and it took up a lot of space, so we decided to blow it up with dynamite. We made a movie of that which was a palindromic film. It, theoretically, could be run forwards or backwards. The sound track of the film told the story of the third man and talked about collaboration. The bottle, in the movie, imploded from nowhere, the third man emerged from the bottle, summoned HP to carry him around. He got pissed off with HP, sent them back into the bushes and then was blown up at the end of the movie. The moral of the story is that collaboration is a difficult task. Collaboration is always seen as a bit of a myth. It's never held up as an ideal that you totally believe in.

We also started doing radio plays. The radio plays started in the middle of the night as an obvious application of our cassette stuff. Patrick and I realized that we should make a radio play. We wrote one right then, in the middle of the night, and performed it. It became evident that with radio it's very easy to empty the ocean or travel to another planet, whereas in film it's quite difficult and expensive to do those things. It was an absolutely chaotic performance which was an embarrassment at the time. But for me the performances that don't work, that are totally odd are those that I look back on with the warmest memories — like the camping trip where it rained every day. Out of that per-

282

formance came other Lux Radio performances with a regular troupe of people and energy — Bill Little, Opal Nations, Bob Amussen, Suzanne Ksinan, the Soni Twins (Glenn Lewis & Kate Craig), Marybeth Knechtel, Patrick, Warren Knechtel, Donna Reeve, Richard Harper, Randy and Berenicci, Robert Amos, Eric, lots of people. The Lux Radio productions were done live and usually at the Western Front where a tape would be made; a four track tape that would later be mixed and aired on Vancouver Co-op Radio. We'd never had any experience with radio before then.

One of our HP theories (which came from Don Davis, the one-man band at the Deccadance) was 'Total Media'. It was a new idea of the Renaissance man. He said Andy Warhol was nowhere because Don Davis had everything — writing, music, all instruments at once; sculpture, books. It was true. He designed covers for his own manuscripts and songs. He just did everything. It was a very strong hype. We liked this idea. You didn't have to be a professional. You didn't have to go through certain specialized channels and then become expert in this area or that area. You could become an expert in all areas on an ad hoc basis. If you wanted to make a movie, you just *made* a movie. The important thing was to get it out. Professionalism really means dedication. You profess to do something, namely, really believing in what you are doing. That's all that is required to be a professional. I reject any sort of authoritarian definition of professionalism.

As HP, we later did a regular broadcast on Vancouver Co-op Radio — 90 minutes a week for two and a half years without a rerun. That took us up to the spring of '78. The concept for the HP Radio Show was Filliou's, 'Games at the Cedilla', which was, basically, that it should be funny. If you are

going to do it, make it funny. It was also an idea of his about a network and his idea that everyone can be an artist. We broadcast as if everyone was an artist. We didn't do esoteric highbrow stuff. We did stuff that a truck driver could relate to. When you're talking about the world, you don't want them to change the station. It was quite possible to do that without compromising anything. In fact, when it came to the crunch, you could present quite esoteric material and people would love it. For instance, David Rosenboom's brainwave

music went over fabulously.

I don't think too hard about what I do. You obviously spend a lot of time reflecting about what you do but that's different. That's one reason why I gave up painting. I'd studied the history of painting, I sat there in my studio and tried to figure out what the next move was in the history of painting, and it was impossible to do anything. We discovered some great things in the history of radio — Bob and Ray was a great discovery and some of those old radio shows were wonderful examples of the

medium, but radio was free from those kinds of ponderous aesthetic ideas.

At the same time as the radio shows and the radio plays, we started the shadow plays. Our first formal performance was done at the Western Front in December 1975. At the end of that performance we unveiled our performance sculpture, the tesla coil. It's a large electric discharge device which sends lightning bolts into the room and causes fluorescent tubes to illuminate of their own volition. Patrick has an engineer's mind which he applies very well to these things. The shadow plays were also very much an application of technology in as much as there were folding screens and ingenious moveable cut-outs and others things.

We were conscious of the Balinese shadow plays. Martin Bartlett was quite interested in them. Shadows gave us the opportunity to create dramatic effects with minimal means. Like radio, it was possible to depict incredible events travelling through the universe at high speeds with minimal means. It was also a collaborative thing working with Patrick, Kate Craig, Glenn, Martin and Josephine Rigg to bring these works together. We have done three shadow plays — the HP shadow play; *Faustroll* in March '77, which was an adaptation of Alfred Jarry's novel, "The Exploits and Opinions of Dr. Faustroll"; and *Visa Vis* in May '78, the most recent shadow play. Jarry has been a heavy influence on HP. His ideas on theatre are very much our ideas on theatre. His idea of pataphysics, a science of impossible situations, is where we want to be. He was a real outsider, original and not the least bit interested in the academic aspect of what he was doing. It's the philosophy that's interesting, not the art history.

The bicycle generator performances use a bicycle to generate electricity. We made a performance with our bicycle generated movie projector about three years ago at A Space in Toronto. It was part of an exhibition called, 'the time dilation machine'. This bicycle was hooked up to an alternator that powered a little regular 8 movie projector. There was so much friction involved — we had built the thing by ourselves — it was a cumbersome item and not as efficient as it could have been. We had to use a tandem racing bicycle for two riders. There was a team of six different cyclists who would peddle their hearts out for 30 seconds before changing riders. It was like a sprint and was extremely exciting. There was a lot of shouting and encouragement. People were steadying the apparatus so that it wouldn't fall over. The effect was that everyone in the crowd watched the bicycle and the generation of power and nobody paid any attention to the movie.

The Religion Canada performances I've been doing lately are new for me, in as much as I'm the spearhead of the performance. Usually I'm not, I'm the support structure. With the new HP imperialism which posits Patrick in San Francisco I have to run the Vancouver office by myself and although Religion Canada has been on HP files for a long time, it's my baby at this point. The religion thing had various origins. My father is a minister, so I'd always thought about religion. I lived with it. In many ways, my interest in art was a transference of religious ideas because religion wasn't working for me. You would try to get in touch with God but it just didn't seem to make much sense, whereas it was much easier to see the religious content in art. For example, Kandinsky's book about spiritualism in art was a big influence. So was Van Gogh. Religion Canada came out of that "personal" history and also out of a light-hearted attempt to glean money from Canadian content — the idea that religion is a good way to make

money from the Canadian government as well as from the contributors who send in their money. Religion Canada (RELICAN) was designed as a kind of imperialism or big corporation which offers you nothing. It's an honest religion. We don't try to trick you; we just ask for the money. Any money that is sent in will be turned back into Religion Canada products and miracles. To make things simple, I am the Great Homunculus of Religion Canada. I'm the God, for lack of a better word.

In the last Religion Canada Performance, April 1, '79, the Gina and Gary wedding, I was introduced, made my appearance and told people that we basically had nothing to offer, that they would have to enlighten themselves and the only thing that we would enlighten them of, was their money. To prove that, I enlightened myself with a block and tackle. I hoisted myself up in a harness with a block and tackle, pulling myself up which is something of a miracle — that block and tackle technology. I was in a situation of levitation. It proved that I was supernatural. This was greeted enthusiastically as a miracle, indeed. We brought the choir in at that point in a '79 Thunderbird, courtesy of Arnie Winrob. It was covered by about 30 women from the 'Girls Club' which is a very exciting new group. They came in howling like banshees all over this car, dressed in pink raincoats. We also had numerous bachelors in black suits who carried the love boat onto the set, a sailboat full of flowers, resplendently decorated by Paul Wong. The love boat was hoisted up on end, standing on its trasom, so that it looked like a church window with the bride and groom standing in front of it. With most weddings, people either feel like they've been married for a couple of months before they get married or, in many middle class situations, they get married but they

don't feel married for months afterwards and maybe never do. With Relican, they know that it is happening to them. We do this with the tesla coil. In Gina and Gary's wedding, they were physically wedded. The lights were turned out, the tesla coil was turned on and the room filled with 200,000 volts of static electricity. The marriage couple stepped through an archway of fluorescent tubes, glowing of their own volition. That was the marriage.

I'm not into bending reality to my design. In terms of my future, I don't have a big

game plan worked out. I want to subvert my career, it I had one, at every opportunity.

If you are dealing with theatre, you are dealing with the theatre tradition. I'd have to deal with the architecture of theatre, the high budget economics of theatre, compared with my life, and the history of theatre.

Performance art, to me, is something that scraps all of that. In General Idea's performances, there is a very conscious distancing from the audience, as opposed to a tendency in theatre to get close to the audience, to

285

move them emotionally, which I find embarrassing. It's extolled as the greatest virtue of theatre — that you have an actual live person in front of you that could do anything, including fall off the stage, and that's supposed to make it exciting somehow, but personally, I can't deal with the intensity.

I look forward to an opera that would be a total media opera, that would be a wedding of science, and art and theatre — in the true operatic sense of combining everything in a truly spectacular thing. This opera would take place in 1984 and would run through the gamut of emotions. It would be heavy duty. My ambition is to play La Scala because those old guys have been in there long enough.

MONDO ARTE AKTION MANIFESTO

in Pigmy Adlib Lingo International.
by Hank Bull

HISTORIA/HYSTERIA/HISTRIONICS

Magnae performae in historiam: Homer, Barabus, Napoleon (schizophrenics), gladiators, danse voodoo, mummers, doctors con stilleto, le Petomain, Harlequin, Piero, Vincent Van Gogh trompe de l'oeil coup de scimitar (cf. Beethoven nein audio funktion). Beau geste as international language. "The world's a play and we mere stages in it." Shakespeare.

Aujourd'hui Weltenschauung: Populus Performus. XXieme siecle tiempo nova bambinos de radio, fotographia, film, TV und gogo tutti quanti on stage cum (COUM) Kojak, les nouvelles and catastrophe natura. Zeitgeist: Paris '68, Teheran '78, Angola, Bangkok, rock'n'role, Wounded Knee, Khamer Rouge. Voici bizarre spectacle (extra) terrestrial accident coda con tempesta forte forte. Presto! Politico, epistemologico esoterica mysterioso. Art, ergot, cogito. Und cogito plus extra cogito ad nauseam. Argot punk ad nauseam. Ergo kultur virus global. Blitzkrieg, propaganda, polemics, image war.

ARK/ARCHEOLOGY/KIOSK

2 power geni in mondo oggi.
Ein: Big bwana guerro/guns/oil/hydro. "Political power comes from the barrel of a gun." Mao Mao.
Dos:ikons/hieroglyphs/media/porno/polaroids. "verbatum power ex gueules des fakirs, papas und artist." Hank Bull, Religion Canada Homunculus.
Sub historia is image charisma. Deux machines: War machines/macchines celibi. Dos satellite guernica: Sputnik bombe lasers/international TV. Hardcore bombe/Softcore bon-bons. Bombe sabotage/bon mots sabotage. Auto war in la strada/lingua franca war in der kopf. Three little words/Three little worlds.

286

ALORS, VANCOUVER

Wikommen, girls i gauchos ad realite Kanadese, banal, bourgeois. Kitsch aristocrats sans gros ghetto. White devil suburbia $$$$ apathia. In outback jungle montagnes des Inuits, Ojibwa, Kwakiutl nativadad ab origine, whisky, anarchy et poco par poco piano piccolo Indian revolution gogo tres lentement, tres laundromat. In cite no big war. Juste pygmy graffitti (PUNK RULES) Molotov cocktails (drunk workers). Voici milieu pacific N/W d'art performers in Western Front, Pumps, Video Inn, KitKat und Smiling Bhudda Nightclub.

Poets, musiciens, aktors, bandes, ad hoc troupe gang de beatnics on radio, cable TV, in art cabarets und video performance. Capiche comme ci:

1. Conspiration. Toute la gang bar cerveca ganja partytime et sprechen-zie talk-back pense script-girl coup d'arte plan A strategie plot en route. Opera ensemble.

2. HaHaHa!! Drole pun jeu de mots dadakaka kollage stupid toctoc.

3. Anti-Professional. Auteurs amateurs portapak U-turn underground Maquis banditos sans culottes. When everybody is an artist totalitarian capitalism will be destroyed by a spontaneous combustion of the cultural unconscious. Happening now?

4. Nobody capiche. Savez? Cette art brut bueno pour tutti famiglia, grande mama and bambino. Nobody capiche/tutti gogo jumping on stage. Olé? A OK? No good? No bueno?

X _____

PERFORMANCE IN NEW YORK
Towards the 1980's

Peter Frank

THROUGHOUT THE UNITED STATES, but especially in New York, artists have been reassessing their use of fashionable media. The heretofore irresistible allure of video, film, performance, installations, and even artists' books and periodicals has dimmed somewhat. All these popular formats are still being examined and exploited, but few artists continue to pronounce them as the only viable media left. In fact, there is a growing body of artists, younger and older, who create paintings and performances, sculptures and films, and/or prints and books with equal emphasis and concern. This indicates a healthy re-examination of what performance, video, books, paintings, etc., are: nothing more than *available formats*. Artists are becoming interested in aspects of aesthetic communication beyond — or at least in addition to — the purely formal, self-reflexive aspects of their work. This can be interpreted as a resurgence of content in art, but it is more complex than that. What it is, at least in part, is a loosening of our formalistic appreciation of modes and media as movements (e.g. Video Art, Performance Art, Book Art). The medium is no longer the whole message, but just a part. As Douglas Davis insists, the video camera is equivalent only to a pencil, not to a manifesto.

Thus, there is an increasing perception of the performance format as just one possibility or cluster of possibilities among many media. This perception has led artists to explore the modes that exist *between* media.

This exploration, in turn, has renewed interest in the earliest, heavily intermedial performance styles: Happenings, Fluxus, visual and sound poetry, and the expanded and blended modes of music and dance introduced by revered but still not fully understood figures like John Cage and Merce Cunningham. Artists with backgrounds in the traditionally discrete arts have taken greater and greater interest in expanded-arts formats and potentials: when, for instance, a composer of electronic music becomes intrigued more by the gestures of dancers, theatrists, and performers than with the continuing purity of electronically generaged sound, that artist is now more likely than ever to seek a synthesis of his or her native medium with the other, newly attractive media.

The versatility of a single creative individual among several media is nothing new: "poly-artists" (to use Richard Kostelanetz's term) have existed at least since Michelangelo. What *is* new is the desire of multi-talented artists to apply their various talents to the invention of a single, unified artwork. This desire has been infrequent enough among European artists until now, but among North Americans — especially those working in or oriented towards the New York scene — the idea of aesthetically heterogeneous works of art has been a heresy against the formalist strategies predominant in all the arts in New York. This pertains no longer. In the late 1970s more and more modes and media are available

to more and more artists. Or, perhaps I have it backwards: more and more artists are available to more and more modes and media.

New York being the style-conscious marketplace that it is, artists are fusing the media one medium at a time. Each year there is a surge of interest among artists, dealers, curators, and critics in a different single possibility. This began with the introduction of video at the end of the '60s, continued with performance, focused recently on books, and this year promises to concentrate on music. Artists have been incorporating music into their static and kinetic visual works for years, even centuries, but artists are now singing their own songs, playing instruments, and even producing recordings and radio broadcasts. What differentiates this current development from past coordinations and blends of sound and image — ranging from grand opera to experiments in synaesthesia — is that neither sound nor image play a role secondary to the other. Artists who take up music in the current climate are not playing Ingres's violin; they are incorporating music as a formal and contextual element, even focus, in their static and performed visual work. The most prominent example — or grouping of examples — of course is the metamorphosis of artists into Punk rockers. Unlike the jazz-playing artists of the postwar era, artists involved in Punk rock do not consider their music a sidelight to their artistic activity; they see it *as* their artistic activity. With performance now established as a fully legitimate medium for artists to practice, Punk is a logical form for artists equally concerned with sound and with gesture to adopt. Sound is gesture in Punk, and stance (political, social, aesthetic, fashionistic) is sound.

The exploration of music as tool and substance by visual-performance artists goes well beyond Punk (just as Punk's ramifications go well beyond art). More standard musical forms such as rock and roll, jazz, and classical styles are finding their way into performance work. Some artists incorporate "found music" — usually recordings — while others create or commission original sound for their presentations. Performances and installations feature artists as singers, instrumentalists, composers, and/or lyricists, either central to the content of the performance or, like opera, peripheral to but supportive of the visual and verbal activity.

Interestingly, the tradition that exists in all forms of music of performance by ensemble seems to be influencing the shape of current performance art, whether or not the art actually incorporates music. The Happenings and theatre pieces of the late 1950s and early 1960s normally featured more than one performer, but more recent performance artworks tended to feature only the activity of a single person. This "emptying of the stage" resulted from the influence of Fluxus — its intimacy and its emphasis on the interpretive involvement of any individual who beholds the verbal or graphic "score" — and the even more pervasive model of "classical" Conceptual art, with its Minimalist rarefication of form and gesture. The solipsistic orientation of Body Art and autobiographical art can be seen as the end product of single-person performance. Of late, however, performance artists have taken renewed interest in ensemble presentations, despite the difficulties — personal and economic — involved in coordinating people. Not only music, but new theatre pieces like those of Robert Wilson and Richard Foreman have provided formal and contextual models; of course, there is also the historic model of

289

the Happening.

The introduction of music into performance art and the growth of interest in ensemble performance structures, like many other established and emerging phenomena pertinent to performance, are occuring in other art centres besides New York. However, as a New York-based commentator, I can assure you only that these phenomena are manifesting themselves as I have described them in New York. I should emphasize as well that these phenomena, and my analyses of them, are at once larger and smaller than any of the artists to whose work they pertain. I have not singled out any New York performance artists as examples of music-users or ensemble-organizers so as not to pigeonhole them, nor to give an imbalanced idea of the shape or scope of the phenomena themselves. All noteworthy New York performance artists are creative enough to use — rather than be used by — the ideas of music-in-performance and ensemble presentation, and such artists continue to produce unmusical as well as musical, and solitary as well as group, events.

New York, September 1978

AUTOMATONS/AUTOMORONS

AA Bronson

HERE IN TORONTO, surrounded by the signs of an affluent, middleclass and self-satisfied culture, fed by the enlightened, if contested, patronage of the Canada Council, our artists wander, cultural zombies in the land of the living dead. Touched by the fever of perverted eroticism, inverted rationale (called 'sensibility') and the sibilant persistence of social relevance, they career through the bohemian-machine of Toronto's artist-run institutions, meeting expectations like modern kids must with oedipal parents: schizophrenically. Experiencing culture in Canada has always implied the voyeuristic. We experience through the media what the rest of the world takes for granted as reality. Through the applied eye of our television sets we see music, art, film, current events as a succession of fictional events, silent-movie classics impersonating reality. Or is it the other way around? Are we the silent movie masses performing to the instructions of an invisible Cecil B. DeMille, the United States itself?

As artists, as individuals, our sense of reality is unfixed, decentred, eccentric. One thing could just as easily be true as another. Thus we are the suggestible zombies of which I write in this article, ambisexual, ambimoral, catholic in our experience of life: it is important that we meet all value systems set by the outside world, or that we *think* the outside world might set. Hence we are socialistic, yet capitalistic, humorous, yet serious, big hearted, but practical, intellectual, glamourous, and nice-as-pie. We are zombies. We have moved beyond beat alienation and hip pseudo-involvement to exist quite happily, thankyou, in the land of the creatively comatose.

In the last few years writers have been discussing autobiography and narcissism in contemporary art, and now they are writing about eroticism. Each of these themes is but an aspect: the artist is interested neither in story-telling nor confession, but rather in a slow transmutation of the artist himself into an animated object, a machinic conjunction (hence disjunction) of sounds/limbs/histories meant to be observed. This year eroticism too will provide tangential access to the trance-like state of the contemporary artist, onto the *surface* of his desire.

As the micro-politics of our capitalist lifestyle forces each of us, each part of our bodies, into productive, co-ordinated machines, then there is a natural byproduct. The flip side of the Ford fantasy (computerized or not) is the desiring machine automaton/auto-moron.

Perhaps it is our generation's experience of reality through the television set that has set in close union performance and video. With the support of the Canada Council and a long history of performance involvement, it has been possible to act out the theories about which artists in other countries could only speculate.

Canadian artists leapt into the video/performance conjunction as early as the mid-sixties: Intermedia, in Vancouver and Intersystems in Toronto were both artists' groups exploring group-cooperation and technology/performance conjunctions as

distinct relevant workingstyles/lifestyles. Such early groups have long since transformed into the sophisticated schizophrenia of Canada's hyperactive performance/video scene, a scene which focuses particularly at the Western Front and Pumps in Vancouver, and in the Queen Street West area of Toronto.

This article is a commentary on the work of five Toronto artists: Colin Campbell, Lisa Steele, Elizabeth Chitty, David Buchan, and Susan Britton. The comments are not intended as a thorough critique of their work, but rather as an initial definition of a specific genre of activity.

COLIN CAMPBELL

Colin Campbell is not a performance artist. Nevertheless, his videotapes, like those of many Toronto artists, involve eccentric personal performances in apparently narrative structure. In fact, Colin Campbell's last 8 tapes feature himself as the 'star' (sometimes only) performer.

The emphasis on alienated, detached behaviour, which in the earlier 'New York' series reached almost expressionistic heights, has now developed into a more complex form.

In the *Woman From Malibu* series of 1977, Colin Campbell plays the part of a caricaturized middle-aged woman from California. Almost all the tapes follow the same visual format: head and shoulders conventional framing, in which the woman from Malibu looks out upon us, as if into a mirror. Her obsessive monologues juxtapose eccentric detail in lengthy series, not so much to describe either her character or a plot, as to map out the culture surrounding her, as if to see her in negative relief. And with each word spoken, phrase after phrase assembled with acute deliberation, the portrait that is painted is an almost Martian

construct of femininity: the insistence upon, for example, salads in which one finds a strict mathematical (but verbal) order of natural elements in almost Japanese artificiality: one cherry tomato, two squares of green pepper, three green onions, and so on. The salad and the woman from Malibu each consist of a linear assemblage of natural elements added in time . . . a strictly limited vocabulary of gestures and objects: the wig, the lipstick, the false eyelashes like quotation marks, all on the traditional modernist background of white walls and white make-up. Cultural details provide the spots of colour on this flat ground; the Mojave Desert, pony skeletons, leisure suits and Farrah Fawcett-Majors are dropped into the monologue in nasty little anecdotes actually taken from California newspapers.

In the last tape in the series, Colin Campbell is revealed at the dressing table, putting on his feminine guise as he talks. Beside him sits a video monitor showing the desert highway from a moving car window. The artist is not so much revealed as a drag queen, a man in disguise, as he is revealed as a video artist. In the final scene, he walks out into the desert and disappears into the horizon, a scene which signified more romanticism than it actually contains, thus setting the tone for all that precedes it.

Colin Campbell cross-dressing is not a drag queen. He doesn't try to become, or even impersonate, a woman. Rather, he wears the clothes and gestures as individual significations, each article of clothing, each gesture, each intonation a discrete element in a perverse collage. He never attempts illusion, acting, but rather places in disjunction male and female elements. The result is, on the one hand, humour; on the other, the inhuman, the macabre.

In his most recent videotape *Modern Love,* Colin Campbell appears as Robin, a

292

much more subtle form of androgeny: note the bisexual name. The make-up too is more subtle, as are the gestures. But everything signifies innocent femininity while in fact portraying nothing of the kind. Colin's true age and sex are all too visible behind the transparent mask . . . no, not mask, but behind the sparse vocabulary of gestures and visuals which signify his alteration. It is this conflict between image and signification that creates the skeleton upon which the story hangs.

Robin is a 'punkette'. She works a xerox machine by day and hangs out at the Beverley Tavern at night, listening to *Martha and the Muffins,* a local punk band. Now in fact Colin Campbell works at a stockbrokerage, and his work involves operating a xerox machine; and he does occasionally hang out at the Beverley Tavern, a Toronto locale, especially when *Martha & the Muffins* are playing. (As an aside, it's interesting to note that Martha herself is an art student working in video). It is here that Robin/Colin meets La Monte del Monte, a broadly-painted show-biz hustler, who sweeps Robin off her feet and empties her of money, food and sex before abandoning her in the name of 'Modern Love' an hour and a half of video later. La Monte del Monte is a character created by and played by David Buchan, in fact a recurring character in his own work, as we shall see later.

The soap opera scenes, very drily played, are interrupted sporadically by odd-ball love scenes between two sexual clichés: the German blond bombshell, played by Rodney Werden, and the sauve French playboy, played by Susan Britton. These two dally on screen in a constant struggle to find a common language for their love, quite literally, too, as she speaks pidgin German while he speaks pidgin French. Like cuckoo clock characters, they can never come together.

Both Rodney Werden and Susan Britton are video artists themselves, and both have incorporated elements of performance into their own work. Through cross-dressing, Colin removes them from the context of their own work, while heightening the violent struggle between actuality and signification: Heidi wears a man's watch, Pierre's mustache is patently attached, and neither of them can speak a word in their supposed mother tongues. Nonetheless, their performances are brilliant. The terse articulation of cultural signifiers is framed and accented by the lack of atmospheric or ambient detail.

While Heidi and Pierre can find no words for their love, Robin and Monte can do nothing but talk. The bloated rhetoric of love and sex transactions builds through the main body of the tape, and ends in a rapid fizzle, in which the rhetoric unwinds itself into damp little strings of platitudes. It is this attention to the signifiers and conventions of sex and love in our society that keep the tape from veering into pure camp.

LISA STEELE

Lisa Steele's early explorations of her own past, physicality and psyche have developed, in the newer performance and videotapes, into a complex enactment of her eccentric characters.

Lisa is consciously passive in her tapes. Her tapes act upon her; her performance quality derives from *not* acting, from being acted upon. The characters she chooses to put on, like old clothes for housecleaning, are precisely characters one knows from *observation*. These are not characters that dominate us, that we see, but rather characters that draw us into the vacuum of their presence, of their all-too-vocal non-presence, characters *that are seen by us*. Hence characters upon whom we must pass judgment of a certain kind (as the girlfriend does in the recent videotape 'Makin' Strange': "oh, how nice for you, etc. . .") We are requested, by the lack of qualitative comment, to fill that gap with our approving comments.

Like Colin, Lisa manages to avoid campiness as her characters struggle in this backwards quest for attention, although, God knows, sometimes campiness would appear comfortably *natural* against this strain of non-being. While in the earlier Scientist tapes, Lisa composes an image perfectly vacuous, hence modern, *Makin' Strange* features Lisa as a welfare mother who imagines her similarity to Howard Hughes (and she's right). .an image more graphically vacuous, moderately factual, in fact more matter-of-factly modern.

Passivity was more demonstrative in her early tapes, like *A Very Personal Story*, where she tells the story of finding her mother dead, or in *Birthday Suit*, a listing of scars from her past, all of which *chose to leave their mark upon her*. Here death visits the body in marks, marking entry points on her body. The story is a story of 'accidents' (again, Lisa is passive), but the sub-text is a perverse sexuality in which death visits the body in a series of kisses, moments rather than meanings, metaphorical hickies. Each mark sexually thrills the viewer (the voyeur), interrupting the story before continuing the autobiographical narrative.

Similarly, her miscarriage (actual) leaves its mark upon her, and is displayed, in *Damages*, like a sexual lobotomy that has left her sexually ageless. In this tape she plays a character who vacillates in age from an apparent twelve to thirty-five. This is the first developed appearance of the auto-moron, the eccentric dismembered activity which climaxes her most recent work.

This work depends primarily on performance quality, and the exceptional quality of that performance depends on a certain disjointedness combined with infallible timing. The inability to keep her limbs co-ordinated becomes a conscious manipulation of the body. The slackness of the mouth, the droopiness of the eyelids, all demand a mental concentration to *help her keep things together,* to help her keep her face all in one place.

In *Damages*, developed through a series of tableaux, Lisa gives her face the sculptural potential of silly-putty. In the precise timing of this tape one senses the animal idling beneath the complacent surface, waiting for the lobotomized flesh to yield forth its inner survivor. It is this animal — not lurking, but waiting — which gives the tape its superb tension, I am tempted to say its *narrative* tension, but in fact *Damages* is barely narrative at all. The narrative is set in motion by a series of presented moments, moments when no-one is watching (we are watching no-one wat-

Lisa Steele with Steven Davey in *Makin' Strange.*

ching, knowing we are watching no-one watching) which set the character into its tunnel perspective as one who is seen, one who is framed and formed, the character unwittingly molded into the negative space of her environment. In this sense, we can call this a 'feminist' statement.

In her most recent videotape *Makin' Strange,* Lisa's narrative is more conventionally structured, dealing with a single mother on welfare who is being arrested, apparently because she is housing, and sleeping with, another welfare recipient Wayne (played by rock star Stephen Davey). They are not married. In her relation to others, specifically her girlfriend (and this marks another exceptional appearance by artist Susan Britton) Lisa gives her character a certain looniness. This is the normality of this character: a rambling chain of ill-fitting rationalizations, defences and platitudes. And of course her boyfriend is a *poet,* the passive observer, whose most picturesque quality is his inability to *do,* in fact the fact of *being* a poet. For that is enough. She must be observed to exist.

Lisa Steele works in a women's crisis centre, and has for several years. Many of the observations, attitudes that constitute this schizophrenic, collage-character come from direct interaction with the women at that centre.

Perhaps the finest and most unique performance by Lisa portrayed this character in a performance context. At the Body Politic Rally in Toronto, January, 1979, many artists presented works in support of the Body Politic, a gay newspaper charged with sending immoral material through the mails. Although the issue for the readers of the newspaper was primarily one of sexual freedom, the issue for the artists was considerably larger: the right to exhibit (and not only exhibit but investigate and develop)

"perverse" behaviour. For in the performance and video work which most of these artists produce, behaviour provides the axis along which they can escape (and reveal) today's definitions of reality.

Lisa wandered on stage in her pajamas, no props, no set, no action. Her rambling monologue was not acted but reenacted. The story unwound itself like a series of social questions printed on toilet paper. The constantly branching sequence of thoughts (and 'she' was never sure which branch to take) was not so much descriptive as symptomatic. The story of a woman who finds her pregnant daughter dead in the bathtub, the narrative provokes the character into a series of double binds, into non-action, while clearly illustrating the social conditions of a type. This perhaps makes the performance sound more direct than it is. It is the constant hiatus, fragmentation of thoughts, interruption of gesture which speaks so clearly in this performance. Like a voodoo witchdoctor, Lisa is possessed by the voice of her character. The energy of this transaction short-circuits the body in a sequence of intentions become spasms. She doesn't know whether she is telling her story or seeing it for the first time. She intercuts the reactive gestures of recognition with the purposeful gestures of story-telling to create the schizo flicker of a new phenomenon: social drop-out from high capitalism.

295

DAVID BUCHAN

The lip-synch device, so essential to the Clichettes' formal strategy, was first used by David Buchan in his performance *Geek Chic,* a fashion show combining fashion show and variety show formats to display a carefully manipulated series of non-fashions. David calls himself a wardrobe artist and he is: clichés of the unfashionable were deftly manipulated into highly stylized costumes that were as much sculptural as they were ironic.

All of David Buchan's performances may be seen as enactments of desiring-machine effects. Constructed within the familiar but loosely knit formats of television variety shows and disco hours, they assemble costumes and music through the medium of (auto)biographical narrative. The chief character is David's alter-ego La Monte del Monte, who also appears in Colin Campbell's *Modern Love.*

La Monte del Monte has a long history of Canadian cliché pasts: he has been metamorphised from model-car builder to bible school convert to bowling enthusiast to hippy to glitter queen to high-fashion fascist and so on. This is not a story but an excuse for the lip-synch choreography and sculptural clothing which *are the real motives for the exercise.*

Like a drag queen, David Buchan lip-synchs popular songs, usually with a yearning sub-theme, adding heavily-designed movement based on mass media vocabularies. The effect is mechanical: as demonic as a wind-up toy. Lip-synch initiates the mechanical pacing: the moving lips matching music matching mo-town movements (in which the arms and legs especially become detached signifiers with their own vocabulary) combine with the added costumes (assembled *semantic* per-sonalities) to create a meshing of separated parts.

Only the smart-alec campiness of some of the pieces prevents them from transmuting into startrekian other-worldliness, into a juxtaposition of awkwardnesses and uglinesses become, as in Edith Sitwell, the grammar of fascination.

My mention of *Startrek* is not accidental. Contemporary involvement with the media has altered our relation to death. Through police shows/westerns/hospital drama/*Startrek* — but especially *Startrek* — death has been distanced to a gesture, rarified in *Startrek* into a rapid vapid evaporation of the body into dust.

So, too, David Buchan's characters are animated by ulterior motives and alien tongues. They are decorative corpses inhabited by a program of action. The choice of clothing, from bowling shirts to punk bondage gear, all possessed of a semantic value, collages together a monologue of many voices which in the end forms no single image but the image of death disguised in many cute costumes.

In his performance *Fruit Cocktails* at the Fifth Network Video Conference, 1978, the reaction of the audience was particularly revealing. The performance was divided into a variety-show format series of choreographed movements lip-synched to popular music. Each scene involved local personalities from the new art/new music Toronto scene acting out the significations of Television stars. The audience was right on cue. It was not performance they applauded, but rather the recognizable cues of when to applaud. It was not the personalities they applauded, but rather the signification of applaudable personalities. The audience was aware of the irony of this, but enjoyed joining in the method of the performance to complete the work of art.

David Buchan in *Fruit Cocktails*

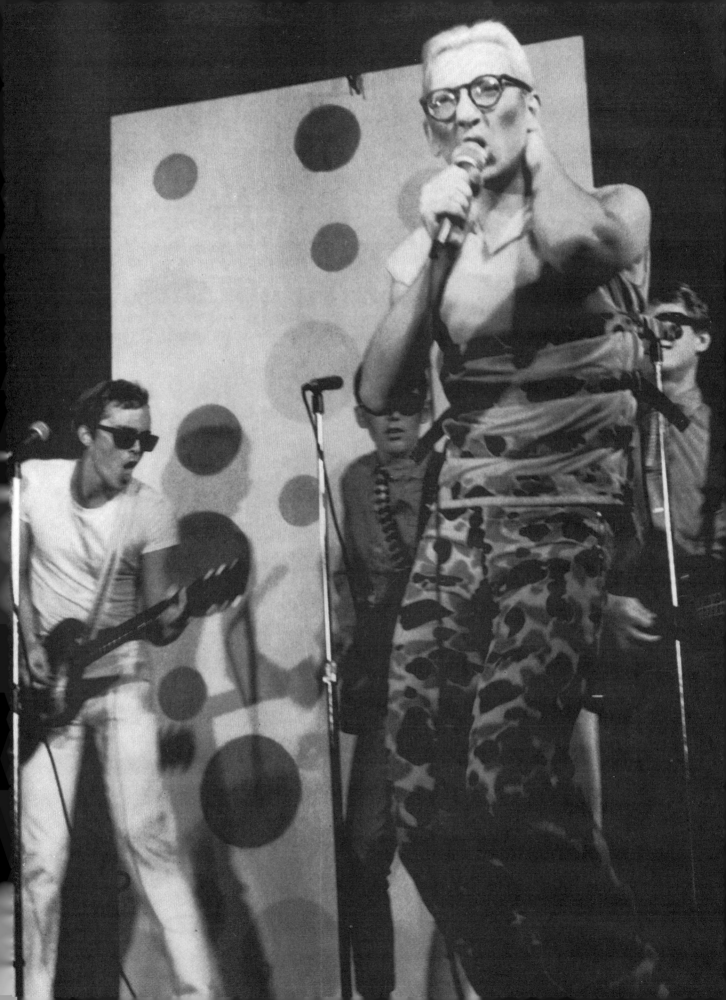

ELIZABETH CHITTY

A more intellectualized form of this modern mannerism may be found in the video and performances of Elizabeth Chitty. A dancer by background, Elizabeth's work has incorporated her own body/personality, and video, in all but one choreographed work.

In *Demo Model*, a performance presented at the Fifth Network Video Conference, Toronto, in 1978, she combined the actual machinery of modern communications technology with such specific vocabularies as deaf and dumb language, or semaphore.

In a series of distinct movements, she essentially played the part of the 'Demo Model', that female figure on TV who so effectively displays consumer products on quiz shows; or the airline hostess who demonstrates emergency oxygen masks. In this sense her performance was specifically feminist. Each segment juxtaposed a technology or communications mode, and a part of the body into a working 'machine'. For example: her head becomes disembodied over the light (death-blue) of the xerox machine, mechanically passing, which is reproducing the polaroid photos of a previous segment of the performance, photos we cannot see. It is not the copier that is the machine here, but the entire structure of head, photographs, copier, moving light.

There is a sort of sexual tremor to this work, as Elizabeth disconnects parts of her body and plugs them into 'machines'. Her hand, fingers mechanically tapping, becomes the focus for a TV camera in another segment. Her other hand operates the camera as she sits watching the image of her tapping hand on television. This closed system negates the presence of her own body except as hand and eyes.

There is no expression in this work, but only intention. Sensibility is co-opted by the mechanical workings of her desiring-machines, each occupying a different part of her body.

Elizabeth is also one of the original members of the Clichettes, a four-girl team posing as a singing team, but through lip-synching and choreography actually performing a dance-work in disguise. The use of costume, lip-synch, gestures of suffering and of love and of suffering love, combine with themes of women in cultural bondage to create a complex visual/audio code which is as ironic as it is compelling. The machinic conjunction of cultural images drawn from the mass media creates a neurotic obsessive combine. The Clichettes' most popular piece is the actual number one hit: *You Don't Own Me*.

Elizabeth Chitty's incorporation of information and languages from the popular media is described in her own words in an interview with Peggy Gale in the Performance issue of Centerfold, December, 1978:

"The 'briefing' tape in DEMO MODEL, 'assemble data, define the policy' — about two-thirds of the phrases were lifted out of newscasts, with the content removed. There is a whole language in television news and newspaper news. The story about the massacres in Africa was taken right out of the paper with no changes at all. It's all so manipulative, words like 'bludgeoned with rifles', words with such a strong emotional reaction. And yet there's the irony of the removal into print at the same time, we are brought close to the information but kept away from the true reality. But it was also happening on a pure emotional level as well. While this was being read, I was doing endurance poses, which was the most metaphorical the movements ever got. Listening to this horrible story, which if you bring yourself emotionally close to it . . . And the voice-over was saying 'stop', 'no, don't go on', and of course the voice continued on.

The pure movement parts of DEMO MODEL came directly from a perception of dance in semiotic terms.

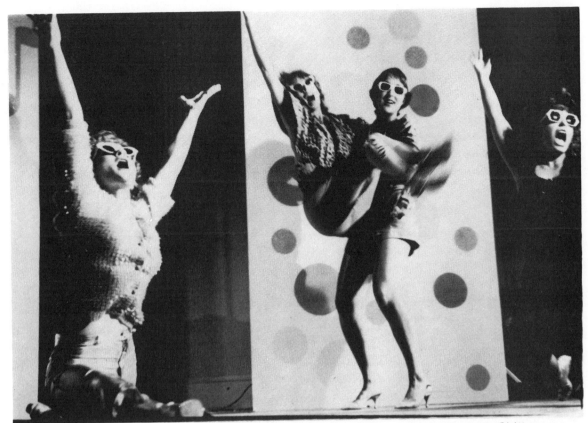

The Clichettes premiere in David Buchan's *Fruit Cocktails:* (left to right) Elizabeth Chitty, Janice Hladki, Louise Garfield, Johanna Householder.

Elizabeth Chitty in *Demo Model.*

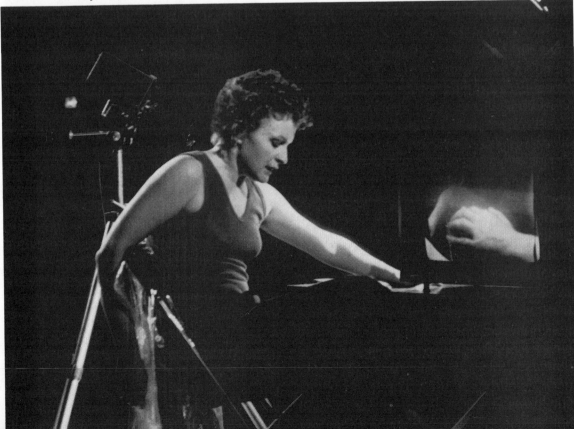

Even before I was familiar with the academic terminology of semiotics, I was aware that I was looking at dance from the point of view of what the movements expressed, and looking at traditional dance vocabulary as a cliched method of language. This is specifically in modern dance; gestures represent emotions. In this piece, and in the earlier work *Extreme Skin,* I reduced the movement to blatant sign systems, such as the deaf mute, and semaphore, and the poses also representing simplified but particular feelings.

In *Demo Model* there is a more elaborate sense of theme. I started out at the beginning knowing that the piece would be about information, and how information is relayed. Information is very different as image or movement or words, and information is relayed differently by moving images as opposed to still images. I would say that *Demo Model* is the most content-oriented work that I've done.

It's full of messages for me; it's practically a catalogue of languages. There's the video language, both live and pre-recorded. Then there were the polaroids (on-the-spot recording) and the pre-recorded photographs that were also looked at by the video camera. There was semaphore, xerox, sign language, the maps . . .

Actually that backdrop was a xeroxed collection of various things, again on a theme of language. There were a few sheets of playing cards, because of the way pattern relates to language, and diagrams from dance technique manuals. There were also some newspaper stories, including one about NBC being sued by a girl who felt she had been raped as a direct consequence of a TV programme about such things. There was also the newspaper story there about the MPs being sued for libel. The political sense was very much there, and comes from a perception of the kind of right-wing politics that's coming forward now."

S U S A N B R I T T O N

Because I like her work and because she combines so easily the fight between the intellectual who does not trust the intuitive and the intuitive does not trust the intellectual, I feel compelled to add Susan Britton to this essay at the last minute. After recently viewing her new tapes at Art Metropole, specifically *Tutti Quanti* and *Message*

From China, I am struck by the video patois she speaks, in which anarchy, marxism, high fashion, the cult of the personality, and punk join hands to form a language.

Sometimes watching Susan Britton's tapes one has the impression she doesn't know what she is talking about. But then you realize that you are confusing her content with her vocabulary. Just as the woman who drives a car need not be a mechanic, Susan is not a theoretician but a conversationalist.

In *Tutti Quanti,* a three-monitor video presentation lasting an hour and a half Susan juxtaposes personalities on the centre monitor, all played by herself, with atmospheric video-related images on either side (the same image on each side, forming an environmental trilogy). The characters which appear are alternately a fashion figure ('on top of the head is the hat'), a welfare mother ('who are you calling a bitch?). For the last 45 minutes of the tape, both side monitors are blacked out, the environment is turned off, for a high-contrast message from the end of the world. This is a tape recorded onto a capsule by the last survivors of the human race. The lighting becomes high contrast, the voices loud and grating with lots of static. In fact, every possible device is used to make the image and the sound as difficult to watch and as difficult to hear as possible. Susan's anarchist/punk message is loud and clear:

Destroy the tower! Destroy the tower!' And the tower is control and destruction at once, the death impulse in this political/stylistic amalgam. Thus the many faces of Susan Britton, which appear individually in many of her tapes and are finally set against each other here, dissolve into the chaotic amalgam of flickering light, flickering sound which cries out its single line against control.

BIBLIOGRAPHY

1969

SHARP, Willoughby. An Interview with Joseph Beuys. Artforum, December 1969.

1970

ANTIN, David. Lead Kindly Blight. Art News, November 1970. (Acconci).

BAXENDALL, Lee. & Darko Suvin. Happenings: An Exchange. The Drama Review, Fall 1970.

BURNHAM, Jack. Alice's Head. Artforum, February 1970. (Acconci)

KIRBY, Michael. Futurist Performance: Introduction by. The Drama Review, Fall 1970.

HEIN, H. Performance as an Aesthetic Category. Journal of Aesthetics, Spring 1970.

JOWITT, Deborah. Indulate, Lope, Twine. Village Voice, April 9 1970. (Dance column: Yvonne Rainer's Continuous Project - Altered Daily at the Whitney)

_____. Life Pageant. Village Voice, May 28 1970. (Dance column: Robert Wilson's The Life and Times of Sigmund Freud)

PERRAULT, John. Street Works. Arts Magazine, January 1970. (Acconci).

_____. In and On. Village Voice, February 26 1970. (Art column: John Perrault, Deborah Hay, Marjorie Strider, Hannah Weiner, at the Judson Church)

_____. Only a Dummy. Village Voice, May 14 1970. (Art column: The Saturday Afternoon Show at Max's Kansas City: Vito Acconci, Edwardo Costa, Ira Joel Haber, Deborah Hay, Stephen Kattenbach and Frank Owen, Abraham Lubeski, Scott Burton, Hannah Weiner, Paul Pechter, Adrian Piper, Brigid Polk, Marjorie Strider, John Perrault.

SHARP, Willoughby. Interview with Jack Burnham. Arts Magazine, November 1970. (Acconci)

_____. Body Works. Avalanche, Fall 1970.

1971

(STRIDER, Marjorie). 'Cherry Smash' by Marjorie Strider at the Whitney. The Drama Review, Summer 1971.

ACCONCI, Vito. Vito Acconci on Activity and Performance. Art and Artists, May 1971.

_____. Interfunktionen 6. September 1971.

BAAL, Frederic. Two Pieces. The Drama Review, Fall 1971.

BEAR, Liza and Willoughby Sharp. Rumbles. Avalanche, Fall 1971. (Acconci, Winsor, Gilbert and George, Glass)

BEUYS, Joseph and Terry Fox. Action. Interfunktionen 6, September 1971.

GODARD, Colette. Luca Ronconi's XX. The Drama Review, Fall 1971.

JOWITT, Deborah. Yvonne says No Roses. Village Voice, January 14 1971. (Dance column: Yvonne Rainer and Grand Union at NYU)

_____. A Parade, Never Concluding. Village Voice, March 4 1971. (Dance Column: Robert Wilson's Deafman Glance)

_____. Company Spirit. Village Voice, April 1 1971. (Dance column: Grand Union at Laura Dean's)

_____. (Trisha Brown's Another Fearless Dance Concert. Village Voice, April 8 1971.

_____. May Week - A Festival. Village Voice, June 3 1971. (Yvonne Rainer: Grand Union Dreams)

_____. (Trisha Brown's Planes, Accumulation, Rummage Sale and The Floor of the Forest at NYU) Village Voice, October 28 1971.

_____. Even the Bushes are not to be Trusted. Village Voice, November 4, 1971. (Meredith Monk: Vessel)

LARSEN, Lance. Liquid Theatre. The Drama Review, Summer 1971.

LE VA, Barry. A Continuous Flow of Fairly Aimless Movement. Avalanche, Fall 1971.

LONG, Mark. About the People Show. The Drama Review, Fall 1971.

NESMER, Cindy. Interview with Vito Acconci. Arts Magazine, March 1971.

_____. Subject-Object Body Art. Arts Magazine, September 1971.

PERRAULT, John. Cockroach Art. Village Voice, April 8, 1971. (Art column: Vito Acconci at John Gibson)

_____. Oedipus - A New Work. The Drama Review, Summer 1971.

_____. (Vito Acconci's Claim at Willoughby Sharp's). Village Voice, September 23 1971.

PINCUS-WITTEN, Robert. The Singing Sculpture at the Sonnabend. Artforum, December 1971. (Gilbert and George)

PLUCHART, Francois. Body Art. Artitudes, No. 1, 1971.

_____. Les Aggressions d'Acconci. Paris: Combat, June 14 1971.

RYAN, Paul Ryder. The Living Theatre in Brazil. The Drama Review, Summer 1971.

_____. Terminal, Interview with Robert Sklar. The Drama Review, Summer 1971.

SCHECHNER, Richard. Audience Participation. The Drama Review, Summer 1971.

SHARP, Willoughby. Interview with Dennis Oppenheim. Studio International, November 1971.

SMITH, Larry. Participation on a Pier: The Untrustworthy Artist. The Village Voice, May 20 1971. (Accouci)

TREMLETT, David. The Art of Searching. Avalanche, Fall 1971.

1972

(GRAHAM, Dan). Dan Graham's TV Camera/Monitor Performances. The Drama Review, June 1972.

(ISRAEL, Robert). Robert Israel's Theme and Variations. The Drama Review, June 1972.

ACCONCI, Vito. Performances. Interfunktionen 8, January 8 1972.

_____. Performances. Interfunktionen 10, 1972.

_____. Notes for a Performance at Documenta 5. Artitudes International No. 1, October/November 1972.

ANTIN, David. Talking at Pomona. Artforum, September 1972. (Acconci)

ASHTON, Dore. The Dionysian Dithyramb - Tosun Bayrak. Art and Artists, February 1972.

BAKER, Kenneth. Roeluf Louw - Challenging Limits. Artforum, May 1972.

BATTCOCK, Gregory. Guerilla Art Action - Tache and Hendricks Interviewed. Art and Artists, February 1972.

BENTHALL, Jonathan. The Body as a Medium of Expression: A Manifesto. Studio International, July/August 1972.

BERG, M. Metamorphic Theatre. Arts Magazine, December 1972.

_____. Performance as Experience. Arts Magazine, December 1972.

BEUYS, Joseph. Direkte Demokratie - Joseph Beuys Talking at Documenta. Avalanche 5, Summer 1972.

BORDEN, Lizzie. Cosmologies. Artforum, October 1972. (Acconci).

CELANT, Germano. Musdan. Rome: Galleria I'Attico, 1972. (New Music and Dance in USA)

DE JONG, Constance. Organic Honey's Visual Telepathy. The Drama Review, June 1972. (Joan Jonas)

FOX, Terry. Pont. Artitudes International No. 1, October/November 1972.

FRIED, Howard. The Cheshire Cat. Avalanche 4, Spring 1972. (Interview with L. Bear, videotapes, lists)

GLASS, Phil. An Interview in Two Parts. Avalanche 5, Summer 1972. (Interviewed by Willoughby Sharp and L. Bear)

GRAHAM, Dan. Interfunktionen 8. January 1972.

GRAHAM, Dan. Eight Pieces by Dan Graham. Studio International, May 1972.

HIGGINS, Dick. Something Else About Fluxus. Art and Artists, October 1972.

JONAS, Joan. Organic Honey's Visual Telepathy (Script). The Drama Review, June 1972.

JOWITT, Deborah. Some Dances are Shaggier Than Others. Village Voice, April 13 1972. (David Gordon and Douglas Dunn at Merce Cunningham's Studio)

_____. Some Performances and their Detritus. Village Voice, April 27 1972. (Yvonne Rainer at the Whitney)

_____. Quiet Please: A Berry is Breaking. Village Voice, May 4 1972. (Robert Wilson's Overture for Ka Mountains)

_____. (Meredith Monk's Education of the Girlchild Part One). Village Voice, May 11 1972.

KIRBY, Michael. On Acting and Non Acting. The Drama Review, March 1972.

_____. Theatre Laboratorie Vicinal - The Vicinal's Tramp. The Drama Review, December 1972.

KNIZAK, Milan. Aktual in Czechoslovakia. Art and Artists, October 1972.

KOCH, Stephen. Performance, A Conversation. Artforum, December 1972. (Trisha Brown, Robert Dunn, Richard Foreman, Yvonne Rainer, Daniel Ita Sverdlik, Twyla Tharp)

KOUNELLIS, Jannis. Structure and Sensibility: An Interview with Jannis Kounellis Avalanche 5, Summer 1972.

MACUNIAS, George. Tenth Flux Lead Anniversary Contents. Art and Artists, October 1972.

McDONAGH, Don. Notes on Recent Dance. Artforum, December 1972.

McNAMARA, Brooks. Vessel: The Scenography of Meredith Monk. The Drama Review, March 1972.

MEKAS, Jonas. (Yvonne Rainer at the Whitney) Village Voice, May 4, 1972.

MONK, Meredith. Meredith Monk Interviewed by Simon Field. On the Move. Art and Artists, September 1972.

PANE, Gina. Je. Artitudes International No. 1, October/November 1972.

PERRAULT, John. Punishing the Victims: Anti-Aphorisms on Art. Art and Artists, March 1972.

_____. A Dance of the Silent Victims. Village Voice, April 27 1972. (Scott Burton's Behaviour Tableaux at the Whitney)

PIERCE, Robert G. The Bang of One Spoon Rolling. Village Voice, January 18, 1972. (Joan Jonas' Organic Honey's Vertical Roll at Leo Castelli Gallery)

_____. Circling the Monotonous. Village Voice, December 28 1972. (Laura Dean's

Circle Dance at Lo Gindice Gallery)

PINCUS-WITTEN, Robert. Vito Acconci and the Conceptual Performance. Artforum, April 1972.

PLUCHART, Francois. Le Grand Ceremonial de Terry Fox. Artitudes International No. 1, October/November 1972.

RAINER, Yvonne. The Performer as a Persona: An Interview with Yvonne Rainer. Avalanche 5, Summer 1972.

ROBBINS, Aileen. Tristan Tzara's Handkerchief of Clouds. The Drama Review, December 1972.

SAINER, Arthur. Only Mental, Where's My Foot Gone? Village Voice, August 10 1972. (Ontologic-Hysteric Theatre: Doctor Selavy's Magic Theatre: The Mental Cure at the Lenox Arts Centre)

_____. Theatre for Strong Stomachs. Village Voice, December 7 1972. (Hermann Nitsch's Orgies Mysteries Theatre at the Mercer Arts Theatre)

SHARP, Willoughby and Liza Bear. Rumbles. Avalanche 4, Spring 1972.

_____. Rumbles. Avalanche 5, Summer 1972.

SMITH, Michael. (Scott Burton's Behaviour Tableaux at the Whitney) Village Voice, April 27 1972.

SONNIER, Keith. Illustrated Time - Proscenium II. Avalanche 5, Summer 1972

WALTHER, Franz Erhard. First Workset. Avalanche 4, Spring 1972.

WOLMER, Denise. Vito Acconci at Sonnabend, The Grand Union at 112 Greene Street. Artsmagazine, March 1972.

WATERMAN, Doug. (At A Space) Interfunktionen 9, 1972.

WEIERMAIR, Peter. New Tendencies in Austrian Art. Studio International, May 1972. (Gunter Brus, Hermann Nitsch)

1973

MAX HUTCHISON GALLERY. Hybrids. (Group Show Review) The Drama Review, June 1973. (Warren Rose, Hans Breder, Dan Deprenger.

NICE STYLE POSE BAND. (Reviewed) Studio International, November 1973.

ACCONCI, Vito. Untitled. Flash Art, March/May 1973.

ARGELANDER, Ronald. Scott Burton's Behaviour Tableaux 1970-1972. The Drama Review, September 1973.

BERGER, Mark. A Metamorphic Theatre. Artforum, May 1973. (Meredith Monk)

BORDEN, Lizzie. Laura Dean, Circle Dance, Lo Gindice Gallery. Artforum, February 1973.

_____. Trisha Brown: Accumulating Pieces and Accumulations, Sonnabend. Artforum, June 1973.

_____. Yvonne Rainer: This is a story of a woman who... Theatre for the New City. Artforum, June 1973.

BOURGEAUD, B. Cinema et Video - Body Works: Acconci, Fox, Oppenheim. XXme Siecle, December 1973.

BROOK, Donald. Idea Demonstrations: Body Art and Video Freaks in Sydney. Studio International, June 1973.

BURDEN, Chris. The Church of Human Energy. Avalanche 8, Summer/Fall 1973.

BURNHAM, Jack. Contemporary Ritual: A Search for Meaning in Post-Historical Terms. Arts Magazine, March 1973.

CALANDRA, Denis. Experimental Performance at the Edinburgh Festival. The Drama Review, December 1973.

CHILDS, Lucinda. A Portfolio. Artforum, February 1973.

DALEY, Janet. Situation Uncritical. Art and Artists, April 1973.

DE JONG, Constance. Joan Jonas: Organic Honey's Vertical Roll. Arts Magazine, March 1973.

D'OR, Vic and David Young. Dr. Brute/Leopard Reality. Proof Only, December 1973.

EHRENBERG, Felipe. On Conditions - Felipe Ehrenberg discusses the work of Anthony McCall. Art and Artists, March 1973.

GENERAL IDEA. Gold Diggers of '84: An interview with General Idea, Toronto. Avalanche 7, Winter/Spring 1973.

GIROUARD, Tina. If I'm Lyin', I'm Dyin', On the Road to Catahoula. Avalanche 8, Summer/Fall, 1973. (Dialogue with Liza Bear)

GRAHAM, Dan. Intention - Intentionality Sequence. Arts Magazine, April 1973.

HORVIST, Robert Joseph. Nature as Artifact: Alan Sonfist. Artforum, November 1973.

JOWITT, Deborah. It Doesn't Take a Lot... Village Voice, February 15, 1973. (Meredith Monk and Ping Chong: Paris)

_____. (Batya Zamir at Cubiculo) Village Voice, February 22, 1973.

_____. (Trisha Brown's Accumulating Pieces at Sonnabend) Village Voice, April 5 1973.

_____. Nobody Doesn't Like Sara Lee. Village Voice, April 12, 1973. (Yvonne Rainer's This is a story of a woman who...)

_____. (Deborah Hay at the Dance Gallery) Village Voice, April 26, 1973.

_____. (Laura Dean's Group at Eisner Lubin's)

_____. (The Grand Union at the Dance Gallery) Village Voice, May 24 1973.

_____. Who is that woman with the Moustache? Village Voice, June 28 1973. (Meredith Monk's Education of a Girl Child)

_____. Godliness to Cleanliness. Village Voice, December 20 1973. (Lucinda Childs at the Whitney)

KIRBY, Michael. Richard Foreman's Ontological Hysteric Theatre. The Drama Review, June 1973.

MELZER, Anabell Henkin. Dada Performance at the Cabaret Voltaire. Artforum, November 1973.

_____. The Dada Actor and Performance Theory. Artforum, December, 1973.

PANE, Gina. The Body and Its Support - Image for Non-Linguistic Communication. Artitudes International 3, February/March 1973.

PERRAULT, John. (Vito Acconci at the Earle Hotel) Village Voice, April 26 1973.

PIERCE, Robert. Kiwis on Sunday, Bananas on Monday. Village Voice, October 25 1973. (Ping Chong's I Flew to Fiji, you went South)

_____. Drowning in the line of duty. Village Voice, December 20 1973. (Douglas Dunn's Time Out at the Exchange Theatre)

PLAGENS, Peter. Four Women: Los Angeles County Museum of Art. Artforum, February 1973. (Including Maggie Lowe)

PLUCHART, Francois. Gina Pane's Performances. Artitudes International 3, February/March 1973.

_____. L'Espace Mental de Gina Pane. Artitudes International 5, June/July/August 1973.

_____. Acconci's Performances. Artitudes International 2, December 1972/January 1973.

RINGOLD, Faith. Documenta: Interview with Lil Picard. Feminist Art Journal, Winter 1973.

SAINER, Arthur. More Moved than Moving. Village Voice, March 22 1973. (Yvonne Rainer's This is the story of a woman who...)

_____. Slightly Astonishing Emanations. Village Voice, November 8 1973. (Ping Chong's I flew to Fiji, you flew South)

SCHECHNER, Richard and Cynthia Mintz. Kinesis and Performance. The Drama Review, September 1973.

SHARP, Willoughby and Liza Bear. Rumbles. Avalanche 7, Winter/Spring 1973.

_____. Rumbles. Avalanche 8, Summer/Fall 1973.

SMITH, Roberta. Robert Welch at the John Gibson Gallery. Artforum, December 1973.

STEPHANO, Effie. Performance of Concern - Interview with Gina Pane. Art and Artists, April 1973.

THWAITES, John Anthony. Franz Erhard Walther. Art and Artists, February 1973.

TRILLIG, Ossia. Robert Wilson's Ka Mountain and Gardenia Terrace. The Drama Review, June 1973.

TROYANO, Ela. Notes: Yvonne Rainer. Art-Rite, Summer 1973.

WESTWATER, Angela. Meredith Monk: An Introduction. Artforum, May 1973.

1974

ABROMOVIC, Marina. Flashart, June 1974. (Marina Abromovic)

ACCONCI, Vito. Command Performance. Avalanche Newspaper, May/June, 1974.

ALEXIS. A Visit to the Cabaret Voltaire. The Drama Review, June 1974.

BEAR, Liza. Rumbles. Avalanche Newspaper, December 1974. (Barbara Dilley, Tina Gerouard, Joseph Beuys, Chris Burden, Sylvia Whitman)

BORDEN, Lizzie. The New Dialectic. Artforum, March 1974.

BURDEN, Chris. Bach to You. Avalanche Newspaper, May/June 1974.

CARROLL, Noel. Laura Dean and Company; Changing Pattern, Steady Pulse. Artforum, March 1974.

_____. Lucinda Child's Performance at the Whitney. Artforum, March 1974.

_____. Mabou Mines at the Performing Garage. Artforum, May 1974.

_____. Douglas Dunn at 308 Broadway. Artforum, September 1974.

COLLINS, James. Chris Burden at Ronald Feldman Gallery. Artforum, May 1974.

COUM. Coum Decompositions and Events. Intermedia Vol 1, No. 1. 1974.

DAVY, Kate. Foreman's Pain(t) and Vertical Mobility. Drama Review, June 1974.

DEAK, Frantizek. Robert Wilson. The Drama Review, June 1974.

FOREMAN, Richard. Ontological-Hysterical Manifesto II. The Drama Review, September 1974.

FORTI, Simone. Dancing at the Fence. Avalanche Newspaper, December 1974.

GORDON, Mel. A History of Performance 1918 - 1920: Dada Berlin. The Drama Review, June 1974.

HARTNEY, Michael. Nice Style at Garage, London. Studio International, November 1974.

HAUSMAN, Raoul. Dadatour. The Drama Review, June 1974.

HECHT, Ben. Dadafest. The Drama Review, June 1974.

JOWITT, Deborah. Forgetting to Remember the

Walrus. Village Voice, January 10 1974. (Robert Wilson's The Life and Times of Joseph Stalin)

_____. Spinning at the Centre of Things. Village Voice, April 25 1974. (Laura Dean at NYU's Loeb)

_____. Climbing in the Ghost Ship. Village Voice, May 23 1974. (Douglas Dunn's Performance Exhibit)

_____. (Trisha Brown) Village Voice, June 27 1974.

_____. Many People Are Islands. Village Voice, July 18, 1974. (Meredith Monk and Ping Chong, Paris-Chacon)

_____. Red in the Face or Just Blue? Village Voice, December 20 1974. (David Gordon with Valda Setterfield at Paula Cooper's Gallery)

KNIZAK, Michael. Stone Ceremony. Source 11, January 1974.

MEKAS, Jonas. (Yvonne Rainer's A film about a woman who...) Village Voice, December 23 1974.

MICHELSON, Annette. Yvonne Rainer, Part One: The Dancer and the Dance. Artforum, January 1974.

_____. Yvonne Rainer, Part Two: Lives of Performers. Artforum, February 1974.

MINTON, James. Decca Dancing in the City of Angeles (Cont'd). Artweek, March 2 1974.

MOORE, Alan. Ray Johnson, Meeting of the Asparagus Club, Rene Block Gallery. Artforum, December 1974.

MOORMAN, Charlotte. Biographical Material. Flashart, June 1974.

PANE, Gina. Il Corpo come Linguaggio. Domus, October 1974.

PERRAULT, John. It says so on the door. Village Voice, March 28 1974. (Live, A group show at Stefanotty Gallery, Dennis Oppenheim, Allan Kaprow, Hans Haacke, Les Levine)

PINCUS-WITTEN, Robert. Notes. Art-Rite No. 6, Summer 1974. (Laurie Anderson)

PLAGENS, Peter. John White - Notes from a Conversation. Artforum, March 1974.

POMEROY, R. Moving Things. Art and Artists, November 1974.

ROSENBACH, Ulrike. Isolation is Transparent. Avalanche Newspaper, May/June 1974.

RYAN, Paul Ryder. The Living Theatre's Money Tower. The Drama Review, June 1974.

SHARP, Willoughby. Help. Avalanche Newspaper, May/June, 1974.

_____. The Phil Glass Ensemble. Avalanche Newspaper, December 1974. Laub

_____. Stephen Lamb's Projections. Avalanche Newspaper, December 1974.

SMITH, Jack. Excerpt from a Talking Performance. Art-Rite No. 6, Summer 1974.

SMITH, Michael and Arthur Sainer. Bubbles of Joy in a Sober Field. Village Voice, April 11 1974. (Richard Foreman's Ontological-Hysteric Theatre: Pain(t) and Vertical Mobility)

SMITH, Roberta. Joseph Beuys' Performance at Rene Block. Artforum, September 1974.

STEPHANO, Effie. Interview of Vito Acconci. Art and Artists, February 1974.

TISDALL, Caroline. Beuys: The Coyote. Art-Rite No. 6, Summer 1974.

TUFFIN, Andrew. Marien Lewis 'Dance Soap' at Edgewater Hotel. Proof Only, January 1974.

VERGINE, Lea. Body Language. Art and Artists, September 1974.

WITTENBERG, Clarissa. Wilson at Art Now. The Drama Review, September 1974.

1975

ANON. An Article on Scott Burton in the Form of a Resume. Art-Rite No. 8, Winter 1975.

_____. Soup and Tart. Art-Rite No. 8, Winter 1975. (Phil Glass, Donald Munroe, Joan Schwartz, Diego Cortez, Jean Dupuy, Charles Atlas, Kate Parker, Dickie Landry, John Gibson, Charlemagne Palestine... Group Performance at the Kitchen)

ACCONCI, Vito. Reception Room. TriQuarterly 32, Winter 1975.

ALLIATO, Vicky. Performance a Milano. Domus, April, 1975.

ANDERSON, Laurie. Confessions of a Street Talker. Avalanche, Summer 1975.

APPLE, Jacki. Digging. Intermedia, Vol. 1, No. 3, December 1975.

BEAR, Liza. Rumbles. Avalanche, Summer 1975.

BEUYS, Joseph. I Like America and America Likes Me. TriQuarterly 32, Winter 1975.

BOURDEN, David. Body Artists without Bodies. Village Voice, February 24 1975. (Chris Burden, Vito Acconci, Robin Winters)

BOURDEN, David. Beuys will be Beuys... Village Voice, April 28 1975.

_____. (Ben Vautier at the John Gibson Gallery) Village Voice, October 20 1974.

BROOKS, Rosetta. Ninth Paris Biennale. Studio International, November/December 1975.

BURDEN, Chris. Intitled. Flash Art, June/July, 1975.

BURTON, Scott. Furniture Pieces, Chair Drama. TriQuarterly 32, Winter 1975.

BUTTERFIELD, J. Through the Night Softly. Arts Magazine, March 1975. (Chris Burden)

CARROLL, Jon. Watching the Media Burn. Village Voice, July 14 1975. (Ant Farm's Media Burn)

CARROLL, Noel. (James Barth, Douglas Dunn, David Woodberry). Artforum, February 1975.

CHAPLINE, Claudio. Two Performances. Intermedia Vol 1, No. 3, December 1975.

DILLEY, Barbara. In the Dancing Room. Avalanche 12, Winter 1975.

FEINGOLD, Michael. The Potato's the Thing. Village Voice, December 29 1975. (Richard Foreman's Rhoda in Potatoland)

FERRARI, C. Chris Burden: Performance Negli USA. Domus, August 1975.

FOREMAN, Richard. Third Manifesto: Ontological-Hysteric Theatre. The Drama Review, December 1975.

FRANCBLIN, Catherine. (Women's Body Art in Europe). Art Press, September/October 1975.

GENERAL IDEA. General Idea and the Cultural Cliche. Flash Art, October/November 1975.

GILBERT AND GEORGE. The Singing Sculpture. TriQuarterly 32. Winter 1975.

GOLDBERG, Roselee. Space as Praxis. Studio International, September 1975.

HAWKINS, Lucinda. Ant Farm - Media Burn at the Cow Palace. Studio International, September/October 1975.

HAYUM, A. Notes on Performance and the Arts. Art Journal, Summer 1975.

HOWELL, J. Performance. Art in America, May 1975.

JOWITT, Deborah. Falling Among Friends. Village Voice, February 24 1975. (Douglas Dunn and David Woodberry)

_____. (The Grand Union at La Manna) Village Voice, March 31 1975.

_____. When is not enough too much? Village Voice, April 7, 1975. (Lucinda Childs)

_____. Dancing in step with the Angels. Village Voice, April 21, 1975. (Laura Dean's Drumming)

_____. (Douglas Dunn's Gestures in Red, Common Ground Festival). Village Voice, May 26 1975.

_____. Festivals, Fables and Twice Told Tales. Village Voice, June 16 1975. (Meredith Monk)

_____. When I Dance, Who Am I? Village Voice, July 7 1975. (Trisha Brown's Locus)

KAPROW, Allan. Echo-Ology. Artforum, Summer 1975.

KERNER, Leighton. Winged Victoria. Village Voice, March 31 1975. (Robert Wilson's A Letter for Queen Victoria)

KOZLOFF, Max. Pygmalion Reversed. Artforum, November 1975.

KUBISCH, Christina. Music and Dance: New Tendencies in New York. Flashart, October, November 1975.

KUHN, Annette. Can you tell the eccentricity from the art? Village Voice, October 6 1975. (12th Avant Garde Festival)

LIPPARD, Lucy. Yvonne Rainer on Feminism and Her Film. The Feminist Art Journal, Summer 1975.

MAYER, R. Dan Graham's Past/Present. Art in America, November 1975.

MEKAS, Jonas. (Movie Journal) Village Voice, March 24 1975. (Yvonne Rainer's Film about a woman who...)

MOORE, Alan. Stefan Eins at 3 Mercer Street. Artforum, February 1975.

_____. Group Show at 597 Broadway. Artforum, Summer 1975. (Alan Saret, Kirstein Bar Bates, Gerard Houagimyan, Scott Billingsley, Willoughby Sharp, J.B. Cobb, Scott Johnson, Gianfranco Mantegna, Dick Miller, Stefan Eins, Lee Fur, Julia Heyward, Dara Birnbaum, Michael McClard, Dan Graham, Robin Winters)

_____. Arman: Conscious Vandalism. Artforum, Summer 1975.

_____. Willoughby Sharp's Doubletake. Artforum, April 1975.

MYERS, Rita. A Remote Intimacy. Avalanche 12, Winter 1975.

NAYLOR, Colin. Couming Along: Colin Naylor interviews Genesis P-Orridge. Art and Artists, December 1975.

NICE STYLE. The World's First Pose Band. Flash Art, June/July 1975.

OLTHUIS, Stan. Going Thru the Motions. Only Paper Today, September/October 1975. (General Idea)

PAXTON, Steve. Like the Famous Tree. Avalanche, Summer 1975.

PETES, S.W. Vostell and the Vengeful Environment. Art in America, May 1975.

PLAGENS, Peter. Indecent Exposure. Artforum, March 1975.

NINETY, Radz. Chris Burden at A Space. Only Paper Today, November/December 1975.

_____. Glamazon. Only Paper Today, November/December 1975. (Dawn Eagle, Granada Gazelle)

ROSENBACH, Ulrike. Gina Pane at the Galerie de Appel. Flash Art, October/November 1975.

SAINER, Arthur. Finding a Collective Rhythm. Village Voice, May 26 1975. (Experimental Theatre Festival, Ann Arbor)

_____. Let us now praise famous potatoes. Village Voice, December 29 1975.

(Richard Foreman's Rhoda in Potatoland)

TISDALL, Caroline. Je/Nous - Circus Event, Saltoarte, Ixelles, Brussels. Studio International, July/August 1975. (Boltanski, Beuys)

TUCKER, Carll. An Entirely Unfamiliar Human Way of Perceiving. Village Voice, March 24 1975. (Robert Wilson's A Letter for Queen Victoria)

WILSON, Robert and Christopher Knowles. Because Why. Avalanche 12, Winter 1975.

WINTERS, Robin. Fairly Regular Hours. Avalanche 12, Winter 1975.

1976

ANON. Poetry in Action. Kontexts, Spring 1976.

ANCORA PER ASSUADO. 32 Feet Per Second. Performance San Francisco. Domus, October 1976.

ANDERSON, Alexandra. The Chemical Bank Encounter and Other Events in the ArtLife of Stephen Varble. Village Voice, May 10 1976.

BARACKS, Barbara. Meredith Monk/The House - Quarry. Artforum, June 1976.

BEAR, Liza. Rumbles. Avalanche 13, Summer 1976. (Barbara Smith, Reindeer Werk, William Leavitt, Gilbert and George)

BRISLEY, Stuart. 24 Hour Performance in the Basement of the EAF. Experimental Art Foundation 1976.

CHAIMOWICZ, Marc. Moments of Decision/Indecision: Stuart Brisley at Gallery Studio, Warsaw. Studio International, January/February 1976.

_____. David MacLagan at Tone Place, Charlie Hooker at PMJ Self, Kevin Atherton at Garage. Studio International, March/April 1976.

_____. Klaus Rinke at Oxford, Paul Negeau and His Generative Art Group at the Arnolfini. Studio International, May/June 1976.

CELANT, Geramano. Jannis Kounellis Studio International, January/February 1976.

CORTEZ, Diego. An Obvious Kind of Eyesore. Avalanche 13, Summer 1976.

COHEN, Debra. The Lost Ones, The Mabou Mines. The Drama Review, June 1976.

DAVIES, Douglas. The Size of Non-Size. Artforum, December 1976.

DAVY, Kate. Kate Manheim as Foreman's Rhoda. The Drama Review, September 1976.

DUNN, Peter. New Contemporaries' Live Work Show at Acme Gallery. Studio International, September/October 1976.

FEINGOLD, Michael. The Two by Four is a Whorehouse Again. Village Voice, May 10 1976. (Richard Foreman's production of The Threepenny Opera)

FLAKES, Susan. Robert Wilson's Einstein on the Beach. The Drama Review, December 1976.

FOOTE, Nancy. Anti-Photographers. Artforum September 1976.

FOREMAN, Richard. The Carrot and the Stick. October 1, Spring 1976.

FOX, Terry Curtis. Mabou Mines Evolves a Masterpiece. Village Voice, August 2 1976.

FRANK, Peter. Auto Art - Self Indulgent? And How! Art News, September 1976.

FRIEDRICH, G. Atonumente durch medien ersetzen. Kunstwerk, July 1976.

GOLDBERG, Roselee. Recent Performance Work. Studio International, May/June 1976. (Scott Burton, Eberhard Blum, Sally Rubin and etc)

HAMMER, Signe. Against Alienation - a Postlinear Theatre Struggles to Connect. Village Voice, December 20, 1976. (Meredith Monk's Quarry)

HANDFORTH, Robert. Imported Angst at A Space. Only Paper Today, March/April 1976. (Charlemagne Palestine)

_____. Marcel Just Interview. Only Paper Today, September/October 1976.

HOWITZ, Robert. Chris Burden. Artforum, May 1976.

JOHNSON, Tom. Philip Glass Writes an Opera for Ordinary Voices. Village Voice, January 26 1976. (Philip Glass, Robert Wilson: Einstein on the Beach)

_____. Meredith Monk Doesn't Make Mistakes. Village Voice, May 3 1976.

JONATHAN, C. Alan Kaprow's Activities. Arts Magazine, September 1976.

JOWITT, Deborah. Trisha Brown Makes Dances that Talk Back. Village Voice, January 12 1976.

_____. Some Dances are Tonic For The Mind. Village Voice, January 26 1976.

_____. What Does that Body Mean. Village Voice, Feburary 16 1976. (Lucinda Childs)

_____. (Batya Zamir) Village Voice, March 22 1976.

_____. Underwater All Islands Connect. Village Voice, April 26 1976.

_____. Will You Survey My Terrain? Village Voice, May 3 1976. (Douglas, Foreman)

_____. The Spring Dance Storm Is Here! Village Voice, May 17 1976. (Laura Dean, Grand Union)

_____. Douglas Dunn Makes Dance About Making Up His Mind. Village Voice, June 14 1976.

_____. What is $E=MC^2$ to a Dreamer. Village Voice, December 20 1976. (Philip Glass, Robert Wilson: Einstein On the Beach)

KAPROW, Allan. Non Theatrical Performance. Artforum, May 1976.

KENNY, Annson. Conceptual Radio, Five Performances. The Drama Review, June 1976.

KILLER, P. Kollektivkunst - vonden ban hutten zur grupendynamik. Werk, Vol 1, 1976.

KIRBY, Michael. The Marilyn Project: A Structuralist Play? The Drama Review, June 1976.

KOENIG, Carole. Meredith Monk: Performer/Creator. The Drama Review, September 1976.

KUHN, Annette. Why is Performance Art Different From All Other Art. Village Voice, February 23 1976.

LEVINE, Les. EAF 76. Experimental Art Foundation, 1976.

LIPPARD, Lucy. The Pains and Pleasures of Rebirth: Women's Body Art. Art in America, May/June, 1976.

LORA-TOTING, Arrigo. Verbotecture, Theory. Kontexts, Spring 1976.

MACLOW, Jackson. A Vocabulary for Peter Innisfree Moore. Kontexts, Spring 1976.

MARSHALL, Stuart. Alvin Lucier's Music of Signs in Space. Studio International, November/December 1976.

MLCOCH, Jan. Two Performances: Prague and Tarzan. Flash Art, October/November 1976.

MONK, Meredith. Invocation/Evocation. Avalanche 13, Summer 1976.

MORRISON, C.L. Jim Self and Friends - White on White. Artforum, June 1976.-

NABAKOWSKI, Gislind. Interview with Ulrike Rosenbach. Heute Kunst, October/December 1976.

NOEL, B. La Langue du Corps. XXme Siècle, June 1976.

NYMAN, Michael. George Brecht Interview. Studio International, November/December 1976.

OLIVA, Achille Bonito. Process, Concept and Behaviour in Italian Art. Studio International, January/February 1976.

PALESTINE, Charlemagne. Interviewed by Raymond Gervais and Chantal Pontbriand. Parachute 5, Winter 1976.

POST, Henry. Garbage Fashions. Penthouse, April 1976. (Stephen Varble)

RAINER, Yvonne. Film about a woman who... October 2, Summer 1976.

WERK, Reindeer. EAF 76. Experimental Art Foundation 1976.

ROBINS, C. Alan Sonfist: Time as an Aesthetic Dimension. Arts Magazine, October 1976.

ROSS, Janice. Reduction of Time, Space and Energy. Artweek, May 1 1976. (Steve Paxton)

SALTE, P. Vito Acconci Recent Work. Arts Magazine, December 1976.

SAPIEN, Darryl. Performance Proposal: Splitting the Axis. La Mamelle, Winter 1976.

SARGENT, David. The Met Will Dance a Different Tune. Village Voice, November 22 1976. (Phil Glass, Robert Wilson: Einstein on the Beach)

SONFIST, Alan. Natural Phenomena as Public Monuments. Domus, August 1976.

SIMMONS, Steven. Rhoda in Potatoland: Ontological Hysteric Theatre, Richard Foreman. Artforum, March 1976.

_____. Scott Burton: Pair Behavioural Tableaux. Artforum, May 1976.

SKOGGARD, R. Vito Acconci's Stars and Stripes. Art in America, November 1976.

SMITH, Roberta. Jared Bark: Lights On/Off, The Neutron Readings at the Idea Warehouse. Artforum, January 1976.

SOMMER, Sally. JoAnne Akalaitis of Mabou Mines. The Drama Review, September 1976.

STEMBERA, Petr. Flash Art, October/November 1976.

TISDALL, Caroline. Performance Art in Italy. Studio International, January/February 1976.

_____. Jimmy Boyle, Joseph Beuys: A Dialogue. Studio International, March/April 1976.

TREBAY, Guy. Pat Oleszko Puts her Art On. Village Voice, October 11, 1976.

ULAY. Performance FOTOTOT, Galerie Beyer. Kunstoff, March 1976.

WETZSTEAM, Ross. The Making of a Masterpiece: BlahBlahBlahBlah.. Village Voice, April 12 1976. (Glass, Wilson: Einstein on the Beach)

WEIGAND, Ingrid. Vito Acconci Finally Finds Himself - Through Others. Village Voice, October 18 1976.

WILKE, Hannah. Shuffling Off To Buffalo, My Country 'Tis of Thee, Performance: Albright Knox Museum, Buffalo. Unmuzzled Ox, Vol. 4, No. 2 1976.

WOOSTER, Ann Sargent. Robert Wilson and Ralph Hilton, Spaceman at the Kitchen. Artforum, March 1976.

_____. Robert Kushner:Persian Line II, Holly Solomon Gallery. Artforum 1976.

_____. Carolee Schneeman: Up To and Including Her Limits, The Kitchen. Artforum, May 1976.

1977

ANON. An Act Respecting Bankruptcy. Performance by S.W. Long at A Space. Only Paper Today, September 1977.

_____. Alex Misheff's Swimming Pool. Flash Art, November/December 1977.

_____. The Theatre of Mistakes._ Flash Art, November/December 1977.

_____. Reportage Sur 03 23 03 - Recontres Internationales d'art contemporain._ Parachute 7, Summer 1977.

BANES, Sally. _Lucinda Childs: Simplicity Forces You To See._ The Village Voice, May 16 1977.

BARACKS, Barbara. _Einstein on the Beach._ Artforum, March 1977. (Glass, Wilson)

_____. Jill Kroesen - Stanley Oil and His Mother, Kitchen._ Artforum, Summer 1977.

BEAR, Liza. _Interview with Tina Girouard, Two Trees in the Forest._ Parachute 6, Spring 1977.

BUCHAN, David. _Femmes Artistes Invitees Celebration Rituelle._ Vie des Arts, Spring 1977.

BURDEN, Chris. _Garcon, Shadow, Natural Habitat._ Flash Art, January/February 1977.

_____. Garcon, Hanson Fuler Gallery._ La Mamelle, Art Contemporary, Vol. 2, No. 2/3 1977.

(CALAGUIAN, Virgil). _Four for Virgil - reviews by Guy Brett, Robert Tai, Emmanuel Cooper and Robbie Kravitz._ Readings No. 1, February 1977.

CAVELLINI. _Museo Ferrara._ Flash Art, June/July 1977.

CHAIMOWICZ, Marc. _Performance - Report on Dan Graham, Kevin Atherton._ Studio International, January/February 1977.

_____. Reviews of Furlong/McLean, Paul Neagu._ Studio International, March/April 1977.

COLETTE. Flash Art, November/December 1977. (Interview)

COUM. _34 Missions._ Flash Art, January/February 1977.

DE JONG, Constance. _Notes on Modern Love._ Readings No. 1, February 1977.

DIMITRIJEVIC, Nena. _Berlin: New York in Europe and Downtown Manhattan, SoHo._ Studio International, January/February 1977.

DUNN, Peter. _Marc Chaimowicz and Ron Haselden._ Studio International, January/February 1977.

DIMITRIJEVIC, Nena. _Interview with Yvonne Rainer._ Flash Art, March/April, 1977.

EPP, Elli and Will Milne. _Tuning Up, Annabel Nicholson._ Readings No. 1, February 1977.

FEINGOLD, Michael. _Unlayering Wilson's Cortex._ Village Voice, June 13 1977. (Robert Wilson's _I was sitting on my patio this guy appeared I thought I was hallucinating_)

FOREMAN, Richard. _How I write my(self: plays)._ December 1977. The Drama Review, December 1977.

FORTI, Simone. _Big Room._ Flash Art, March/April 1977.

FOX, Terry Curtis. _The Quiet Explosions of JoAnne Akaloitis._ Village Voice, May 23 1977. (Colette)

FRANK, Peter. _Stuart Sherman: Spectacles, Open Space Theatre._ Artforum, Summer 1977.

GOLDBERG, Roselee. _New York: Performance at P.S.1. and Artist's Space._ Studio International, January/February 1977.

GOULD, Norman. _Performance, Oregon Dunes._ La Mamelle, Art Contemporary Vol.2, No. 2/3 1977.

HARRISON, Margaret. _Notes on Feminist Art in Britain 1970-1977._ Studio International, May 1977.

JOWITT, Deborah. (Simone Forti). Village Voice, January 3 1977.

_____. Hot Weeks on the Concert Circuit._ May 23 1977. (Douglas Dunn's _Lazy Madge_)

_____. Fall, You Will Be Caught._ Village Voice, September 5, 1977. (Conference on Contact Improvisation)

_____. Laura Dean: Slowly Catching Fire._ Village Voice, November 14 1977.

_____. No One Knows How Souls Move._ Village Voice, November 14 1977. (Steve Paxton, David Moss: _Backwater_)

_____. Somebody Take that Dancer's Pulse._ Village Voice, November 21 1977. (Lucinda Childs)

KAPROW, Allan. _Participation Performances._ Artforum, March 1977.

KENT, Sarah. _Engendering Self-Respect._ Studio International, May 1974.

KLAUKE, Jurgen. _In the Shadow of the Cathedral._ Flash Art, November/December 1977.

KNIZAK, Milan. (Interview) Flash Art, March/April 1977.

KRID, Dr. N. _Reindeer Werk at Film Co-Op._ Readings No. 1, February 1977.

LEVINE, Edward. _In Pursuit of Acconci._ Artforum, April 1977.

LIPPERT, Werner. _Alternatives from New York._ Flashart, March/April 1977.

MILLER, Roland and Shirley Cameron and Clive Robertson. _Deux Attitudes._ Virus 1977.

MILNE, Will. _Modern Love: Constance de Jong at the Women's Free Art Alliance._ Readings No. 1, February 1977.

MUNK, Erika. _Foreman Pushes Theatre Shifts._ Village Voice, March 21 1977. Richard Foreman

NEAGU, Paul. _Gradually Going Tornado._ Readings No. 2 1977.

NICHOLSON, Annabel. _Paul Berwell: The Museum of Illegal Medicine._ Readings No. 1, February 1977.

ORD, Douglas. _Geek/Chic or All Dressed Up And_

Nowhere To Go. Only Paper Today, July 1977. (David Buchan)

ORRIDGE, Genesis P. The Dormant Virus of Art, Or Linear Genetics of Thee Media. Virus 1977.

OWENS, Craig. Einstein on the Beach, The Primacy of Metaphor. October 4, Fall 1977.

PERLBERG, Deborah. Eleanor Antin: The Angel of Mercy. Artforum, April 1977.

ROBERTSON, Clive. The Constructivism of Clive Robertson as Joseph Beuys. Queen Street Magazine, Spring/Winter 1976/1977.

SKOGGARD, Ross. Geoffrey Hendricks at Rene Block Gallery. Artforum, March 1977.

_____. Poppy Johnson performance at Castelli. Artforum, March 1977.

STELTNER, Elke. Elke Steltner talks to David Buchan.- Geek Chic. Only Paper Today, July 1977.

TICKNER, Lisa. Kate Walker, Death of a Housewife. Studio International, May 1977.

WHITMAN, Robert. Light Touch. October 4, Fall 1977.

WILSON, Bruce. Dick Higgins at A Space. Spill February 1977.

WILSON, Robert. I thought I was hallucinating. The Drama Review, December 1977.

1978

ANON. Post Avant-Garde Performances: Stran Amore's City Lights, La Gaia Scienza, Il Carrazone's Presages of the Vampire. The Drama Review, March 1978.

ANDERSON, Laurie. Autobiography: The Self in Art. Art-Rite, No. 19, June/July 1978.

BANES, Sally. David Gordon, or, The Ambiguities. The Village Voice, May 1 1978.

_____. Simone Forti: Out of the Kinesthetic Rut. The Village Voice, September 4 1978.

BARTOLUCCI, Guiseppe. The Post Avant-Garde: an Auto-Interview. The Drama Review, March 1979.

BARBER, Bruce. The Terms: Limits to Performance. Centerfold, September 1978.

BIENVENUE, Marcella. John Oswald: In Between the Stations. Centerfold, April 1978.

BLUMENTHAL, Eileen. On Structure, Song and the 70s. The Village Voice, June 12 1978. (Meredith Monk: The Plateau Series)

CALAS, Nicolas. Bodyworks and Porpoises. Artforum, January 1978. (Acconci, Burden, Fox, Beuys, Schwartzkogler)

CELANT, Germano. Simone Forti. Parachute No. 11, Summer 1978.

CHITTY, Elizabeth. Demo Model. Spill No. 12, 1978.

FILLIOU, Robert. Transcript: The Gong Show Tape. Centerfold, April 1978.

FISCHER, Hal. Antfarm. Artforum, September 1978.

_____. Randy and Bernicci. Artforum, September 1978.

_____. The Beeldend Group. Artforum, November 1978.

_____. Daryl Sapien. Artforum, November 1978.

_____. Winston Tong. Artforum, 1978

FOREMAN, Richard. 14 Things I Tell Myself When I Fall Into The Trap Of Making The Writing Imitate "Experience". Semiotexte, Vol. 3, No. 2.

FROEHLICH, Peter and Spanish Eddy. Blurbs. Parachute No. 12, Fall 1978. (Discussion of the Performance Art Festival, Musée des Beaux Arts de Montréal)

GALBRAITH, Elinor. Meredith Monk/The House. Spill No. 10, 1978.

GRAEVENITZ, Antje.Von. Ben d'Armangac. Excerpts from an Interview. Dutch Art and Architecture Today.

JOHNSON, Tom. The Kitchen Grows Up. The Village Voice, June 5 1978. Phil Glass, Laurie Anderson, Meredith Monk, Robert Ashley, Steve Reich.

JOWITT, Deborah. Mediating Between Sky and Ground. The Village Voice, March 27, 1978. (Laura Dean)

_____. In and Out of Bounds. The Village Voice, May 15, 1978. (Douglas Dunn's Rille)

_____. Trisha Brown's Reckless Again. The Village Voice, May 22, 1978.

_____. (David Gordon/Pick Up Company: Not Necessarily Recognizable Objects). The Village Voice, May 29 1978.

_____. Not All Explosions are Violent. The Village Voice, June 12 1978. (Trisha Brown)

_____. Tempt Me With Simplicity. The Village Voice, June 26, 1978. (Meredith Monk's Plateau No 3, No 2)

_____. Lucinda Childs. The Village Voice, November 13 1978.

KEEFE, Jeffrey. Guy de Cointet and Bob Wilhite at the California Institute of Technology. Artforum, January 1978.

LORBER, Richard. Max Newhans, Times Square. Artforum, January 1978.

LOTRINGER, Sylvère. Douglas Dunn Interview. Semiotexte, Vol 3, No. 2, 1978.

_____. Robert Wilson Interview. Semiotexte, Vol 3, No. 2, 1978.

_____ and Bill Hellerman. Phil Glass Interview. Semiotexte Vol 3, No. 2, 1978.

LARSON, Kay. Jarry Amplified, Vicious Video'd. The Village Voice, October 9 1978. (Videocabaret)

_____. ...and Timid Performance Art. The Village Voice, November 6 1978. (Stephen Laub, Mary Overlie, Aileen Schloss, Meyers)

MAYS, John Bentley. Should Karen Ann Quinlan Be Allowed To Die? Only Paper Today, February 1978. (Hummer Sisters)

MUNK, Erika. A Dog's Life. The Village Voice, March 6, 1978. (Mabou Mines' The Shaggy Dog Animation)

NYEBOE, Ingrid. The Shaggy Dog Animation. The Drama Review, September 1978.

POLITI, Helena Kontova. Flash Art Performance. Flash Art 82,83/May/June 1978.

_____. Flash Art Performance. Flash Art 84,85/October/November 1978.

_____. Interview with Marc Chaimowicz. Flash Art 84.85/October/November 1978.

RACINE, Rober. Festival de Performances du MBAM. Parachute No. 13/Winter 1978. Performance Art Festival, Musee des Beaux Arts.

_____. Tele-Performances/Toronto. Parachute No. 13, Winter 1978.

RAMSDEN, Ann. It aint what you make, its what makes you do it, An Interview with Dennis Oppenheim. Parachute, Winter 1978.

RANDY AND BERNICCI. Soap Burns. Inprint, January/February 1978.

ROBERTSON, Clive. Laurie Anderson. Centerfold, December 1978.

_____. Pirhania Farms. Centerfold, December 1978. (Eric Metcalfe, Jane Ellison, Hank Bull)

PERLBERG, Deborah. Martha Wilson, Story Lines, The Kitchen, Jacki Apple, 112 Greene Street. Artforum, February 1978.

_____. Ann Wilson's Butler's Lives of Saints. Artforum, March 1978.

_____. Stuart Sherman, The Tenth Spectacle. Artforum, May 1978.

PERRON, Wendy. Dumb Art: Beautiful but not too bright. Village Voice, January 2, 1978.

PONTBRIAND, Chantal. Interview with Yvonne Rainer. Parachute 10, Spring 1978.

SOMMER, Sally. Mary Overlie: Enigmatic Witness. The Village Voice, June 12 1978

VIDEO CABARET. Only Paper Today. Vol. 5, No. 3, April 1978. (Hummer Sisters, The Government, Michael Hollingsworth, Randy and Bernicci)

WEBB, D. Geek Chic Performance at Artspace, Peterborough. Inprint, January/February 1978. (David Buchan)

314 WONG, Paul. Extreme Skin and True Bond Stories.

Performance by Elizabeth Chitty at A Space. Spill, January 1978.

SPECIAL ISSUES

ART AND ARTISTS JANUARY 1973. Actions and Performances Issue.
Dan Graham - Interview with Simon Field, Douglas Hubler - Klaus Honnef, Art for Whom? - David Medalla Interviewed by Alastair MacIntosh, Terry Fox: Himself - Tom Marioni.

ART CONTEMPORARY: LA MAMELLE SPRING 1976.
Clive Robertson, Peter D'Agostini, Tom Marioni, Nancy Buchanan, Terry Fox, Bonnie Sherk, Lynn Hershman, Monte Cazazza, Soon 3 - Alan Finnerman, Linda Montano, Anna Banana/ Dadaland, T.R. Uthco, Jeffrey Abouaf - Performer's Rights and Performance Art.

ART CONTEMPORARY: LA MAMELLE VOL 2, NO 4 1977
Performance 1976 Issue.
Documentation of Performances by: Susan Wick, Margaret Fischer, Alan Finnerman, Phil Deal, Stefan Weisser/Ishi Sharpe, Paul Cotton, Paul Forte, T.R. Uthco, Nina Wise, Hesh Rosen, MOTION/The Women's Performing Collective, Jack Reynolds, Carl E. Loeffler, Kevin Costello, Woffy Bubbled and Mr. E., Dana Atchley, Norman Gould, Willoughby Sharp, Terry Sendgraft, Peter Wiehl, Martha Wilson, Bay Area Dadaists, Margaret Fisher, John Adams, Virginia Quesada, The Registry, Richard Newton, Joseph Reez, Geoffrey Cook with Dadaland, Richard Alpert, Don Button, Anthony Gnazzo, R. Pritchard et al, Carlos Guttierrez-Solana.

ART RITE NO 10, FALL 1975 Special Performance Issue, edited by John Howell.
David Antin - Warm up, A.R. - Ralston Farina, John Howell - A Few Things We Know About Her, Jeremy Gilbert-Rolfe - Performance: A Comment from Outside, John Howell - Performance: State of the Art in Arts, Walter Robinson - The Chorus Line: Role, Style, Media, John Howell - Dance: Orderly Pleasures, Diego Cortez - Notes on Painter/Patient Performance, Not Realized, Charlemagne Palestine - Untitled.

AVALANCHE 6, FALL 1972. Vito Acconci Issue.
Introduction - Notes on Performing A Space, Early Work - Movement over a Paper, Early Work - Moving My Body into Place, Body as Place - Moving in on Myself: Performing Myself, Peopled Space - Performing Myself through Another Agent, Occupied Zone - Moving In: Performing on Another Agent, Concentration - Container - Assimilation Power Field - Exchange Points - Transformations - Excerpts from the Tapes with Liza Bear. Biography, Bibliography, Index.

CENTERFOLD, DECEMBER 1978. Teleperformance.
Peggy Gale - Elizabeth Chitty: Demo Model, Jo Anne Birnie Danzker- General Idea: Towards an Audience Vocabulary, Rene Blouin - Tom Sherman: See the Text Comes to Read You, Vera Frenkel - Clive Robertson: A Beuys-Shaped Frame,

Colin Campbell - David Buchan: La Monte del Monte and the Fruit Cocktails, Glenn Lewis - Dennis Tourbin: In Conversation with a Diplomat, Nancy Nicol - Marshalore: Another State of Marshalore, Rober Racine - Jean-Francois Cantin: Propos Type (French Text), Paul Wong - Daniel Dion and Daniel Guimond: Extra Regle/ Extra Rule, Randy and Bernicci - Centre of a Tension, Willoughby Sharp How I Lost My Video Virginity to the Hummer Sisters, Tom Sherman and Clive Robertson - The Government: Electric Eye.

THE DRAMA REVIEW, SEPTEMBER 1972. The New Dance Issue.
Introduction by Michael Kirby, Karen Smith - David Gordon's The Matter, Steve Patton - The Grand Union, Sally Sommer - Equipment Dances: Trisha Brown, Janelle Reiring - Joan Jonas' Delay Delay.

THE DRAMA REVIEW, MARCH 1972. Performance at the Limits of Performance.
Vito Acconci - Works, Adrian Piper -Catalysis, Scott Burton - Self Works, Mark Long - Yellow Suitcases, Stephen E. Will - Street Works at Noon, Alain Arais Misson - A Madrid.

THE DRAMA REVIEW, MARCH 1975. Post-Modern Dance Issue.
Noel Carroll - Air Dancing (Batya Zamir, Stephanie Ivanitsky), Joan Jonas - Seven Years, Trisha Brown - Three Pieces, Lucinda Childs - Notes 64 - 74, Simone Forti - A Chamber Dance Concert, Steve Paxton -Contact/Improvisation, David Gordon - Its About Time, Allan Kaprow - Take Off: An Activity in Geneva, Dorothy S. Pam - The New York Apparition Theatre of Ken Jacobs, Kate Davy - Pandering to the Masses: A Misrepresentation, Richard Foreman's Ontological Theatre.

FLASH ART, FEBRUARY/APRIL 1978. Danger in Art.
Jundrich Chalupecky - Art and Sacrifice, Sarah Kent - Stuart Brisley: excerpt from an Interview, Helena Kontova - Interview with Marina Abramovic/Ulay, Francois Pluchart - Risk as a Practice of Thought. Artists Contributions By: Gina Pane, Peter Weibel, Petr Stembera, Helmut Schober, Paul Buck, Coum Transmissions, Mike Parr, Stelarc, Klaus Boagel and Holt Appels. Miscellaneous Performance Review Section.

HIGH PERFORMANCE VOL 1, NO. 1, 1978
Suzanne Lacy - Three Weeks in May and A Woman's Street Life: Interview with Suzanne Lacy, Moira Roth Interviews Norma Jean DeAK. Artist's Chronicle: BDR Ensemble - Station Event, Nancy Buchanan - Meager Expectations, Brian Daley - Vice, Tony Delap - Florine, Child of the Air, Jurgen Klauke - Ritual Trinken, Alison Knowles - The Shoemaker's Assistant, Paul McCarthy - Grand Pop, Richard Newton - Touch a penis with the former Miss Barstow, Gina Pane - Action Laure, James Pomeroy/Paul de Marinis - a Byte at the Opera, Darryl Sapien/Constancia Vokeitaitis - The Principal of the Arch, Jill Scott - The Side of a Warehouse, Barbara Smith -

Ordinary Life, Bradley Smith - Roll, Richard Turner/D. Gattin - Forbidden Colours, Robert Wilhite - Sculpture.

HIGH PERFORMANCE VOL 1, NO 2, JUNE 1978
Performance Interruptus: Interview with Paul McCarthy, Moira Roth interviews Darryl Sapien. Artists' Chronicle: Bob and Bob - Brace Your Yourself for Action, Nancy Buchanan - Deer Dear, Theresa Cha - Reveille dans la Brume, Lowell Darling - One Thousand Dollar a Plate Dinner, John Duncan/Cheri Gaulke - Connecting Myths, Cheri Gaulke - Talk Story, Kim Jones - Telephone Pole, Leslie Labowitz/WAVAW - Record Companies Drag Their Feet, Richard Newton - Last engagement of the former Miss Barstow, Gina Pane - A Hot Afternoon, Rachel Rosenthal - The Head of Olga K, Martha Rosler - Traveling Garage Sale, Peter Wiehl - Arrowcatchers, Martha Wilson - Story Lines.

HIGH PERFORMANCE NO. 3 SEPTEMBER 1978
Jim Moisan - Interview with the Kipper Kids, Nancy Buchanan - Interview with Hermann Nitsch. Francis Brown, Claudia Chapline, Judith Barry, Tom Jenkins, Linda Evola, Laura Selagy, Dennis Hathaway, Paul Sutinen, Barbara Smith, Suzanne Lacy. Jose Maria Bustos, Karen Jossel, Richard Newton, Stephen Seemayer, Bill Gordh/John Malpede, The Waitresses, Vanalyne Green, Feminist Art Workers, Randy and Bernicci, Roy Arden, Gerhard Theewen, Jerry Benjamin, Claire Fergussen, Red and the Mechanics, Paul Maurice Best, Michel Cardena, Donna Jenez.

HIGH PERFORMANCE NO. 4, DECEMBER 1978
Moira Roth - Interview with Linda Montano, Linda Montano - Mitchell's Death, Dead Dog and Lonely Horse - Adventures in Art, Jim Moisan - Interview with Petr Stembera Artists' Chronicle: Miroslav Klivar, Steven Durland, Mother Art, Jurgen Klauke, Peter D'Agostino, Michael J. Berkowitz, X. Marine, Gina Pane, Alzek Misheff, Richard Newton, Paul McCarthy.

NEW PERFORMANCE VOL 1, NO 1 FALL 1977
Bill Irwin and Michael O'Conner - Brief Reflections on New Theatre, Irene Oppenheim - On Criticism, Pamela Quinn - Conversations on Contact: An Interview with Mangrove, Doug Skinner - Personal Remarks from an Appreciation of Socrates, Nancy Walter - Unexpected Encounters.

OBERLIN COLLEGE BULLETIN SPRING 1973

STUDIO INTERNATIONAL JULY/AUGUST 1976.
Richard Cork - Editorial, Hugh Adams - Against a Definitive Statement on British Performance Art, Douglas Crimp - Joan Jonas's Performance Works, Katia Tsiakna - Hermann Nitsch: A Modern Ritual, Caroline Tisdall - Stuart Brisley and Marc Chaimowicz Roselee Goldberg with Laurie Anderson and Julia Heyward and Adrian Piper - Public Performance: Private Memory, Shirley Cameron - Why So Far and No Further?, Roland Miller - Description of MyWork, Kate Davy - Richard Foreman's Theatre, Marc Chaimowicz - Interview with Sally Potter: Women and Performance in the UK, Caroline Tisdall - Beuys: Coyote, Mark Segal - Yvonne Rainer: A Mirror to Experience, Genesis P. Orridge and Peter Chris

topherson - Annihilating Reality, Antje Von Graevenitz - Then and Now: Performer's Art in Holland, Rose·ee Goldberg - Performance: The Art of Notation, George Jappe - Performance in Germany and Interview with Klaus Rinke and Interview with Franz Erhard Walther.

BOOKS

ABRAMOVIC, Marina & Ulay. Relation in Space. Venice:Cavallino, 1976.

_____. Three Performances. Graz/Insbruck: Galerie H/Galerie Krinzinger, 1978.

ACCONCI, Vito. Think/Leap/Re-Think/Fall. Dayton: University Art Gallery, Wright State University, 1976.

ALLIATA, Vicky. (ed.) Einstein on the Beach. New York: EOS Enterprises, 1978.

ART AS LIVING RITUAL. N.p.: Horst Gerhard Haberl, 1974. (Includes Acconci, Burden, Girouard, Wilke)

BATTCOCK, Gregory. (ed.) Minimal Art: A Critical Anthology. New York: H.P. Dutton, 1968.

BEUYS, Joseph. 1A Gebratene Fischgrate. Berlin: Edition Hundertmark, 1972.

BRECHT, George and Robert Filliou. Games at the Cedilla, or the Cedilla Takes Off. New York: The Something Else Press, 1968.

BURDEN, Chris. B-Car. N.p.: Choke Publications, 1977.

CHRIS BURDEN 1971-1973. N.p.: Published by Chris Burden, 1974.

CHRIS BURDEN 1974-1977. N.p.: Published by Chris Burden, 1978.

BUREN. Daniel. Legend. Two Vols. London: Warehouse Publications, 1973.

BURNHAM, Jack. Great Western Saltworks, Essays on the Meaning of Post-Formalist Art. New York: Braziller, 1974.

CELANT, Germano. Precronistoria 1966-1969. Florence: Centro Di, 1976.

CHIARI, Guiseppe. Musica Madre. Milan: Giampaolo Prearo Editore, 1973.

_____. Teatrino. Brescia: Banco, Ed. Nuovi Strumenti, 1974.

_____. Senza Titolo 1971. Milan: Edizione Toselli, 1972.

DAVEY, Kate. (ed.) Richard Foreman: Plays and Manifestos. New York: The New York University Press, 1976. (Drama Review Series)

DIACONO, Mario. Vito Acconci. N.p.: Out of London Press, 1975.

FILLIOU, Robert. Teaching and Learning as Performing Arts. Cologne: Verlag Gebr. Koenig, 1970.

FORTI, Simone. Handbook in Motion. N.p.: The Press of the Nova Scotia College of Art, 1974.

GOLDBERG, Roselee. Performance: Live Art 1909 to the Present. London/New York/Paris: Thames and Hudson/Harry Abrams/Edition de Chene, 1979.

GRAHAM, Dan. Dan Graham. London: Lisson Publications, 1972.

GUERILLA ART ACTION GROUP. GAAG. New York: Printed Matter, 1978.

GUERILLA ART ACTION GROUP. GAAG. New York: Printed Matter, 1978.

HANSEN, A.C. The Art of Time/Space. New York: Something Else Press, 1965.

HENDRICKS, Geoffrey. Between Two Points. Reggio Emilio: Edizioni Pari e Dispari, 1975.

HOWELL, Anthony and Fiona Templeton. Elements of Performance Art. London: n.p., 1976.

H.P. H.P. in a Pickle. Vancouver: H.P., 1974. (an edition of thirty copies)

INGA-PIN, Luciano. Performance - Happenings, Actions, Events, Activities, Installations. N.p.: Mastrogiacomo Editore Publisher, 1978.

KAPROW, Allan. Assemblage, Environments, Happenings. New York: Harry Abrams, 1966.

Kirby, Michael. Happenings. New York: E.P. Dutton, 1966.

_____. The New Theatre: Performance Documentation. New York: NYU Press, 1974. (Reprint from the Drama Review Series)

KUBISCH, Christina. Works 74/75. N.p.: Giancarlo Politi Editore, 1977.

LIPPARD, Lucy. Six Years: The Dematerialization of the Art Object. London: Studio Vista, 1973.

LIVET, Anne. (ed.) Contemporary Dance. New York: Abbeville Press, 1978.

McLEAN, Bruce. King for a Day and 999 other pieces/works/things/etc. London: Situation Publications, 1972.

MEYER, Ursula. Conceptual Art. New York: E.P. Dutton, 1972.

MITCHELL, John and Vincent Trasov. The Rise and Fall of the Peanut Party. Vancouver: AIR, 1976.

N.E. THING CO LTD. N.E. Thing Co. Ltd., Volume One. Vancouver: n.p., 1978.

NITSCH, Hermann. 1,2,3 uf 5 Abreaktionspiel/ Konig Odipus/Fruhe Aktionen. In Three Volumes. Naples: Edizioni Morra, 1978.

_____. Orgien Mysterien Theatre. Darmstadt: Marz Verlag, 1969.

_____. Das Orgien Mysterien Theater 2. Naples: Edizioni Morra, 1976.

OLIVA, Achille Bonito. Europe/America: The Different Avant Gardes. N.p.: Deco Press, 1976.

_____. 91 Territorio Magico. Florence: Centro Di, 1972.

PINCUS-WITTEN, Robert. Postminimalism. Torino/New York: Out of London Press, 1977.

POLISH ART COPYRIGHT. N.p.: Author's Agency, 1975. (Includes Haka, Lachowicz, Ll, and Sosnowski)

RAINER, Yvonne. Work 1963-1973. Halifax: The Nova Scotia College of Art and Design Press, 1974.

REINDEER WERK. ...for the development of Behaviourism. Reindeer Werk, November 1976.

_____. M. Yek, N. Krid at Today's Place, Antwerpen. Antwerp: Today's Place, 1978. (an Edition of 200 numbered and signed)

RINKE, Klaus. Time Space Body Transformation. N.p.: Kunsthalle Tubingen, 1972.

SCHNEEMAN, Carolee. Cezanne she was a great painter. New York: (Privately Published), 1975.

_____. Up To and Including Her Limits. New York: (Privately Published), 1975.

SHATTUCK, Roger. Alienation. New York: Doubleday, 1971.

SONDHEIM, Alan. Individuals: Post-Movement Art in America. New York: E.P. Dutton, 1977.

TISDALL, Caroline. Joseph Beuys Coyote. Munich: Schirmer/Mosel, 1976.

VERGINE, Lea. Il Corpo come Linguaggio : La Body Art e Storie Simili. Milan: Giampaolo Prearo, 1974.

VOSTELL, Wolf. Happening und Leben. LDS Luchterland Typeskript.

_____. Wolf Vostell. Berlin: Galerie Rene Block, 1969.

WILSON, Robert. A Letter For Queen Victoria. Paris: Byrd Hoffman Foundation, 1974.

WORKS. A Conceptographic Reading of Our World Thermometer. Calgary: W.O.R.K.S., 1973.

_____. W.o.r.k.s.c.o.r.e.p.o.r.t. Calgary: W.O.R.K.S., 1975.

YOUNG, La Monte. and Jackson MacLow. An Anthology. New York: Heiner Freidrich, 1963, 1970.

CATALOGUES

ABROMOVIC, Marina. Zagreb: Galerija Suvremene Umjetnoste, 1974.

ACCONCI, Vito. Lucerne: Kunstmuseum, 1978.

ASPECTS of Polish Modern Art. Warsaw: Galeria Wspolczesna, 1974.

BEUYS, Joseph. Stockholm: Moderna Museet, 1971.

BURDEN, Chris. Do You Believe in Television? Calgary: Alberta College of Art, 1976.

BURTON, Scott. Pair Behaviour Tableaux. New York: The Solomon R. Guggenheim Museum, 1976.

CHIARI, Giusseppe. Video-Concert. Paris: ARC, Musee d'Art Moderne de la Ville de Paris, 1976.

FILLIOU, Robert. Der 1,000,010 Geburtstag der Kunst 17 Januar, 1973. Aachen: Neue Galerie im Alten Kurhaus, 1973.

FLUXSHOE Add end a 1972 - 1973. Cullompton: Beau Geste Press, 1973.

FLUXSHOE. Cullompton: Beau Geste Press, 1972.

GENERAL IDEA. The 1970 Miss General Idea Pageant. Toronto: General Idea, 1970.

_____. Miss General Idea. Toronto: General Idea, 1971.

GRAHAM, Dan. Dan Graham. Basel: Kunsthalle, 1976.

HORN, Rebecca. Rebecca Horn/Zeichnungen, Objekte, Fotos, Video, Filme. Cologne: Kolnischer Kunstverein, 1977.

KUNST Bleibt Kunst Projekt 1974. Cologne: Wallraf-Richartz-Museum, 1978.

NITSCH, Hermann. Action 48-Paris 1975. Paris: Galerie Stadler, 1975.

_____. Zaichnungen. Innsbruch: Galerie Krinzinger, 1976.

PAIK, Nam June. Werke 1946-1976. Musik-Fluxus-Video. Cologne: Kolnischer Kunstverein, 1976.

PARACHUTE. 02-23-03. Montreal: Editions Parachute, 1978.

PERFORMANCE Oggi (Settimana internazionale della performance, Bologna, 1-6 June 1977). Pollenza: La Nuova Foglio, 1978.

PERFORMANCE Art Festival. Cultureel Animatiecentrum Beursschouwberg VZW Brussel, Introduction by Roger D'Hondt, 1978.

PERFORMANCE Seminar, 11/28 - 12/10 1978. Aachen: Neue Gallrie, Sammlung, 1978.

REINDEER WERK. Behavioural Art. Warsaw: Galeria Remont, 1976.

RINKE, Claus. Ex-Hi-Bi-Tion. Oxford: Museum of Modern Art, 1976.

_____. Travaux 1969/1976. Paris: ARC Musee d'Art Moderne de la Ville de Paris, 1976. (introductory essays by Suzanne Page, Evelyn Weiss)

ROBERTSON, Clive. Television: Adjusting the Hold. Calgary: Alberta College of Art Gallery, 1977.

_____. In the Singular. Montreal: Vehicule Art, 1975.

SOHM, Hans. Happenings and Fluxus. Cologne: Kolnischer Kunstverein, 1970.

ULAY. _Fototot_. Zagreb: Galerya Suvremene Um-
jetnoste, 1977.

VOSTELL, Wolf. $\sqrt{40}$ 10 Happening Konzepte 1954
to 1973. Milan: Multhipla Edizioni, 1976.

WEIBEL/EXPORT. _Wien. bildkompendium wienerak-_
tionismus und film. Vienna:Kohnkunstverlag,
1970.

GROUP SHOW CATALOGUES

10e BIENNALE DE PARIS 1977. Laurie Anderson,
Ant Farm, Bruce Barber, Marc Chaimowicz,
Colette, Marco Del Re, Ralston Farina, General
Idea, Tina Girouard, Julia Heyward (Duka Del-
ight), Christina Kubisch, Stuart Marshall,
Jan Mlcoch/Petr Stembara, The Ting (Theatre
of Mistakes), Dragoljub Rada Tosodijevic,
Ulay, William Viola.

DOCUMENTA 5. _Individuelle Mythologien 1 and 2._
Acconci, Arbeitszeit - Anatol Herzfeld, Bert-
ram Weigerl, Joseph Beuys, Gino de Dominicis,
Ger Van Elk, Terry Fox, Howard Fried, Gilbert
and George, Rebecca Horn, Joan Jonas, Yoko Ono,
Dennis Oppenheim, Guiseppe Panone, Vettor Pis-
ani, Klaus Rinke, Franz Erhard Walther.

DOCUMENTA 6. _Joachim Diederichs: Zum Bagriff_
Performance. Laurie Anderson, Ben D'Armagnac,
Jared Bark, Stuart Brisley, Chris Burden, Scott
Burton, Ralston Farina, Tina Girouard, Jurgen
Klauke, Bruce McLean, Antoni Miralda, Gina
Pane, Reindeer Werk, Helmut Schober, H.A.
Schult.

INDEX OF ARTISTS

Other publications from ART METROPOLE:

Colin Campbell. **MODERN LOVE.**
Photos and text from the videotape of the same name. The artist as Robin, punkette, who falls in love with a very modern man, La Monte del Monte, played by David Buchan.
16 pp., 8 in. x 10 1/2 in., paper $2.95. Signed edition of 10 with original photograph $15.00.

Colin Campbell. **THE WOMAN FROM MALIBU.**
Photos and text from the videotape of the same name. Nine self-portraits of the artist as another alter-ego: 'I've always considered myself very modern.'
24 pp., 8 in. x 10 1/2 in., paper $3.50.

General Idea. **MENAGE A TROIS.**
Three men and their single idea: 'What art needs today is a sound (re)-location.' Photos and text.
24 pp., 8 in. x 10 1/2 in., paper $3.50.

General Idea. **S/HE.**
Ten texts, ten photos, concerning artists and models, both male and female.
16 pp., 5 in. x 8 in., paper $2.50

Tom Sherman. **3 DEATH STORIES.**
Three short stories by this artist/writer/performer in his unique visual style: detailed, improbable, precise.
50 pp., 8 in. x 10 1/2 in., paper $5.00. Signed edition of 25, paper $10.00

Lisa Steele. **THE BALLAD OF DAN PEOPLES.**
A unique narration in deep south vernacular: the artist tells a story of her grandfather's childhood in his own voice. This is a transcript from the videotape of the same name. Three photographs.
24 pp., 8 in. x 10 1/2 in., paper $3.50.

VIDEO BY ARTISTS.
Edited by Peggy Gale. Biographies, bibliographies, video listings and artists contributions from Ant Farm, David Askevold, General Idea, Dan Graham, Lisa Steele, Bill Vazan, and ten others. Essays by Les Levine, Dan Graham, Peggy Gale, AA Bronson, Jean-Pierre Boyer. Photoworks by Ant Farm, Askevold, General Idea. Profusely illustrated.
?24 pp., 8 in. x 10 1/2 in., paper $10.00

?y Werden. **PAULI SCHELL.**
 with a sadomasochist, illustrated. A transcript from the videotape of the same name.
 ? x 10 1/2 in., paper $3.50

319

ostage and handling per item.
7 Richmond Street West, Toronto, Canada M5V 1W2.